It's All Allowed
The Performances
of Adrian Howells

D1127654

edited by Deirdre Heddon and Dominic Johnson

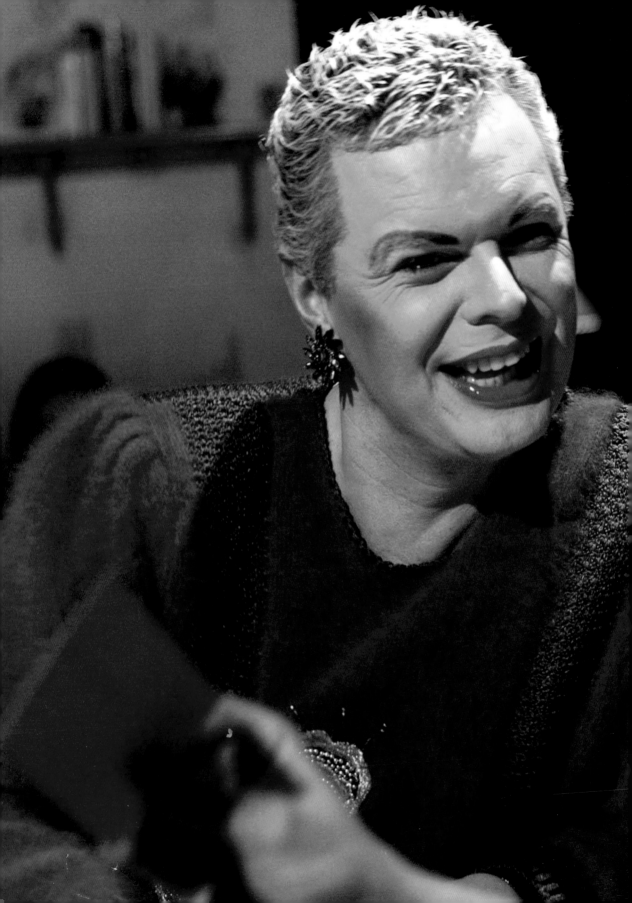

First published in the UK in 2016 by

Live Art Development Agency
The White Building, Unit 7, Queen's Yard
White Post Lane, London, E9 5EN, UK
www.thisisLiveArt.co.uk

and

Intellect, The Mill, Parnall Road,
Fishponds, Bristol, BS16 3JG, UK
www.intellectbooks.com

First published in the USA in 2016 by

Intellect, The University of Chicago Press,
1427 E. 60th Street, Chicago, IL 60637, USA

Edited by Deirdre Heddon and Dominic Johnson, 2016

Contributions © the individual contributors, 2016

Designed by David Caines Unlimited
www.davidcaines.co.uk

Printed and bound by Gomer Press, UK

ISBN 978-1-78320-589-9

ePDF ISBN 978-1-78320-590-5

Published with the support of Creative Scotland, Live Art
Development Agency, Arts Council England, University of Glasgow,
Society for Theatre Research, Battersea Arts Centre, National Theatre
of Scotland, and Queen Mary University of London.

Front cover: Adrian Howells, *The Pleasure of Being: Washing/Feeding/Holding*,
performed at Battersea Arts Centre as part of the One-on-One Festival, 2010.
Photo by Ed Collier. The audience-participant is Deborah Pearson.

Inside front and back cover: Set for Adrian Howells, *An Audience
with Adrienne*, Singapore, 2009. Photo by Dan Prichard.

Previous page: Adrian Howells, *An Audience with Adrienne: Her Summertime
Special*, performed at Drill Hall, London, 2007. Photo by Robert Day.

Overleaf: Adrian Howells in a studio shoot for publicity images towards *Held*,
which were first used in the version performed at Fierce Festival, Birmingham,
2007. Photo by Niall Walker.

Intellect Live

*It's All Allowed: The Performances of Adrian
Howells* is part of Intellect Live – a series of
publications on influential artists working at
the edges of performance. Intellect Live is a
collaboration between Intellect Books and
the Live Art Development Agency. The series
is characterised by lavishly illustrated and
beautifully designed books, each of which is
the first substantial publication dedicated to
an artist's work.

Series Editors: Dominic Johnson,
Lois Keidan and CJ Mitchell.

ISSN 2052-0913

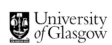

For Adrian

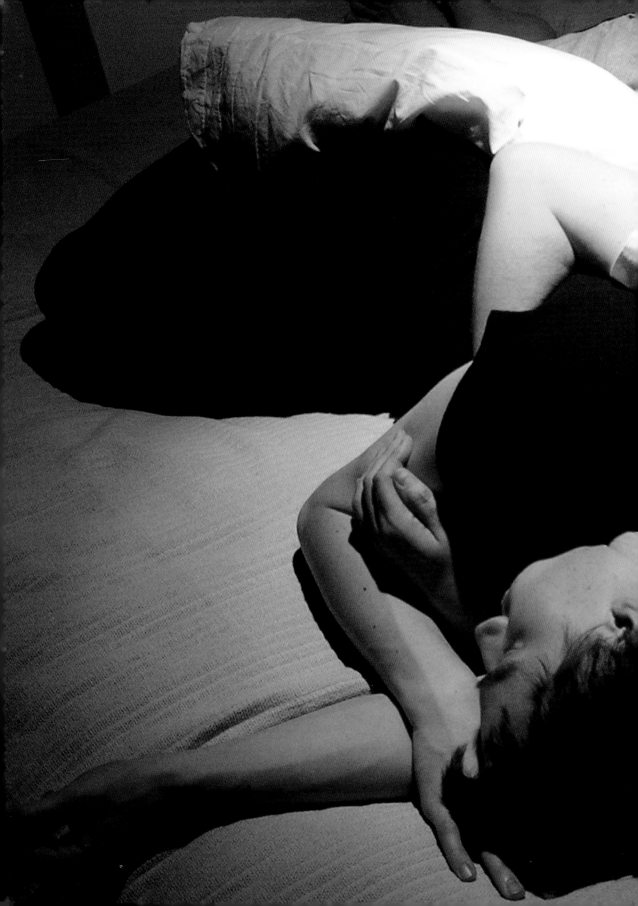

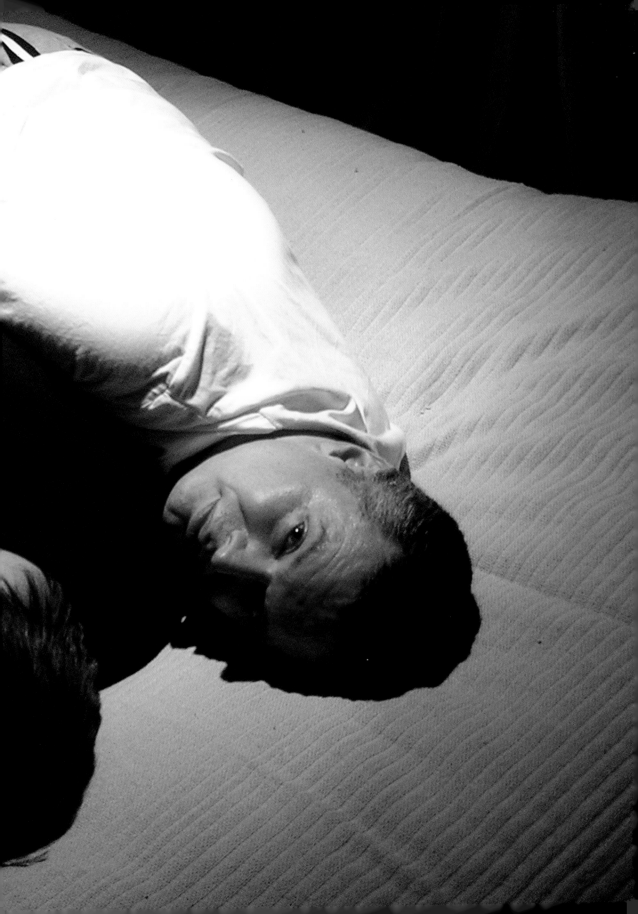

Contents

Introducing the Work of Adrian Howells

Deirdre Heddon and Dominic Johnson

Adrian Howells was an artist whose central imperative, across a range of performance strategies and forms, was to create intimate, immersive, and transformative encounters with others. He privileged the possibility of direct, immediate, authentic experiences, though he was aware of the seemingly insurmountable impediments that representation, theatricality, and mediation impose for such ambitions. To undertake a performance with Howells as an 'audience-participant' (his preferred term) was to be inducted into an experiment regarding the nature of the encounter.[1] Encounters with Howells in performance took place in a thoroughly mediated form, complete with elaborate sets and detailed settings where – even when an appropriated venue was used, such as a hair salon, hotel room, or laundry room – every item that featured in the performance had been carefully chosen for its aesthetic and affective appeal. In spite of this mediation, Howells succeeded in giving an impression of immediacy (or non-mediation) through his concentrated focus and attention on the individual moment of encounter. Whether spooning an audience-participant on a bed, or bathing, feeding, or holding one, washing one's hair or feet, Howells' encounters were rigorously planned and simultaneously, forcefully open to negotiation, challenge, and change.

Frequently choosing to distil the experience of the theatre to a one-to-one encounter, or other pressingly responsive forms, Howells would devise performance situations of 'accelerated friendship' that were often powerfully affecting and responsive to contemporary conditions of living.[2] Howells' one-to-one performances – for which he is perhaps best celebrated – were directed towards the singular experiences of others. Yet these one-to-one performances, like the performances for larger audiences that he continued to make throughout his life, were also conspicuously provoked by his own personal questions – about love, intimacy, wellbeing, and learning, and the impediments life poses to these goals. His performances were therefore concerned fundamentally with care, safety, generosity, affirmation, and pleasure. Such affirmative aspirations were nevertheless tempered, in performance, with

Previous page: Adrian Howells in a studio shoot for Nigel Charnock + Company, ca. 1996-97. The shoot took place for publicity towards a performance – likely *Love, Sex and Death* (1997). Photo by Hugo Glendinning.

Opposite: Adrian Howells, *Lifeguard*, performed at Govanhill Baths, Glasgow, 2012. Co-produced by National Theatre of Scotland, The Arches and Govanhill Baths Community Trust. Photo by Simon Murphy, courtesy of National Theatre of Scotland.

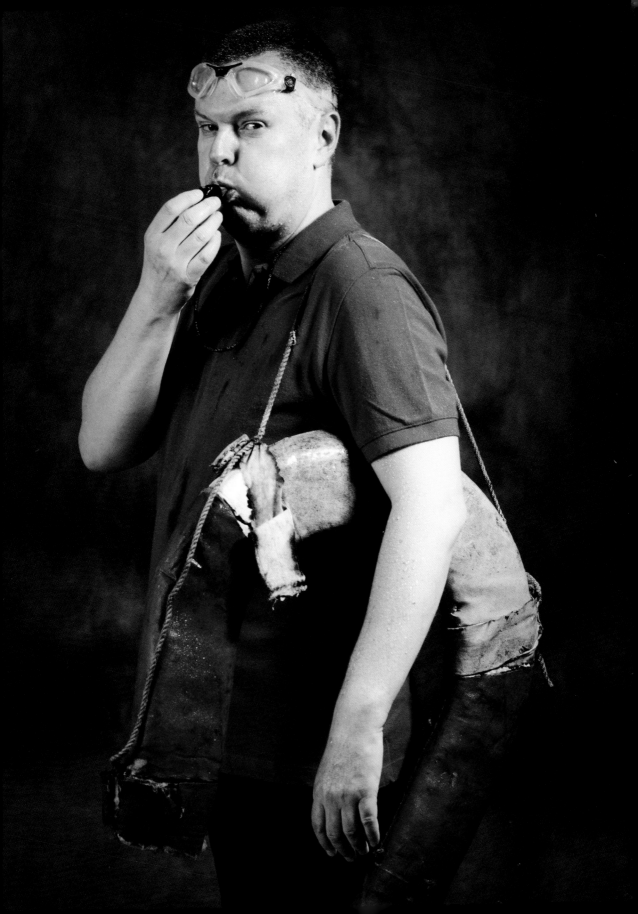

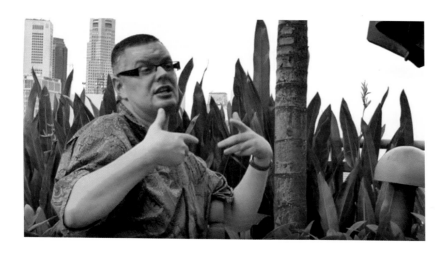

discomfort, embarrassment, risk, and grief, as sometimes-unwelcome effects of
the practice of personal and intimate exposure. Howells' finely tuned calibration
of the pre-set and the improvised left space precisely for the appearance or
eruption of unanticipated effects, delivering a form that bore the potential to
admit sophisticated insights into what it means to be together with another
person in a social relation, to be connected, and, outside that provisional
relation, what it means to be thrown back upon oneself once again, alone.

Howells' personal warmth and caring orientation to others was a profound
factor in the design of his performed encounters, and also the catalyst for the
political ramifications of his work. The politics of these ramifications were
perhaps not always evident to Howells himself; it was as if the tenderness
central to his practice served to veil, for him at least, the real political work
that it was doing. Talking in Singapore, for a candid video recorded by the
British Council, Howells explains to Dan Prichard the structure of feeling that
conditions his outlook in and beyond performance. He says,

> I can't bear the fact that so many people literally carry around this
> weight of shame and guilt about things they've done in their lives. I
> know I don't want to feel bad about things I've done in the past, and I
> don't want other people to feel bad. I kind of feel that what I'm doing
> is almost like a collective catharsis. A *global* catharsis – that's what I'm
> after, that's what I'm interested in [*laughter*].[3]

In this interchange, Howells is clear here about the ethical or moral imperatives
of his work, which is seemingly founded on its potential for catharsis, or the
purgation through the aesthetically controlled incitement or production of
emotional intensities. He begins in serious terms, explaining what might
appear to be a uniformly 'feelgood' figuration: 'I don't want other people to

Above: Adrian Howells in a still from a video interview with Dan Prichard at Lasalle College of
the Arts, Singapore, 2010. The video was recorded by Nicholas Chee and commissioned by the
British Council in Singapore to accompany a performance of *Foot Washing for the Sole*.

feel bad'. In a characteristic move, he gets partly carried away with his mission, and the claim for the reach of his intervention falls apart under the weight of his good-hearted-ness, prompting his own warm laughter.

The final sensibility he demands in the sequence – a *global* catharsis' – is tonally both serious and laughable, for Howells. Laughable or not, it is a sentiment that many of us may aspire to, even if only the most ambitious of romantics lay claim to it in words. Quentin Crisp writes, 'If being in love involves laying bare one's body and soul to one person, then I am in love with the world and my whole life is a slow and often interrupted wooing of the human race'.[4] Crisp was the mother of all gay raconteurs, and the kind of ribald, camp figure with whom Howells would likely have identified in some ways (akin to his other stated influence, the drag artist Danny La Rue). Like Crisp's universal ambition, Howells *means it*, as an ineffable, impossible feat he sets himself as the project of his life's work. Both pioneers are able to laugh at their own sudden grandiosity: at the improbability of the challenge – unconditional love, global catharsis – and the implicit silliness or narcissism of their personal ambition. Winking aside, the point of Howells' claim sticks. As a person who struggled with serious depression throughout his adult life, Howells had perhaps a vested interest in the project of attaining and sustaining wellbeing, and his personal experience will likely have influenced his commitment to securing wellbeing in others. By sharing his stories, he suggests in his statement, he hopes to prompt others to similarly unburden themselves, thus relieving the global tendency towards 'feeling bad', in serial or sequential intimate encounters. He implies this will bring about a collective transformation – a *cathartic revolution* – while also inserting a spark of levity into his proposition. He falls about laughing, but the laughter does not undermine the seriousness of his intervention.

It's All Allowed

One of Howells' counters to the cultural pervasiveness of a guilt-induced 'feeling bad' was to proclaim 'It's all allowed'. As mantra, catchphrase and method, it suggests his openness and generosity of spirit as a person, artist, mentor, and educator. Many of the essays collected here cite the saying. The phrase appears in public forms in many of his performances, his writings and notes, and in his private advice. In one performance of *An Audience with Adrienne* (Glasgay!, Glasgow, 2006), for example, Howells specifically reminds his audience that 'It's all allowed', in the course of setting up the open shape and loose parameters of the performance. Dressed as his alter ego Adrienne, with bleached hair, casually crude 'Pat Couldn't-Be-Butcher' makeup, and wearing a tabard, he tells his audience, with a wink and a nudge, that his work is borne upon 'a lifetime of servicing others'.[5] A consummate raconteur, he proceeds to talk through anecdotes from his life, with titles such as 'Pre-Teen Tranny', 'Charles Bronson's Weeping Wounds', 'My Birthday Super Slovak', and 'Early Morning A&E' – stories of childhood humiliations, sexual fiasco, or desultory showbiz achievements, which audience members pick from a menu.

The performance itself stages the formal permissiveness signalled by his saying. The openness of his format includes the lack of a script, the loose and inviting score, and opportunities for his audience to both direct and divert the agenda of the performance, as well as to interject their own questions and stories into the dramaturgically freewheeling mix. *It's all allowed.*

For Howells, his permissive mantra meant that in a performance, both the artist and the audience-participant could feel empowered to divest themselves of artifice, or indeed to embrace it. Additionally, one ought to be free to engage in a performed encounter in a fleeting, playful or diverting way, or to reroute it into a vast, demanding, and life-changing experience. One may follow the rules of an encounter or scenario, or abandon its guidelines. In a published email exchange with Rachel Zerihan, Howells writes,

> My insistence on the spontaneous, a flexible structure and on non-scripted, improvised exchange allows for the audience-participant to contribute so much of themselves and to recognise that they have agency in the piece, which can often lead to them negotiating a total change of content and development of the piece. And this is ALL allowed![6]

Zerihan asks how the unpredictability of audiences' responses is accounted for in the design of a performance, particularly in a one-to-one performance, where the opportunity for detours or fiasco is emphasised. 'My answer', he replies, 'is to say that my personal mantra and philosophy IS "It's ALL allowed", so this is something that I uphold in my performance work'.[7]

Above: Adrian Howells, *An Audience with Adrienne*, Singapore, 2009.
Photo by Dan Prichard. Howells is shown with his designer, Theo Clinkard.

Howells' mantra suggests freedom of expression, and a liberal 'anything goes' approach to creativity, participation, autonomy, and the intimate potentials of the consensual situations he constructed in his performances. However, as Deirdre Heddon, Helen Iball and Rachel Zerihan suggest in their co-authored essay (a revised version of which appears later in this collection), the granting of permission is not in itself a performative act; its proclamation does not deliver or guarantee autonomy and agency on the part of the participant. Zerihan provides an excellent example. She hates strawberries and yet, in spite of Howells' insistence in *The Garden of Adrian* (2012) that she must not do anything she doesn't want to do during the performance, Zerihan is demonstrably unable to free herself from her burden of being a 'good' audience-participant. To be an audience-participant *is*, after all, *to* participate. In one-to-one work, one is exposed as a participant. Howells works hard to secure that participation, his attentive charm aiming and most often serving to disarm resistance. In the moment of performance, Zerihan eats not one strawberry but two. Despite her disgust, she projects pleasure. Zerihan literally *performs* her pleasure, in order to confirm her role as good participant and to please Howells. Her performance is so convincing that she is rewarded with a second strawberry. Autonomy and agency cannot be enforced. This seeming contradiction at the heart of Howells' work and imperative is undone, though, under the very same rubric of it all being allowed. Zerihan's capitulation to theatrical habits and mores is allowed too, and so she has no reason to feel bad.

The consummate care and attention that Howells paid to the ethics and aesthetics of his work, to the importance of detail and his commitment to genuine, authentic interaction, also suggests his catchphrase was sometimes a tactical misrepresentation. Howells was deeply concerned by the ethics of his practice and as a reflective practitioner he developed what came to resemble something of a code of practice. His commitment to facilitating and holding the experience of the audience-participant set high levels of expectations, not just of himself but of the organisations and individuals with whom he collaborated. Whilst the mantra 'It's all allowed' was undoubtedly one element of his code, intended to reassure and liberate participants, such apparent permissiveness was buoyed by steadfast rigour. Making it seem as if anything goes was one of Howells' remarkable skills as a practitioner.

Situating the Work of Adrian Howells

Howells' intimate, immersive, and transformative forms of performance, developed over a period of 15 years (and founded upon an earlier decade of collaborative and company work), invoke a number of artistic contexts or critical frames within which to situate his practice. Some of these are contexts with which Howells identified and engaged directly and explicitly. Others are part of the wider discursive landscape in performance studies, each having some bearing on how one might approach, encounter, receive or respond to Howells' work. Many of the contextual lines we précis here – autobiographical performance, dialogical aesthetics, relational aesthetics, and one-to-one

performance – are returned to variously and in more detail in the contributions that follow later in the book.

Autobiographical Performance

The history of autobiographical performance provided a key frame of reflection for Howells. As noted in the next chapter mapping out his performance biography, he undertook a long period of focused practical research on the relationships between autobiography, intimacy, risk and space. In her monograph *Autobiography and Performance*, Heddon offers one history of the form, locating the emergence of explicitly autobiographical material as content for performance in the second-wave feminist movement of the 1970s, tied as it was to consciousness-raising tactics.[8] Personal experiences – not just *what* happened, but how it happened and the feelings and emotions attached to those events alongside cultural responses – can be understood as the result of historical, cultural and structural conditions and therefore are not 'personal' at all, in the received sense of the word, but shared and political. Performance offered a site to explore the seemingly personal *in* public; to name it and/or challenge it, to legitimate it and/or revise it. Autobiographical performance, a place of utopian potential, affords both the space for stories not yet told and the technologies with which to rewrite the tales told too often. This utopian potential of autobiographical performance, pivotal to which are its simultaneous temporal layers, is invoked in the closing sentences of Heddon's book:

> [These] are performances of aspiration and possibility, creative acts that have the potential to contribute to ongoing cultural transformations. Looking at the past through the present we are urged to consider the future and what we might choose to make there.[9]

The history of autobiographical performance, attached as it is to acts of political resistance staged by marginalised subjects – including women, queer, black, and disabled individuals – offered Howells a significant foundation and context for developing his work. Heddon addresses Howells' work in the concluding chapter of her study as an example of what she identified as a trend emerging in the autobiographical landscape of the UK towards the end of the first decade of the twenty-first century: intimate and one-to-one performance. In its intimate form of staging, where personal material is shared and mirrored in intimate spatial configurations, the autobiographical is brought literally close.

The intimate and the autobiographical were always imbricated in Howells' work, the personal content reflected and supported by an intimate *mise en scène*. As Howells reveals in his interview with Dominic Johnson, his initial encounter with autobiography as material for live performance was through his collaboration on *Asylum* (2001) with Nigel Charnock + Company. In the

Opposite: Adrian Howells, *Adrienne's Dirty Laundry Experience*, performed at The Arches, Glasgow, as part of Glasgay!, 2003. Photo by Niall Walker.

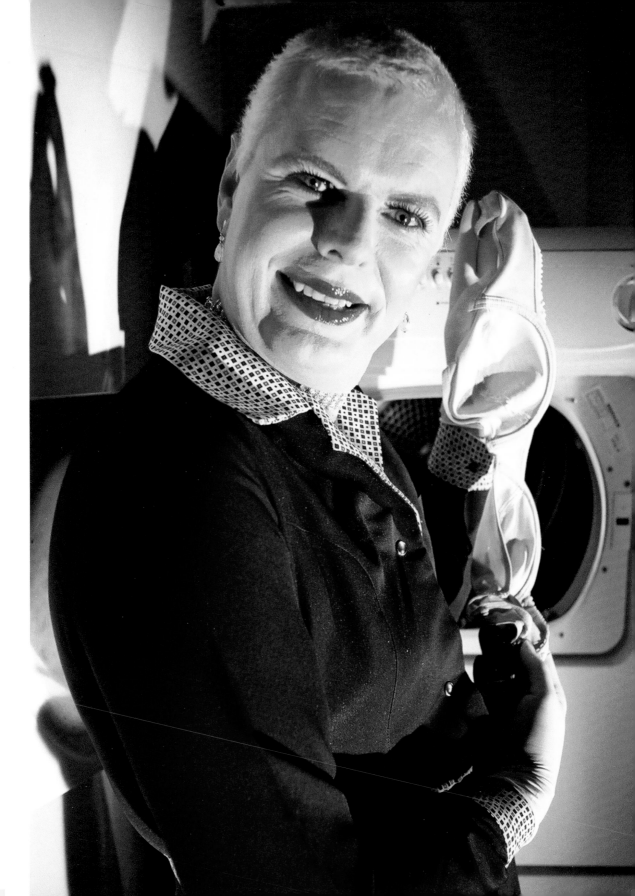

devising process, Charnock used the performers' 'personal information and life histories to create scripts and scores'.[10] That experience is credited by Howells as being, in part at least, the impetus for creating work that was intimate spatially as well as narratively:

> Since the run of *Asylum* I was feeling nervous about doing shows with large audiences. I felt I had reached a stage in my life where I wasn't sure I wanted to 'wash my dirty laundry in public' (as I identified it then) in front of a group of people who didn't necessarily care about me.[11]

The other, interconnected origin of Howells' development of an intimate, autobiographical form is found in the invitation in 2001 by Area 10 to create a 'radical drag' performance. Howells created a performance 'with me talking about my life but involving a kind of meaningful engagement that offered the audience an opportunity to do the same thing', in a mode that seemingly necessitated serial, short performances for small, intimate audiences.[12] It is no coincidence that Howells followed this initial exploration of an intimate, autobiographical form with *Adrienne's Dirty Laundry Experience* (2003) – knowingly and willingly washing his 'dirty laundry' in semi-public/semi-private space, and inviting his audience-participants to do the same.

The presentation of autobiographical performance in an intimate environment, though marking the beginning of a new trajectory for Howells, was not, in itself, unique. Other practitioners had developed intimate forms of autobiographical practice, including: Bobby Baker's *Kitchen Show* (1991), first performed in her own kitchen; Mike Pearson's *Bubbling Tom* (2000), which took a relatively small number of spectators on a walk around the village of his childhood; and Curious' *On the Scent* (2003), presented in different rooms throughout the real homes of hosts.

Prompted by their enduring commitment to a form of intimate practice and an exploration of audience-performer dynamics, Curious' co-directors, Leslie Hill and Helen Paris, have written at some length about proximity in their work, focusing on the impact and effects of staged, close encounters, understood to be 'experiential' and 'sensuous', with sensory stimulus a key feature of their work (especially taste and smell). They also recognise the 'intense labour' attached to and required by performing for and close to small audiences, a topic we return to later.[13] Their study of proximal relations, *Performing Proximity: Curious Intimacies*, shares territory with another trope trending in the field: immersive performance. Josephine Machon's *Immersive Theatre: Intimacy and Immediacy in Contemporary Performance* includes the work of Howells, specifically *Foot Washing for the Sole* (2008) and *The Pleasure of Being: Washing/Feeding/Holding* (2010-11).[14] Immersive theatre submerges the spectator in the experience to which they are in attendance, transforming them from a spectator of to a participant in an event. In essence, immersive theatre is experiential and, for Machon at least, it 'prioritises human contact'.[15] As Machon's subtitle signals, the staging of intimacy is part of any work's

immersive capacity and vice versa. In another recent publication, *Audience Participation in Theatre: Aesthetics of the Invitation*, Gareth White proposes that the immersive and the one-to-one are new trends.[16] Howells' performances brought the forms together.

Whilst Howells' work could be considered both proximal and immersive, its singularity resides in its *open* autobiographical structure – that is, Howells harnessed the space of intimacy in combination with sharing intimate stories to encourage *dialogue*. He shared stories from his life and sought to offer the audience the same opportunity. Whilst other autobiographical performers like Peggy Shaw, David Hoyle, Stacy Makishi, or Kim Noble certainly break down the theatrical fourth wall by acknowledging the presence of the audience with direct address and exchange of gazes – the sharing of time and space is an explicit feature in the work – Howells extended the form by developing a much more explicit modality of co-authorship. In place of a script and lines learnt, Howells created a structure to be filled through the encounter itself. If, as Heddon has suggested, criticism directed towards autobiographical practice often presents it (albeit lazily) as solipsistic and narcissistic – as all about the performer – then Howells responded with an innovative model of auto/biography premised on exchange.[17] In his carefully constructed intimate spaces, whether located in theatres, galleries, or appropriated spaces, the stories he shared – by turns hilarious, poignant, flimsy and profound – encouraged the contribution of stories from his audience-participants. His work modelled a practice of call and response, or a show and tell that invited a show and tell in return. Howells' autobiographical performances, then, were as much about the autobiographies of those sharing the space with him as they were about his own stories. Indeed, over the course of his career, the performances would become less about him and more about his audience-participants. We might propose this as a model of *inter-personal performance*, providing a link to Grant Kester's dialogical aesthetics and Nicolas Bourriaud's relational aesthetics.

Dialogical Aesthetics

Grant Kester's focus on dialogue offers a useful context for considering Howells' autobiographical performance, rooted as it is in structures of exchange. Kester's notion of dialogical aesthetics, discussed in detail in *Conversation Pieces: Community and Communication in Modern Art*, recognises firstly that dialogical exchange depends on a 'reciprocal openness' that is sensitive to the *singular subjectivities* of those engaging in dialogue rather than abstract and instrumental communicative practice. That is, dialogue is specific and contextual. Secondly, he proposes that a dialogical work of art is 'a process of communicative exchange rather than a physical object'.[18] In the context of theatre and performance, reference to a physical object instead of a process is redundant since there is generally only ever process. At least alert to this, Kester attempts to clarify the difference of dialogical aesthetics from the 'traditions of theatre' – traditions nevertheless overstated and under-scrutinised – by pitting the 'performer' as 'the expressive

locus of the work' against something more context- and participant-dependent. As Kester sees it, the artist's role in the production of dialogical aesthetics is to facilitate conversation and exchange, acting as a 'context provider' or 'catalytic converter', rather than 'content provider'.[19]

Howells' work shuttles between Kester's compartmentalisations. Howells offers his own content – autobiographical stories in the main, as well as popular cultural references – precisely in order to prompt others to conceive or share content, and then responds in the live moment by revising his own. This attentive, reflective practice offers a model of dialogical exchange that might be better termed *dialogical auto/biography*.[20] He values expressively his lived experiences and what they reveal in ways that are by turns sincere, convivial, serious, humorous, open and *invitational*. His process of responsive improvisation demonstrates, to the audience-participant, an 'apophatic' listening and speaking practice.[21] Apophatic listening resists anticipating the content of speech in a monological fashion, whereby what one hears, and perhaps even solicits, is what one expects to hear in order to confirm and bolster existing ideological positions. Instead, apophatic listening seeks to disclose (to dis-close is to open). Whilst one might typically consider this opening as an opening *of* the other, within the terms of apophatic listening we propose that it is also an openness *to* the other. This is the demonstrably hard work of apophatic listening. The other discloses – opens – in response to openness and in the service of one who is open. To be open to what is said, to hear openly, is to be open too to the transformation of self.

Relational Aesthetics

Howells' commitment to mutual transformation or 'cathartic revolution' implicates his practice within the orbit of *relational aesthetics*, a term introduced by the critic-curator Nicolas Bourriaud to describe a politics of art that he deemed typical of developments in performance and interactive art in the 1990s. Bourriaud defined relational aesthetics as 'an art taking as its theoretical horizon the realm of human interactions and its social context, rather than the assertion of an independent and *private* symbolic space'.[22] Writing at the end of the 1990s, Bourriaud observed that 'artistic praxis appears these days to be a rich loam for social experiments, like a space partly protected from the uniformity of behavioural patterns'.[23] 'Relational aesthetics' offers itself as another apposite context for an encounter with Howells' work, given the profound commitment to what he understood to be the unique potential of art as a setting in which to explore and rethink and ideally to reconstitute social relations (that said, as it happens, Howells was not especially interested in it as a context for his own thinking).

Asserting that 'art has always been relational in varying degrees' in its ability to trigger and ground dialogue, discourse, or argument, Bourriaud argues that the new 'relational' art is distinctive because '*it tightens the space of relations*'.[24] Bourriaud is perhaps incorrect to situate the new tendencies as an upheaval: performance already had long been committed to this 'tightening'

or activation of the social, as a promise of the political relations it sought to invoke. Such a claim to newness is symptomatic of Bourriaud's characteristic distinctions, validated by his ahistorical approach, which tends – like Kester's – to ignore the history of theatre and performance in order to legitimise the apparent novelty of the visual art he favours in his critique, from Gabriel Orozco's slinging of a hammock in the garden of the Museum of Modern Art in New York (*Hamoc en la moma*, 1993) to interactive installations in museums and galleries by Rirkrit Tiravanija, Sophie Calle, Philippe Parreno, or Carsten Höller. Bourriaud's political claims are tentative: when, say, one slides down Höller's helter-skelter (*Test Site*, 2006), or eats from Félix González-Torres' stack of colourfully wrapped sweets (*Untitled (Portrait of Ross in LA)*, 1991), the pleasure or poignancy of active participation models a positive or convivial relationality: 'through little gestures', he writes, 'art is like an angelic programme, a set of tasks carried out beside or beneath the real economic system, so as to patiently re-stitch the relational fabric'.[25]

In comparison to the dramas of social interaction Howells chose to orchestrate, the 'little gestures' – the hammocks and candies – that concern Bourriaud may look rather tepid. *Foot Washing for the Sole* is perhaps apposite in this regard. It receives significant attention in the present book, not least through Howells' own anthologised writings, but a brief gloss here helps to assert the deep sympathy between Howells' works in performances and the overarching politics Bourriaud mapped in his 'angelic programme'. For *Foot Washing*, Howells developed a private, serial, one-to-one scenario in which he sought to demonstrate that '[t]wo bodies in close, physical and touching proximity have the potential to engage in an often self-revelatory, but silent, conversation'.[26] In *Foot Washing*, this occurs through the offer to wash, dry, oil, massage, and scent the feet of the audience-participant, while asking questions, which one may choose whether or not to answer, with Adrian ending the encounter by offering to place a kiss upon the audience-participant's pampered feet and wishing them peace by speaking the words 'Shalom' and 'Salaam Alaikum'.

The series of actions are servile, secular: a gift of kindness, generosity, and strategic selflessness. Bourriaud's theory – and the 'social turn' in performance studies that it participated in – provides a useful context for contextualising Howells' performances, and for assessing his importance. Yet Howells exceeds its formal slightness and questions its emotional tone or tenor. In one-to-one performances such as *Foot Washing for the Sole*, or participatory performances for collective audiences such as *An Audience with Adrienne* (2006-10), Howells animates the oppositional social and aesthetic value of relational art – what Jen Harvie has recently described as the 'many, subtle, partial and effective responses to neoliberal capitalism's support for self-interested individualism'.[27] That the one-to-one performance offers a service for one audience-participant at a time raises other questions about its relationship to self-interested individualism, an issue we return to shortly.

Overleaf: Adrian Howells, *Foot Washing for the Sole*, performed in Nazareth, Israel, 2008. Photo by Hisham Suleiman.

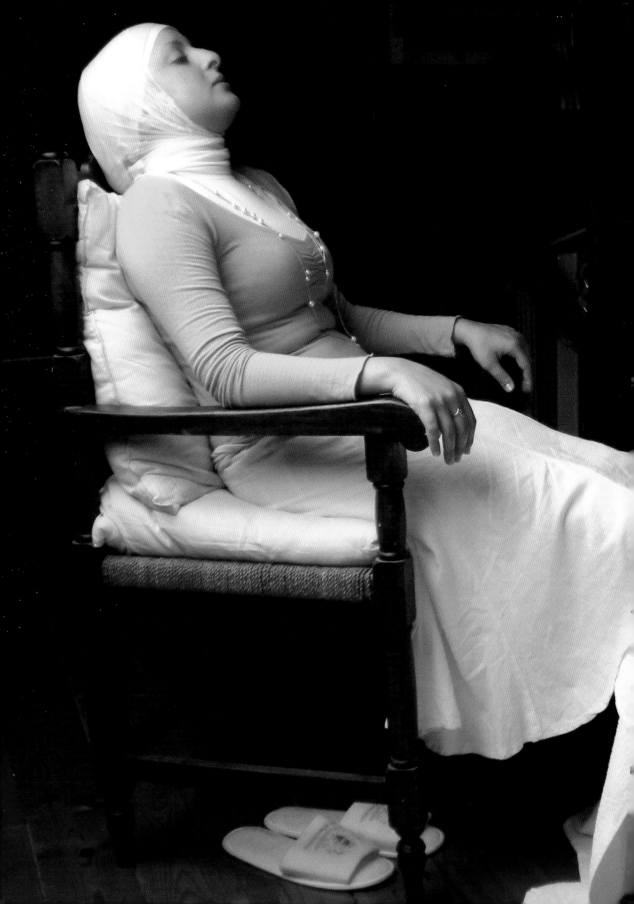

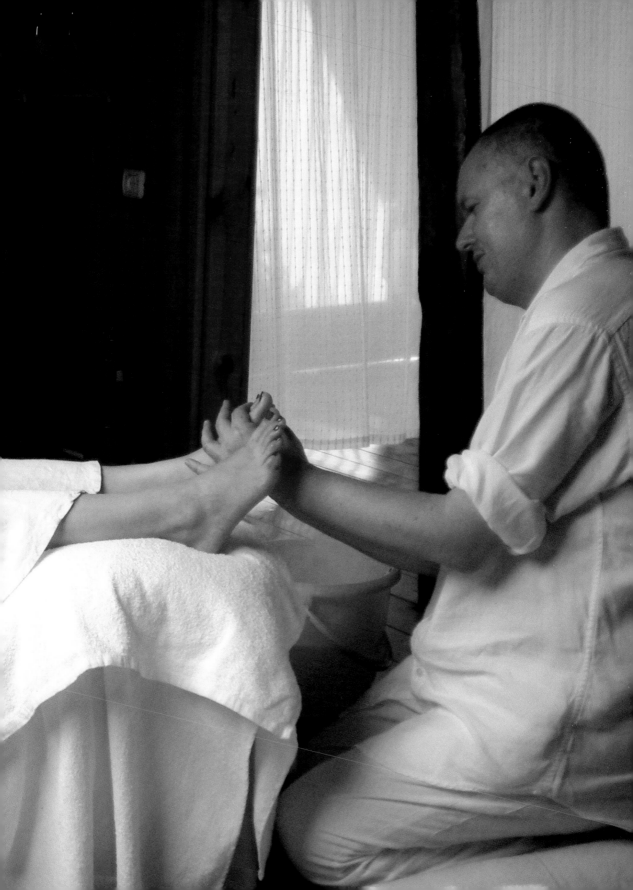

A vocal sceptic of relational art, Claire Bishop questions the *aesthetic* value of works that privilege collectivity, collaboration, and dialogue with communities or individual participants, arguing that critics tend to assume that the social efficacy of such works trumps its success as art. She writes that ethical criteria take precedence over properly aesthetic questions, such that a work's status and quality are given as an article of faith. 'Emphasis is shifted away from the disruptive [aesthetic] *specificity* of a given work and onto a *generalized* set of moral precepts', Bishop argues, because relational art and its reception are 'dominated by *ethical* judgments on working procedure and intentionality'.[28] While his performances might strike some audiences as demotic, alien, specialised, or intrusive, Howells was not interested in qualifying or proving the legitimacy, value or success of his performances *as art*. 'It doesn't so concern me to then have to make an argument for its status as art', he stated (over and above his own belief in its efficacy as art); 'I feel committed to what happens in the performances. I believe we live in increasingly brutal and brutalising times, and we need to find ways of physically connecting more'.[29]

Bishop has since acknowledged that in relational or participatory art, 'quality is often a contested word: rejected by many politicised artists and curators as serving the interests of the market and powerful elites, "quality" has been further marred by its association with connoisseurial art history'. Yet she continues to fetishise the (self-validating) critical efficacy of conferring 'value judgements' upon such works.[30] For Howells' work, an attempt at the conferral of value poses a problem, not least because it tends to generalise the individual experience of a one-to-one performance, by assuming its functional surrogacy for many other individual, contingent, self-directed interactions (the other one-to-one iterations that the critic is not party to). This is an issue acknowledged in the essay by Heddon, Iball and Zerihan, in which they propose a new critical methodology called 'Spectator-Participation-as-Research' (SPaR).[31] Writing from an acknowledged and accepted place of individual and singular spectatorship at least aligns with Howells' thoughts regarding the efficacy and social value of his performances: 'the proof of the pudding is in the eating'.[32] It is difficult to eat a pudding vicariously.

One-to-One Performance

Whilst the fact that every audience member has a singular experience of each and every performance is something of a truism in our discipline, that singularity is foregrounded and exploited in the one-to-one form. Though now well established in the UK, at the time of embarking on his own exploration of the intimate form in 2001, Howells claims to have been unaware of one-to-one work. In his interview with Johnson he acknowledges that following *Adrienne's Dirty Laundry Experience* he remembers seeing more of it.[33]

Whilst Howells might not have been aware of the form, precedents for its emergence can be located in participatory works in Europe and the United States since the development of Happenings in the late 1950s, and visceral

performances centring on the use of the body as material. In the latter, one-to-one performances complement and extend a sub-history that emphasizes the fact that all performances involve complicity with the frequently unstated terms of a social contract. Since the 1970s, artists have zoned in on this aspect of being an audience, for example in Marina Abramović's notorious participatory performance *Rhythm 0* (Studio Morra, Naples, 1974), in which her audience was invited to utilise assorted objects – including soothing materials (bread, oil, flowers, painkillers) and potentially dangerous implements (saws, knives, chains, a gun, and bullets) – in their encounter with Abramović's passive body. The litany of interactions concluded after six hours when an overzealous participant placed a bullet into a revolver – the artist provided both artefacts – and aimed the loaded gun at the artist's head. The performance staged a shocking pre-emptive strike on the assumptions behind Bourriaud's central ethical imperative for the critical reception of relational art, namely his question, 'Does it give me a chance to exist in front of it, or, on the contrary, does it deny me as a subject, refusing to consider the Other in its structure?'[34] Upon reflection, the performance taught Abramović a harsh object lesson: 'the public can kill you. If you give them total freedom, they will become frenzied enough to kill you'.[35]

Though Abramović would be a stated influence on Howells' later in his career, he admits to Johnson that at the time he began to develop his one-to-one practice he was oblivious to the form's place in the history and landscape of performance art and live art.[36] With a background in 'traditional theatre' he was 'highly suspect and uncomfortable about live art', and so was unaware then of work by, for example, Oreet Ashery, Kira O'Reilly and Franko B.[37] During the three years of his Creative Fellowship at the University of Glasgow (discussed in the next chapter), Howells cultivated his knowledge of others' creative practice, saw a wide range of types of performance, and interviewed relevant practitioners. He built a historical and critical context for his own experimental practice. This context was primarily live art, and included a strand of one-to-one performances that tended to involve highly mediated acts of self-injury, such as the work of Abramović, O'Reilly, Franko B, and Ron Athey.[38]

Kathy O'Dell traces a broader 'masochistic' streak in performance art to the 1970s, noting the frequent presentation of docile or servile artistic bodies in performances that may expose – frequently through invitations to participation – the sadomasochistic nature of social interactions beyond the scope of art and performance.[39] Howells incorporated a sadomasochistic dimension in his one-to-one performance, *The 14 Stations of the Life and History of Adrian Howells* (2007-8). Stations of the performance include scenes in which the audience-participant is induced to play a part in – or at the very least to observe – Howells drinking vinegar, being brought to tears, or showered in ice (some may have attempted to prevent these actions too). He recalled, 'participants said they felt very uncomfortable, and saw the actions as confrontational. I am aware that I have deliberately used opportunities and experiences to put people

in a place of discomfort, which I hope leads them to question what it is in the action that makes them feel challenged'.[40] Notably, whilst Howells continued to urge the audience-participant into challenging positions of vulnerability, and the question of risk remained central to his work, he did not repeat this experiment with spectatorial complicity in the performer's subjection – or at least not explicitly.

Nevertheless, the models of social relationality that Howells was invested in staging and questioning do refer to the relations of power, privilege, and sympathy that condition our interactions with – or embodiment as – those who work in the service industries. From the blue tabard that Adrienne wears, to the artist's productive and deliberate activity of washing and caring for his audience-participants, to the material and social exchanges that take place in a range of encounters, Howells was fundamentally engaged with his performances as part of a sector of immaterial labour that requires the undertaking of physical activities on the part of the labourer, for the enjoyment or relief of the consumer. The gendered nature of both the work and its consumption is relevant here, both to immaterial labour in general, and Howells' appropriations specifically. As Bojana Kunst has written, 'the performer becomes the ideal virtuoso worker of contemporary capitalism, producing "communication through the means of communication"; the means are the language and actions of the body', which produce effects – images, gifts, and services, rather than objective products – through modified types of immaterial labour.[41] The 'consumer' in Howells' case consumes experiences, and the labourer experiences the burden of physical work, and the added psychological burden of having to perform – and thus marketise – their own performance of emotion, in the material form of affective labour, in an economic context in which, as Kunst writes, 'human sociality is at the core of production and […] our cognitive, affective and flexible abilities are part of the production of value'.[42] The intimate nature of the work demands its repetition – he cannot perform just once, for a single audience member. Borrowing from Leslie Hill and Helen Paris, an appropriate term to describe Howells' would be 'shift worker'. These issues are explored in much more detail in chapters by Stephen Greer and Fintan Walsh.

Howells' performs as an immaterial labourer and shift worker in most of his one-to-one 'Adrienne' works, including *Salon Adrienne* (2006-7), in which he washes and styles the hair of an audience-participant;[43] or helps an audience-participant to address their body image through dress-up, in *Adrienne's Personal Shopping Experience* (Bluebird, King's Road, 2005). In *Adrienne's Room Service* (Great Eastern Hotel, London, 2005), a particularly dolled-up Adrienne is called to a specific room by an audience-participant, and delivers a meal, glass of wine, and dessert on a trolley; Adrienne and her customer-cum-date sit or lie on the bed together, while the latter eats, and they talk about

Opposite: Adrian Howells, *Adrienne's Room Service*, performed at Great Eastern Hotel, London, 2005. Photo by Marko Waschke.

whatever issues come up (in the single documented encounter, they talk about sex, eating, working out, body image, self-hatred, and sitting down to pee). Adrienne shares a dessert with the guest, then leaves, returning to the hotel's kitchen to await another order. Though Howells drops his 'Adrienne' persona in later works, he continues to function as a service provider by washing his audience-participants' feet and variously bathing, feeding and holding them – the latter, for example, structures his performance *The Pleasure of Being: Washing/Feeding/Holding*.

References to 'real-world' unmediated labour ghost Howells' performances. Though he enacts that labour 'for real' within the frame of performance, and though as a performer he is part of a sector of immaterial labour, another site of labour is invoked through his work. Many of Adrian's/Adrienne's tasks remain predominantly coded as feminine: washing (bodies and clothes), shopping, feeding, caring, hairdressing, hostessing. This everyday labour takes place in precarious conditions, with few rights and protection afforded to those (mostly women) who undertake it. The gendered stratification of this insecure labour market is perhaps remarked upon by Howells' persona 'Adrienne' (and potentially challenged when he chooses to remove that mask). Howells' own working conditions were precarious, too, of course – as an independent artist, he had no job security (not even the minimum wage), nor employment rights (he was not a member of Equity or other unions). The evidence of these precarious conditions of performance labour is discussed in more detail in the essay by Stephen Greer.

Though Howells continued to explore the one-to-one form throughout his career, in discussions with Heddon he did admit to concerns about its potential impact. The very structure of the one-to-one raises questions about its place within the public sphere. If a key motivation for the sharing of private details in performance is to render them visible and public, so as to prompt discussion and debate, what sort of public is an intimate one? How can the almost-privacy of one-to-one – where the private is shared in semi-private – lead to one-to-two, to-three, to-four, to-more? Does the one-to-one model really participate in or create wider cultural transformations, or does it reiterate the individuation of the self through a psychologized confessional mode of introspection?

One response to these anxieties is to acknowledge that performance often manages to escape the moments of its presentation. The 'one' becomes 'two' and more through anecdotes shared in the bar after the performance, when experiences are shared and compared; in journalistic and academic writings about the work by those who were there (and also by those who were not); or in presentations by Howells and other artists. Whilst each experience is singular, these experiences do not occur in a vacuum. They may not be *of* the public sphere, but they do enter it, after the event; or, more accurately, a performance takes place as an event that proliferates.

Another response is to recognise the ways in which Howells' work cultivated both an awareness and practice of mutual responsibility in the performance of dialogic exchange. The intimate performances created by Howells engendered feelings of both vulnerability and safety, the ethical frame of attending and caring serving to draw attention to one's responsibility as a citizen and participant in the world: a subject who attends and cares too. As Eirini Kartsaki, Brian Lobel and Rachel Zerihan propose, one-to-one performance 'creates the conditions for a particular ethical relationship'.[44] Citing the relational and ontological theories of philosopher Emanuel Levinas, the one-to-one, a structure of the one and the other, activates a relationship of mutuality, the participatory format prompting shared response-ability (even though 'it's all allowed'):

> [S]pectators and performers have to respond to the question: How shall I act? The question of acting *for* the other has been explored by Levinas [...]: 'The other becomes my neighbour precisely through the way the face summons me, calls for me, begs for me, and in so doing recalls my responsibility, and calls me into question'.[45]

In an article that Howells co-authored with Heddon in 2011, reprinted later in this collection, he makes specific reference to the importance of the ethics of the face-to-face encounter, in fact equating it with the one-to-one structure: 'my work has been motivated by the sense that in this age of mass-mediation and technological advancement there is a necessity to prioritize opportunities for audiences to have intimate face-to-face, one-to-one encounters in real-time with real people'.[46]

Trusting the Audience

To engage an ethics of mutual responsibility, both parties are required to trust the other, and to lay their trust in the format or function of the performance in which they placed themselves. In *Violence and Splendor*, Alphonso Lingis defines trust:

> Trust is taking what is not known as though it were known. [...] There is *trust* where we are aware that the future is not knowable. Trust makes contact with an individual, a power of initiative unto himself but also innately endowed with skills to hide what he does not know, to misinform, and to deceive and dupe others. We trust, have to trust, the surgeon. Before committing to surgery, we find out all we can about her training, competence, and experience, but in the end we realize she is capable of misjudgment in diagnosis, neglect of available research, lapse of skill, inattentiveness, or callousness.[47]

Howells achieved and employed his trust in performance by way of his faith in the *power* of intimate encounters. In a presentation at the Institute of Contemporary Arts, London in 2010, he defined himself as 'an exponent of not just the intimate in one-to-one performance, but a practitioner specifically

interested in exploring ideas of intimacy within intimate performance that has recognisably therapeutic benefits and fosters a sense of mutual nurturing'.[48] In the course of his argument for 'an authentic or real intimacy in performance', Howells pits this possibility against 'the formality of traditional theatre and the inability to interact with what is on stage'. From his robust early experiences within the industry, he critiques theatre for its privileging of 'mass-consumption and depersonalised experience – rather than striving to understand and cater for individual needs/wants/taste'.

Trusting the audience, one individual at a time, was for Howells a means of interrupting the traditional device of the communal audience, which he understood to be 'frequently emotionally unfulfilling and inaccessible', because of the 'considerable emotional and physical distance' between the spectator and performers, on account of conventional staging and seating arrangements (most notably in plays, but also in all manner of experimental performance setups), but also through fakery, characterisation, and other techniques of what he calls 'synthetic reality'. He illustrates the latter with an example: having just attended a play at the Royal Court, and confirming that he is 'not a fan of plays and characters', he describes a scene in which one character slaps another. Watching the 'stage slap', he says he 'felt cheated', because 'she didn't really administer a slap and he didn't really experience it'. When we're asked 'to invest in that version of reality', the theatre shows itself to be 'out-of-step with contemporary cultural interests'.[49]

Howells constructed situations of 'authentic' engagement that might admit unfeigned happiness or pain (though stopping short at a slap in the face), as well as the often-tricky emotional business of being held, bathed, pampered, questioned, or otherwise administered in a situation of what Howells calls 'giftfulness'. Elsewhere, however, he warns against the risk of 'velvet oppression', a suggestive phrase he uses to describe situations of 'over-caring to the point at which you are denying individuals their human rights to feel things', thus oppressing a person (often but not always a vulnerable one), by infantilising or over-protecting them.[50] As we have seen, his performances often centred on caring interactions. In *Held* (2006), for example, first performed in a private apartment in Glasgow, the one-to-one encounters lasted one hour, and involved Howells holding the participant's hand across a kitchen table, then hugging or otherwise sitting in close quarters on a sofa in the living room, and finally, the artist holding the participant from behind ('spooning') while lying on a bed. Howells' particularly memorable encounters in such performances involved situations of mutual transformation, of emotional 'breakthrough', even. A repeated example he liked to give described an encounter in *Held*: a devout Christian woman signed up for the performance, and as he spooned her, he would say that it felt like he was 'sharing a bed with a bicycle', but that after a tender few minutes, she 'melted', under the novel challenge of physical and emotional intimacy with a stranger. Such a situation

of interpersonal dependency – and the potential achievement of *a bicycle that melted* – requires trust, he suggests, because it is an affectively risky bargain (even if the description of the terms of the encounter, or the limits to its promiscuity, might make it seem tame to certain readers).

Howells' one-to-one performances require personal agency on the part of the performer and audience-participant, clear boundaries, consent, and the co-creation and mutual management of 'a place of vulnerability', in which one may be challenged, exposed (sometimes quite literally), and even embarrassed. The risks, Howells asserts, are worthwhile when intelligently designed and held, and can be coped with by even the most exposed of participants. The rhetoric of 'risk' can tend to become overblown in writing and thinking about performance. Howells himself was willing to note that the risks were manageable for most viewers, even if the prospect of being held, bathed, or the subject of what he called 'accelerated friendship' might be embarrassing. Citing Grayson Perry, he quips, 'Nobody ever actually died of embarrassment'.[51]

A Note on Language

Key to the ways Howells discussed his work and spoke inside the performances is his idiosyncratic vocabulary or terminology. In the instances when he is cited in this book – particularly strikingly, perhaps, in Marcia Farquhar's and Jennifer Doyle's essays – and in his interviews and writings, his voice is idiosyncratic. His discourse was partly colloquial, and substantially formal or learned, but frequently shot through with his linguistic playfulness. When he wrote to friends and scholars, his writings were littered with CAPITALS. It's an endearing trait, which emphasised key words and phrases, and reflected Howells' own excitable, EMPHATIC way of speaking. In a combination of such tendencies, he writes to Zerihan, for example:

> I think the honest answer to WHY I am so keen to explore intimacy in my work is because I have issues with it in my everyday life, so want to experiment with it and exploit this opportunity in my work. I also want to offer here a passionately held belief that the more isolatry and disconnected our experience of life becomes [the more...] people are in real need of nourishing, intimate, person-to-person, eye-to-eye, flesh-on-flesh experiences and exchanges. AND NOTHING ELSE CAN BE A SUBSTITUTE FOR THIS![52]

Also typical in this missive is his enjoyment of neologism. 'Isolatry' is not a common word, or even a readily intelligible one, but it works in Howells' permissive usage. He means the ways in which social life produces or requires solitude and isolation – modern life isolates us from each other, and perhaps from ourselves, and thus is isolating/isolatory. Howells' neologism 'isolatry' sounds and looks a bit like *idolatry*, too, which reminds one of how this position – countering the nicety or platitude that imagines social media, instant messaging, reality TV, and communications technology might explode

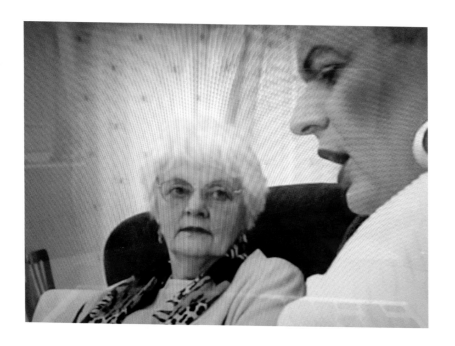

the possibilities of one-to-one and interpersonal communions – might be idolatrous, blasphemous, or iconoclastic. Throughout his public discourse, Howells invents or manipulates words, like 'tenderizing' (not to mention – perhaps more informally – 'gorge-arse', 'jetslag', and 'undercrackers'). The encroachment of linguistic inventiveness (and sometimes mishaps?) into his critical discourse occurs partly on account of his auto-didacticism (his self-education, outside of actor training), his sympathy for academic practices and languages, and perhaps a personal aspiration to a particular quality of speech.

In a video frequently screened in *An Audience with Adrienne* – from a series created with the filmmaker Ben Wright – we learn from his Aunty Noreen that Adrian's first word was 'Umbala', an invented term that apparently worked like an infant technology for the germinal performance artist, who may have clung to it as though it were a totem, or a tool, or perhaps an affirmation of new life. In his adult wordplay, Howells also moves between preferred usages of more commonplace or accepted terminologies, like 'confession' and 'revelation', abandoning the former to some extent, in favour of the latter, which he found to be less loaded with the trappings of religious implications, and better suited to secular, post-religious, or pluralistic contexts of intimacy and exposure. ('Revelation' may not be a fully secular logic, but it is perhaps better aligned with the concept of 'disclosure' – something is revealed in the process of dialogue.) Never jargonistic, his language is nevertheless heightened, distinctive, and specialised. In the written form, his linguistic verve is to some extent

Above: Adrian Howells and his mother in a still from *Fatally Attracted to Colourful and Glittery Things*, 2006, a video directed and edited by Ben Wright and shown as part of performances of *An Audience with Adrienne*.

preserved. 'I look around this room at all you gorge-arse people', he says at the beginning of *May I Have the Pleasure…?* (2011), and 'I am looking forward to the pleasure of pleasuring each and every one of you before the evening's through'. We miss, here (and separately, in our mourning), the sparkly, sibilant, and ribald quality that frequently characterised his spoken delivery.

Responsibility

On the 15th or 16th March 2014, having suffered from recurring bouts of chronic depression throughout adulthood, Adrian Howells took his own life. As shock and grief gave way to more studied reflections on what we had lost, and public tributes and remembrances flooded forth from friends and admirers, we were confronted by the urgent reality of a 'body of work', or a *corpus*, something sounding so sudden, final, and devastatingly complete. Jacques Derrida claims that all art works – and, indeed, all signatures and proper names – always already project loss and death, invoking mortality and a mourning in advance: 'the death that always comes before coming'.[53] A posthumous body of work – discrete, yet properly unfinished – depends on the cessation of the literal, corporeal body that created its constituent parts. In death, there is no longer the possibility of new work to extend or rewrite what has gone before. In the *Unfinished Conversation*, Maurice Blanchot writes of that moment when 'everything is completed, the books written, the universe silent', and in which 'there is left only the task of announcing it'. But, Blanchot asks of that moment of finality, or of its conferral: 'where to find the force to say it? where to find another place for it? – it is not pronounced and the task remains unfinished'.[54]

Writing about – or for, or to – the dead seems to carry a greater weight of responsibility than writing about the living; the dead will not offer a rejoinder or revision. Jean-Paul Sartre's words haunt: 'To be dead is to be a prey for the living'.[55] Accepting this, in the absence of Howells and in the face of his body of work, we nevertheless felt it important – like a duty, a debt, an acknowledgement, an address, a gift, or an act of love – to assemble a document which not only committed his ephemeral performances to a more permanent record but which also testified to his accomplishments and the significant contributions to and influence he made on the field of contemporary performance. A body of work has the contradictory capacity to live on, past the life of the body in which it originated.

The emotional burden of this book has at times been heavy. The sentiment was felt particularly acutely while we worked in Howells' archive. The Adrian Howells Collection resides in the Scottish Theatre Archive, in the library of the University of Glasgow. Howells was always a tidy administrator, sorting his working notes, writings, documentation, administrative records, props,

Overleaf: Photos of a selection of the 35 uncatalogued boxes of papers and artefacts in the Adrian Howells Collection, Scottish Theatre Archive, University of Glasgow. Photos by David Caines.

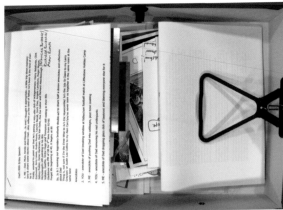

and relevant personal effects into separate crates and cardboard boxes. Some of these records were in storage at the University of Glasgow, whilst more recent ones were stored at his home. Shortly after his death, much of these materials were moved to Heddon's office, and subsequently donated – nearly in full – to the Scottish Theatre Archive, which also houses a range of other archival collections (including the papers of the Citizens Theatre, the company at which Howells 'cut his teeth' professionally; and The Arches Theatre Company, where Howells had been Artist in Residence). The Scottish Theatre Archive received 35 boxes of Howells' papers, and produced a summary box list. The contents exist in the state in which they were received, and remain uncatalogued at the time of publication. We worked methodically through every box, reading and studying the contents; in a subsequent research session, we invited the designer David Caines, who accompanied us, and he photographed the archival crates, and their contents, including a wide range of documents reproduced in this book. Stephen Greer, who also spent time in the archive, studies the contents in extensive detail in his essay, noting not least the staggering extent of Howells' administrative capacities.

At times, in the archive, we were overcome by sympathetic laughter, and comic identification with our lost friend, for example when finding laminated cut-outs of the faces of his inspirational figures – Jesus Christ, Lily Savage, Pam St. Clement, Gary Glitter, Lassie – and matching hats and beards, each designed to match the heads and chins of his (sometimes surprising, sometimes dubious) icons.[56] The archive represents both the deadly seriousness of Howells' creative life, and the famous, lovable silliness that often accompanied his endeavour. Another kind of archiving, or writing, and of remembering might eclipse his silliness, and leave a more stolid, serious figure for history. (How to theorise, document, or archive the silly?) The archive, and the present project of critical remembering, each hope to preserve him in his contradictions, including the one (which he sometimes seemed unable to see) between his political acuity and the triviality with which he sometimes dressed it.

We have endeavoured to make the present book comprehensive in textual and visual terms. This involved gathering, seeking, and creating photographic documents, through screen grabs, photographs of diaries, notes, flipcharts, and ephemera. The place of photography is complex in Howells' work, and subsequently in this book, not least because his own ethical relation to his favoured one-to-one form prohibits photographic documentation. Howells often chose to stage one single encounter of a complete run – usually with a friend – for the camera, to produce a series of images or a video. Otherwise, photographs were staged in a distinct setting outside the performance, particularly with his frequent collaborator, Hamish Barton. For example, to create a set of images for *The Garden of Adrian* (2009), Barton and Howells staged a series of portraits on a bench outside a coffee shop in Glasgow. Barton recalls, 'Adrian sat on this bench and I asked the people who were entering and leaving if they would mind responding to Adrian at a physical level in

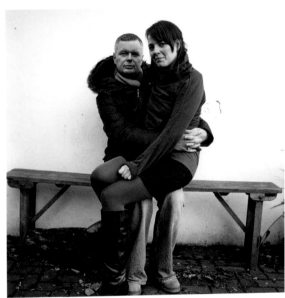

Above: Adrian Howells with four of 12 audience-participants he met in the street, performing for camera to produce publicity stills for *The Garden of Adrian*. The resulting performance was staged at Gilmorehill, University of Glasgow, 2009. Barton used a Rolleiflex twin-lens reflex camera, and one roll of film, yielding 12 images – one for each of Howells' encounters (including one image of Howells solitary on the bench, after an invited audience-participant refused to participate). Photos © Hamish Barton.

relation to how comfortable they were to enter a stranger's space, or allow a stranger to enter theirs. Any response was appropriate. They could lie on his knees and cuddle him or they could sit at the furthest edge of the bench'.[57] Other photographs were taken in a more conventional studio setting, with the intention of using these for promotional materials, including flyers and posters, or alongside previews of live performances, or in Howells' frequent public lectures and teaching engagements. The present publication brings together an unprecedented spectrum of such photographs, including more straightforward documentation of performances for collective audiences, and much of what we collected is previously unpublished.

Each decision we have made concerning the content of this book has been informed by our intimate knowledge of Howells and his practice, by thinking and asking: 'Does this fit him? Does this do justice to the "spirit" of his person and of his performances?' Not all decisions have been straightforward, as this Howells – like the one in life – remains a complex interlocutor. Our individual and singular relationships with Howells ensure he remains rounded, unpredictable, and somewhat elusive. Like all subjects of critical (and, indeed, personal) attention, ultimately, he exceeds our knowing, in death as in life. One thing we are certain of, though, is that Howells – all versions of him – would want, expect and indeed demand a 'gorge-arse' book (to borrow one of his favourite turns of phrase). We hope this is what we have achieved through collaborative attention to Howells, and attentive collaboration with each other, with designer David Caines, and with all those who have contributed directly and indirectly to this collection.

This book is an enduring act of friendship. Friendship in this book's context is less a conflict of interest than a defining relation of sympathy, and a challenge to forge an impossible relation of responsibility and duty to Adrian. Our responsibility, as editors, then, is not only to Howells. Whilst both life and death are singular, they are also relational and multiple, each 'I' a 'we' beyond a 'me' and a 'you'. Even in death this 'we' persists, albeit now as a tear or rent in the fabric of our worlds constructed with the one we mourn for.[58] Howells is firmly part of – an absent present in – many such multiplicities. In planning this collection, as co-editors we wanted to represent the 'we'; in fact, *our* attempt to represent Howells can only ever be multiple. That multiplicity is extended here through invitations to other people with whom Howells worked, played, learned, loved and affected. Each of these offers a different 'we'; but, yet, given the hundreds or thousands of people Howells related to, in performance, in life, and in the blurred spaces in-between, these are inevitably far too few.

Summaries of chapters

It's All Allowed brings together both new and previously published writings, by scholars and artists who knew Adrian personally, and also by scholars who did not. The writings gathered take the form of longer scholarly essays on a

broad spectrum of key themes in Howells' practice, and shorter essays by a variety of contributors, including artists who have been inspired, provoked, or sustained by Adrian's example. These are complemented by an interview with and writings by Howells. The book begins with a co-written biographical survey of Howells' work, from his adolescent forays into community theatre, to professional work in ensemble theatre, to his key collaborations, and the formative developments across as full an extent of his career as possible. The survey is followed by Adrian's own voice, mediated in the form of the edited transcript of an extended conversation with Johnson. The book proceeds with an essay by Stewart Laing, which explores Howells' early theatrical work. In a co-authored essay, Heddon and Howells narrate key developments across Howells' work, perhaps prefacing some of the overarching problems and themes addressed in subsequent essays. In an essay on Howells' construction of intimacy and engineering of disclosure, Jon Cairns demonstrates his critical sensitivity towards the politics of his latter performances, specifically in *An Audience with Adrienne* and *The 14 Stations of the Life and History of Adrian Howells*.

Cairns' essay sets up a series of scholarly and creative encounters with Howells' one-to-one performances, including Caridad Svich's poetic meditation on distillations of the theatrical encounter, and a critical essay by Deirdre Heddon, Helen Iball, and Rachel Zerihan on the same theme. The artist Marcia Farquhar considers the affective and personal force of Howells' example. After an essay by Howells on his landmark one-to-one performance, *Foot Washing for the Sole*, Helen Iball analyses the ethical implications of the format more broadly. Kathleen Gough focuses back in on the historical, social, and religious contexts for the use of the one-to-one format in *Foot Washing*. Essays by Robert Walton, Rosana Cade, Fintan Walsh and Lucy Gaizely, Gary Gardiner and Ian Johnston focus in on the political and intimate effects of Howells' generous orientations to performance, as well as to audiences, collaborators, students, and peers. Essays by Shelley Hastings, Jackie Wylie, and Stephen Greer explore the material conditions of production for Howells, from the experience of producing his works, in Glasgow and London, to the relation between Howells' performances and broader issues concerning archiving, and immaterial and affective labour. Tim Crouch's essay returns to some of the earlier themes of the book, namely Howells' relationship to more traditional theatrical forms, specifically in terms of Howells' performance in Crouch's controversial play, *The Author*. Laura Bissell and Jess Thorpe lead a discussion with young artists in Glasgow, to explore Howells' influential practice as a mentor – and elder of sorts – in that city's artistic community, a theme which the artist Nic Green explores in elegiac terms in her own written contribution. Finally, Jennifer Doyle closes the book with a moving essay on Howells' formidably affective engagements with the themes of depression, grief, loss, forgiveness, personal failure, and responsibility.

Whilst this collection testifies to the work that Howells made, it is intended neither as a hagiographic act, nor an uncritical celebration of Howells' work. Neither approach would do justice to the complexity of his practice, the processes Howells explored, the experiences encountered and the questions raised. Howells did not respond well to negative criticism of his work (indeed, who does?), but he did want to be taken seriously. This collection substantially tries to do the latter, accounting for the rigour of his approaches, the contexts from which his works drew, and the profound effects he sought – and often achieved – in his performances. It also, though, tries to bring to life something of the multifaceted Howells, our singular and thus irreplaceable friend. As with any act of tribute, or of collective memorialisation, we have found many different versions of the same object – many different *Adrians* – suggesting a plurality that we hope *It's All Allowed* will manifest, or foster.

One of the challenges of writing this introduction, and of compiling and editing this book, is how to negotiate the extent to which one writes about Adrian, in the course of – or, less favourably, in the place of – trying to write about the work of Adrian Howells. The two provinces seem strikingly analogous, but are not identical or self-same. In the essays that follow – and indeed, already in this introduction – authors refer primarily to 'Howells', but also to 'Adrian' when it is clear that the person (an intimate subject) is being addressed, or when a more formal attribution might seem unfeeling or otherwise inappropriate. There is, of course, some slippage. We imagine he would have approved of and enjoyed this difficulty.

While no one can possibly fill the gaps left by Adrian Howells, our aim here is that his many sides come through: his spirituality, his humanity, his campness, his sadness, his generosity, his vulnerability, his queerness, his rigour, his determination, but mostly, his joy and humour. After all, *it's all allowed.*

1. Howells states his preference for the term 'audience-participant' in Josephine Machon, 'Adrian Howells: The Epic in the Intimate', in *Immersive Theatres: Intimacy and Immediacy in Contemporary Performance* (Basingstoke and New York: Palgrave Macmillan, 2013), pp. 260-8 (p. 261).

2. Howells uses the term 'accelerated friendship' in Adrian Howells, 'The Burning Question #3: What's it Like Washing Feet Every Day?', *Fest*, 16 August 2009, <http://www.theskinny.co.uk/festivals/edinburgh-fringe/fest-magazine/the-burning-question-adrian-howells> [accessed 11 November 2015].

3. Dan Prichard, *Adrian Howells* (video), Interview for British Council, Singapore, Part 1, *YouTube*: <https://www.youtube.com/watch?v=C7btf8Tdg_s> [accessed 13 June 15].

4. Quentin Crisp, *How to Become a Virgin* (London: Flamingo, 1996), p. 106.

5. Pat Butcher was a character in the British TV soap opera *EastEnders* for several decades from 1986 to 2012 (played by Pam St. Clement). Adrian used to often joke that he was 'Pat Couldn't-be-Butcher', due to their similar penchants for peroxide blonde hair, thick matte foundation and gaudy earrings.

6. Rachel Zerihan, *One to One Performance: A Study Room Guide*, Live Art Development Agency, 2012, p. 35: <http://www.thisisliveart.co.uk/resources/catalogue/rachel-zerihans-study-room-guide> [accessed 24 September 2015]. Emphasis in original.

7. Ibid.

8. Deirdre Heddon, *Autobiography and Performance* (Basingstoke: Palgrave Macmillan, 2008).

9. Ibid., p. 172.

10. Dominic Johnson, 'Held: An Interview with Adrian Howells', in *The Art of Living: An Oral History of Performance Art* (Basingstoke and New York: Palgrave Macmillan, 2015), pp. 262-85 (pp. 264-5).

11. Ibid., p. 264.

12. Ibid., p. 265.

13. Leslie Hill and Helen Paris, *Performing Proximity: Curious Intimacies* (Basingstoke: Palgrave Macmillan, 2014), pp. 2-3, 18.

14 Machon, *Immersive Theatre*, pp. 260–8.

15. Ibid., p. xvi.

16. Gareth White, *Audience Participation in Theatre: Aesthetics of the Invitation* (Basingstoke: Palgrave Macmillan, 2013).

17. Heddon, *Autobiography*, p. 4. See also Deirdre Heddon, 'Performing the Self', *M/C Journal*, 5.5 (Oct 2002), < http://journal.media-culture.org.au/0210/Heddon.php> [accessed 17 January 2015].

18. Grant Kester, *Conversation Pieces: Community and Communication in Modern Art* (London and Berkeley: University of California Press, 2004), p. 90.

19. Ibid., pp. 1, 69.

20. Of course, all autobiography is dialogical in Bakhtin's terms, but also in terms of individual life stories being multiply populated. See Deirdre Heddon, 'Beyond the Self: Autobiography as Dialogue', in *Monologues: Theatre, Performance, Subjectivity*, ed. by Clare Wallace (Prague: Litteraria Pragensia, 2006), pp. 157-184.

21. See Leonard Waks, 'Listening and Questioning: The Apophatic/Cataphatic Distinction Revisited', *Learning Inquiry*, 1.2 (2007), 153-61; and Andrew Dobson, *Listening for Democracy: Recognition, Representation, Reconciliation* (Oxford: Oxford University Press, 2014).

22. Nicolas Bourriaud, *Relational Aesthetics*, trans. by Simon Pleasance, Fronza Woods and Mathieu Copeland (Dijon: Les Presses du réel, 2002), p. 14. Emphasis in original.

23. Ibid., p. 9.

24. Ibid., p. 15. Emphasis in original.

25. Ibid., p. 36.

26 Adrian Howells, 'Foot Washing for the Sole', *Performance Research*, 'On Foot', 17.2 (2012), 128-31 (p. 128). This essay is reproduced in full in the present publication.

27. Jen Harvie, *Fair Play: Art, Performance and Neoliberalism* (Basingstoke and New York: Palgrave Macmillan, 2013), p. 25.

28. Claire Bishop, 'The Social Turn: Collaboration and its Discontents', *Artforum* 44.6 (February 2006), pp. 178-83 (p. 181).

29. Johnson, 'Held', p. 274.

30. Claire Bishop, *Artificial Hells: Participatory Art and the Politics of Spectatorship* (London and New York: Verso, 2012), p. 7.

31. Deirdre Heddon, Helen Iball and Rachel Zerihan, 'Come Closer: Confessions of Intimate Spectators in One to One Performance', *Contemporary Theatre Review*, 22.1 (February 2012), 120-33 (p.122). A revised version is reproduced in the present publication.

32. Johnson, 'Held', p. 274.

33. Ibid., pp. 268-9.

34. Bourriaud, *Relational Aesthetics*, p. 57.

35. Abramović in Sean O'Hagan, 'Interview: Marina Abramović', Guardian, 3 October 2010, <http://www.theguardian.com/artanddesign/2010/oct/03/interview-marina-abramovic-performance-artist> [accessed 17 January 2015].

36. Howells was influenced by Abramović's work during the development of *Lifeguard*. The opening scene of what was otherwise quite a theatrical production intended to show Howells cleaning the surface of the pool in real time and with real – rather than acted – effort.

37. Johnson, 'Held', p. 179.

38. During his Fellowship at the University of Glasgow Howells created a file for performance fliers of shows he had seen which bore some relation to his own work. Living in Glasgow from 2006, he also attended the annual National Review of Live Art, becoming better informed about live art practice and acquainted with a range of artists working in this context. As he began to appear in performance and live art festivals, such as Fierce (Birmingham), his knowledge expanded further.

39. Kathy O'Dell, *Contract with the Skin: Masochism, Performance Art and the 1970s* (Minneapolis and London: University of Minnesota Press, 1998).

40. Johnson, 'Held', p. 276.

41. Bojana Kunst, *Artist at Work: Proximity of Art and Capitalism* (Winchester and Washington: Zero Books, 2015), p. 31.

42. Ibid., p. 42.

43. *Salon Adrienne* was originally conceived for Battersea Arts Centre at the Ocean salon in 2005 and was performed that same year at Cromerford Hairdressing as part of Glasgay! It toured to various venues including Byron's Salon, Lancaster in association with Nuffield Theatre; Voodou Hair Salon, Liverpool as part of Homotopia and Hush Hair, Birmingham as part of Fierce Festival.

44. Eirini Kartsaki, Brian Lobel and Rachel Zerihan, 'Editorial', *Performing Ethos: An International Journal of Ethics in Theatre & Performance*, 3.2 (2014), 99-105 (p. 104).

45. Ibid.

46. Deirdre Heddon and Adrian Howells, 'From Talking to Silence: A Confessional Journey', *PAJ: A Journal of Performance and Art*, 33.1 (2011), 1-12 (p. 2). This essay is reprinted in the present publication. Heddon has subsequently returned to explore and challenge the terms of one-to-one in Howells' performance, *The Garden of Adrian*, proposing that the one-to-one is in fact more-than-one, reading the attention Howells pays to the more-than-human as a model of ecological, collaborative practice. She does this by moving away from Levinas and towards Jean-Luc Nancy, who replaces 'one and the other' with 'one with the other'. See Heddon, 'The Cultivation of Entangled Listening: An Ensemble of More-than-Human Participants' in *Performance and Participation: Practices, Audiences, Politics*, ed. by Helen Nicholson and Anna Harpin (London: Palgrave Macmillan, 2016).

47. Alphonso Lingis, *Violence and Splendor* (Evanston: Northwestern University Press, 2011), pp. 12-13. Emphasis in original.

48. Adrian Howells, untitled presentation, *The Epic and the Intimate*, chaired by Lyn Gardner, as part of London International Festival of Theatre's 'LIFT Debates' series, Institute of Contemporary Arts, London, 1 July 2010. Quotations are from his handwritten notes in an untitled and unpaginated journal, Adrian Howells Collection, Scottish Theatre Archive, University of Glasgow, Box 21. The editors have amended his notes to expand abbreviated words where appropriate. Subsequent citations from Howells in this section are from this same source, unless otherwise stated.

49. Ibid.

50. Howells in Machon, 'Adrian Howells: The Epic in the Intimate', p. 261.

51. Howells, untitled presentation, *The Epic and the Intimate*.

52. Howells in Zerihan, *One to One Performance: A Study Room Guide*, Live Art Development Agency, 2012, <http://www.thisisliveart.co.uk/resources/catalogue/rachel-zerihans-study-room-guide> [accessed 5 November 2015], p. 36. Emphasis in original.

53. See Jacques Derrida, *The Work of Mourning* (Chicago: University of Chicago Press, 2001), p. 136.

54. Maurice Blanchot, *The Unfinished Conversation*, trans. by Susan Hanson (Minneapolis and London: University of Minnesota Press, 1993), p. xv.

55. Jean-Paul Sartre, *Being and Nothingness* (New York: Washington Square, 1956), p. 695.

56. These were used in a festive-themed 'break-out' sequence in Howells' one-off performance *An Audience with Adrienne: A Cosy-Rosy Christmas Comedown* (Drill Hall, London, January 2007).

57. Hamish Barton, personal correspondence with Dominic Johnson, 31 July 2015.

58. Derrida, *The Work of Mourning*, p. 147.

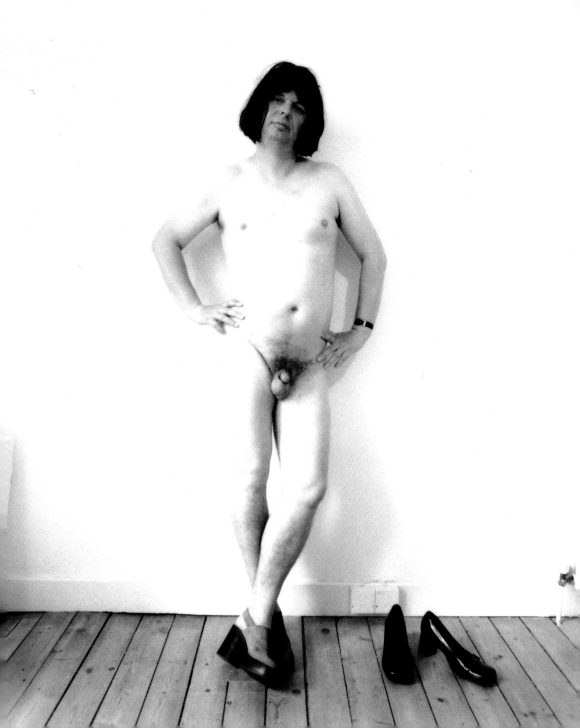

Adrian Howells: A Working Biography and Survey

Deirdre Heddon and Dominic Johnson

When writing towards the performances of Adrian Howells, one is likely to be drawn to try to depict his personality, which was so deeply imbricated in his work. The temptation may be to go 'in deep and personal', as it were, in our posthumous encounters with the artist. To do so may seek to escape all decorum, or critical apologia, and to plunge headlong into one's own memories, personal sadness, and attendant grief, in order to face frontally what now looks like the un-navigable interdependence of his art and life.

In the chapters of this book, our assembled authors thus inevitably wrestle, at times, with the slippery distinction between the person and the artist, and its effects for reading his performances. That challenge persists here, but the purpose of this chapter is to provide a summary of Howells' working life. We aim to describe and explain (and, intermittently, give a sense of Howells' own perspectives on) the many substantial phases, forms, and idiosyncrasies of the broad range of performance modes that he practiced, from the late 1970s until his death in 2014. Whilst we admit that a risk of biographical reconstruction is that the dots become joined in a way they were not so in reality, in surveying Howells' working life we are nevertheless struck by just how numerous and varied his influences and experiences were. Our attention focuses mostly on the work that preceded the emergence of what became Howells' signature style, namely his intimate, autobiographical and one-to-one performances, as these works are given very detailed attention throughout the book. We also discuss the works Howells developed in the final years of his life, which have not been received otherwise in substantial ways. This chapter will begin to set up the subsequent negotiations of the public and personal aspects of Howells' work, in part by establishing a biographical context, and more substantially by giving an inevitably selective survey of his practice as a theatre artist.

Opposite: Adrian Howells poses for a 'character study' by the photographer Hamish Barton at Howells' home in Partick, Glasgow, 2009. Barton photographed friends and other sitters for a series examining male nudity. Photo © Hamish Barton.

Theatrical Beginnings

Adrian Howells was born at teatime on 9 April 1962, in his grandmother's house, in the small village of Bapchild, Kent. He grew up in nearby Sittingbourne, Kent, a small industrial town in the South-East of England, some 72km from London. At the time of his birth, his father worked as a security guard at a papermaking factory, and his mother worked as a secretary in a primary school.[1] As a child, Howells attended Minterne County Junior School and enrolled at Borden Grammar School, a single-sex school for boys, after he passed the '13 plus' (or Common Entrance) examination. He felt held back in his progress in academic studies: he described himself as having 'always struggled with reading and writing' throughout his formal education; he would also remark that he was considered intellectually less advanced than other students, and was placed in a 'Special Withdrawal Class for remedial children' at primary school.[2]

In a series of compelling videos recorded in 2006 at his parents' house, Howells interviewed his parents, Danny and Brenda, about his early history. These videos offer a tangible example of the blurring of Howells' life and art. The videos were screened in various versions of *An Audience with Adrienne* (2006-10). We presume Adrian made them with that performance in mind. They are works of art in their own right – highly structured, mediated and performed documents – but nevertheless they still shimmer somewhere between 'life' and 'art'. The introductory video begins with Howells, in full drag, lip-syncing to *When Will I See You Again* by the Three Degrees ('Ooh, aah, precious moments!'), as his taciturn parents read magazines in their tidily apportioned dining room. In a video in the series titled *Sensitive Boy*, he asks, 'I was a sensitive little boy, wasn't I?', prompting vigorous agreement from his family. He recalls being a fearful child – he and his mother remember him being afraid of 'carnivals, particularly nativity scenes', 'pneumatic drills, escalators', and itchy fabrics. The young Adrian, as described in this video, seems a rather effeminate young thing, keen on the colour pink, 'dollies and teddy bears', and – his Aunty Noreen adds – 'ladies' things – that was quite obvious'. His childhood affectation was to take out a compact mirror in public spaces, and ostentatiously powder his nose. He was *Fatally Attracted to Colourful and Glittery Things*, a phrase that lends itself to the title of another video in the series. In *Poofter*, the final video in the series, he remembers having a hard time at school, and his older brother Julian sticking up to playground bullies on his behalf.

However, he was also a self-appointed 'court jester' at school, and developed an early enthusiasm for theatre. He starred in many school productions, won the school prize for drama in Year 12, and was a member of the Kent County Youth Theatre.[3] Howells' first notices were published in response to his performances in local theatrical productions. One of the earliest items in Howells' archive is a laminated full-page clipping from a Kent newspaper, the *Gazette and Times* (29 March 1979). Though written about a 16-year-old boy, much in the report resonates with the Howells we would come to know some decades later.[4] Under the strapline, 'The Drama Dream that Came True', journalist Barry Roberts

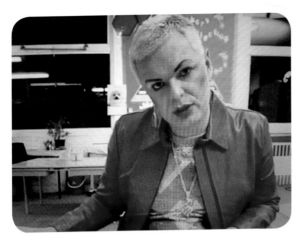
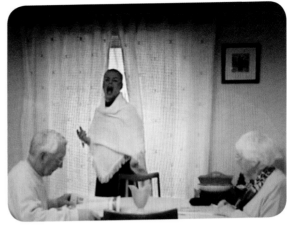
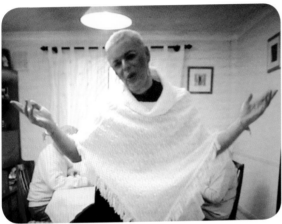
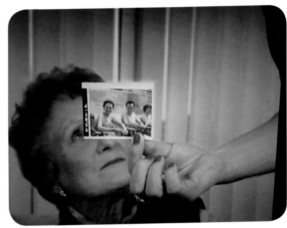

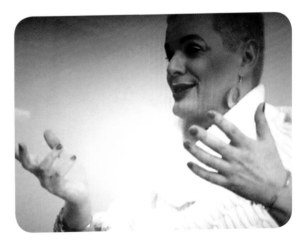

Above: Stills from four videos made by Adrian Howells in 2006 for performances of *An Audience with Adrienne* (2006-10). Directed and edited by Ben Wright, the videos are: *Introduction, Sensitive Boy, Fatally Attracted to Colourful and Glittery Things*, and *Poofter*.

reports on the first production of the newly formed Sittingbourne Youth Theatre: *The Life of the Insects*, a play written in 1922 by Czech writers Josef and Karel Capek, here produced and directed by Howells.

Roberts credits the creation of Sittingbourne Youth Theatre to Howells, who 'aspires to become either a drama teacher or an actor'. Howells was motivated to set up the new company, Roberts cites him as saying, because people who had left school to attend college or start work 'had nowhere to carry on doing drama'. The company, managed by a committee of six, decided on the plays to be produced, though Roberts describes it as 'natural' that Howells was elected as director of the company and producer of this first show. Howells reveals his hopes for the company's next production: a musical, 'possibly *Godspell*.'

The Life of the Insects was Howells' and his then-19-year-old co-founder Louise Pickles' first experience of directing and designing costumes for a play, and 'both found it extremely strenuous but also a joy' – a typical Howellism. Whilst Howells was credited as director and producer, Pickles proclaimed herself a 'general dogsbody', though Roberts describes her performance in the play – as a 'flirtatious butterfly' – a 'bright light' of the production.

The news article is illustrated by a number of black and white production shots of the cast, and also of Howells, Pickles and their stage manager during rehearsals. A series of four smaller black and white portrait photographs runs down the left hand side of the double-page spread, under the strapline 'Faces of the producer'. Each of these photographs features only Howells and carries a witty caption. A pale-faced boy, in school uniform – shirt, tie, and blazer – and with a head of thick dark curly hair, is clearly animated by his role and responsibility. Howells appears dynamic, demanding and charmingly charismatic.

Howells left Borden in 1980 and from 1981-84 attended Bretton Hall College, Wakefield (part of the University of Leeds, and now no longer extant), graduating with a bachelor's degree in Drama and English. Richard Wolfenden-Brown, a friend of Howells and a peer on the Drama course, recalls that the programme had a focus on devised work, with students encouraged to direct their own productions as well as to participate in productions directed by other students.[5] Wolfenden-Brown's recollection of the time and place is evocative:

> Bretton was isolated, few students had transport and most were passionate about developing their skills, so the college was always a hotbed of artistic activity. It felt like plays were being rehearsed at all times of the day and night in every nook and cranny of the mansion house including the cellars, the underground chapel, the 'Kennel Block' bar, the orangery and throughout the beautiful college gardens which were home to the burgeoning Yorkshire Sculpture Park.

An early production in which Howells participated was *Theseus and the Minotaur* (1981), 'a devised piece which began with the characters appealing directly and desperately to individual members of the audience for assistance in their plight'.

Faces of the producer

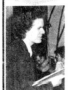

Producer Adrian Howells points out the difficulties... EE569/25

"Well the problems are... EE569/26

"Get the expression right... EE569/27

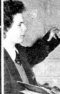

"And make sure we don't do that again... EE569/28

"Well I'm sure it will be all right on the night." EE569/29

"You were marvellous" (pointing at one of the cast) EE569/30

CURTAIN UP ON THE YOUTH THEATRE'S FIRST SHOW — AND IT'S A BIG SUCCESS

The drama dream that came true

THE Youth Theatre, Sittingbourne, put on its first production since forming five months ago — "The Life Of The Insects" — and played to a sell-out first night audience on Thursday.

And the people who went to see the play, which was totally organized from inception to finish by the youngsters, must have gone away impressed with the authority the group displayed.

Two months of hard graft went into the Thursday, Friday and Saturday night productions, but there were many slip-ups and mishaps on the way, none more so than during the dress rehearsal the night before the opening.

But the youngsters adopted the attitude of "the show must go on" and so it did.

The production saw the culmination of 18-year-old Borden schoolboy Adrian Howells's dream of starting a youth theatre.

He had wanted to start up the youth theatre because he had spare time on his hands which he felt he could devote to drama.

Response

Together with ex-Westlands head girl, Louise Pickles (19) and another girl who has since withdrawn from the group their discussions turned into reality when they approached 24 youngsters who had nowhere to do drama on leaving school.

They had a very good response and today the youth theatre is flourishing, after just five months, with members from local schools.

Adrian Howells, who aspires to become either a drama teacher or an actor, said: "Although I am involved with the Kent County Youth Theatre I still felt that I had a lot of spare time and felt I could put more energy into the theatre. I knew a lot of people who had moved from school to either college or work who had nowhere to carry on doing drama."

Naturally enough, Adrian was elected director of the company and producer of the show. A six strong committee decides what plays will be performed and who shall be responsible for directing and producing them.

"Life of the Insects" by Czechs Josef and Karen Kapek was chosen from among five plays which the committee read and finally decided upon with the help of Borden's drama teacher Jon Adams.

Help in providing a theatre and costume material was not too hard to find as John Killick of Brenchley House offered the theatre for the group's use and mothers readily provided the material.

An air of excited anticipation prevailed at the group's dress rehearsal last Wednesday and scenes of organized confusion dominated the night.

The group had been working non-stop for the two weeks previous to the production but suffered a flooding from the leaking Brenchley House theatre roof and a faulty dimmer light.

Before the theatre became available the group had to work in small rooms and at the Newhouse Youth Club.

Musical

Adrian Howells hopes that the group's next production will be a musical — possibly "Godspell".

He said: "We definitely want to go on and do something else. It is my own choice that we should do something like Godspell. If the public like us we will carry on. But I think we will go on and do some other work anyway."

Louise Pickles, who now is studying costume design at Medway College of Technology describes her part in the group as "general dogsbody." At first she volunteered for the costume design but became roped in to do make-up and to help with direction.

All the costumes designed were thought up by Louise, who has starred in various Westland School productions, such as "Sweet Charity" and "Half A Sixpence."

Joy

At first she designed grandiose costumes but realized it would have been impossible to make them with the group's limited resources.

For Adrian and Louise, it was the first time they had attempted directing and costume designing for a play.

Both found it extremely strenuous but also a joy.

Louise said help from mothers and other people had been very useful. She said: "Everybody has been very good to us. Mothers have given us material and helped make the costumes."

The costumes had to be based more on the characters than the insects they were playing, although the costumes were made in attempt to symbolize or represent the insects, such as a black shiny outfit for a beetle.

The play showed through the analogy of insect life that all the "nasty" characteristics attributed to creatures are in fact human traits.

Main theme of the play was lust and the chase, killing and war. All of which are directly attributable to humans. A drunken tramp falls down to sleep in the long grass, watches the world of the insects and is outraged by each such goings on.

Rachel Edmonds (17) was compelling and convincing as the tramp, with Paul Cooper impressive as the impulsive romantic butterfly.

Other bright lights of the play were Louise Pickles as a flirtatious butterfly, Chris Billington (14) as the snail and Victor butterfly and Tricia Hills (16) as dictator ant.

STORY: BARRY ROBERTS

PICTURE: PETER MARSH

Louise Pickles in her butterfly costume, producer Adrian Howells and stage manager Alison Nicholls discuss the show so far. EE569/9

Michael Porter (left) on sound, Andrew Swift on lighting and Janet Dodd assisting the lighting were behind the scenes. EE570/17

Two snails make each other up before the dress rehearsal. Here Paul Cooper puts the finishing touches to Chris Billington. EE570/22

The cast of "The Life Of The Insects" at their dress rehearsal. EE570/14

Above: Howells clipped and laminated Barry Roberts' article 'The Drama Dream that Came True', from the *Gazette and Times* newspaper, published on 29 March 1979. Adrian Howells Collection, Scottish Theatre Archive, University of Glasgow, Box 12.

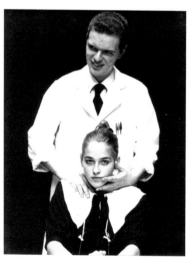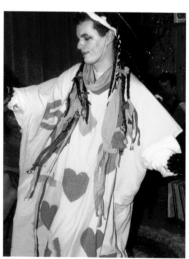

Wolfenden-Brown remembers that, before the play began, 'each actor eyeballed an audience member and struck up a one-to-one relationship, if only briefly'.

In 1982, Howells appeared in *Mrs Milburn's Diaries*, another devised piece, this time documentary in form, and developed from a 'second world war diary of a middle class woman who experienced life on the home front'. The project coincided with the Falkland's War, leading to a heated debate between cast members as to whether the documents used should instead relate to contemporary events. In the end, Mrs Milburn's diaries won. In 1983, the performance project was Thomas Kidd's *The Spanish Tragedy*, a culmination of the second year course, History of Drama, which covered Greek, Roman, medieval and pre-Shakespearean theatre.[6] Course tutor Arthur Pritchard, with whom Howells remained in contact throughout his life, recollects that in Howells' class there were 21 students (ten men and 11 women). To ensure that everyone had sizeable speaking roles in the production, some characters were played by several students, with actors switching roles midway. Pritchard remembers that happening in this production: 'Adrian played the nicely dressed messenger who drifts in with a message for Lorenzo. He then changes places with the onstage Lorenzo to become the character and read the letter'.[7]

In his third year, Howells performed in *Chamber Music*, a one-act play written in 1962 by absurdist playwright Arthur Kopit, directed by one of Howells' peers. The play, set in an asylum, presents eight famous women from history, including Gertrude Stein, Susan B. Anthony and Amelia Earhart. Howells played the sadistic doctor.[8] In the summer of that final year – 1984 – Howells and his peers used 'techniques honed by Mike Leigh' to devise *Eating Eyeballs*,[9] which was presented not only at the college but – a highlight of the course – at a youth centre in Wakefield.

During his final year at Bretton Hall, Howells became for a time a born-again Christian.[10] He was president of the college's Christian Union, and had not yet come out as gay. He also struggled with chronic depression. A serious suicide attempt was followed by a period in hospital, though Howells returned to college before the course ended.

In his reminiscences from this time, Wolfenden-Brown comments on the supportive atmosphere of Bretton Hall, with staff always available to students, a sentiment confirmed by the fact that following his breakdown and hospitalisation, Howells stayed with his English tutor, the head of Bretton Hall's English Department, Denis Watson. Watson remembers Howells as 'a wonderfully intelligent and hard-working student' and 'too conscientious for the real world'.[11]

Opposite: Selected photographs from Howells' personal collection. These and others were frequently installed in his performances, including *Salon Adrienne* and *Adrienne: The Great Depression*. These photos document Howells in his adolescent years; in costume at parties; graduating from university; and in some of his earliest performances in the 1980s and early 1990s in plays and street theatre. Adrian Howells Collection, Scottish Theatre Archive, University of Glasgow, Boxes 26 and 27. Photographers unknown.

Howells' deep fondness for Bretton Hall, and his recognition of the support he received there, was demonstrated through his continuing relationship with his tutor Arthur Pritchard and his return to Bretton Hall in 2007, as a successful alumni paying personal homage to the institution before it closed.[12]

Following graduation, Howells was invited by Wolfenden-Brown to join Cityslice Theatre in Didsbury. Cityslice had been established the previous year by seven members of the Manchester Youth Theatre (MYT), who collectively made strategic use of the government's Enterprise Allowance Scheme to support themselves and their new business.[13] Howells played an autistic footballer in the company's 1985 touring production of *The Autist*, by John Chambers. Through an introduction by Wolfenden-Brown, Geoff Sykes, the director of MYT since 1966, invited Howells to direct Willy Russell's *Our Day Out*, presented at The Library Theatre in 1988. This led to further directing invitations by Sykes, including *A Tale of Two Cities* (1989), *Twelfth Night* (1990) and *The Wall Game* (1990).[14]

Howells lived at this time with Wolfenden-Brown and his wife, Joy (who had also been at Bretton Hall with Howells and had been Howells' girlfriend for a few weeks during their first year at college). The three of them 'travelled to rehearsals each day in [Wolfenden-Brown's] Morris Minor singing loudly to Whitney Houston on the cassette tape'. In 1991, Wolfenden-Brown asked Howells to join him and musician Matt Baker in providing summer arts workshops for children in Ellesmere Port, Cheshire on behalf of Action Transport Theatre Co. Conjuring another of Howells' unique, invaluable and enduring skills, Wolfenden-Brown recalls that by the second day of the course Howells was able to greet, by name, each of the 40 or so children individually as they arrived at the door of the theatre. He recollects, '[e]very child felt special'. Indeed, Howells would use this technique throughout his life. For example, in *An Audience with Adrienne*, he would ask each audience member their name as they entered the space and then use their name during the performance. There were typically 20 or so names to remember – and he never failed. He continued to make people feel special. He also revived the skill in the part of 'Adrian' in Tim Crouch's play *The Author* (2009).

Other directing credits in the early 1990s included *A Christmas Carol* and *Aladdin* for the Coliseum Theatre Company (1991-92), *Get Stalker!* for City Life (1992, Green Room, Manchester), and *Conspiracy to Pervert*, by Blunt Instrument Theatre Company (1992, Green Room, Manchester). Howells' CV from the period portrays the life of a jobbing actor. Alongside his acting work with Cityslice and his various directing jobs, he taught Drama and English, or drama workshops, at a number of schools and colleges including Sanders Draper School (Essex), The Islamic College (London), West Cheshire College, Leyton Sixth Form College (London) and St. Paul's Girl's School (London).

The Citizens Theatre

In the 1990s, apparently following the advice of his early mentor, Sir Ian McKellen, Howells became an assistant director at Glasgow's Citizens Theatre

(the 'Citz').[15] At that time the Citizens was led by the impressive gay triumvirate of Philip Prowse, Giles Havergal, and Robert David MacDonald.[16] Havergal explains that the Citizens was not a 'gay theatre company' as such. 'It wasn't like Gay Sweatshop or one of those [companies] that was actually setting out to change the gay agenda', he recalls. 'We didn't do gay plays', he adds, although gay-inflected themes and adaptations were welcome: 'discovering that Mercutio has a crush on Romeo was absolutely up for grabs'.[17]

In his first year at the Citizens, from 1990-91, Howells was Assistant Director on *Man and Superman*, *Mourning Becomes Electra*, *The Rivals*, *The Gospels*, *Mother Goose*, *Jane Shore*, *The Housekeeper*, and *Mrs Warren's Profession*. In 1992, he assisted with *The Comedy of Errors*, directed by Havergal for the Wexford Opera Festival; and in 1993, he was Assistant Director on the Citizens' production of *The Soldiers*, at the Royal Lyceum, Edinburgh. In 1992-93, Howells stepped up from an assistantship to Associate Director on the Citizens' version of *The Jungle Book*. Reflecting on Howells' role as an assistant director, Havergal remembers:

> He was very, very good. If you asked him 'does that work?' or 'which of those two alternatives is best?', he would give an opinion. He was always fantastically positive, which in the rehearsal room is very important, particularly when the going gets rough, which it does from time to time, inevitably.

Havergal describes the assistant director role at the Citizens:

> The assistants in Glasgow didn't do any directing, but in a way they were absolutely crucial in how the whole thing hung together. Very often the assistant director translated for the actors what the director said. If an actor said, 'I don't understand what he means when he says that', Adrian would say 'Actually, I think what he means is this and this'. He was terribly good at it.

Alongside his functions as an Assistant and Associate Director, Howells also took on minor acting roles. Working for Prowse and Havergal at the Citizens and elsewhere, he acted as the Monk in *Enrico IV* (1990), Francis in *The Picture of Dorian Gray* (1993), Captain Pirzel in *The Soldiers* (1993), Benvolio in *Romeo and Juliet* (1993), and Sir James Royston in *Lady Windermere's Fan* (1994).

Havergal reflected on what Howells might have learnt from his time at the Citizens. Of the engagement with the audience in the company's productions, he recalls that their approach was 'based on a very in-your-face attitude to the audience, who were absolutely our main concern'. Asked if Howells' experience at the company was more of an inspiration, or a precedent to oppose in his works, Havergal replied, 'doing those plays on the big stage with lights and all that seems a million miles away from him intimately washing somebody in a bath with rose petals. It's a big bridge'. He continues, 'there's only so far the theatre can go – but Adrian would try to go further'.

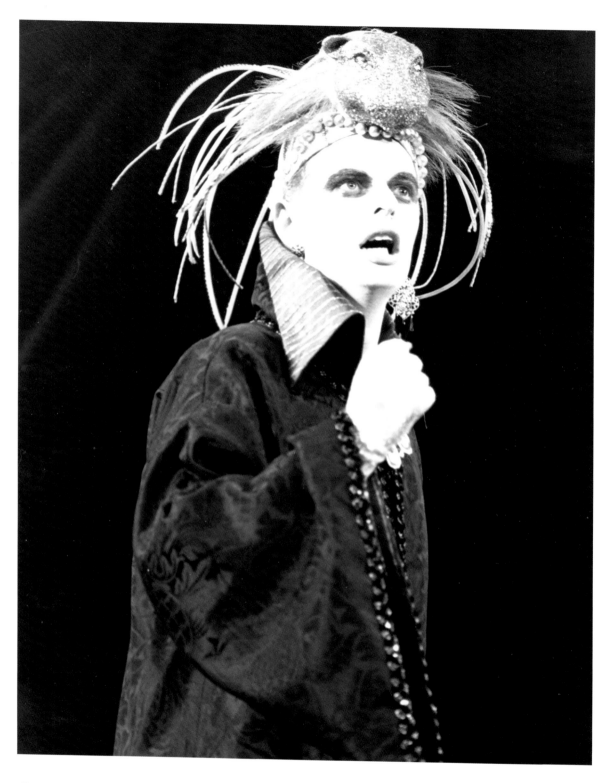

Above: Adrian Howells performing as the Wicked Queen in *Snow White and the Seven Dwarfs*, directed by Kim Joyce, performed at Hertsmere Centre, Borehamwood, 1987-88. Adrian Howells Collection, Scottish Theatre Archive, University of Glasgow, Box 26. Photographer unknown.

The Homosexual

Whilst at the Citizens, Howells worked alongside Stewart Laing, performing in plays and devised works directed by Laing for his new company TV Productions (co-founded with Lorna Ferguson). In 1993, Howells performed as Madre in the company's debut, namely a production of Copi's *The Homosexual or the Difficulty of Sexpressing Oneself* (written in 1971). Howells performed alongside the influential art-fashion icon Leigh Bowery (as Madame Garbo), the drag performer Ivan Cartwright (as Irina), and a small ensemble cast, and the production – co-directed by Laing and Gerrard McArthur – opened at Tramway, Glasgow on 24 June 1993. This experience was pivotal for Howells, as it instructed him in new approaches to the theatre's potential to challenge conventions, through the use of outrageous humour, as prompted by Copi's outrageous script, and Laing and McArthur's excessive and visually effective staging.

In an interview in the *Times Higher Education* in May 2008, Howells recalls, somewhat hyperbolically, that he began his career as a 'pantomime actor', but 'changed direction after meeting the director Stewart Laing and performance artist Leigh Bowery'.[18] One can almost hear the relish in his voice as he tells the interviewer that '*Time Out* described it as a hymn to tastelessness. I blacked up and was an Asian transsexual with a *Carry on up the Khyber* accent'.[19] The quip in *Time Out* was meant kindly, and Howells enjoyed the notoriety it allowed him. 'More ridiculous than the Ridiculous Theatre Company, more disgusting than the Jim Rose Circus, more kitsch than Coronation Street', the reviewer writes, the play was 'wonderfully bizarre': 'Few taboos are left unturned in TV Productions' hymn to tastelessness'.[20] Embellishing Copi's already monstrous play, Howells and Laing concocted a politically dubious persona for the Madre, adding extra piquancy and shock to her delivery of lines such as (with reference to Madame Garbo's pet): 'You've put that mouse up your arse-hole. [...] Come and shit it out. You could catch foot and mouse disease'.[21] Howells' reflections on the impact of this production are included later in this collection, excerpted from his interview with Johnson. Laing also offers witty and precise reminiscences of the 'odd group of homosexuals' he collected as a company to work through Copi's portrayal of a scatologically fixated group of transsexuals and prostitutes in Siberian exile.

Bowery and Howells became close friends during the production, and remained intimate until Bowery's AIDS-related death in 1994. Bowery's experience of the production is recounted in Sue Tilley's biography, where he tells of his incentive for performing the play: 'It's got all the things I really like. You know: abortions, infanticide, a whole range of scatological things. It's funny and sort of grotesque'.[22] Using interviews with both Bowery and Howells, Tilley describes their relationship:

> [Adrian] was very camp and very 'actor-ish' which greatly amused Leigh. He would entertain Leigh for hours by acting out make-believe conversations in the back of a cab between Dora Bryan, Su Pollard and Rex Harrison. [...] In return Adrian loved hearing Leigh's camp expressions

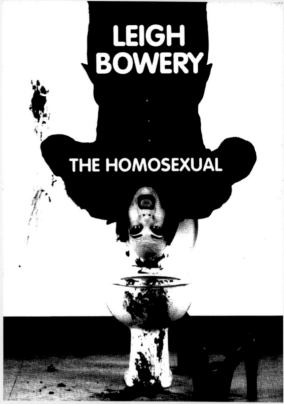

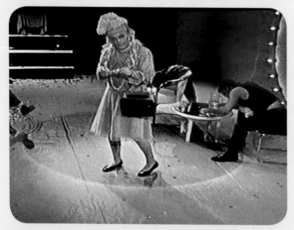

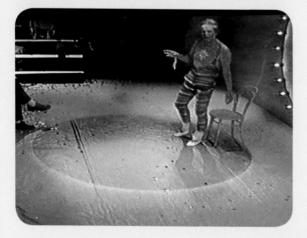

Three stills from video documentation of Adrian Howells, *The Night I Grooved to Disco Tex and the Sex-o-Letts in Barry Blue's Poncho*, performed at Citizens Theatre, Glasgow, in association with Glasgay!, 1995.

Promotional flyer (showing Leigh Bowery) for *The Homosexual: Or, the Difficulty of Sexpressing Oneself*, performed at Tramway, Glasgow, 1993.
Photo by Matthew Donaldson, courtesy of Stewart Laing.

such as 'Sit down and take the weight off your slingbacks' [...] and all the tales of his cottaging.[23]

Indeed, Tilley recounts that Bowery tried to teach Howells how to cottage by taking him on a night-time foray into Russell Square, a park in central London formerly renowned for gay cruising – with amusing consequences that both personalities enjoyed recounting.[24]

Working with Laing had a profound influence upon Howells, who seemed to overcome some of his personal, sexual and political boundaries in the course of the rehearsals and brief tour of *The Homosexual*, thanks in great part to the constructive influence of working with Bowery and Laing. Howells continued to work with Laing on other projects, performing as Daniel Defert/Philip Horvitz in Laing's production *Brainy* (with Nick Philippou, CCA, Glasgow, 1995); as Willie in Laing's production of *Happy Days* (Tramway, Glasgow and Traverse, Edinburgh, 1996); and as Paradise Dupont in Laing's production of Mae West's *The Pleasure Man* at the Citizens in 2000. Howells will likely have enjoyed what the Herald described as the 'liberal sprinkling of cross-dressing and sexual forwardness' in the latter.[25] Howells also appeared in the first production of Laing's company, Untitled Projects, namely *J. G. Ballard Project: Phase 1* (Tramway, Glasgow 1998), and the follow-up, *Myths of the Near Future J. G. Ballard Project Phase II* (Govan Swimming Baths, 1999).[26]

Laing's influence on Howells is perhaps evidenced in his decision to write, direct and perform in *The Night I Grooved To Disco Tex and the Sex-o-Letts in Barry Blue's Poncho*, at the Citizens Theatre as part of Glasgay! 1995.[27] Described by the reviewer from *The Herald* as 'a celebration of the tack 'n' cack-style of the seventies', Howells apparently took 'great relish in conjuring up taste nightmares which have the audience howling with recognition'.[28] The show was largely comprised of four dramatic monologues delivered by Howells in four different personas: 'a glamrock has-been singer, a campy dancer, an obnoxious old actress, and a vituperative child star'. Supported by Russell Barr, Ian Sizeland and Max Sharp – the latter of whom had worked with Howells in *The Homosexual* – it is notable that the monologues were 'interspersed with game-show antics requiring audience participation', with Sharp playing the role of garish game-show host.

Nigel Charnock + Company

In 1996, alongside his continuing work with Laing, Howells began a fruitful working relationship with Nigel Charnock, a pioneer of queer performance, new dance and physical theatre. A co-founder of DV8 with Lloyd Newson in 1986, Charnock formed his own company, Nigel Charnock + Company in 1995. Howells was in Charnock's second piece, *Watch My Lips*. Commissioned by queerupnorth, London's Drill Hall, and Podewil and Tanzwerkstatt (two

Overleaf: Leigh Bowery (left), Ivan Cartwright (middle) and Adrian Howells (right) in *The Homosexual: Or, the Difficulty of Sexpressing Oneself*, 1993. Photo by Eileen Heraghty, courtesy of Stewart Laing.

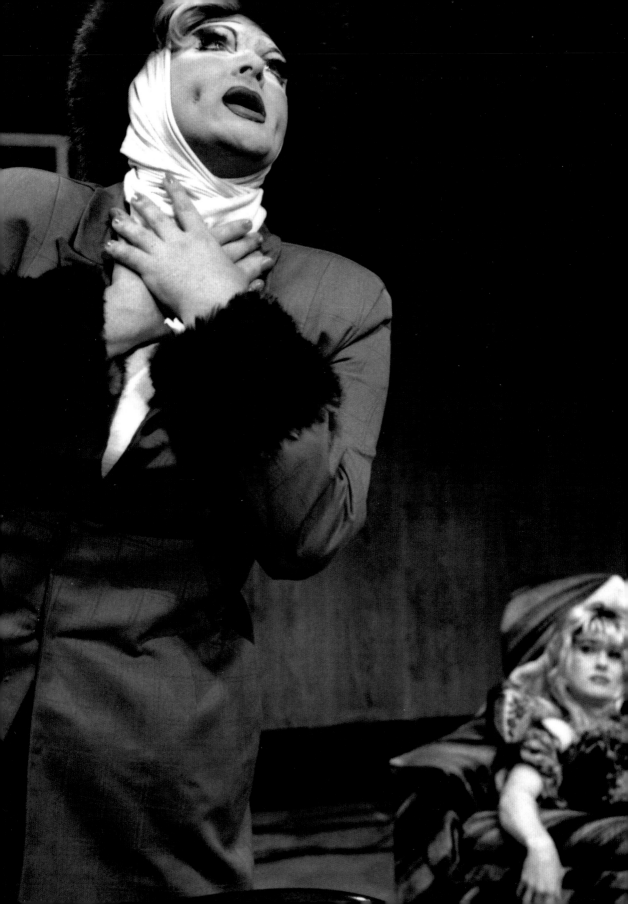

organisations based in Berlin), the show premiered at the Bluecoat Arts Centre, Liverpool on 20 February 1996, before touring. Clare Bayley reviewed the piece for the *Independent*: 'There is a voracious celebration of sex in all its forms: comical, tragical and farcical. Nothing is withheld'.[29] Most of the show takes place on 'a large red plush sofa [which] sits resplendent centre stage' and 'provides the backdrop to a frenetic exploration of sex, love and gratification', where 'choreography and sexuality collide'. A bisexual woman attempts to have sex with a gay man, and later seduces a heterosexual woman who has been dumped by her lover, who in turn allows himself to be seduced by the bisexual woman's gay friend (Howells). It is unsurprising to learn from Bayley that it results in 'heartache all round', but 'not before a great deal of energetic, graphic, nude and beautiful sex', all of it accompanied by more use of four-letter words ('cunt', 'cock' and 'fuck') than Bayley had ever experienced.[30] In an interview in 2007, Howells recollected he had to deliver a long monologue, called 'Blue': 'As I remember it, it was me on the stage, alone, talking about the death of my lover and I remember this emotionally charged speech which went on and on'.[31]

Following *Watch My Lips*, Howells appeared in a number of Charnock's productions: *Love, Sex and Death* (1997); *Heaven and Hell* (1998); *The Room* (1998-99); *I Miss my Swiss Miss, my Swiss Miss Misses Me* (1999); and *Asylum* (2000). Howells described *The Room* as 'a bedsit installation in which we, the performers, "existed" and allowed ourselves to be led by imagination and spontaneity'.[32] Performing unstructured improvisations, the performers 'were voyeuristically observed through windows and peep holes, or by live feed to a bank of monitors outside the space'.[33] *Asylum*, meanwhile, is described in Nottingham Dance festival's programme as a 'comically disturbing musical', which 'takes a harrowing and hilarious look at youth and beauty, ageing and the mid-life crisis' and offers a 'ruthless exposé of how mad we are to be normal'.[34] In his interview with Dominic Johnson, included in this publication, Howells reveals a little more of the process undertaken to create this piece, which included improvisations using autobiographical material, mixed with high-energy choreography. Howells also performed in *Stupid Men*, commissioned for the Venice Biennale (2007). *Stupid Men*, another improvised piece, was in this instance also improvised in performance. It was created and performed by four men – the eponymous stupid men – Charnock, Howells, Mike Winter, and Itay Yatuv.[35]

Developed during 2006, an online blog written at the time recorded some fragments of the devising process:

> Now we're stupid and we're men ... Or we're men and we're stupid ... Talk? I don't want to talk here ... Kind of up to them what they do ... They're all students I think ... Adrian and Mike could you stand up ... Blindfold Mike for me ... Lie on the floor ... Relax ... Stay relaxed ... Don't respond ... Whatever we do ... don't respond ... If we do anything very painful just say 'Stop' ... Erm ... we can ... erm ... we can do anything we like ... But you don't have to say anything ...

Above: Studio shoot for Nigel Charnock + Company, *Watch My Lips*, 1996.
Clockwise from upper right, the performers are Christian Flint, Victoria
Harwood, Adrian Howells, and Di Sherlock. Photo by Hugo Glendinning.

The blog also includes fragments from a dialogue between Nigel (sitting apart from group) and Adrian (blue t-shirt), in which details given may be fictionalised:

> Nigel: (*frenetic, luminous*) I go to a psychotherapist and they make me better. I feel: so what? You seem to want me to be like somebody who wants to have a relationship with somebody ... It is total chaos, there is no going anywhere ... It-is-it, it-is-just-this, it-just-is-it ... I'm kind of watching. I'm observing; not only other people, but also myself ...
>
> Adrian: What is your happiest memory of your mother?
>
> N: Hmm ... when she was dressed up for a fancy dress as a 1920's Charleston girl ... with a cigarette holder ...
>
> A: How old were you?
>
> N: Probably four or five, um.
>
> A: Do you think of that much?
>
> N: (repeatedly dotting an invisible 'I') You have to understand you're playing the game now ...
>
> A: What game are you playing?
>
> N: Ummm, do I think about it? Yeah, a lot.
>
> A: Do you talk to her ... ?
>
> N: Yes, she is a constant presence ...[36]

Graham Watts' review of *Stupid Men* invokes the chaos, humour and (personal and political) risks of the performance, alongside the clear demarcation of the performer's roles:

> The four men are most convincing as an anarchic, gay gang [...]. So, Howells is the fat man, initially bullied and regularly insulted by the aggressive one (Winter), but later snogged voraciously by him to a slow number on the dance floor. Israeli dancer, Yatuv, is regularly taunted with 'Jew boy' early on, the shock of this quickly fading through the familiarity of repetition. Charnock is always the 'ring master', the man who sets the sequence to come, either verbally or through his control of the music. [...] At the extreme end of their grossness, we had the juvenile innocence of spitting and licking sweaty armpits escalating to Howells' invitation to use his man-boobs for a 'tit-wank' and then a ritual licking of testicles. But in the spirit of open improvisation don't expect to see any of this tomorrow.[37]

In 2007, Charnock and Howells collaborated on their first two-hander. Presented at the Drill Hall Arts Centre, *Gorgeous* was supported by the National Theatre Studio and was described as an intimate work which 'combines their wit, energy and unpretentious avant-garde joy'. Comprised of a series of scenes that were 'part-written, part-improvised', it was 'forged from the depths of depression and the giddy heights of love', as 'Howells and Charnock bicker and snap their way through ugly scenes of gentle obscenity and playful horror'.[38] *Gorgeous* seems to bear resemblances to two films written and directed by Charnock,

featuring Charnock and Howells and made as part of a National Theatre Studio development scheme: *Are We Not Gods* and *Staying on Till the End* (both 2008).

The short films are witty and dark in tone, formally beautiful, and absurd in style. In *Are We Not Gods*, for example, Charnock ('Black' – and dressed in black) and Howells ('White' – and dressed in white) discuss with relish and intrigue the apparent murder of a pregnant woman and the suicide of her husband. Seemingly a camp and bitchy take on *Waiting for Godot*, the film demonstrates both artists' nuanced performance styles, and Charnock's writerly indulgence in clever language play, as Charnock and Howells engage in word association, spoonerisms, malapropisms, and irreverent dialogue. In one short scene, Charnock and Howells walk along the beach taking it in turns to intone what seems at first a heartfelt lament at the state of the world but is then unexpectedly spun in a less righteous direction:

> Oh the whales
> Oh the dolphins
> Oh the mothers
> Oh the forests
> Oh the seas
> Oh the poor
> Oh the weak
> Oh the dying
> Oh the dolphins
> Oh the whales
> Fuck 'em
> Fuck 'em.

Shot on a pier, another scene suggests autobiographical content and watching it today is challenging on account of its candidness and black humour – and the troubled suggestion of its prescience:

> White: So, your end, the end of it all.
> Black: Well, I could do a DIY job, go by my own hand.
> White: You certainly come by it.
> Both: Ooooh.
> Black: Oh, suicide schmooicide, as long as you're happy.
> White: You ain't got the guts.
> Black: That's true. You did though.
> White: Yes, I did.
> Black: Sorry.
> White: It's all right. Sometimes it's good to go there.
> Black: Location, location, location. I'm glad you came back though.

White: No choice dear, doctors, stomach pumps, I didn't stand a chance.
No, pills are dodgy. I've taken my hat off to the jumpers and the hangers.
Black: Jumpers on hangers? Isn't that bad for the wool?
Short spin, dry flat.
White: The final cycle. They're the ones who get it right.
Black: God, yes, it must be awful to get your own suicide wrong.
White: Rather than someone else's?[39]

Howells and Charnock had a loving but somewhat turbulent collaboration. The process of working together prompted Howells to consider ways of refining or harnessing the affective power of performance, which he thought might be overly dispersed or squandered in performances for large audiences. In an interview with Johnson, Howells reflected that his theatrical collaborations with Charnock tended to be emotionally and physically draining – and perhaps unmanageably so.[40] Howells recalled that performances with Charnock often felt 'self-lacerating', from giving so much of himself, either through autobiographical confessions (about his mother, his 'seven years of bedwetting', and so on), or as characters that were, at best, only very thinly veiled. 'I would have to go back to a hotel room each night', he reflected, 'and carefully stitch myself together again', metaphorically speaking, in preparation for the next performance.[41] Charnock's performances were deliberately hard to handle, provocative to both performers and spectators, yet through his participation, Howells urged himself to develop ethically responsible strategies to care for audiences during performances, and to give aftercare to himself in their wake.

That said, Howells was devoted to Charnock, and respected and admired him as a friend and peer. When Charnock died of stomach cancer on 1 August 2012, aged 52, Howells left a moving public tribute on Charnock's Facebook page:

> Nigel, you were absolutely pivotal in my development as an artist and as a human being! You offered me amazing opportunities to perform, travel and to meet and work with inspiration individuals [...]. Thank you for the privilege of choosing me to create work with you and for pushing me and challenging me to give more of myself and to go beyond my expectations of myself. 'Watch My Lips' was a brilliant and unparalleled first experience for me, gave me the unprecedented opportunity to 'reveal' myself creatively, and set the bar for the next 7 shows we collaborated on together. Thank you, too, for your unswerving love, generous support and unflagging care of me. You were simply 'the best platform from which to jump beyond myself'. Thank you! Kahlil Gibran says 'when the earth shall claim your limbs, then shall you truly dance'. Boy, are you dancing now, Nigel! My love to you. Adrian xxx

Boys, are you dancing now...

Developing Intimate Performances

Working with Citizens Theatre (particularly Giles Havergal), Stewart Laing, and Nigel Charnock was certainly influential for Howells' development as an artist. In a journal entry written around 2002, shortly after completing a tour of *Asylum* with Charnock, and on the cusp of his first signature works as a solo artist, Howells asks himself how 'to unblock your creativity', and to overcome his feeling of 'being afraid to commit to being a creative artist'; his answer, in part, is to model himself on Laing and Charnock: '[I] want to earn £500 [a] week. Want a career/life like Nigel's or Stewart's. They never sign on [to the dole], are always having meetings about projects, planning research, developing even when not actually doing a hands-on project. They get to travel [and] exist in other cultures. […] And they don't just exclusively do one thing'. Modelling his future career on Laing and Charnock's ability to survive on directing, performing, teaching, and designing, he asks himself: 'how to work consistently. How to make enough money so as not to sign on/claim HB [housing benefit]?'[42]

After working with three artist-led companies, Howells was planning and preparing for his own departures into a more singular practice in performance, which would find its form in intimate encounters with audiences. Notably, following his extensive collaborative, devised and ensemble works, Howells embraced the principle of improvisation and co-creation – in his own works, with audience-participants, rather than with a peer artist – and rejected the theatrical

Above: Studio shoot for Nigel Charnock + Company, *Watch My Lips*, 1996.
From left to right, the performers are Victoria Harwood, Christian Flint, Di Sherlock and Adrian Howells. Photo by Hugo Glendinning.

setup he had explored to date. As noted, working with Charnock in particular fuelled him to recognise a perceived tension between the emotional charge of the performances and the urge towards a profound relation (of sympathy or of antagonism) between a performer and the audience – and the distinct structural impediments to such effects.

In 2001, Howells made his first intimate work, *Adrienne's Living Room*, for the collective Area 10's cabaret night in London, 'Bob's Punkt'. Howells devised the piece for 'one, two or three people' at a time and was dressed in an outfit he had worn in a video made for (but cut from) Russell Barr's play, *Sisters, Such Devoted Sisters*.[43] Each encounter lasted 30 minutes, after which time his friend, Linda Dobell, would announce the arrival of his next guests. As Howells recalls in his interview with Johnson, Linda made up his drag name, 'Adrienne', on the spot and the name stuck.[44]

Howells continued to mine and develop this intimate form of practice from 2001 onwards. A site-specific work created with Laban students at a residential house, *Adrienne's Dancing Room* was performed later that year. He recalls:

> I installed myself in a bedroom and set myself two rules: to continually drink red wine (which I hate!), and to keep dancing to an eclectic soundtrack for the five hour performance, allowing the influence of the alcohol to dictate the disintegration of my physical appearance and movement.[45]

'Adrienne' appeared in various guises over the next decade, hosting numerous intimate encounters. A commission by The Arches for Glasgay! produced *Adrienne's Dirty Laundry Experience* (Arches, 2003), followed by *Adrienne: The Great Depression* (Great Eastern Hotel, London, 2004), *Adrienne's Room Service* (Great Eastern Hotel, London, 2005), *Salon Adrienne* (BAC, London, 2005), *A Love Unlimited Christmas with Adrienne* (BAC, London, 2005), *An Audience with Adrienne: A Lifetime of Servicing Others* (Glasgay!, Glasgow 2006), *An Audience with Adrienne: Her Summertime Special* (Drill Hall, London, 2007), *An Audience with Adrienne: A Cosy-Rosy Christmas Comedown* (Drill Hall, London, 2007), *An Audience with Adrienne: A Night at the Opera* (Munich National Theatre, 2009).[46]

Opposite clockwise from upper left: Adrian Howells, *An Audience with Adrienne*, Singapore, 2009. Photo by Dan Prichard. Supported by the British Council, the performance was presented with an invitation-only audience at a private venue, owing to concerns about the illegality of homosexuality in Singapore.

Adrian Howells in *Salon Adrienne*, performed at Comerford Hairdressers, Glasgow, as part of Glasgay!, 2005. Photo by Niall Walker. Howells performed at the working hairdressing salon for two consecutive Sundays, and he performed on the days between in a specially adapted space in The Arches.

Adrian Howells singing into a hot pink vibrator in *An Audience with Adrienne*, Singapore, 2009 (see above). Photo by Dan Prichard.

Adrian Howells, *Pool Attendant*, performed as part of Home Live Art's event Back to School at the Pool, Camberwell Baths, London, 2005. Photo by Andrew Whittuck, courtesy of Home Live Art. Howells was the MC for the event. As Adrienne, he distributed towels beforehand, and subsequently performed an intervention by attempting to walk on water, traversing the floor of the pool in heels, a brunette wig, red feather boa, and a bright blue swimsuit.

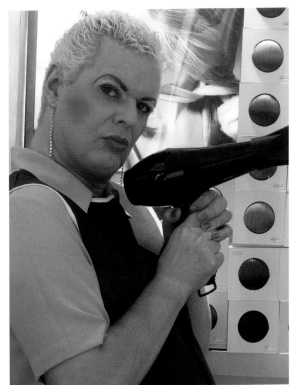
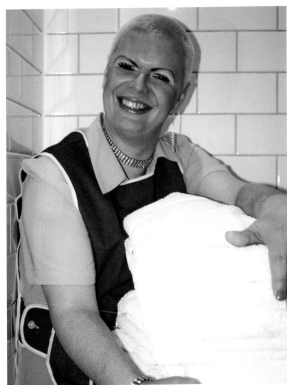
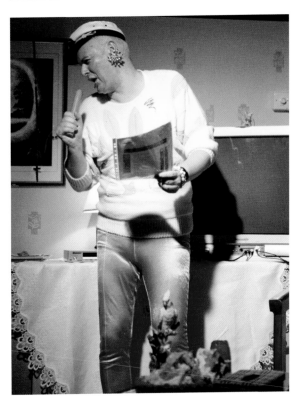

In all of these autobiographical performances, many of them discussed in the essays that follow, Howells aimed to create an intimate and non-threatening atmosphere and to encourage dialogic exchange. He explicitly set his work against what he saw as the ironic depersonalisation fostered by a mass-mediatised confessional culture, which he considered brutalising and dehumanising. He offered his own work as a site – a space and time – for more authentic and meaningful connection.[47] For Howells, the intimate form provided a unique possibility for what he often termed authenticity, therapy, communion, connectivity, confession or revelation. Of his first intimate performance in 2001, he recounted, 'It was clear that it was confessional theatre and one young guy emerged to tell my friend [Dobell] who was helping out at the door, that the experience for him had been like "drag therapy". I discovered my practice as an artist'.[48]

One-to-One Performances

Developing performances for small audiences, testing out and honing his skills in intimate and improvised scenarios and understanding the power and potential of intimate practice, it was perhaps inevitable that Howells would find his way to the one-to-one form. As he recalled in an interview with Rachel Zerihan:

> I remember thinking that if the art of 'acting' is to try and achieve intimacy or connection with each individual in an audience, as though you're performing just for them, even when you're clearly performing to a large collective, then why not just have a more conducive set up and actually just perform a piece for one person at a time? And, I was craving a more authentic and nourishing experience of exchange with another human being and one-to-one performance was able to facilitate this.[49]

Howells' experiments in performance for an audience of one boldly allowed him to absolve himself, to some extent, of his suspicion that the communal or collective theatrical experience works to subdue or abstract the ethical and political imperative to 'push back [an audience's] personal and experiential boundaries'.[50] Such formal innovation inevitably brought risks – of failure, overexposure, or exhaustion – but Howells mostly revelled in these challenges. As he recounted to Rachel Zerihan, 'I welcome audience-participants taking the initiative and doing something unpredictable, as this is an assertion of their agency, and is often indicative of the fact that they feel so relaxed and comfortable with me and the piece'.[51]

An immediate context for one-to-one performance in the United Kingdom in the early 2000s includes Franko B's visceral *Aktion 398* (1998–2002) and Oreet Ashery's *Say Cheese* (2001). Featuring Ashery's male alter-ego Marcus Fischer, *Say Cheese* was performed at Home, Laura Godfrey-Isaacs' living-room gallery in Camberwell, South London, which was a hub for many early British one-to-one performances, from 2001 to around 2006 (as Home Live Art, the organisation has since shifted to a broader curatorial remit). Howells performed *Adrienne's Dirty Laundry Experience* at Home in 2005, in a series of one-to-one or similarly intimate performances programmed between January and March (other artists

in the series included Helena Goldwater, Kira O'Reilly, Bobby Baker and Third Angel). Howells offered an explicitly therapeutic experience, framed with tongue firmly in cheek. As the programme note stated:

> Been through the mangle recently? In a lather about your life? Want to put some much-needed softness back where it belongs? [...] Forget about shamanic didgeridoo healing, colonic irritation [sic] or the latest faddish therapy, because Adrienne promises to penetrate you deeper and harder, and guarantees to put the freshness back into your whiter than white life![52]

As the substance of this book demonstrates, Howells is conspicuous for his sustained commitment to one-to-one performance, and his remarkable innovations in the form. Other artists' usages of the format usually last several minutes, in order to facilitate enough audience encounters in a single day or short run. One of Howells' key innovations was to undertake much longer interactions, which usually lasted around 30 minutes, or in some cases approached more conventional theatrical durations of more than an hour.

Howells innovated in his one-to-one performances in part by directly addressing their function as a kind of immaterial labour. When his alter-ego receives an audience-participant in a makeshift launderette, in *Adrienne's Dirty Laundry Experience*, and washes the punter's clothes while having tea, biscuits, and a natter, Howells appropriates, refashions, and explores what it means to work, both as an artist – a specialised form of cultural worker – or as someone who labours in more broadly affective and immaterial ways. He refers to his persona, Adrienne, as 'looking like someone in the service industry'.[53]

Though Howells would begin to develop work separate from 'Adrienne' from 2007 onwards, he remained committed to practices of immaterial labour, exploring in particular the boundaries of risk and trust. In 2010, he created a remarkable and challenging piece of intimate and one-to-one performance, probably his most challenging work ever: *The Pleasure of Being: Washing/Feeding/ Holding*, commissioned by the Battersea Arts Centre (BAC) for their One-to-One Festival. A predominantly non-verbal work, over the course of 30 minutes spectator-participants (most often fully naked) were bathed by Howells. He washed them purposefully and carefully, then wrapped them in a clean white towel and cradled them, feeding them chocolate. The piece demanded vulnerability and trust from the participant – an offering up of the self to the care of another. *The Pleasure of Being* subsequently toured to Milan and a Creative Scotland Made in Scotland Award supported its presentation at the Edinburgh Fringe Festival in 2011, before its return to BAC later that year.[54]

Creative Fellowship

In 2006, Howells took up a Creative Fellowship in the Creative and Performing Arts at the University of Glasgow, funded by the Arts and Humanities Research Council (AHRC). The title of his Fellowship project was 'The Nature of, and Relationship Between, Intimacy and Risk in the Context of Confessional One-

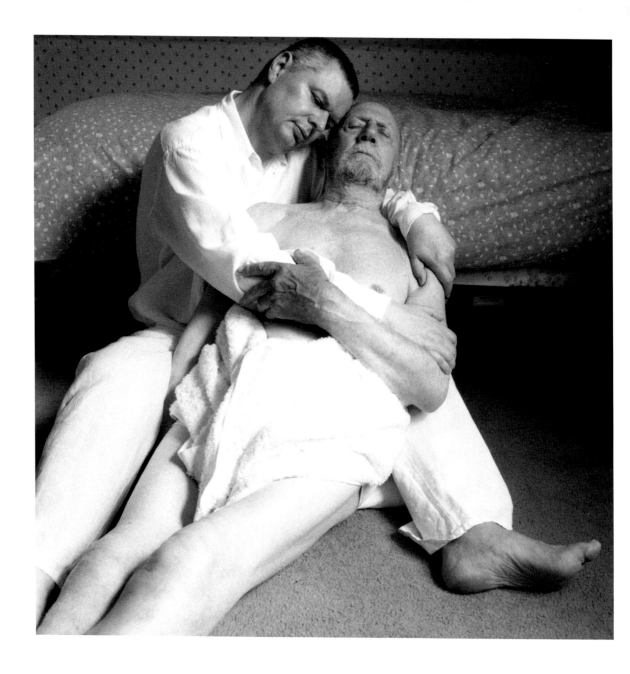

Above: Adrian Howells performing for Hamish Barton's camera to support the development of *The Pleasure of Being: Washing/Feeding/Holding* in 2010. Howells washed the audience-participant, Bill Sutherland, in a bath in the latter's home near Edinburgh, dried him, and the two posed together in a series of embraces. Photo © Hamish Barton.

to-One, Solo Performance Practice in Contrasting Sites'. During his Fellowship, Howells hoped to determine, through practical exploration:

> i) the potential of one-to-one performances to engender exchange between performer and spectator
> ii) the extent to which risk-taking is dependent on intimacy
> iii) the degree to which sites can influence intimacy and exchange
> iv) the process by which specific sites can be recreated in other sites and the potential affect [sic] of such recreation on the sense of intimacy
> v) the potential effects or function of confession in performance.[55]

A key aim was to explore how intimacy was created in performances, and in different spaces. Howells also wanted to use the Fellowship opportunity to explore the work of various performance-practitioners in order to stimulate, challenge and interrogate his practice.[56] The Fellowship provided Howells with a secure income for three years, an office, access to the University library, rehearsal and production space, and an academic mentor (Heddon). As a Fellow, Howells was also able to submit funding applications to the AHRC for additional financial support for his practice-led research.[57]

Hosted by the Department of Theatre Studies, Howells became an important and integrated member of the teaching team, not only contributing to the delivery of the curriculum, but also attending Theatre Studies meetings and participating in annual Away Days and planning sessions. His sense of humour was priceless (his fart gag was long-running: whenever his colleague, Anselm Heinrich, bent down to pick something up, Howells would make a loud raspberry noise; it never failed to amuse – and the Theatre Studies team continue to stage the gag as an act of homage). Also memorable was Howells' proclivity for, and talent at, flirting explicitly and teasing gently with his determinedly heterosexual male colleagues (who invariably enjoyed it even if they did blush on occasion): 'Michael, I do hope you are wearing your Lycra cycling shorts to work tomorrow'.

Howells seemed to relish being part of an institution (he enjoyed his ID card, office keys, and alarm code; this was also true about his time as an Artist in Residence at The Arches).[58] Perhaps being part of an institution afforded him a sense of belonging and greater security, when set against a background of precarious employment and self-reliance. Rather than finding the bureaucracy cumbersome or irritating, Howells approached the many hoops as opportunities for learning and for extending his network. He was curious about how things worked, including large organisations, and within a short space of time had made friends with research ethics officers, corporate communications staff, secretaries and cleaners. One member of staff at the University offered him her holiday flat in Paris, an offer he accepted; such was Howells' incredible capacity as a relationship-builder. He was open to and genuinely interested in everyone with whom he came into contact, irrespective of their roles or functions within the university. The openness that was a foundation and feature of his work was as much a foundation and feature of his life.

Anchored in the intimate, confessional work he had developed over the past five years, Howells sought to use his Fellowship – and the substantial time and unprecedented resources that it allowed – to reflect, in-depth, on the interrelations between 'confession', 'intimacy' and 'risk' in one-to-one performance practice. In his first research-led work, *Held* (2006), Howells removed for the first time the mask of 'Adrienne', and also began to explore touch as a form of communication. Structured in three parts, Howells and the audience-participant start by sitting at a table in the kitchen, holding hands, drinking tea, eating Bakewell tarts and chatting about hand-holding rituals and practices; they then move to the sitting room and sit side-by-side on a couch, listening to and talking about a song selected by the audience-participant; finally, they spoon together in a double bed in the bedroom, in silence, Howells' arm held gently around the audience-participant. Over the course of his Fellowship, Howells would continue to explore different modes of communication, confession and revelation, ultimately replacing spoken speech entirely with touch and acts of embodied listening in his final performance, *The Garden of Adrian* (2009).[59]

The four performances created during his Fellowship – *Held* (2006); *The 14 Stations of the Life and History of Adrian Howells* (2007); *Foot Washing for the Sole* (2008); and *The Garden of Adrian* (2009) – were each created for an audience of one and invited an unprecedented level of physical intimacy between Howells and his individual audience-participants.[60] As well as exploring intimacy in performance, Howells sought to interrogate the differences that 'site' made to the spectator-participant's experience. For example, *Held* was staged in a studio dressed up to look like a residential flat, and on another occasion, in an actual flat borrowed from a friend. *Foot Washing for the Sole* was presented in the basement of The Arches, in a yoga studio, and in a prayer room – all in Glasgow – before touring extensively. However, irrespective of the location, Howells took meticulous care with the dressing of each space so that the spatial differences and potential effects of these were actually minimised.[61] In any case, the constant in each space was Howells' interaction with his spectator-participants and the quality of this persisted: he was always attentive, attuned, and present. As his collaborator and producer, Lucy Gaizely, expressed it, the most important aspect of Howells' practice, and the feature that differentiated it from other work, was his engagement with people. This engagement with people was the experience at the core of the work; in Gaizely's words, 'it wasn't about image, structure or meaning, it was simply about that, the relationship'.[62]

Howells developed a personal method for devising his performances. For each project, he kept a detailed process journal, filled with notes ranging from the reflective and philosophical, to the thematic and imagistic. He would undertake exploratory reading around the core subject of his work. For example, for *The Garden of Adrian* he read various books and articles about gardens and ecology, including *Derek Jarman's Garden* (1995).[63] Notes from his reading would be transcribed into his journal – with his trademark CAPITAL LETTERS signalling significant insights, and question marks marking the active, ongoing

reflection and enquiry. He would also visit relevant sites – for this piece, he visited Kew Gardens, the Eden Project, the Lost Gardens of Heligan, and Ian Hamilton Finlay's Little Sparta at Dunsyre. He would also consult experts (in this case, a botanist at Kew Gardens).

The ideas noted in his journal offer a tangible narrative of how his thinking progressed, with early ideas either consolidated or discarded. These ultimately would be given fuller shape on sheets of flipchart paper, as he began to sort his extensive observations and questions into themes, and to develop an overall structure for the ensuing performance. Headings functioned as dramaturgical building blocks, sketched in thick multi-coloured felt-tip pens on large blank flipchart sheets. As he moved into rehearsals, he would Blu-Tack the sheets onto the studio wall, testing out the structure, and rewrite as he went along. The sketched structure functioned as an architectural 'script', allowing him freedom to improvise responsively to the live encounter with each audience-participant. As part of his rehearsal process, he would often invite supportive 'critical friends' into the space, and gather feedback.[64] The sheets would be roughly folded and stowed away once the process was well underway, and many of these are stored in his archive at the University of Glasgow. He would also provide guest books for audiences to leave comments, reflections or feedback (these are also held in his archive).

To mark the end of his AHRC Creative Fellowship, Howells and Heddon curated a weekend symposium at the University of Glasgow, *i confess...* (13-14 June 2009). The programme included the showing of invited artists' solo and intimate work, including performances by Howells, Sam Rose, Martina van Holn and Harminder Singh Judge, alongside contributions in the form of academic papers, discussions, and critical responses from invited speakers including Roberta Mock, Yvette Hutchison, Oreet Ashery, Helen Iball, Rachel Zerihan, Dominic Johnson and Marcia Farquhar. The symposium signalled not only the end – and the profound achievements – of Howells' Creative Fellowship, but served as evidence of his embeddedness in research cultures and academic contexts. The University of Glasgow's decision to appoint him as an Honorary Research Fellow following the end of his AHRC funding testified to the contributions that Howells' continued to make to the Higher Education sector. These included numerous research presentations given at Universities and Colleges across the UK and internationally, workshops delivered to hundreds of undergraduate and postgraduate students, and copious in-person, telephone, and email interviews with students writing dissertations about his work and the field of intimate performance practice.

Travel

Howells' performances were regularly programmed on the international touring circuits for live art, performance art and experimental theatre. His extensive international touring was partly a result of British Council support. Representatives from the British Council had attended *An Audience with Adrienne* at its showing in the Edinburgh Fringe Festival in 2007, resulting in an invitation to show work outside the UK. In 2009, Howells was part of the British Council Edinburgh Showcase, a platform for artists to connect with international

CHILDHOOD / SCHOOL / PLAYING / UMBALA

* 1. STAYING UP FOR PIPPA DEE PARTIES
½ 2. KAREN BAKER ABDUCTING ME — Garden shed
* 3. KAREN BAKER'S STRIPTEASE
4 4. LADY PENELOPE — from Ken + Mary Shaw's
2 5. PLAYING WITH THE ROWE'S / PATRICIA HILLS Hotels/shops
* 6. CLOMPING UP + DOWN ROAD IN FROCK/HIGH HEELS — Dad's reaction
3 7. ONLY BOY IN COUNTRY DANCING TEAM
6 8. SCHOOL FETE — AUSTRIAN 'NATIONAL COSTUME'
4 9. FREEMAN'S CATALOGUE CUT-OUTS
4 10. PAPER DOLLS 3 CAKE DECORATIONS
4 11. ON TRAIN WITH LITTLE BAG + COMPACT
3 12. BIG DOLL IN PINK → Mystifying presents?
5 13. AFRAID OF EVERYTHING — Left in car/Girl@ Church
5* 14. 'OCHY' CLOTHES / MESS ON HANDS
4 15. TELLING MRS GOUDDEN MUM'S PREGNANT
6 16. BEDWETTING — endless remedies sharing bed with Julian @Nana's Plastic Sheet
5 17. FIRST TAPE RECORDER afraid of dark checking wardrobes/under bed
½ 18. BORDEN SCHOOL DISCOS / mobile discos for homicidal murderer
— 19. K.C.Y.T. / DRAMA CLUB / S.Y.T. — Dungarees

BACK TO NURTURE

- TAKING TIME — SLOWING EVERYTHING DOWN
- 'TUNING IN' — TO OURSELVES + EACH OTHER
- LISTENING — REALLY LISTENING WITH OUR EARS + OUR BODIES PAYING ATTENTION
- BEING IN THE MOMENT
- BEING + BEINGNESS
- PRESENCE
- TOUCH-WITHOUT-TOUCH
- "HANDS THAT DON'T WANT ANYTHING"
- NON-JUDGEMENTAL GAZE
- FRAMING INTERACTION WITH ANOTHER AS A DANCE
- EQUAL PARTICIPANTS / PARTNERS IN THE DANCE

SEXPLOITS

1. EARLY STUFF — Fantasies about Tarzan Ron By
 6 — Looking after Charles Bronson nursing his wounds on my bed + in bath
 — 'Uncles' in swimming trunks
 — Crushes on Peter Davidson Tony Curtis Tarzan Ron
5 2. SITGES DJ — Do it properly!
7 3. BARCELONA JOAQUIN
4 4. WALTER IN GLASGOW
5 5. CRUISING IN KELVINGROVE PARK → Peggy Lee
8 6. NIGEL TAYLOR → Holy Water
5 7. MALCOLM SWIFT — Schoolboy Crush — Xmas Vac — late night stories
5 8. MR OLIVE
9. MARIO, THE PROZZIE

DEPRESSION / ATTEMPTED SUICIDE Refs. to Adrienne show?

6 1. EARLY ORIGINS — In room listening to sad songs
7 2. TAKING HANDLE OFF DOOR / TABLETS 'Honey'
7 3. ATTEMPTED SUICIDE
½ 4. DEPRESSION 2 YEARS AGO

ESSENTIAL INGREDIENTS

- WARM RECEPTION (PUTTING AUD. AT THEIR EASE / CREATING RELAXED ATMOS)
- INTIMATE ENVIRONMENT (PHYSICAL SETTING / PROXIMAL + SPATIAL RELATION-SHIP, ETC)
- INTIMATE / CONFESSIONAL SHARING
- INTERACTIVITY (GAMES / DISCUSSIONS / DANCING, ETC.)
- MEANINGFUL SELF-EXPOSURE + RISK + VULNERABILITY (DIGGING DEEP / PLACE OF DISCOMFORT)
- SINCERE NOSTALGIA (TO CREATE CONNECTION / UNIVERSALITY)
- HUMOUR + PATHOS
- POTENTIAL FOR ENDING TO BE UPLIFTING / MOVING / TRANSFORMATIONAL
- SHARING OF RITUAL (FOOD / DRINK, ETC)
- DANCING (BOTH ONE-ON-ONE + COLLECTIVE)
- CHATTY / INFORMAL / SPONTANEOUS / NON-SCRIPTED FEEL TO TEXT + EVENING ? (STRUCTURE OF WEDDINGS SPEECHES, ETC)
- POTENTIAL FOR MORE 'FORMAL' WRITING

Above: Eight sheets of Howells notes on flipcharts from various projects, including *(clockwise from upper left)*: *An Audience with Adrienne* (2006-10); the *Back to Nurture* workshop (2011-12); two sheets from *Lifeguard* (2012); two from *The 14 Stations of the Life and History of Adrian Howells* (2007-8); *May I Have the Pleasure...?* (2013); and memories for stories to be selected by audience-participants in *An Audience with Adrienne* (2007-10). These and many more flipchart sheets are held in the Adrian Howells Collection, Scottish Theatre Archive, University of Glasgow, Boxes 4, 7 and 22.

KEY THEMES/CONCEPTS FOR ① LIFEGUARD

1. MEMORY + WATER (WATER + HUMANS NOT SWIMMING POOLS + HUMANS)

2. NATURE + CULTURE

3. SEXUALISATION OF POOLS

4. TRANSFORMATION

Transformative potential of water

LITERAL ⟶ SPIRITUAL/METAPHORICAL
Experience of feeling CHANGED after swimming

- Particularised re: Govanhill Baths
- Ideas of 'real' + 'serious' swimming (outdoors) in rivers/the sea, etc.)

S. TENSION

Audience enter pool
Sit in silence + focus on pool

Brick thrown in + The swimmer retrieves it
He gives me the brick + I enter the pool today "I love to swim in this pool, then I go round the audience + tell them stories about experiences of water.
I and the swimmer get into pool + I 'teach' him to swim. He becomes a proficient swimmer + shows off.
We both show how much sheer pleasure + joy the water + swimming gives us — as a dance.
I talk about some of my other's' saucy experience in pools + in the water.
The swimmer + I demonstrate a more eroticised experience of being together + in the water.
We both end up fooling around by side of pool.
He makes me feel picked upon/victimised + intimidated by his swimming + physical prowess. The horse play leads to me pushing him in.
He 'drowns' — whilst lying at the bottom of the pool, I tell audience about what its like to drown and what it feels like to save someone (?) —
I rescue the swimmer and place him by the side of pool in a coma position + I 'resuscitate' him
He is 'reborn' + dives into pool
We are both transformed by this experience + have become other/wiser by it

STATION 1 : CONDEMNATION / SELF-CONDEMNATION

* (Adrian listens to condemnations made against him + condemns himself)

- Laptop — containing my quotes in " " + initialled AH + dated
- Infallibility of word printed/ABSOLUTE!
- Black Address book + select condemning quotes from people through my life
- Last condemnation to do with dressing up/being effeminate (I) (am)

Adrian is condemned by others and (myself) himself

STATION 2: Adrian accepts his effeminate (+ gay) 'lot'

- With use of music box/child's light
- Timed to music
- Tries to get into little girl's dress + shoes
- REAL TASK
- Try different ways of getting into it
- Go through variety of emotions?

promoters. He presented *Foot Washing for the Sole* there, which went on to became his most toured work: it was performed in Glasgow, London and Brighton, Dresden and Munich, Belfast and Kilkenny, Terni (Italy), Singapore, Tokyo, and Toronto from 2009-2011. Indeed, his popularity, influence, or success as a visiting artist is perhaps demonstrated by the fact he was frequently invited back to an international city or organisation subsequently or serially. This tendency evidences the profoundly compelling, sympathetic and frankly unusual way Howells engaged with people – with new audiences, workshop participants, and peer artists – and his effusive and kind capacity to build enduring relationships with those people in the very short period of time that international performance engagements usually allow for.[65]

The popularity of his work and his well-known good will enabled Howells to travel widely – an opportunity that he greatly enjoyed. On a more profound level, international travel to festivals and programmes of performance in Europe, the Middle East, North America, and Asia urged Howells to expand his political and cultural awareness, directly challenging his understandings of the key themes of his work: intimacy, trust, confession, revelation, identity, and other technologies of the social. In a remarkable video document produced during his tour of *An Audience with Adrienne* to the International Women's Festival in Holon, Israel (March 2008), Howells publicly negotiates this (sometimes fraught) learning process. The video is a pilot episode for a series of short documentaries on international visitors to Israel; its title translates to *Accidental Tourist*.[66] In a subsequent projected series, Howells was also to undertake unusual life experiments in Israel, for example by living in Ben Gurion International Airport, and running *Supermarket Sweep*-style games with travellers in duty-free shops. In the extant episode of *Accidental Tourist*, however, Howells explores Tel Aviv, struggles with haggling, ill-advisedly dives underwater in the painfully salty water of the Dead Sea, learns first-hand about homophobia in the streets of Tel Aviv, and questions the passive misogyny of local drag acts. His travelling companion, the artist Ella Finer (then a student at Glasgow, serving as his Production Manager), acts as a sounding board for some of Howells' more baffled realisations.[67]

In a news article about his subsequent visit to Israel, Howells admitted his ignorance about contemporary Israel, owning – in an act of remarkable honesty – his prior cluelessness about the Israel-Palestine conflict. 'A lot of my previous understanding of Israel', he says, 'I'm embarrassed to admit, was really governed by what I remember of biblical descriptions, of landscape, shepherds and sheep, and biblical garments'.[68] Elsewhere, he misunderstood angry references to 'the Wall', thinking this must mean Jerusalem's Western or 'Wailing' Wall, rather than the Israeli West Bank Barrier, about whose existence and function he was unaware. Importantly, though, he acknowledges his ignorance and comes to terms with the shame his privilege causes him, and opens himself to learning more about the political and social realities of the situation, which then influenced the performance of *Foot Washing for the Soul* that he presented in Israel.

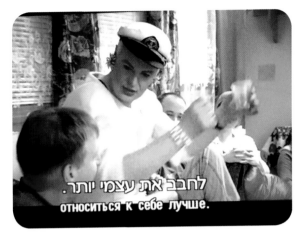

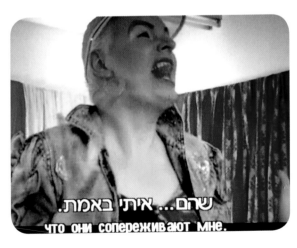
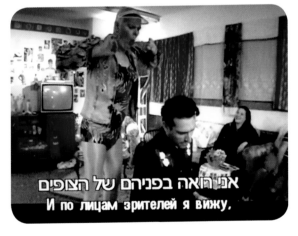

Above: Stills from video documentation of Adrian Howells preparing and presenting a performance of *An Audience with Adrienne* at the International Women's Festival in Holon, Israel, 2008, from the short televised documentary *Accidental Tourist* (2009), directed by Shiri Kleinman and Timi Levi for Channel 8/Noga Productions.

Beyond Solo

The final performance of Howells' Fellowship, the one-to-one performance *The Garden of Adrian*, perhaps signalled a shift in his practice.[69] Though he continued to explore intimacy in performance, replacing spoken exchange with a focus on deep attention to the five senses, and retained the one-to-one form, Howells chose to develop this work with a close-knit creative team: artist and designer Minty Donald, artist and production manager Nick Millar, composer Nichola Scrutton and lighting designer Mike Brookes. Together, they created a Zen-style garden installation in Gilmorehill, the University of Glasgow's theatre space (a converted church).

This ostensible move away from working as a solo and individual artist seems also to be signalled by another piece in which Howells participated that same year: Tim Crouch's *The Author* (Royal Court, London, 2009). However, this was a radically different experience for Howells, as he participated as an actor in a more or less traditionally scripted play. Though Crouch had written a part based on Howells after seeing him in *An Audience with Adrienne* at the Edinburgh Festival in 2007, 'Adrian' was nevertheless still a character, and one that Howells struggled to identify with. Howells performed in the premiere run at the Royal Court Theatre, but chose to withdraw before its subsequent tour (where he was replaced by Chris Goode). As Howells told Helen Iball:

> I was very uncomfortable with this idea of lulling people into this place of thinking that we cared about them and that we wanted to find out about them and get to know them. I remember Tim said to me, not callously 'I'm not interested in the audience, Adrian' – he meant that he was not interested in individuals, in the way that I am.[70]

Iball followed up by asking how it felt 'to be in a play where your nurturing skills, your audience skills, were being used in order to pull the rug from under the audience?' Howells replied:

> I wasn't comfortable with it and I think that's a big reason why I decided not to be in the touring production. I don't think that Tim or the directors, Karl [James] and Andy [Smith], were ever dishonest. They were actually quite transparent about what they were interested in. It just didn't happen to align with what I've been about with my work in the past 10 years. [...] I had thought that my involvement was going to be something different than it ended up being. I had thought that I was there to really look after the audience, making them feel comfortable, but actually it was about me being of service to the play.[71]

The experience of being an actor in *The Author* also confirmed for Howells his preference for and skill at responsive improvisation:

> I'm not sorry that I did the project, because I learned all sorts of things. I learnt that I don't want to be doing plays and learning lines and having to deliver them in a particular way. I learnt to know that what I am doing, and that I am good at, is what I want to be doing.[72]

Nevertheless, in 2012, Howells embarked on another more formally scripted work – albeit his own. *Lifeguard*, a co-production between the National Theatre of Scotland (NTS) and The Arches, and in association with Govanhill Baths Community Trust, was staged in the disused Govanhill Baths in Glasgow.[73] Again using a collaborative approach (in this instance facilitated by funding from the NTS and The Arches), Howells developed the show with Minty Donald and Nick Millar (who made and projected remarkable images of life-sized swimmers doing lengths up and down the pool, and of synchronised swimmers later in the performance), Rob Drummond (dramaturg), Jane Mason (choreographer), Mike Brookes (lighting designer) and Nichola Scrutton (composer). He was also joined in the pool (effectively the stage) by a fellow performer, Ira Mandela Siobhan, an actor and dancer.

The script for *Lifeguard* emerged partly from conversations Howells conducted with members of the local community. This gathering of materials began two years earlier in 2010, before the show was even conceived as an idea. An Artist in Residence at The Arches at the time, Howells wanted to make a piece of work about his love of water and was interested in finding stories of the memories water prompted in a range of people. A resident of Govanhill, The Arches' Creative Learning Programmer, Lucy Gaizely, was keen to engage the Govanhill community in the theatre's outreach programming, and received funding from the Creative Scotland's Awards for All initiative.[74] Gaizely recalls that Howells' research prioritised the participation of local elderly citizens, including marginalised or vulnerable people, with whom Howells worked to develop an impressive rapport.

Recognising the potential scale and demands of such a project, Gaizely and Jackie Wylie (Artistic Director, The Arches) met with the Artistic Director of the National Theatre of Scotland, Vicky Featherstone, to discuss the possibility of co-funding the project. This led to a National Theatre of Scotland commission for *Lifeguard*, which also drew in additional institutional support from St. Bride's Primary School, Cuthbertson Primary School, and Govanhill Voices (a community choir). As the show was staged in the actual training pool, its reinstatement for the production was left as a legacy for the Govanhill Baths Community Trust.

Water had already been a feature in a number of Howells' performances, including: *Foot Washing for the Sole*, in which he washes the feet of participants; *Salon Adrienne*, in which he washes their hair; *The Garden of Adrian*, which involves a scene in which one's hands and forearm are washed; and *The Pleasure of Being: Washing/Feeding/ Holding*, in which the audience-participant has her or his whole body washed by Howells, in a bath of scented water. The press release for *Lifeguard* explains Howells' fascination with water, as well as specifically with swimming pools:

Overleaf: Adrian Howells, *Lifeguard*, performed at Govanhill Baths, Glasgow, 2012. Co-produced by National Theatre of Scotland, The Arches and Govanhill Baths Community Trust. Howells sits at the edge of the pool and Ira Mandela Siobhan performs in the water. Photo by Simon Murphy, courtesy of National Theatre of Scotland.

Since my childhood I have always been strangely drawn to, and fascinated by, swimming pools. I love swimming and the sensation of my body being buoyed up by the water and I find it thrilling to watch other bodies - diving, cutting through the surface and especially moving underwater, always graceful in their suspension. I'm intrigued by the fact that swimming is such a solitary pursuit, but we're so often doing it surrounded by other people, constantly part of a transient community. And I'm attracted to the layers of paradox that co-exist within the environment of a public pool: they contain ideas of both public and private behaviour; they're intended as centres of pleasure and abandonment, yet they're also places which are highly regulated and sanitised; they promote a celebration of life and living, yet the risk of drowning and death is an ever pervasive threat. Hence the need for, and constant presence of, a vigilant lifeguard.[75]

The performance incorporated various styles of narrative, including: moments of apparent autobiography (Howells reflecting on being pushed into the deep-end by his father); imagining a young man drowning (performed by Siobhan); social history (spectators were introduced to an older man who learnt to swim in the Baths as a young boy, and later watched a young boy who had learnt to swim during the performance's making); and intimacy and choreographed participation (the audience for the show was small and at the end – a highlight of the piece – everyone was invited to join Howells in the pool). Whilst some of Howells' performance trademarks were evident – including the integration of video elements, personal disclosure, and audience participation – the performance was much more tightly scripted, without moments of improvisation or deviation. The result was a more elegiac and mannered performance than evidenced in his solo work. The unusually detailed and formalised script is held in Howells' archive.

TouchBase and The Arches

Though Howells is best known for his auto/biographical and one-to-one work – forms he continued to push radically in all sorts of directions – he also challenged himself by developing work within community settings, with and for diverse audience-participants. In May 2011, funded by the Creative Scotland/National Lottery Partners in Residence Scheme, Howells joined The Arches as Artist in Residence, in association with Sense Scotland at TouchBase.[76] TouchBase is a day-centre in Glasgow providing a cross-arts programme for adults with complex learning and communication difficulties, and Howells worked with its residents and users until shortly before his death. (The length of his residency was extended because Howells had a period of sick leave during the two years.) His relationship with TouchBase was engineered by Lucy Gaizely, then the Creative Learning Programmer at The Arches, and Paul Hart, Head of Arts at TouchBase; Hart's

Opposite: A heavily annotated page from Adrian Howells' working script for *Lifeguard*, performed at Govanhill Baths, Glasgow, 2012. Co-produced by National Theatre of Scotland, The Arches and Govanhill Baths Community Trust. Adrian Howells Collection, Scottish Theatre Archive, University of Glasgow, Box 29.

lifeguard swims, demonstrating his ease and confidence in water, to the three different sides of pool and adopts contrasting and relaxed poses/attitudes as he immerses himself in three distinctly different 'characters'. He informally shares the following monologues that will be delivered either live or as voiceovers on main speakers. A world within a world and outwith the present time will be created through light and sound that continues to underscore throughout the monologues.

During this following section the swimmer is also taught/instructed to perform a selection of swim-related gestures/moves by the lifeguard whilst he is sat at side of pool. Each time the lifeguard instructs the swimmer, it is made clear through attitude and stance that he is operating in the present and as himself. This should be very light and playful in tone. Introducing idea of pushing swimmer in.

Projection on bottom of pool before lifeguard gets in? "NO PUSHING"

[handwritten left margin: First time his told story — starts with a more 'serious' intention] [handwritten: lighter]

lifeguard: Yeah, I've always been a bit shit scared of getting outta my depth. I get kinda paralysed with fear if I can't put both my feet on the bottom. It all dates back to when I was seven and my Dad taught me to swim. Or rather, he *didn't* teach me! He tossed a brand new 50p into the deep end of our local pool and said "It's yours, now go and get it". (Then he pushed me in (Deep exhalation of breath) I'll *never* forget the [handwritten left margin: Pacis +] force of that push, how it felt, his hands on my back.... And that look on his face. A look I'd never seen before or since. Jeez, I can vividly recall the sickening, all-consuming panic that overtook me, the immediate shock of the cold water, swallowing so much of it, choking underwater, the burning at the back of my throat and nostrils. (Look, I'm getting sweaty palms just talking about it! Everything was a blur of bubbles and foam as I thrashed about. But somehow I made it to the side and clambered out. He didn't even help me. As I stood there, bent double, pathetically spluttering and coughing, my nose running, eyes stinging from the chlorine, I clearly [handwritten left margin: lighter (laughing despite harm)] saw a look of shame on my Dad's face. An act of betrayal. And I remember thinking "How can he tell me he loves me and yet he's just tried to drown me?" I taught my own son to swim but it had to be from the side of the pool. [handwritten: Realises that the] (Head out of water at end of speech). [handwritten: is shame]
The following projected text then appears on the bottom of the pool:

"Complex, contradictory, infinitely mutable"

lifeguard then 'dissolves' the text by disturbing the water and swimming across it as he swims to another side of the pool to share the next monologue.

[handwritten: SENSUAL TONE]

lifeguard: I can spend literally hours in a bath. I lie there, deeply submerged, water up to my ear lobes, head just bobbing above the surface, [like Martin Sheen in 'Apocalypse Now'] imagining my body is some kind of South Seas archipelago surrounded by perilous waters, prone to being agitated by underwater, volcanic eruptions. My bent knees are the unscalable mountains, my chest the uninhabited upper plains and my fleshy belly is an island of paradise, my belly button an ever-bountiful watering hole for its natives and wildlife. [The trail of my pubic hair running

interest in intimate communication offered an obvious fit with Howells' interests and practice, leading to the artist-in-residency partnership.

Speaking at 'The Arches' Commons' (curated by Heddon and Laura Bissell) in September 2013,[77] Howells discussed his work at TouchBase, and acknowledged the invaluable opportunity of working with individuals for whom touch is the primary means of communicating with others and navigating the world: 'How exciting for me as an artist working with ideas of touch to have an unparalleled opportunity to learn from collaborating with touch-specialists'.[78] During his induction at TouchBase, Howells explained, he became aware that whilst individuals were touched all the time, the properties of that touch were 'predominantly pragmatic and functional'. This contrasted with Howells' interest in touch's capacity for nurturing. In an interview with Heddon, Gaizely recollected that with no prior experience of traditional community-based practice, Howells 'was intimidated by the environment' of TouchBase.[79] The first three months were challenging as he grappled with the practice, pragmatics and ethics of communicating with individuals with profound disabilities. Gaizely recalls that he worried about how disabled individuals – including severely learning-disabled, and deafblind participants – might give and withdraw their informed consent in relation to intimate touch, and he was anxious about how 'intimate' touch in this context might constitute *inappropriate* touch. He also expressed frustration at the seeming lack of progress he was making during his time at TouchBase, in contrast, perhaps, to the achievements he was used to making on projects in non-applied situations. By this time in his performance career, he was confident in the power of his communication skills – he knew the effects and affects of his intimate and dialogic practice. Working with a deaf-blind person, however, the majority of techniques he had fine-tuned were thwarted. As Gaizely points out, he was used to quick impact, and was conscientious about consent and negotiation in the performance situations he was familiar with, but these strategies foundered in the specialised context required at TouchBase: Howells had 'to find something else'.[80]

A steering group was established to support Howells during his residency and at its first meeting, in response to Howells reflections on the challenges of the process so far, Heddon suggested 'patience' as something to explore as both concept and methodology, allowing a focus on the time and space around and within each interaction. Against a background of anxiety about the appropriateness of touch, and the question of consent, Howells was prompted to reflect on different languages of touch: 'appropriate and safe, that lie between the practical or functional and the sexual'.[81] He also began to explore the idea of 'touch without touch', a concept introduced to him by psychotherapist Farida Mutawali (e.g. being 'touched' or moved by voice, or song). Another member of the steering group, and Head of the Strathclyde Centre for Disability Research at the University of Glasgow, Nick Watson, suggested listening to each other's heartbeats. Howells initiated what he called the *Heartbeats Project* (2012), taking Watson's suggestions further by using a stethoscope, which amplified the sounds of a heart's

beat (the stethoscope in its plastic case is kept in Howells' archive). The experience proved profound: the shared rhythms of hearts beating made tangible to him both the fact of human connection and the appearance of human similarity across differences – a synchronisation perhaps, rather than dialogic exchange, made possible despite differences in cognitive, physical, or communicative ability. In his presentation, Howells recounted one particular encounter:

> M, a woman who eight months previously I didn't know if I had her permission to touch, [during] the last two sessions came into [the] space tapping her heart area with her one good hand and in [the] final session she even beat out the same rhythm of my heartbeat as it was amplified in the space, with her hand over her heart area.[82]

Howells also admitted an additional, unplanned and at the time unacknowledged outcome:

> The process of the *Heartbeat Project* legitimised and gave me permission to touch these six to eight individuals [the most severely disabled] who I collaborated with and who I was so anxious about touching, not just with arranging microphones and having contact with their flesh, but also by me proactively tapping out the rhythms of our different heartbeats on backs of hands, forearms, foreheads, cheeks, noses, backs of necks, earlobes, etc., and placing and holding their hands over their own hearts, as well as over mine – and feeling for pulses on different and appropriate parts of their bodies.[83]

Though he was developing attentive and patient work with TouchBase individuals, a candid talk with Hart (Howells' mentor throughout the residency) served to ease his anxiety and pressure somewhat. Hart acknowledged and reminded Howells that his expertise lay in being a solo artist, not an artist working with individual community participants to create collaborative performances. The performance frame was always present, they both conceded, and this revealed itself as important for the development of the residency. Implicitly, Hart gave Howells permission to work with this format in the applied context.

Hart's intervention proved pivotal to the residency. Howells made micro-performances within TouchBase for service users and support workers. For example, on one occasion he wore a laminated sign on a string around his neck that read 'Please Hug Me'; as Gaizely comments wryly, this exercise wasn't hugely successful because many of the service users at TouchBase could not read.[84] However, the intervention did perhaps challenge staff and support workers to question the boundaries of touch and the potential for different forms of touch other than the functional.[85] It was a memorable action: at TouchBase, Howells became known as the 'hugging man'. TouchBase have had the sign framed (a further sign with the same statement is also held in Howells' archive).

Often, Howells spent his time at TouchBase simply talking to people. As Gaizely comments:

> I would get frustrated because we'd create a plan for him in TouchBase and then I would go into TouchBase and he would just literally be sat in the café holding court, and sometimes I'd be thinking, 'that's not really what you're actually meant to be doing'. But then I'd [realise that] this is actually his practice. And the effect is brilliant.[86]

Pursuing an expansive idea of touch, Howells extended an invitation to singer and theatre artist Judith Williams – who was also Howells' flatmate at the time – to collaborate on a mini-project called *Home from Home* (2013). This was modelled very much on Howells' performance practice: a music room was transformed into what he described as 'an intimate, homely space with furniture and furnishings from our shared home together – lit with candles and fairy lights – rose oil burning', strongly reminiscent of the salon spaces he conceived for Adrienne, for example. Williams' contribution led in turn to Howells developing an interest in the spoken voice and he experimented with delivering reading sessions, sharing different kinds of spoken poetry with individuals, encompassing the secular and sacred and the ancient and modern, including Haikus, and the writings of the Sufi mystic poet, Rumi. Howells was interested in how the different forms, rhythms, constructions and compositions of various poetic modes could have different impact in terms of 'focus, attention, stillness, being present'.[87] Howells continued this line of enquiry by inviting three other Glasgow-based artists to contribute to his residency: Laura Bradshaw (sharing traditional Scottish stories and songs); Alan Bissett (reading from his novel *The Incredible Adam Spark*, 2005); and Martin O'Connor (composing poems using Glaswegian dialect and singing traditional Glasgow songs).

(He's the Greatest) Dancer

During his residency, Howells had been struck by the dynamic energy of one of TouchBase's service users in particular, Ian Johnston (although Johnston was not, initially, very taken with the 'hugging man' and recoiled from his touch). Early on in his residency, Howells and Gaizely had seen TouchBase Performance Group's production of *Home* (2012) at Platform Theatre, where they witnessed Johnston's response to the applause, his transformation, how – Howells recalled – Johnston 'ignited into this super-confident performer and took multiple bows and strutted and peacocked across the stage like Mick Jagger, and we, the audience, lapped it up!'[88]

Perhaps sensing a kindred spirit, Howells was impressed by Johnston's pleasure in 'being fully lit centre stage and being [the] centre of people's attention'.[89] Howells next saw Johnston perform at TouchBase's *Summer Sensations* music concert (also 2012). At the end of the concert, Johnston put on Kylie Minogue's *All the Lovers* CD and began to dance with what Howells considered 'unbridled joy and abandonment', dancing 'totally in the moment' and without any apparent self-consciousness. Observing Johnston's dancing prompted Howells to consider

dance 'as a means of communication – and potentially – as an alternative way to communicating touch'.[90] He also saw that Johnston wanted 'to be a professional artist, or a professional dancer, and [that] he should be'. Over a period of some 18 months, Howells began to develop a performance with Johnston. When he first saw Johnston perform at Platform, he had compared his movements to the physicality of performance-maker Gary Gardiner (Gaizely's partner). Gaizely suggested that Howells, Johnston and Gardiner create a process-led piece of work for The Arches Live Festival. Howells considered Johnston and Gardiner a perfect 'double act' and knew that he wanted to take on a facilitating, directorial role, rather than to perform in the piece.

Johnston, Gardiner and Howells initially met once a fortnight, and, later in the process, twice a week. Drawing on his own practice, Howells acknowledged that the 'social, lunch and tea-drinking aspects' of their time together were as important as the explorations undertaken in the rehearsal room – an insight corroborated by the essay Gaizely, Gardiner and Johnston wrote for this book.[91] The trio would make a piece about Johnston's and Gardiner's shared love of dancing. Howells was clear that the process and the performance would not be concerned with developing and learning a series of movements. The aim, rather, was to provide a structure which would support Johnston to have agency over his own choreography and 'to push the politics of who has the permission to dance and why'.[92]

Working with Gaizely, Johnston and Gardiner, Howells' creative process changed. Instead of sketching structures out on paper, as had been his method up to this point, the trio played in the rehearsal space, creating material through doing, and being on their feet.[93] 'For a couple of months', Howells explained, 'Gary, Ian and I set ourselves the task of bringing in different choices of music that we liked to dance to and then created different "rules" or ideas to follow in our movement interpretations'.[94] Other materials were created from watching YouTube videos of various dance styles and from quiz-based exercises.

Another artist invited into TouchBase during his residence was Israeli dancer Itay Yatuv (with whom Howells had appeared in Nigel Charnock's *Stupid Men* in 2007). Yatuv undertook a week of one-to-one contact improvisation sessions for TouchBase. Two aspects of Yatuv's practice struck Howells. First, Yatuv would stand very close to an individual, without any touching, and would simply listen: in Howells' words, Yatuv was 'tuning in'. The result was that 'nine times out of ten, it was the service user who initiated the touch', and no-one rejected Yatuv's touch either. Second, Howells witnessed Yatuv collaborating with each individual 'as an equal, not as a patient, client, or even a service user', but 'as a dance partner creating a duet with him'.[95] Yatuv's interaction was framed from the outset as dance. Yatuv also delivered a masterclass at The Arches during his visit to Glasgow, which Howells and Gardiner attended. Following this experience, they committed to doing an hour of improvised dance every time they met with Johnston, the three of them dancing to a wide range of music and being tactile with each other, as in contact improvisation.

The performance they created, *He's the Greatest Dancer*, was comprised mostly of dancing, though neither Johnston nor Gardiner are professional or trained dancers. The piece also contained autobiographical text, some of it written on cards. Howells found out from Johnston's father that Johnston's maternal grandfather had been a ballroom dancer, which led to the decision of dressing Johnston and Gardiner in tuxedos and creating a ballroom aesthetic. Howells reflected that working with Johnston had led him to an expanded sense of 'choreography', and that 'rather than moves getting created and then set and rehearsed […] there was a much more organic and free-flowing possibility, where Gary might offer something and Ian would either respond with something that resembled what was offered or make his own choice [and] change what was offered in the live moment'.[96]

He's the Greatest Dancer premiered at Arches Live 2013. Reviewing the performance for the national Scottish newspaper the *Herald*, dance critic Mary Brennan wrote astutely that the piece 'challenges our assumption that words are how we best express ourselves'. Whilst Gardiner 'takes charge of the speaking' and 'is a bit cocky-confident' against Johnston's more shy presentation, when the music starts it is Johnston 'who truly outclasses him because he is totally "in" the music. And in those moments we see who Johnston is – not just a great dancer, but an inspiring one'.[97] Following its premiere, Gaizely submitted an application to Unlimited, a commissioning festival that supports disabled artists to develop ambitious, high quality work for public presentation. The successful outcome of this application, announced just shortly after Howells' death, allowed Gaizely, Johnston and Gardiner to continue developing the piece – now titled *Dancer* – and to tour it extensively in 2015 (to London's Southbank Centre for the Unlimited festival, as well as Aberdeen, Glasgow, Birmingham and Belfast). Johnston has become the professional artist Howells immediately recognised him to be.

Reflecting on Howells' practice, Gaizely links his skills as a facilitator to his unique way of inspiring people by really paying attention to them and noticing and then valuing them as individuals:

> He would do this gentle facilitation. He would tell me I was absolutely brilliant. He would tell everybody else I was absolutely brilliant. He would create a little miniature pedestal for you to be on […] Someone constantly telling you that you're hugely capable makes a huge impact.

Gaizely also notes that one of Howells' great strengths as a facilitator and collaborative artist was that he was expressly anti-hierarchical in his manner. She recalls:

> He'd remember details, so when we'd be sitting in TouchBase and different people would come in, he would remember details about support workers, no-one would be marginalised, and there'd be no hierarchy because he'd spend as much time with the cook in TouchBase as he would with Paul Hart.[98]

At the same time as Howells was working on *Dancer*, he was developing another unnamed piece for TouchBase, in which deafblind individuals would lead the audience on a journey through different rooms. Though the piece was unfinished at the time of Howells' death, it continues to be developed for public performance by Jon Reid, an arts tutor at TouchBase. The title of this work is *It's All Allowed*.

FAG

At the time of his death, Howells was a month away from the first public showing of the final outcome of his residency at The Arches. Scheduled for the Behaviour Festival at The Arches (3-5 April 2014) as a work-in-progress, *FAG* was to be a collaborative show with the Canadian company, Mammalian Diving Reflex. Howells had worked with Mammalian Diving Reflex on the Glasgow performance of *All the Sex I've Ever Had* (2012-14) at the Behaviour Festival in 2013. On a tour of *All the Sex I've Ever Had*, Mammalian Diving Reflex develop each individual performance with local participants and guest artists. In this earlier work, five local people aged 65 and over shared stories with the audience about sexual experiences:

> The five individuals sat on stage in a panel-discussion format – each with a microphone and a glass of water. A moderator sat stage right, occasionally calling out a year to which a participant will respond with an anecdote, always stating their age at the time before continuing with the tale. ('I am 9…'). And so it continues until the year called out is 2013 and the show concludes.[99]

For the subsequent performance, *FAG*, Howells would collaborate with one of the directors of *All the Sex I've Ever Had*, Konstantin Bock, and one of the performers in Glasgow, Aldo Palstra. Wanting to perform in the piece himself, he invited Lucy Gaizely (who had by this time embarked on a freelance career) to be an artistic collaborator and director. Palstra, Howells and Bock, all gay men, spanned three generations. The intention of the work was to continue focusing on sexuality, but to do so in a way that would enable the three performers to reflect upon the politics of sexual freedom, oppression, and rights. As Gaizely recollects, Howells wanted to redress 'a niggling thing that he had which was that though he was, at that time of his life, an outrageous queer, he had never done anything for "the cause"'.[100] Gaizely and Howells worked on the piece for three weeks, with one of those weeks also involving Palstra and Bock. During that week, Howells created a questionnaire for them all to complete, prompting reflections on spiritual beliefs, politics, childhood, and so on. Howells revealed his own anxiety and vulnerability about his political identity: 'no one thinks I'm politicised', Gaizely remembers him saying, 'sometimes it's because I feel stupid and I feel as though if I say stuff, I'll say it wrong'.[101] With another three weeks still to go before the work-in-progress

Overleaf: Adrian Howells, *Adrienne's Personal Shopping Experience*,
performed at The Shop at Terence Conran's Bluebird, King's Road, London, 2005.
Photographer unknown.

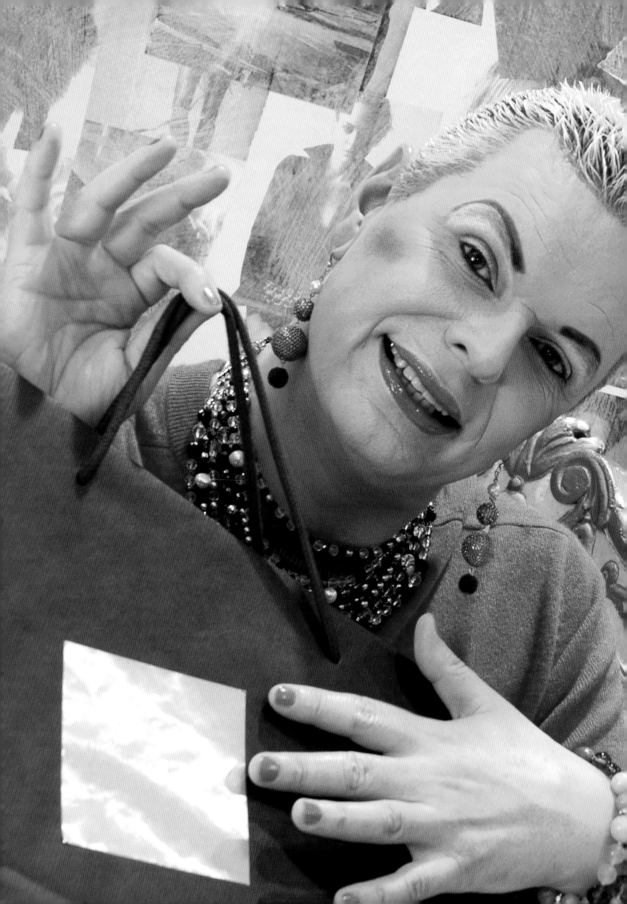

showing, Gaizely already knew that interesting and difficult material was being generated. The studio practice was bolstered by Howells' well-tested, typically eclectic process of research, which in this instance embraced Judith Butler alongside Danny La Rue, each recognised by Howells – rather promiscuously perhaps – as sexual-political touchstones for their times.

What becomes apparent from talking to Gaizely about her work with Howells over the years of his Arches and TouchBase residency was the immense support – emotional and practical – that she gave him, as friend, producer, and artistic collaborator. Gaizely was not simply supporting the work, and its emergence, but worked hard to support Howells, in life and in art, even to the extent of getting him out of bed and into the venue for the day. This is an uncredited role on many people's CVs: supporting the health and wellbeing of the artist, which is vital to maintaining the activity of the creative arts sector. The emotional labour of supporting someone else's work remains largely unrecognised and unacknowledged. During his time in Glasgow, Howells drew upon the support of many close to him, all willing to provide it. The community of which Howells was a part of, which he contributed to and was supported by in equal measures, is addressed in many of the chapters throughout this book.

Howells was devising *FAG* when he took his life. Three weeks of rehearsals remained. Gaizely was acutely aware of his sadness during the entire process, but also reflected that even in spite of his mental state, he turned up at every rehearsal. And then, one weekend, he didn't.

Endings

Adrian Howells took his own life on the weekend of 15-16 March 2014, a few weeks before his 52nd birthday. At the time of his suicide, Howells was profoundly depressed. His means of death was a combination of alcohol and pills, which he consumed in his candlelit bedroom in the flat he shared in Glasgow. He died in bed. His body was discovered on the Sunday, and it is not clear if he died on that day, or the day before.

This was not Howells' first experience of depression, nor was it his first attempt at suicide. These facts – his recurrent bouts of chronic depression and his suicidal attempts – were common knowledge, not just to family and close friends, but to many who attended his performances or presentations about his work, or even engaged in casual conversation with him. Howells was always candid about his mental health and the desperate places it had driven or dragged him.

That Howells had attempted suicide on previous occasions did not make his death by suicide a foregone conclusion. However, as so many of the contributors to this collection testify, Howells' experience of depression and his own mental health did inform, in significant ways, the work he chose to make. In some performances, depression structured both content and form, most obviously in *Adrienne's Great Depression* (2004) at the Great Eastern Hotel in London, a one-

to-one performance that drew on – and to some extent relived, by sharing in a visceral manner – Howells' experience of depression, its affects and aftereffects. In *Adrienne's Great Depression*, Howells inhabited a hotel room for one week, and lived as a version of his drag alter-ego, Adrienne, according to self-devised rules: he could not leave the room or open the curtains; he retained the food and crockery delivered by room service; and having put Adrienne's make-up on at the beginning of the week, he wasn't allowed to remove it, shower, or shave. Throughout, Howells received guests, and conversed with them, in a mounting state of physical and mental dishevelment. The line between acting and being was dangerously, perhaps recklessly, blurred.

If the *Great Depression* responded to his illness, and risked conjuring it in the process, other works inarguably prompted bouts of depression, troubling the neat but limiting fantasy that his practice functioned as an effective, insular, or self-serving method of therapy for himself. One performance was particularly troubling in this regard. In 2011, Howells presented *May I Have the Pleasure?* as an Arches' commission at the Edinburgh Fringe Festival, on the top floor of the plush Point Hotel. The audience were ushered into an environment dressed to resemble the detritus of a wedding reception (deflated balloons, confetti, tables covered in white cloths, drinks, etc.). Howells reveals to the audience seated at their guest tables that he has attended more than 60 weddings and has been best man eight times. Video footage is played of him giving best man speeches, by turns hilarious and excruciating (including at the wedding of his Bretton Hall peers, Richard and Joy Wolfenden-Brown, in 1988). Always the best man but never the groom/bride, Howells' premise for *May I Have the Pleasure?* ultimately consists of a painful confession of loneliness amidst endless celebrations of others' success at finding love. The playing-out of his sadness and sense of personal failure at having never had a substantial relationship is made more upsetting by the seemingly perverse revelation of the staggering amount of weddings he subjected himself to, as a guest, and as principal cheerleader (enough, likely, to weary anyone, depressive or otherwise). Whilst performing for a larger audience, Howells attempted to inject some small moments of intimacy by inviting the audience to choose slow dance tracks, then choosing whom he would dance with.

Howells deemed the performance an unmitigated failure, and its fallout fuelled a serious depressive event. It warranted generally positive reviews, but he took one particular review – in fact a lukewarm rather than expressly negative one – to heart.[102] He would fall into a particularly deep depression that lasted a number of months (in her essay, Jennifer Doyle discusses the performance, and his depression). Howells' pain at the reception of the work, and the ambivalence concerning whom or what was being savaged – his personal or professional failure – testifies perhaps to the slippery distinction between his work and his life, or the lack of clarity between his so-called 'onstage' and 'offstage' personae. Remembering the review as 'startlingly cruel', because it took him to task, as opposed to the performance, Howells recalled being 'devastated': 'I gave so much

of myself to the performance that I have nothing left of myself to fall back on, or to hide behind, when I tried to return to everyday life'.[103]

Howells did find something upon which to fall back, on that occasion, and continued to develop new work as well as to tour existing pieces on the international circuit. By any account, he was a successful artist. His depression returned. Howells' insistence on stating and owning his depression and suicidal experiences as matters of fact, as facts of life – and, now, of death – make any marginalisation of those facts inauthentic. We owe it to Adrian to state those facts here, difficult though that is.

In the Garden

Following Adrian's death, a public memorial garden was created for him – *A Garden for Adrian* – at 9 University Avenue, Glasgow. This garden is next to the Gilmorehill building at the University of Glasgow, where Adrian created *The Garden of Adrian,* the last performance he made as part of his Fellowship at the University. The garden, packed with vibrant and beautiful plants, has been planted and lovingly tended by the gardeners of the University. They never met Adrian, but they care nevertheless.

Heddon talked to the head gardener, Jane Marriott, about Adrian and the performance he created for the theatre next door, and shared some of the production photos. Marriott spotted immediately two of the items from Howells' *mise en scène*: a huge rock and a stone birdbath. During *The Garden of Adrian,* the spectator-participant sat on the large stone, and cradled Adrian's head in their lap. The birdbath was filled with cool, clean water with which Adrian washed the hands and forearms of each participant. Seeing these objects in the photographs, Marriott told Heddon that following the production they had been donated by Howells to the University's Estates services, and had remained in storage. The stone and the birdbath now sit in *The Garden for Adrian*. Both casual and committed visitors wander in the garden, sit on a bench, look at the plants, and pose for and take photographs.

Today we – Dominic and Dee – sit on the bench, a replica of the 'wishbone bench' used in *The Garden of Adrian*. We sit quietly but companionably, wishing, reflecting, and marvelling at the garden beginning to bloom as spring settles in. We dip our fingers into the cool water of the birdbath. We look at Adrian's pictures (which have been affixed lovingly to his great granite 'cradling stone') and we visit with the totems – those of the living and dead – planted in the garden. We add our own.

Opposite: Deirdre Heddon and Dominic Johnson in *The Garden for Adrian* at the University of Glasgow, 2015. Photos by David Caines.

1. John Benson, unpublished interview with Adrian Howells, Glasgow, 13 February 2006.

2. Howells explains this in the course of a workshop at the Harbourfront Centre, Toronto, 26 February 2011, <https://www.youtube.com/watch?v=Hyd57BdUi8Ip> [accessed 4 January 2016].

3. Joyce McMillan, 'Adrian Howells – Obituary', <https://joycemcmillan.wordpress.com/2014/03/20/adrian-howells-obituary/> [accessed 17 January 2016].

4. Barry Roberts, 'The Drama Dream that Came True', Gazette and Times, 29 March 1979. The clipping (which lacks page numbers) is held in the Adrian Howells Collection, Scottish Theatre Archive, University of Glasgow, Box 12. Further citations from Roberts in this section are from the same source.

5. Richard Wolfenden-Brown, personal correspondence with Deirdre Heddon, 31 August 2015. Subsequent quotations from Wolfenden-Brown in this section are from the same source.

6. Arthur Pritchard, personal correspondence with Heddon, 8 September 2015.

7. Ibid.

8. Beatie Edney, personal correspondence with Heddon, 17 October 2015. Edney played Susan B. Anthony in the production.

9. Wolfendon-Brown, personal correspondence with Heddon.

10. Although Howells subsequently rejected the Church, he would remain deeply interested to spirituality, with many of his intimate performances making direct reference to Christian narratives, symbols and sentiments (quite explicitly, for example, in The 14 Stations of the Life and History of Adrian Howells [2007]), as well as to other religions (particularly Islam and Judaism) enabled by his research.

11. Denis Watson cited in Arthur Pritchard, personal correspondence with Heddon.

12. Bretton Hall closed in 2007, with staff and students relocating to the University of Leeds campus in the City of Leeds. Howells performed An Audience with Adrienne: A Lifetime of Servicing Others in May 2007, at the Bretton Hall 1947-2007 May Weekend.

13. The Enterprise Allowance Scheme, established in 1982 by the Conservative Government under Margaret Thatcher's leadership, was intended to be a catalyst to enterprise, supporting business start-up ventures by guaranteeing an income of £40 per week to unemployed people who ventured to start their own business. It was a route used by many artists following graduation (including Heddon).

14. Manchester Youth Theatre operated from 1966 to 2003.

15. Joyce McMillan, 'Obituary of Acclaimed Theatre-Maker Adrian Howells', Scotsman, 20 March 2014, <http://www.scotsman.com/what-s-on/theatre-comedy-dance/obituary-of-acclaimed-theatre-maker-adrian-howells-1-3346849#ixzz3oq5m4qtp> [accessed 26 October 2015]. Helen Kaye, 'Life is no Drag for Adrian Howells', Jerusalem Post, 4 March 2008, <http://www.jpost.com/Arts-and-Culture/Entertainment/Life-is-no-drag-for-Adrian-Howells> [accessed 26 October 2015].

16. Howells moved to Glasgow at this time, and though he would subsequently live in London, he returned to Glasgow in 2006 to take up his AHRC Fellowship at the University of Glasgow. Glasgow remained his permanent base.

17. Giles Havergal, telephone interview with Dominic Johnson, 21 June 2015. Subsequent citations from Havergal are from this source.

18. Olga Wojtas, 'Performance Artist Dresses Up Academy's Act with Sole', Times Higher Education, 29 May 2008, <https://www.timeshighereducation.com/news/performance-artist-dresses-up-academys-act-with-sole/402158.article> [accessed 3 November 2015]. Before arriving at the Citizens, Howells had indeed appeared in regional pantomimes, including Snow White and the Seven Dwarfs (1987/88), in which he played the Wicked Queen; and Sleeping Beauty and the Beast (1988/89), playing Tawny Owl, Frog, and Boris the Bull.

19. Ibid.

20. James Christopher, 'Review: The Homosexual, Bagley's Warehouse', Time Out, 17 November 1993. The review is preserved in Stewart Laing's personal archive as a clipping without page numbers.

21. Copi, 'The Homosexual or the Difficulty of Sexpressing Oneself', in Plays, Vol. 1, trans. by Anni Lee Taylor (London: John Calder, 1976), pp. 37-67 (p. 62).

22. Sue Tilley, Leigh Bowery: The Life and Times of an Icon (London: Hodder & Stoughton, 1997), p. 208.

23. Ibid., pp. 208-9.

24. Ibid., p. 209.

25. [Author unknown], 'Theatre: The Pleasure Main, Citizen's Theatre, Glasgow', Herald, 5 February 2000, <http://www.heraldscotland.com/news/12215375.Theatre_The_Pleasure_Man_Citizens_apos_Theatre_Glasgow/> [accessed 17 December 2015].

26. Howells would create his own piece for and in a swimming bath in 2012, namely Lifeguard.

27. A recording of this production can be viewed at the Live Art Development Agency.

28. Author unknown, 'The Night I Grooved to Disco Tex and the Sex-o-Letts in Barry Blue's Poncho', Herald Scotland, 4 November 1994 <http://www.heraldscotland.com/news/12065503.The_Night_I_Grooved_To_Disco_Tex_and_the_Sex_o_Letts_in_Barry_Blue_apos_s_Poncho__Citizens_apos__Theatre__Glasgow/> [accessed 19 January 2016].

29. Clare Bayley, 'Bare Necessity', Independent, <http://www.independent.co.uk/arts-entertainment/bare-necessity-5623823.html> [accessed 27 October 2015].

30. Ibid.

31. Howells, unpublished interview with John Benson.

32. Adrian Howells, 'Proposal of Research for AHRC Creative Fellowship Application by Adrian Howells', unpublished proposal document, Adrian Howells Collection, Scottish Theatre Archive, University of Glasgow, Box 33.

33. Ibid.

34. The programmes are available in the Dance4 online archive: <http://dance4.co.uk/sites/default/files/project/12-10/nottdance-festival-2001/press.pdf> [accessed 4 January 2016].

35. According to a blog of the process (see below), Jens Biedermann contributed to this development stage of Stupid Men but did not perform in the public work. Howells was not referenced in the blog. Howells would collaborate again with Yatuv in 2013 on He's the Greatest Dancer with Ian Johnston and Gary Gardiner.

36. The process was documented in words and images by Charnock, Julian Hughes, Jonathan Watts, Peter Rumney and Thom Freeth. The first paragraph was posted by Nigel Charnock on Tuesday 29 August 2006; the remainder was posted on Thursday 31 August 2006. See <http://www.stupidmen-nottingham.blogspot.co.uk/2006_08_01_archive.html> [accessed 27 October 2015].

37. Graham Watts, London Dance, 7 October 2008.

38. Archive listing for Gorgeous, UK Theatre Web archive, <http://www.uktw.co.uk/archive/Play/Gorgeous/S1327455844/> [accessed 17 January 2016]. In a Christmas 'Round Robin' letter dated 15 December 2008, Howells advises the reader that the show became Charnock and Howells. Adrian Howells, personal correspondence, Adrian Howells Collection, Scottish Theatre Archive, University of Glasgow, Box 17.

39. Transcription of text from Are We Not Gods; recording provided by Graham Clayton-Chance.

40. Dominic Johnson, 'Held: An Interview with Adrian Howells', in The Art of Living: An Oral History of Performance Art (Basingstoke and New York: Palgrave Macmillan, 2015), pp. 262-85 (p. 265).

41. Ibid., p. 265.

42. Adrian Howells, undated entry (ca. 2002), untitled and unpaginated spiral-bound journal, Adrian Howells Collection, Scottish Theatre Archive, University of Glasgow, Box 21.

43. Barr presented early versions of Sisters, Such Devoted Sisters in 2001, and toured the final version of the play in 2004. See Russell Barr, Sisters, Such Devoted Sisters (London: Oberon, 2005).

44. Johnson, 'Held', p. 265.

45. Howells, 'Proposal of Research for AHRC Creative Fellowship Application by Adrian Howells'.

46. Dates indicate premieres. Many of these works toured over a number of years to various venues, within and beyond the UK.

47. Howells presented this argument in numerous presentations about his work as well as in interviews.

48. Adrian Howells, 'The Art of Being Adrienne', unpublished lecture, Artists Talking the Domestic, Nuffield Theatre, Lancaster University, 4 March 2005.

49. Rachel Zerihan, One to One Performance: A Study Room Guide, Live Art Development Agency, 2012, <http://www.thisisliveart.co.uk/resources/catalogue/rachel-zerihans-study-room-guide> [accessed 18 January 2016], p. 34. In Johnson's interview, collected in the present publication, Howells traces in some detail one story of his emergence into solo performance work.

50. Ibid., p. 35.

51. Ibid.

52. Home Live Art, 'Salon 42', programme note, Adrian Howells Collection, Scottish Theatre Archive, University of Glasgow, Box 5.

53. Johnson, 'Held', p. 266.

54. Like The Arches in Glasgow, BAC offered Howells a home for his work and developed a long and trusted relationship with him. In 2013, it commissioned another one-to-one performance: *Unburden: Saying the Unsaid*.

55. Adrian Howells and Deirdre Heddon, application to the Arts and Humanities Research Council, September 2005.

56. Ibid.

57. Howells secured additional funding in Years 2 and 3 to make two specific performances: *Foot Washing for the Sole* and *The Garden of Adrian*. The research enquiry around *Foot Washing for the Sole* was an 'exploration of performative intimate acts of confession in a secular culture'. For *the Garden of Adrian*, he continued this exploration, but focused on the 'potentialities for the creation of a *mise en scène* and a dramaturgy of confession in a secular, traditional and public theatre space'.

58. Howells' relationship with The Arches began in 2003, when he presented *Adrienne's Dirty Laundry Experience* in one of its basement spaces. The Arches, located in the arches underneath Glasgow Central Station, opened in 1990 and, under the Artistic Directorship of Jackie Wylie, became the foremost venue in Glasgow to support radical performance by both established and emerging artists. Sadly, the venue closed in 2015 as a result of actions by the city's licensing authority.

59. Essays in this book discuss these other works by Howells in detail: on *14 Stations* see the essay by Jon Cairns; on *Foot Washing*, see essays by Howells, Kathleen Gough, and Helen Iball; and on *The Garden of Adrian*, see the essay by Heddon, Iball, and Zerihan. On *The Garden of Adrian*, see also Deirdre Heddon, 'The Cultivation of Entangled Listening: An Ensemble of More-than-Human Participants', in *Performance and Participation: Practices, Audiences, Politics*, ed. by Helen Nicholson and Anna Harpin (Basingstoke: Palgrave Macmillan, 2016).

60. Separate to his Fellowship activity, Howells also performed *Won't Somebody Dance with Me?* (2008), which functioned as a precursor to the more fully developed *May I Have the Pleasure?* (2011). *Won't Somebody Dance with Me?* presented a party-type scenario (perhaps a wedding), and invited spectators – in this instance a room full – to select a song from a playlist and then dance with Howells, as if having the 'last dance' of the evening, inevitably a slow dance.

61. His archive contains numerous Prop Lists. Indicative is the one for *An Audience with Adrienne* which toured to Israel: three pages of props to be taken are listed meticulously, including four different outfits, each itemised in detail (including 'Pair of pink earrings', 'sailor hat', 'silver and white bracelets', 'gold leggings'. Alongside the long list of Stage Props (which includes a 'Union Jack windmill', a 'Pink Dildo', and 'Princess flip-flops') is a Box of Souvenirs (including a 'Jesus candle', 'Buddha', 'oyster shell', and 'Eiffel tower snow globe'.)

62. Lucy Gaizely, interview with Heddon, 31 August 2015.

63. See Derek Jarman and Howard Sooley, *Derek Jarman's Garden* (London: Thames and Hudson, 1995).

64. This was especially so during his Fellowship, when feedback functioned as research data.

65. For example, he visited Toronto twice: firstly, to present *Foot Washing for the Sole* at the Harbourfront Centre in December 2009; and again in February 2011, when he returned to present a free three-day workshop organised by the same venue in collaboration with York University (while working at Harbourfront, Laura Nanni had invited Howells; when she became Festival Director of Rhubarb Festival, Nanni co-produced the subsequent project with the predominantly lesbian and gay theatre, Buddies in Bad Times). The workshop was called *I Wanna Get Next To You* and presented as part of a series called HATCHLab. Laura Nanni, personal correspondence, 27 December 2015.

66. *Accidental Tourist* is a seven-episode series, with each episode focusing on a different visitor to Israel. Howells was also developing a pilot for another TV show set in the airport in Tel Aviv. The latter was never commissioned.

67. The documentary is held in Howells' papers, and is also available to view in the Study Room at the Live Art Development Agency, London.

68. Sarah Lightman, 'Confessions, Cuddles, and Footwashing', *Haaretz*, 13 August 2008, <http://www.haaretz.com/confessions-cuddles-and-foot-washing-1.281981> [URL no longer active].

69. It is also possible to propose that this shift in his practice is due in part to a shift in his status, and his capacity to attract more funding or partnerships to support ambitious projects.

70. Helen Iball, 'Conversations with Adrian Howells', *Theatre Personal*, 2011, <http://theatrepersonal.co.uk/conversations/117-2/> [accessed 4 January 2016].

71. Ibid.

72. Ibid.

73. The Govanhill Baths were closed by Glasgow City Council in 2001. The Govanhill Baths Community Trust was established that year as a campaigning organisation seeking to preserve and reinstate the public swimming pools. See <http://www.nationaltheatrescotland.com/content/default.asp?page=s1003> [accessed 27 October 2015]. In October 2015, the Trust was awarded Heritage Lottery funding to refurbish the building.

74. Gaizely, interview with Heddon.

75. 'Media Release: Lifeguard – A Site-Specific Production in Govanhill Baths Created by Adrian Howells', *All Media Scotland*, <http://www.allmediascotland.com/media-releases/38591/lifeguard-a-site-specific-production-in-govanhill-baths-created-by-adrian-howells/> [accessed 2 November 2015].

76. 50% of Howells' time as Artist in Residence was spent in The Arches and 50% at TouchBase.

77. The Arches Commons was a regular and ongoing series of talks and discussions for The Arches, curated by Heddon and Bissell.

78. Howells, 'Talk as part of Arches Live Commons Event', 28 September 2013, unpublished paper, Adrian Howells Collection, Scottish Theatre Archive, University of Glasgow, Box 33.

79. Gaizely, interview with Heddon.

80. Ibid.

81. Howells, 'Talk as part of Arches Live Commons Event'.

82. Ibid.

83. Ibid.

84. Gaizely, interview with Heddon.

85. Howells, 'Talk as part of Arches Live Commons Event'.

86. Gaizely, interview with Heddon.

87. Howells, 'Talk as part of Arches Live Commons Event'.

88. Ibid..

89. Ibid.

90. Ibid.

91. Ibid..

92. Ibid.

93. Gaizely, interview with Heddon.

94. Howells, 'Talk as part of Arches Live Commons Event'.

95. Ibid.

96. Ibid.

97. Mary Brennan, 'Review: Arches Live [20]13', *Herald*, 27 September 2013, <http://www.heraldscotland.com/arts_ents/13124678.Arches_Live__13/> [accessed 17 December 2015].

98. Gaizely, interview with Heddon.

99. Mammalian Diving Reflex, 'Stories and the Telling of Them', *Sense Scotland Sensory Intern* website, 16 May 2013, <https://sensoryintern.wordpress.com/tag/mammalian-diving-reflex/> [accessed 17 December 2015].

100. Gaizely, interview with Heddon.

101. Howells paraphrased by Gaizely in Ibid.

102. As a courtesy to the reviewer, we have chosen not to reference the review in question.

103. Johnson, 'Held', p. 283.

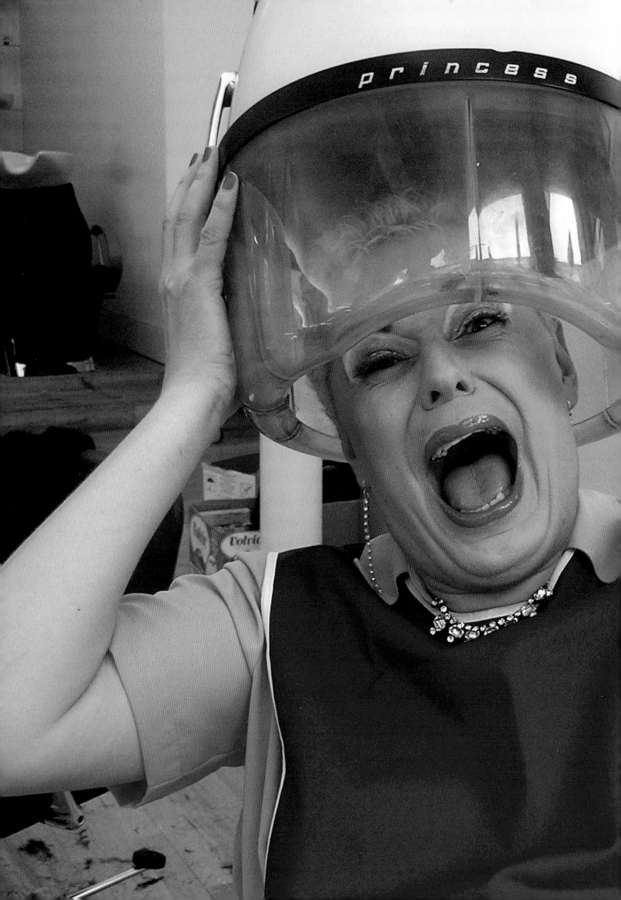

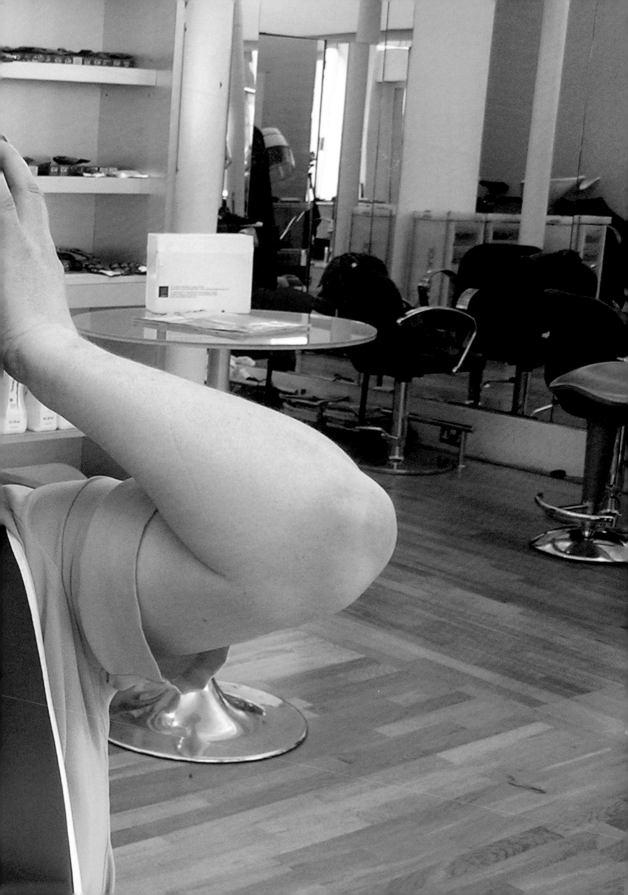

Held: An Interview with Adrian Howells

Dominic Johnson

The last letter Adrian Howells sent me ends with a personal encouragement 'to jump beyond yourself'.[1] It was a birthday letter. His was an upbeat injunction, yet tinged with something like sadness. At least, it looks that way now, as I read over the letter, every now and then, in the months since his death. *Jumping beyond oneself* typifies the kind of gesture Howells sought in his intimate performances, many of which were staged for an audience of one. What is one's self, and how to jump beyond it? How does an individual take the leap to a subject-position outside of the confines of biography, of physical or emotional limitation? How does one seek to become more than the sum of one's own known parts – through performance, friendship, love, or work? And how might scholarship follow Howells' injunction, *to the letter*, towards a broader engagement with what may be available for critical and writerly engagement? These are the provocations of Howells' practice, which felt so urgent, so alive, in the interview undertaken between us – yet, which also seem too far away, now, so delicate and immaterial in his absence.[2]

In late 2012, I was invited to contribute to a special issue of the journal *Performing Ethos*, on the topic of one-to-one performances. I proposed an interview with Howells. We'd undertake the interview in two parts: Part I would be published in the journal, and would focus on one-to-one performance;[3] Part II could range more freely. Parts I and II would be published together in an oral history of performance art, which had then-recently been contracted.[4] We undertook the interview at my flat in London,

in the first weeks of March 2013. A year after the interview, almost to the day, I received author's proofs for *Performing Ethos*, and prepared to return corrections to the publisher. In the midst of re-reading the insights shared in this interview, I received the sudden news that Adrian had died.

The published version of Part I was accompanied by a long, detailed contextual introduction. The proofs had arrived prior to his death, and it was too late to revise my introduction, so I added an 'In Memoriam' notice, and stated that the terms upon which I approached Howells' work now seemed frivolous to me. I'd missed the points that matter now. Otherwise, I left the original content and language intact (including the painful inaccuracy of the present tense), suspending my friend and his work in wishful animation.

All performance is ephemeral, but what remains of Howells' robust work seems *particularly* negligible in its materiality, because the substance of each encounter is categorically singular, intimate, fleeting, and undocumented. Many artists have refused to document their performances, but some of these artists, at least, leave individual works that were experienced by more than one spectator, such that memories, manifestations, and intimations may be canvassed, and a cumulative experience can be imagined by the critic or historian. This is not possible for much of Howells' work, and the *exemplary* transience of his work is confirmed, profoundly, sadly, by his suicide. Our interview assuages a fragment of this sadness.

Howells was much admired by many, prolific, and pioneering – an obituary in the *Guardian* described him rightly as a 'theatre legend'.[5] It was a great pleasure to interview him, and to be able to include him in the publication that the full-length interview first appeared. Below, Howells is generous in his detailed analysis of his own process, and he explains his early attraction to the one-to-one format, and his development of the form from a fairly impromptu usage in 2001 to a much more considered and committed investment in subsequent years. He explains key ideas and imperatives, including the ways audiences appreciate but also resist the apparent requirements of the format. Throughout, Howells is sensitive to the debts his recent work maintains to his earlier work in devised and ensemble theatre. In Part II, we discuss his apprenticeship of sorts in traditional theatre, and other concerns, including his plans for the future, in terms of his work, and his personal circumstances.

For those who knew Adrian as a friend, the final pages might be difficult to read. For those who may be new to his work, I hope the interview will prompt attentive retrospective enquiries and loving reconstitutions. The hard work of honouring his commitments, and securing his posterity, will have begun.

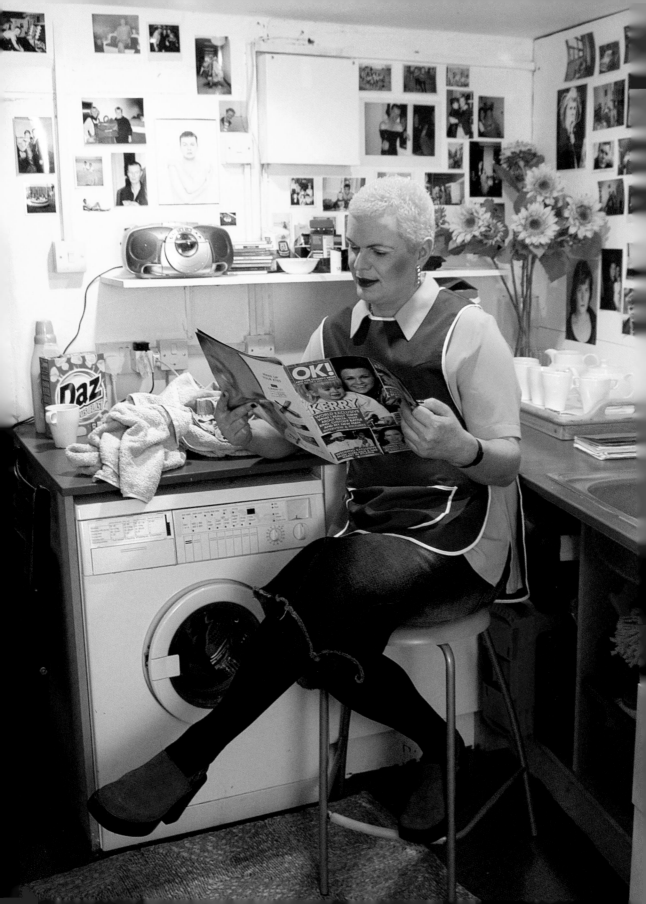

Part I

Dominic Johnson: *What was your first experience of making a one-to-one performance? How did you come to use the form?*

Adrian Howells: In late 2001, I was approached by a collective called Area 10 Project Space that was based at a disused timber warehouse behind the library in Peckham, South London (incidentally, the library Damilola Taylor had left the night he was murdered in 2000). Area 10 hosted a monthly cabaret night called *Bob's Punkt*, and I was invited specifically to do 'radical drag', after a member of the Area 10 collective saw me perform in drag in Nigel Charnock's *Asylum* [2001].[6] I wasn't sure I knew what 'radical drag' was. More importantly, since the run of *Asylum* I was feeling nervous about doing shows with large audiences. I felt I had reached a stage in my life where I wasn't sure I wanted to *wash my dirty laundry in public* (as I identified it then) in front of a group of people who didn't necessarily care about me. In the work I did with Nigel Charnock, we did improvisations during the devising process, which Nigel recorded and made endless notes on, and he would be using our personal information and our life histories to create scripts and scores. In those pieces I was talking about my relationship with my mother, and seven years of bedwetting, and other really personal stuff that I'd also been talking about in therapy. I realised there was never anybody after a show waiting for me at stage door, and asking if I was alright, or offering me company for the night. The work was self-lacerating, and I was ripping myself apart, in the spoken sections, and in the visceral nature of Nigel's choreography, and I would have to go back to a hotel room each night and carefully stitch myself together again for the next day and the next performance.

I explained this to the Area 10 collective, but agreed to go to one of the nights and see what I thought. When I went, I loved the highly experimental, off-the-cuff, spontaneous works artists were doing. One was an angular, bizarre movement piece to loud radio interference, performed in a small, disused office space, with an audience of about a dozen of us seated on boxes around the space. I loved the close proximity between the performer and the audience, and I was aware that the performer had made no attempt to tidy up the space. It was still littered with paper and remnants of its function as an office space. I decided I wanted to do something in the same room, for one, two, or three people at a time, with me talking about my life but involving a kind of meaningful engagement that offered the audience an opportunity to do the same thing. Because I was still responding to the brief of 'radical drag', I wore an outfit I had worn for Russell Barr's play *Sisters, Such Devoted Sisters*, where the two of us had a catfight in drag (for a video that was cut from the final version of Russell's show).[7] Russell had given me a dark wig, a long black leather coat, serious stilettos, and lots of bling, so that's what I wore for the performance for Area 10, as it was all I had. It was quite an intimidating look! I also used lots of stuff from my flat, which I carried

Opposite: Adrian Howells, *Adrienne's Dirty Laundry Experience*, performed at The Arches, Glasgow, as part of Glasgay!, 2003. Photo by Niall Walker.

in suitcases and installed in the warehouse. I dragged in an old battered sofa, and a counter that I turned into a shrine. The space was covered in trinkets, souvenirs, memorabilia, pictures, vinyl album covers, and boxes of photographs and letters. The audience would come in, I'd offer them tea and biscuits, and we'd sit down and have a chat. They could look through my stuff, and ask me about it, and I would talk honestly and openly about my life. Another important factor was that the events started after midnight, but there was no electricity in the whole warehouse, so the spaces had to be lit with candles. As it would happen late at night, by candlelight, in this intimate space, the conditions seemed conducive to a confessional performance.

As it turned out, people were champing at the bit to tell me dark and dirty secrets, and it was very clear that I was perceived as some sort of agony aunt figure. Interestingly, my friend Linda Dobell [the late director and choreographer] was my timekeeper in the performance, and every 30 minutes she'd pull back a dirty curtain and say, 'Adrienne, your next guests are here'. Linda made up my drag name on the spot, and it stuck. So the intimidating look I had at that time developed into the more developed 'Adrienne' look, with peroxide blonde hair, wearing a tabard, and looking like someone in the service industry.

DJ: *Since 2001, the one-to-one format has evolved into your* modus operandi. *How did it develop from that first, tentative experiment at Area 10 – using the opportunities that were available – to a more sustained engagement with the form?*

AH: The next major development of my use of the one-to-one was in response to a commission from The Arches, for Glasgay!, the gay and lesbian festival. I wanted to work with dirty laundry – literally washing audience members' dirty clothes while inviting them to share their metaphorical dirty laundry – and the idea dictated what kind of space I could use in the building, as a washing machine would need to be plumbed into a sink. I used a small basement space, and converted it into a launderette-cum-living-room. *Adrienne's Dirty Laundry Experience* [2003] became a much more formalised version of the one-to-one for me. And as it was programmed in Glasgay! and had plenty of marketing, I think it placed my work, and the one-to-one as a form, on the cultural landscape at that time.

I became really imbued with an awareness of the opportunity for qualitative connections that this dynamic of the one-to-one could engender. I really felt I could get to know somebody, and they could get to know me. I was very attracted to the fact that it became an opportunity for unburdening – *a problem shared is a problem halved*. It felt useful, not just as an aesthetic experience, but as an interaction that might be emotionally and psychologically beneficial, both for me and for an audience participant.

I also became very interested in how a performance could be co-authored. The audience member and I could share the crafting of a performance, moving away from the convention of the artist having the power and control. Although I

would structure the piece, the conversation itself is not scripted. I could allow for flexibility, and for the audience to take the performance in another direction, or share something they felt was important. The conversation would have some forethought put into it, in terms of structure, or general themes and directions, but this was never set in stone as a script on my part.

DJ: *How aware were you of the history of the one-to-one as a form at that point? Had you been a participant in other artists' one-to one performances, for example?*

AH: I wasn't aware of a history of one-to-one performances at that time, and am hard-pushed to think of any that I had experienced before making these two early pieces. After 2003, when I made *Adrienne's Dirty Laundry Experience*, I remember going to more and more one-to-ones. Prior to that time, I can't think of a similar work that was particularly influential upon my decision to work with the form.

As I said earlier, I had become exasperated with working for other practitioners, who were often using my personal history and experience for their work. But I was also imbued with frustration with an idea directors often used – in my time as a jobbing actor, for want of a better term – where they'd say that although you're performing to, say, 700 people, a performer should try to have an intimate connection with each and every person in the collective audience, as though you're performing uniquely for just that one individual. I seriously tried to engage with that sentiment, but of course it's impossible. I never really got how the tangible distance – between the actor on stage, and the audience in rows of seats looking at the back of someone else's head – could be resolved to establish a real sense of intimacy. I understand that this is a question of physical proximity, of spatial awareness, which is different to intimacy. But it was still a problem for me. And how do you have an intimate relationship with 700 people at the same time? So I thought, what if we just chuck the 699 other people out of the room, and try to focus on one person at a time. That struck me as an exciting idea to explore. I became very interested in one-to-one performance as an opportunity to sit really close to somebody – and then, eventually in my work, not just sitting next to someone, but touching them, by washing their feet, or bathing them.

So it wasn't really connected to seeing other artists struggling with the same problem in their work. Interestingly, Daniel Brine [then associate director at the Live Art Development Agency], had told me about Oreet Ashery's use of Marcus Fisher as a distinct performance persona, which did indeed directly influence my creation of Adrienne, but I was not aware of *Say Cheese* [2001] as a one-to-one at that time; I also subsequently found out about Franko B's *Action 398* [1998-2003], but I hadn't experienced it at that time either.[8] Moreover, I was highly suspect and uncomfortable about live art – my background was very much in traditional theatre.

DJ: *Speaking as an artist and also as an audience member, what do you think makes an effective performance? What do you look for in performance?*

AH: I think I look for an experience in which I am touched, moved, and transported. I am immediately aware that I am using the word 'touched'. I am excited when a performer physically touches me in a performance, and I suppose that's because I am so often the one instigating the touching and I'm looking for a little bit of tactile nurturing in return. But I am also interested in being touched emotionally and energetically, as if by an invisible hand. I really like it when I am seriously and devastatingly moved, break down uncontrollably in tears, or experience a moment of acute rage or anger, or inconsolable sadness or melancholy. It can feel like being transported for the moment to a different 'realm' of emotional or sensorial experience that is other than the everyday – I know I'm in danger of sounding a bit mystical here – and yet is simultaneously connected to and rooted in it. But touch is also an extremely powerful facilitator of deep connection with the self and with another. It can and frequently does engender an experience of transcendence or catharsis. When I performed *The Pleasure of Being: Washing/Feeding/Holding* [2010-11] in Milan in 2010, I was bathing a naked 30-something-year-old man, he started to cry uncontrollably and said, 'What I can't get over is that this is absolutely extraordinary and ordinary at one and the same time'.[9] I feel that increasingly I value an opportunity – even for a moment – to experience the extraordinary within the ordinary. The other way round can also be interesting, but certainly I'm fascinated by a slippage between the two.

DJ: *There's a suggestive ambiguity in your valuation of being 'touched, moved, and transported'. How does your work engage with the similarities and differences between being 'touched' emotionally, and 'touched' physically?*

AH: In *Foot Washing for the Sole* [2008-12], which I have performed hundreds of times, the structure, content, spaces, activities and so on are very familiar to me, but each person that enters into the performance is completely different. I'm excited by the fact, in this piece of work, if I think I can predict an emotional response from the next person coming through the door, I am usually wrong-footed. In the moments when I am physically touching somebody – and I have touched many other people in the same way on the same day – suddenly within that actual touch there can be a heightened awareness of the way that skin feels, what it is to touch and be touched in return. Part of the allure is that the experience of touching another human being is a unique thing in and of itself. In skin-to-skin contact, a chemical called oxytocin is released – a hormone that promotes wellbeing. Babies grow physically and emotionally stronger the more they are handled and touched, because of the release of oxytocin. It makes sense to me that a performance that incorporates these experiences of touching, which can make you feel very aware, very sensitised, operate in similar ways to the more traditional ways that a performance might induce emotional experiences.

DJ: *A sceptical audience member might think that it's easier – or somehow manipulative – to achieve an emotional effect by physically manipulating, moving or touching the audience member, as opposed to achieving the effect through more abstract, elliptical means, such as through text, or image, atmosphere, or other techniques in the traditional theatrical apparatus.*

AH: I think that would be an intellectualisation, which is important in some respects, but in an experiential sense the performance provides different information. It's also important for me to point out that I'm not interested in coercing individuals into having experiences that they're really not 'up' for having. What fascinates me is the number of individuals who sign up for my performances and proudly tell me that they did so because they feel they have 'issues with intimacy', 'don't like being touched', or felt they really wanted to 'challenge themselves'. Of course my audience participants – like those of Kira O'Reilly or Franko B in their challenging one-to-ones – tend to be self-selecting, but it never ceases to impress me that so many individuals, from so many different backgrounds, are seeking out what they perceive to be *real, immediate* and *urgent* experiences.[10] I think there is a sense that people are a little disillusioned with the traditional theatrical apparatus – and, of course, I'm delighted that this includes work that is about mutually deeply nurturing and profoundly *tenderising* ourselves through touch and intimacy.

DJ: *Your training or apprenticeship was in traditional theatre, where a key principle is the production of fakery. Your solo work has in some ways overcome this principle, or at least you have distanced yourself from the prevalence of artificiality, towards what might be called a more 'authentic' experience. What is at stake in the departure from theatrical pretence?*

AH: I used to be somebody that was much more involved in 'traditional' theatre. My more clearly theatrical work comes out of that – like *An Audience with Adrienne*, which was performed for 25 people at a time [between 2007 and 2010], or *May I Have the Pleasure...?* [2011], which also has a collective audience. I am very aware of those pieces being 'shows'. But I love the fact that with my particular kind of background I have been embraced by live art. I think that intellectually and conceptually, the discussion in and around live art works is much more interesting than the discussions around traditional theatre. Marina Abramović makes a useful distinction between acting and performing: 'Theatre is fake [...] The knife is not real, the blood is not real, and the emotions are not real. Performance is just the opposite: the knife is real, the blood is real, and the emotions are real'.[11] I am proud to be identified with a group of people who might be working to achieve the real, rather than artifice, pretence and fakery.

In *Foot Washing for the Sole*, or *The Pleasure of Being: Washing/Feeding/Holding*, however, I know that I can slip into being mechanical or habitual, or fall into acting, or become self-conscious. The interaction loses something when that happens – a sense of the 'real' is lost – because I don't feel I'm really engaging with that individual, in terms of the key principle of my work, which is often connectivity. On the whole, though, I don't conceive of individual interactions in terms of success or failure. It's not helpful for me to polarise encounters in that way, or think about particular connections in pejorative terms.

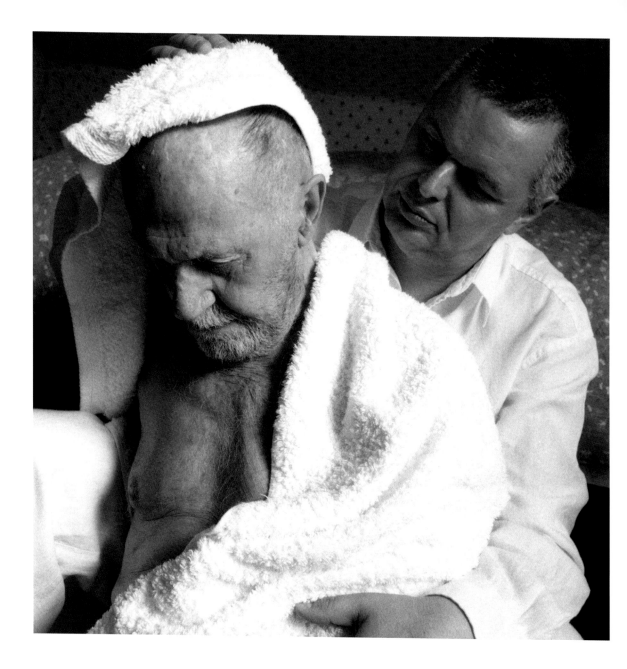

DJ: *Earlier you used the image of distilling the 700 members of the collective audience down to the singular participant. This must have financial implications for institutions seeking to programme your work, unless you are expected to perform a run of 700 consecutive performances, each for an audience of one. Do you have to deal with the apparent impracticalities of the one-to-one performance, or is this kind of consideration outside the work?*

AH: I do, but I am not burdened by it as a consideration. I am sometimes told that if a festival is going to programme a work of mine, they call it a 'loss leader' – they accept they are not going to make a profit from it, as I can only present, say, 24 performances in the three days of the festival. But the festival accepts that it's culturally important that the work is part of the programme, as it has another 'currency' that will not necessarily translate into making money. What is an issue is that because of that fact, a festival will sometimes argue that they don't need to pay me a going rate in terms of what the festival pays other artists – and that isn't good enough. They'll sometimes try and persuade me to do a lot more performances to help them break even. If I say I can only do 12 performances in one day, a festival might ask me to add another four, and make it up to 16 performances a day. But over the last decade, I've got used to having those conversations, even if I do find it a bit exasperating to have to argue that I should not be paid substantially less than another artist in the same festival.

DJ: *Are there instances when an audience-participant will explicitly question, resist, or even reject the conditions of the one-to-one performance, from within their participation? How do you respond to these situations?*

AH: While some interactions do begin with a wrestle of some kind, I've never had an experience where it hasn't moved forward in some way, towards a kind of resolution. For example, I'm thinking of an elderly woman in Munich, who was really quite resistant to the concept of *Foot Washing for the Sole*. She was definitely what I might call 'cantankerous', and literally asked where the rest of the audience was, and was shocked at having to remove her shoes and socks (despite the information in the title and brochure). She said, 'no, I don't want to do this performance', which was fine, and I encouraged her to go back to the box office and ask them to refund her ticket. She stayed, and asked, 'But is this art?' I explained that I didn't know, and that I hoped it was, but that I could definitely claim that it was an experience. She sat there for more time, and eventually said, 'I will do your "experience"', as though she was doing me a great favour. But I could understand her being elderly, and having to go through the rigmarole of taking off her shoes, and then having to remove bandages and plasters from her very damaged feet. I realised that I'm not just dealing with a 'cantankerous' older woman, but a fearful or embarrassed person. The deal I make with myself is that I will always try to dig deeper for the compassion.

Opposite: Adrian Howells performing for camera with an audience-participant, Bill, to support the development of *The Pleasure of Being: Washing/Feeding/Holding*, 2010. © Hamish Barton.

Overleaf: Adrian Howells, *Adrienne: The Great Depression*, performed at Great Eastern Hotel, London, 2004. Photo by Marko Waschke.

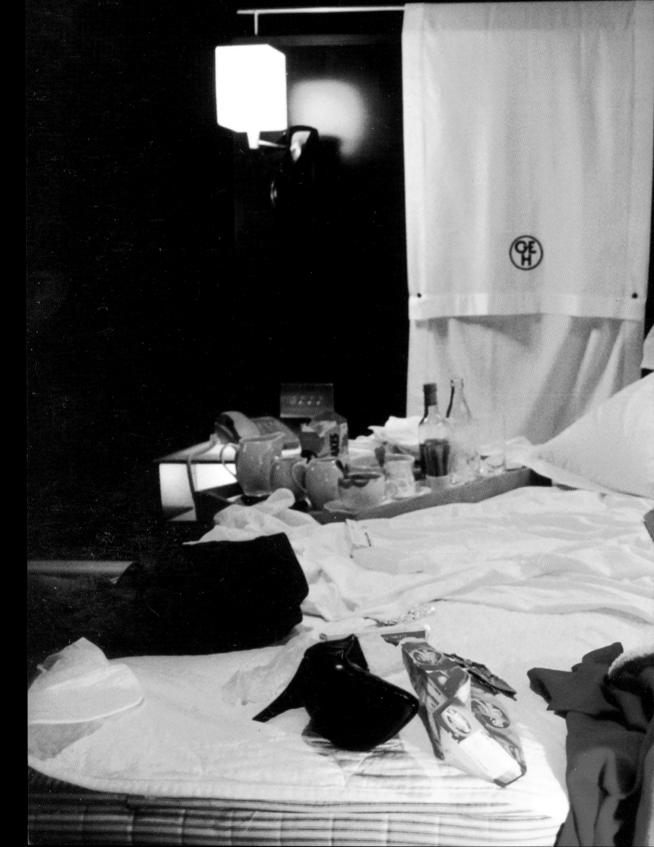

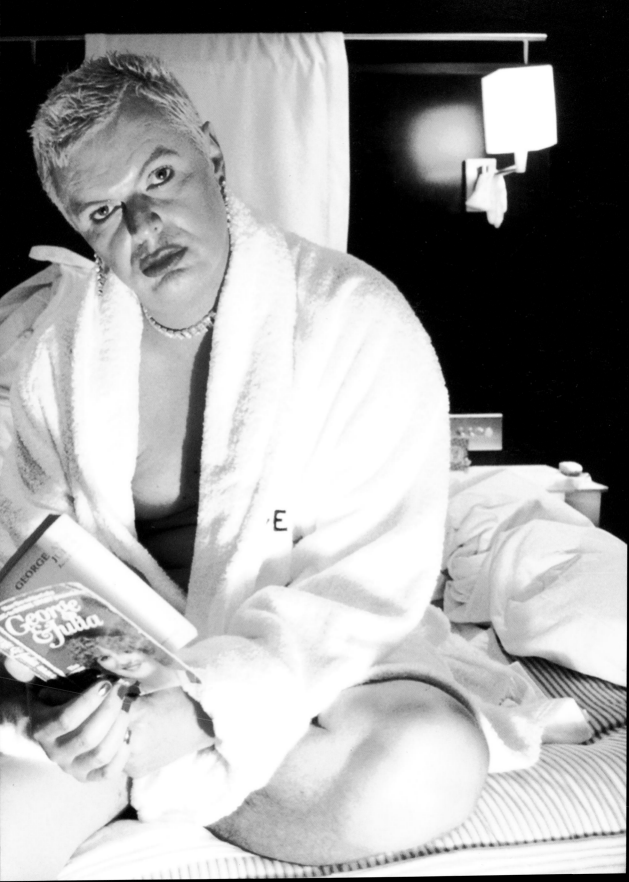

In that performance, I am kneeling in front of the participant, and offering my services, and it's important that I am connecting with humility. It was interesting that the moment I got that, she did enjoy me very respectfully and tenderly washing her feet, she melted, and the experience changed for both of us, and she left the space saying she was pleased she'd decided to stay for the experience. Whether it's because of me – the deeper learning and shift of understanding she engendered in me – or the alchemy of the pleasurable feeling of her feet being washed in warm water, I'd like to think it's a combination of those things. I don't think I'm being coercive, I think I'm also quite practiced at being patient and accommodating and I often offer people the opportunity to leave the experience, but I've never had a situation where a resistant person hasn't seemed to have a change of heart in some way.

DJ: *You mention one resistant audience member, but do you have to deal frequently with uncertainties about the status of your work as art, or as theatre, for example from programmers? Have you yourself been concerned that the departures you undertake might make the works unrecognisable as aesthetic projects?*

AH: It's not an issue for me from the point of view that 'the proof of the pudding is in the eating'. I feel very committed to what I do. There's a place for it, and I feel that it's culturally and artistically significant. But I feel that what's more important is the interactions between performer and participant, what happens organically, chemically in the experience. It doesn't so concern me to then have to make an argument for its status as art, or to argue its place in the cultural landscape, or that it should receive arts funding, or be taken seriously. I feel committed to what happens in the performances. I believe we live in increasingly brutal and brutalising times, and we need to find ways of physically connecting more. I probably sound like I have some sort of missionary zeal, but I guess there is some kind of zeal about me. I'm not interested in having an argument about where we locate this piece of work, just in order to put it in a pigeonhole or a category.

DJ: *There is a qualitative difference between the experience of a one-to-one performance and a commercial interaction – between, say, participating in* Foot Washing for the Sole *and receiving a high-street pedicure. A key difference, for me, is the aesthetic staging of the situation in your work. Can you tell me about how you develop and refine the aesthetic aspects of your work?*

AH: When I first started working with one-to-one performances, I was more general about how things worked in the space. In *Adrienne's Dirty Laundry Experience*, for example, there was a pictorial representation of my 'dirty laundry', including photographs of me from a baby to the present day, and I was very keen to include images of me in drag, at parties, or in compromising situations that would paint me as being a person who gets down and dirty in life. I think of that as a key aspect of the performance. However, when I did the performance at The Arches, I supplemented the memorabilia on display with props from The Arches' storeroom, which I thought looked kitsch, or 'Adrienne-y'. I don't think I would do that now – I wouldn't include something that wasn't 'of' me – from my home,

or something that I haven't specifically chosen and bought for the performance. I'm really careful now to make sure that the objects have associations, and are things I have an attachment to. Now I would also be incredibly careful about placement. In *Foot Washing for the Sole*, for example, I painstakingly work out where the soap dish should sit in relation to the essential oils, and it's those details that take up my time when I'm going to a festival to do a one-to-one performance. I'm really careful about colours, proximity and the space around things, lighting, temperature, and the way objects and arrangements might be read.

So much of this attention to detail comes from having the creative fellowship at University of Glasgow.[12] I was really encouraged to ask and answer the 'why?' question all the time. Why does the bowl I mix the frankincense and sweet almond oil in have to be this particular piece of ceramic? Being in that environment of questioning – especially with Dee Heddon as my academic mentor – was important in this respect. Before that, I never really thought it was important to answer the 'why?' question. I assumed I worked from instinct, but not only is that not good enough, it's not really the answer.

As a very practiced audience member in other people's work I also learn from my experience of this as well. At the PAZZ Festival [in Oldenburg, Germany] in 2012, I went to Rotozaza's auto-performance piece *Etiquette* [2007], which I thought was beautifully executed – but I had an adverse experience because they decided to locate it in a container that was open to the elements, and I was freezing cold. This completely impaired my enjoyment of it – it didn't affect my appreciation of it as a fantastic piece of work, but as an audience participant I found it hard to really engage. In *Foot Washing for the Sole*, for example, it wouldn't matter if I got everything else right if I was asking somebody to put their feet in tepid or cold water. It would no longer be caring and kind, and would sabotage the performance, as well as my intention and integrity as an artist.

DJ: *Cold water might be interesting, if the piece was potentially geared towards a difficult or uncaring encounter. I think intimacy can have a broad range of possible textures or affective qualities, from the agreeable and comfortable to hostile or abusive interactions. A work like* Foot Washing for the Sole *clearly engages with the genial end of this continuum, yet the possibility of difficult encounters arises – like the person you described who was fearful of showing her feet. How do you engage explicitly with less palatable or pleasurable intimacies in your one-to-one performances?*

AH: There's a difference between, on the one hand, making a performance that is discomforting and challenging, and, on the other, those situations in which a participant might have an adverse response to an experience that might be seemingly and purposefully very caring. I created a piece called *The 14 Stations of the Life and History of Adrian Howells*, which is not as well known as *Foot Washing for the Sole* or *The Pleasure of Being*, as it has only been performed twice [The Arches, Glasgow, 2007; and Battersea Arts Centre, London, 2008]. I take individuals on an escalation of uncomfortable experiences because I wanted that to mirror in some way the idea that Christ carrying the cross to Golgotha

became a much more intense and painful experience before he reached the ultimate pain and suffering, namely the crucifixion. In the biblical narrative the centurions force Jesus to strip, and give him a sponge soaked in vinegar and gall.[13] In a very confined space I stripped off in front of the participant, who was induced to be complicit, and when I was naked the participant had to pour out a glass of cider vinegar, which looks like urine. It's vile and bitter, but I drink it. In the commentary afterwards, participants said they felt very uncomfortable, and saw the actions as confrontational. I am aware that I have deliberately used opportunities and experiences to put people in a place of discomfort, which I hope leads them to question what it is in the action that makes them feel challenged. But the problem with *The 14 Stations* is that it is unrelenting. I do think there's a payoff at the end, but because it was literally one thing heaped onto another, the participant ceases to have a perspective on the individual actions, or their own complicity in the performance. One of the stations included me naked on all fours in a paddling pool full of freezing water and I ask the participant to pour a bucket of ice over my back. Some refuse to do it. If they refused I did it to myself.

In another section I stand next to a projected film image of a gorgeous man – a former student of mine who was the object of my unrequited love – and the audience participant watches me as I break down and cry, from the pit of my gut, while I'm listening to a piece of music that takes me back to that particular time in my life. Some people would come over and put their arms around me, or pass me a tissue; three people removed the headphones to stop me listening to the music. Dee Heddon agreed to have her participation in the piece documented, and in the video she stands there helpless, and seemingly doesn't know what to do.

In terms of whether or not participants have negative experiences of works that are intended to be more caring, I think it's really difficult to know if someone has gone away with a negative experience, as I don't always get to hear about that. In *The Pleasure of Being: Washing/Feeding/Holding*, which I do intend to be a loving experience, a student emailed me a year after the performance to tell me that she was experiencing feelings of guilt and shame about what she had done as a participant. She felt it was akin to a one-night-stand, and she regretted having the experience with me. In quite accusatory terms, she said that at no point had I made it clear to her that we could talk during the performance, and that if we could have talked she wouldn't have felt as complicit in her own disempowerment. Interestingly, it says very clearly in the printed guidelines for participation – before you even enter a cubicle to change – that it is entirely up to the participant if we talk or remain silent. But perhaps she was in such a place of anxiety or apprehension that she didn't digest the information. When I got the email I was very concerned for her. She said that she gave herself to me, but felt that if I passed her on the street I wouldn't even recognise her. I thought it was awful that a year later she felt ashamed and dirty, and was wrestling with the experience. I knew it

Opposite: Adrian Howells applies his makeup backstage before a performance of *An Audience with Adrienne: A Lifetime of Servicing Others*, at The Arches, Glasgow, as part of Glasgay!, 2006. Photographer unknown.

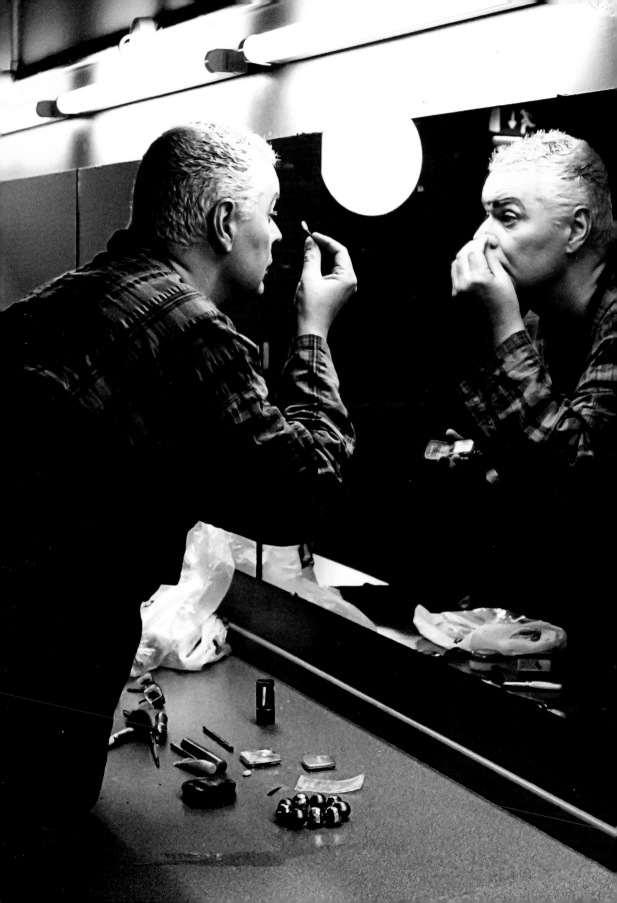

was important for me to really engage with her, and reassure her about what my intentions were for the piece. It wasn't my place to say, 'well I never held a gun to your head and forced you to do the piece', or to engage her with the idea that there might be something valid in her feeling uncomfortable. I felt she shouldn't be giving herself such a bad time, but I could sense she was suffering, and that was what I needed to address at the time.

I'd want to distance my work from the attitude that one-to-one performances – including my own – are only fluffy, warm, and genial, and to be clear that prickly or uncomfortable experiences do indeed take place. In *The Pleasure of Being*, there are unexpected or difficult interactions, including if male participants get an erection and seem to suggest that we're going to have an erotic encounter. It's fine to get an erection. Why wouldn't you? The participant is lying in a really warm bath, with rose petals and milk products, and there's rose oil burning and it's candle-lit, and I'm touching his body in a tender way. It's a physiological reaction, and it doesn't faze me, but in some instances it's clear from a participant's energy that he may be expecting or wanting this to be a sexual experience, especially if they touch me back. If I think of specific instances, I ask myself why shouldn't that happen? Why should the participant know all the parameters? I don't have to go along with it. I can move his hand and continue, and I feel proud that it doesn't become sexualised, and that I can say something else through the piece – that two men can have a qualitative experience of intimacy and that it can remain tender and platonic, and that we can both learn from that. There are conflicts and negotiations, and these may be tricky.

DJ: *What is the place of the contract – social or written – in your performances? How do you deal with unwritten agreements or limitations, which all performances potentially entertain?*

AH: I think there does have to be a level of protection, for the artist and the participant. Partly that comes from my engagement with the university's research ethics committee while a creative fellow. At first I assumed they would be merely prohibitive, but I realised that they were genuinely protecting individuals, including me. I deliberately work with a psychologist, Lisa Mayall, and seek advice from her. In *The Pleasure of Being*, she was adamant that the guidelines needed to be written down – a physical document that the participant could read – as she pointed out that if the guidelines are just spoken to the participant as they enter the space they won't hear me and process the information especially as they may well be anxious, nervous, or apprehensive. I state, for example, that while I invite the participant to be naked, at no point will I wash or go near their genitals, to remove some of the anxiety from the performance. It makes it clear that sexual contact is not on the cards – although participants will sometimes not acknowledge this. The guidelines protect the audience, but also protect me – and the commissioning festival – from legal problems. The bullet-points might look like dos and don'ts, but they try to make it clear what the experience is trying to be, and not something else.

I'm very mindful of the parameters of the experience, and it's important to make these clear and transparent. But I also know that as an audience participant I love to go to performances where the parameters are blurred. However, I feel with the work that I do, I am trying to create safe environments where we feel protected because that is the most likely climate for the work to thrive and be appropriately impactful. But that doesn't mean there can't be some difficult and challenging negotiations too.

Part II

DJ: *To what extent are your one-to-one performances therapeutic for you, and to what extent do you set out to undertake a therapeutic function for your participants?*

AH: I'm very comfortable with the idea of performance as therapy, and about admitting that my work can often have a therapeutic benefit for others. I know it's not fashionable to say that. I've become less comfortable with talking about how the work may have a therapeutic benefit for *me*. I think the dynamic of nurturing someone else is very different to the dynamic of nurturing someone else and being nurtured in return, at the same time. I used to say that if I was nurturing and nourishing another human being, of course I am going to be nurtured and nourished in return. It's not necessarily the case. In *The Pleasure of Being*, for example, it's labour-intensive – someone gives me their body weight, and I'm lifting the arms and legs to wash them – at the end of the day my back is killing me from all the heavy work of bending over a bath and lifting their limbs. Actually, the focus of my attention is on *giving* care and pleasure to that individual. They're not giving it back to me at the same time. I experience *something* of a nurturing nature in return, but it's not the same. That person is surrendering, with their eyes closed, and I'm doing all the work rather than being treated in the same way. That doesn't negate the beneficial experiences that come from the feel of flesh on flesh – but to say that the act of nurturing brings an experience of nurturing in return, well, I think I was simplifying things.

It's poignant and timely that before we started recording, Dominic, you asked me how I'm doing, and I told you I was starting to go on some dates, and that I'm trying to get myself out there again. I've given a lot to people, and I think I've reached a point where I would like to get something back. I want to be bathed or stroked, or caressed, or held, the way I've been doing all these things for other people. My psychotherapist said a very interesting thing to me. I told her I felt reluctant to create a dating profile, but that I didn't think I'd be worried about responding to one. She told me she wasn't surprised I was reluctant – I've been putting myself out there for quite a few years, trying to say, 'this is who I am', but I don't necessarily feel that a lot has come back in return. You know what? I think that if someone else is prepared to give and give, well, the recipient will just keep taking. Earlier we talked about contracts, and sometimes it feels like my performances do not involve a mindful contract, in the sense that we agree that the other person must give me something back. The problem is that I'm not even

doing the work to get something back, or not consciously. But I think I've reached a point where I do want something in return, in performance, or elsewhere.

DJ: *This makes me think of the economy of the gift. You want performance to be closer to this economy, where a gift warrants something in return, even if this compensation is immaterial, and the thing that is given comes at a cost – albeit an emotional or psychic cost.*

AH: What I think I've done is to realise the degree to which my continual giving has been a mask for feeling like I do not need to receive. Speaking of masks, when I started my fellowship at Glasgow, after talking with Dee [Heddon], I made a conscientious decision to dispense with the mask of Adrienne – the makeup, hair, and costume. I wanted to be much more open and honest about risk, and vulnerability – and the *cost*, I guess, of an engagement with another person. I am not very good at receiving. I want to get better at it.

DJ: *If the gift is one economy you seem to work with, another is a sacrificial economy, where you set yourself up as a martyr. I think you're saying that the sacrificial aspect means you give too much of yourself in the encounter.*

AH: Yes. I identify with what you've just said. I think I have had a tendency – not on a conscious level – to *play the martyr*. I guess I've been comfortable with that, as it's all I've ever known. Now I'm conscious of it, I don't want to play the martyr anymore.

My other concern is that if I'm not prepared to receive, *I invalidate my giving.* Surely, for there to be equanimity, I also need to be willing to receive, beyond taking on the burden of another's sadness, joy, or the weight of their transcendence. It's not good enough when – sometimes, only sometimes – the other person has offered, say, to give me a bath during *Washing/Feeding/Holding*, and I've said, unthinkingly, 'no, it's not about me, the experience is about you'. What's interesting to me, now, is how quick I've been to say that. Why can't the experience *include* me?

DJ: *Finally, what's the difference between you the person and you the artist? It strikes me that it's difficult to distinguish where the work ends and you start.*

AH: I do get confused between the inside and the outside of the work. For example, I have become very aware that I'm virtuosic at *performing* intimacy. I am not so good at letting it happen in everyday life, of *having* intimacy without performing. It's cyclical, though, as that is one of the reasons I want to make sure I can explore intimacy in performance. The less intimacy I get, the more I want to

Opposite: Adrian Howells performed for camera with a series of invited audience-participants – Oliver Garrod (shown here), Katy Baird, Susan Yip and Nicola Lawton – to produce images to accompany lectures. Howells and the photographer Hamish Barton invited four people with various body types, abilities, professions, and ethnicities to engage in intimate encounters with Howells, at Gilmorehill Theatre, University of Glasgow, 2008. Photo © Hamish Barton.

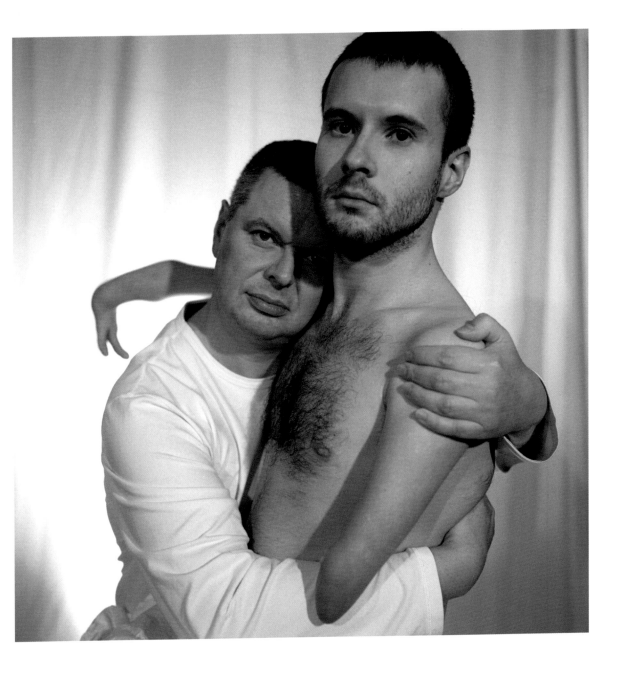

perform it; and the more I perform it, the less I feel capable of finding it in my life. I'm willing to '*fess up* about this.

When I had a breakdown in 2011, I went into a very serious depression. It was after I performed *May I Have the Pleasure...?*, and my psychotherapist said that I terrified myself, because I gave so much of myself to the performance that I have nothing left of myself to fall back on, or to hide behind, when I tried to return to everyday life. That's true. Hence, I put myself in a place of terror. There was no foundation for living, because I had given it away. Interestingly, that show was about me being 49, gay, still single, and having never been in a serious committed relationship, and talking openly and honestly about my isolation, my loneliness. I was in the grip of this knowledge when I made that show. I had no distance – historical or emotional – from what I was looking at. My psychotherapist said – and I love this expression – it was 'too much risk for a risk-taker'. So, yes, I find it very difficult to navigate between performance and 'real life', whatever that might be.

The breakdown was precipitated by a startlingly cruel review of the performance, which, of course, I took to be a demolition of *me* – of my life and my choices. The few bad reviews devastated me. But I *chose* not to separate my self from the work. I think I'm getting much clearer about these things now. How can I make sure I'm safe? How can I be a risk-taker and not take on too much risk to bear? In the future, I should try to work with feelings and experiences that are in the past, and can create narratives in which my memory – my confession – is *fudged*, in order to protect myself. This worked in *Lifeguard* [Govanhill Baths, Glasgow, 2012], where I didn't find myself in such a position of emotional self-exposure. I became a mouthpiece for my own biographical material, but also for other people's experiences, which were muddled together, and the audience never knew which stories were mine, and which belonged to other people. That way, *criticism can't cut so deep.* I'm conscious that I said earlier that with *Adrienne's Dirty Laundry Experience*, the fudging of my possessions and found ones was suspect. However, it's not the same thing. That was accidental, or unthinking – in *Lifeguard* it is a strategy of *self-preservation.*

I realise I'm driven to go to a place of self-exposure, risk and pain so much so that I have to put obstacles in place, to protect myself. I put my hand into the fire. I've been burnt. I put my hand back into the fire. When I do so, I know I'm alive. That's the power of performance. But it can also feel like a fatal attraction to getting burnt.

1. Adrian Howells, personal correspondence with the author, May 2013. Until recently, I assumed this phrase was a quotation from a mystical or philosophical source – perhaps the poetry of Khalil Gibran. It turns out to be a paraphrase from a song by the earnest 1990s singer-songwriter Alanis Morissette. In *Unsent* (1998), she sings, 'I remember how beautiful it was to fall asleep on your couch and cry in front of you for the first time. You were the best platform from which to jump beyond myself'.'

2. Howells was an excellent interviewee, and a number of other published interviews are available. See: Helen Iball, 'Theatre Personal Workshop: Adrian Howells', *Theatre Personal: Audiences with Intimacy*, 1 July 2011, <http://theatrepersonal.co.uk/workshops/with-adrian-howells/> [accessed 30 September 2015]; and Josephine Machon, 'Adrian Howells: The Epic in the Intimate', in *Immersive Theatres: Intimacy and Immediacy in Contemporary Performance* (Basingstoke and New York: Palgrave Macmillan, 2013), pp. 260-8.

3. The first part was published as Dominic Johnson, 'The Kindness of Strangers: An Interview with Adrian Howells', *Performing Ethos: An International Journal of Ethics in Theatre & Performance*, 3.2 (2012), 173-90.

4. Parts I and II were published together as Dominic Johnson, 'Held: An Interview with Adrian Howells', in *The Art of Living: An Oral History of Performance Art* (Basingstoke and New York: Palgrave Macmillan, 2015), pp. 262-85.

5. Nancy Groves, 'Theatre Legend Adrian Howells Dies Aged 51', Guardian, 19 March 2014, <http://www.theguardian.com/stage/2014/mar/19/adrian-howells-glasgow-theatre-legend-dies> [accessed 6 August 2014].

6. Nigel Charnock was a dancer and choreographer, and co-founder of DV8. He died of stomach cancer on 1 August 2012. After *Asylum*, Howells and Charnock collaborated on *Stupid Men* (The Place, London, 2008).

7. Russell Barr is a playwright whose work in the early 2000s included solo monologues, often performed by him, which drew upon and extended the visceral content associated with 'In-Yer-Face' theatre.

8. In *Say Cheese*, Ashery's Hasidic alter ego received guests on a bed in a domestic gallery, Home, in South London. Ashery/Fisher agreed to do anything the participant asked, apart from inflicting pain. In *Aktion 398*, Franko B was installed naked except for a dog's protective cone, with a bloodied gash in the flesh of his abdomen; he received audience members for three-minute encounters.

9. *The Pleasure of Being: Washing/Feeding/Holding* was first performed in a specially installed bathroom space at Battersea Arts Centre (BAC), South London in 2010. Howells bathed each participant in a bath, dried them with a towel; the participant was cradled in his arms, fed chocolate, and held.

10. Kira O'Reilly's most challenging one-to-one is likely *Untitled Action* (2005-06), in which audience-participants are invited to make an incision in her skin; after cutting (or not cutting) her, one holds her naked body in a *pietà*.

11. Abramovic in Sean O'Hagan, 'Interview: Marina Abramovic', Guardian, 3 October 2010, <http://www.theguardian.com/artanddesign/2010/oct/03/interview-marina-abramovic-performance-artist> [accessed 17 January 2015].

12. Howells was the recipient of an Arts and Humanities Research Council (AHRC) Fellowship in the Creative and Performing Arts in the Department of Theatre, Film and Television Studies, from 2006 to 2009.

13. Howells frequently appropriated the images and rituals of Christianity, both indirectly (in pieces such as *Foot Washing for the Sole*) and explicitly in *The 14 Stations*.

Adrian: The Homosexual

Stewart Laing

The Homosexual, or the Difficulty of Sexpressing Oneself (1971) is a play by the French-Argentinian performance artist known as Copi.[1] It is a surreal comedy written for drag queens playing transsexuals and it is set in the freezing tundra of outer Siberia. I'd designed the play when I was at art school, in what was a really fantastic production directed by our tutor, Peter Avery. I originally trained as a theatre designer, but I had aspirations to direct as well. When my design career hit the rocks around 1993, I decided to have a go as director.

The Homosexual was an easy choice for the first play I would direct, in fact a weirdly safe choice in that I knew it so well from the production I'd designed. Hedging my bets, I decided to co-direct with Gerrard McArthur, a classically trained RADA actor who was also interested in directing. He was to be the only professionally trained actor involved in the production, it transpired. Casting Adrian was an easy choice too: we'd been hanging about the Citizens Theatre – 'the Citz' – in Glasgow for a couple of years, making each other laugh hysterically and inappropriately, and that seemed a good reason to work with each other.

Humour was the defining factor in my friendship with Adrian, and it was to be the defining factor in making *The Homosexual*. None of us involved had any process, and our rehearsals became about working out what made us laugh. We explored what was funny to us, but what might not be socially acceptable to laugh at in a public forum.

In the early 1990s there was a noticeable gay rights momentum – but it seemed to us that many of the rights being fought for in the mainstream of gay culture were the right to all go to the gym extensively and the right to all wear white t-shirts and blue jeans with turn ups. There was a homogenised ideal that gays were aspiring to, and it felt like a pretty vacuous aspiration. This combined with a move towards political correctness in culture – a new set of rules attempting to define what could and could not be said about minority cultures.

Opposite: Backstage photographs from the run of *The Homosexual: Or, the Difficulty of Sexpressing Oneself*, performed at Tramway, Glasgow, 1993. Photos by Stewart Laing. *Upper:* Leigh Bowery and Adrian Howells. *Lower:* Max Sharp (aka Homosexual Max) and Adrian Howells.

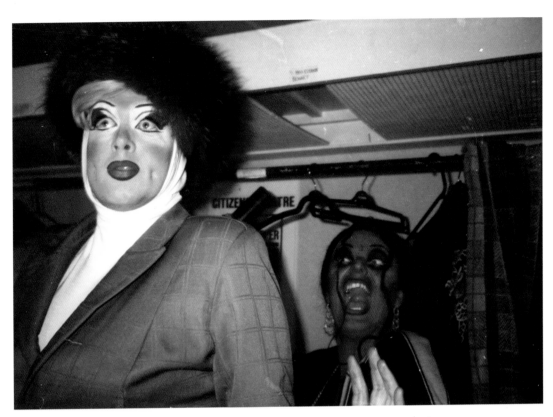

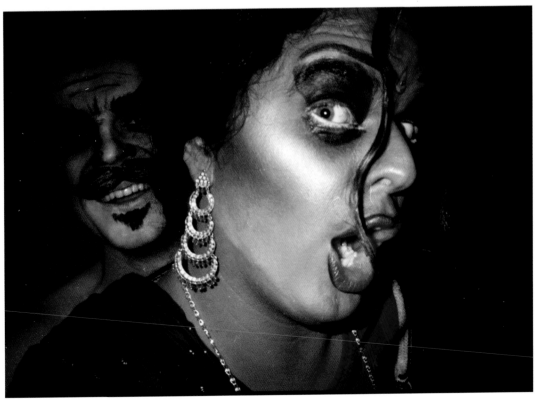

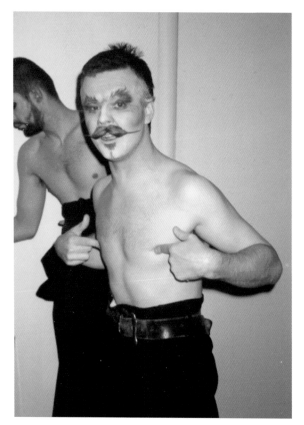
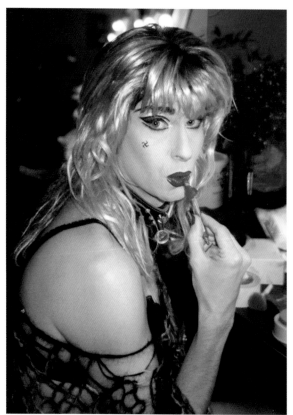
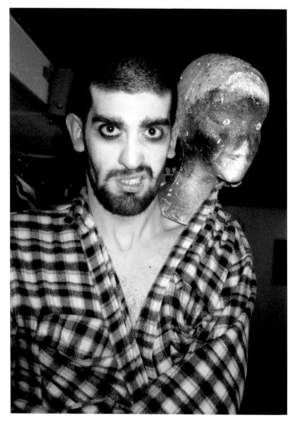
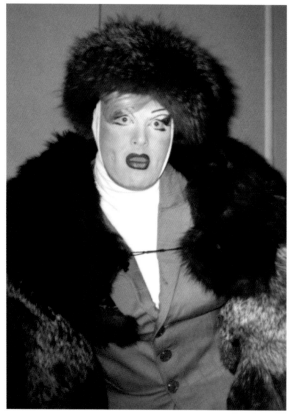

So within this minority group (gay men) there appeared a schism between the mainstream of the minority and a more anarchic alternative culture, that wasn't only challenging a dominant straight culture, but a dominant gay culture too.

So the humour that defined our work on *The Homosexual* was partly politically driven. We were an odd group of homosexuals, a collection of individuals who were definitely not part of the dominant gay culture. We weren't particularly young, we were (mostly) overweight, and we didn't aspire to the cartoon version of masculinity that was the passport to Old Compton Street. Our one rule in devising the production became: if it made us laugh it was in, and if it didn't it wasn't.

The other performers in the show were no strangers to comedy, and dark anarchic comedy at that: Ivan Cartwright had been booed off stage at the Royal Vauxhall Tavern for his impersonation of Myra Hindley; and Leigh Bowery had recently had creative differences with the choreographer Michael Clark over a costume he designed for the stage with the words 'a cunt' scrawled across the chest in thick black letters.

Adrian double-cross-dressed (an expression we both found hilarious, coming from a vaudeville tradition of combining drag and black-face comedy), playing the Madre as a hysterical Indian matriarch in brownface and body makeup, in a sari, with a red dot on his forehead. It was wrong in so many ways, but it made us laugh, so it was in. It wasn't necessarily a naïve decision. We were aware of the Wooster Group's *Route 1 & 9* (1981), where the use of 'blackface' makeup had resulted in their public grants being cut. Our Scottish-Indian stage manager said she thought we should do it, and that Adrian's performance reminded her of her aunties.

Leigh's argument for brownface makeup was interesting. It was an issue of artistic freedom for him: if he was a painter he could paint a person with black skin, and if he was a photographer he could take a photo of a person with black skin; it followed for Leigh that as an artist using his own body as his canvas he had the right to paint a black person on it.

Adrian was always interested in humour and he could quote extensively from Victoria Wood, Dawn French and Jennifer Saunders among many others. But he was also interested in the comedy of the likes of Bernard Manning, and would test people's boundaries by quoting completely racist and misogynist jokes. He knew that laughter was sometimes a way of processing harsh realities and unbearable pain. He knew how to use humour as a weapon too – off stage and on.

Opposite: Backstage photographs from the run of *The Homosexual: Or, the Difficulty of Sexpressing Oneself*, performed at Tramway, Glasgow, 1993. Photos by Stewart Laing. *Clockwise from upper left:* Max Sharp, Ivan Cartwright, Leigh Bowery, and Riccardo Iacono.

The other strand of comedy that made Adrian laugh, and inspired much of his work, was the 'female impersonators': Dick Emery, Stanley Baxter, and above all Danny La Rue, who were regularly on British TV as we were growing up. 'They're big and they're round, you can bounce them on the ground' was one of Adrian's favorite catchphrases. *The Stanley Baxter Picture Show* was certainly an event in our house, and one of the first and most memorable things I saw in a theatre was Stanley Baxter in *Cinderella*. These performers were part of a mainstream culture, and never, as far as I'm aware, identified as gay or queer. After we had finished doing *The Homosexual*, Adrian and Leigh went together to see Danny La Rue play live in London. Adrian loved this popular tradition of cross-dressing and he loved pantomime. His early experiences as a professional performer were in English regional pantomimes. Adrian was obsessed with comedy, as you have to be about something to make good art – immersed in it, holding your breath until you have to come up for air.

I should mention the two young men who played the male parts in *The Homosexual*. They were 'in boy drag', as Ivan described it. There was Max, who Adrian adored; I can never remember Max's surname and straight Max was in my address book as Homosexual Max, and of course Adrian thought this was funny.[2] He was always Homosexual Max to Adrian; he maintained a life long friendship with Homosexual Max, his wife Holly and their kids. And Riccardo Iacono, an artist and maker of experimental films: he painted on each individual film cell then edited them together. Riccardo is, along with Adrian and Leigh, one of the most principled and committed artists I ever met.

If our production of *The Homosexual* was anything, it was of its time; we wouldn't get away with it in the twenty-first century, and I doubt very much we would want to. The show had a 'mixed' reception: it was tolerated in Glasgow, booed in Manchester and whooped in London, on the nights that anybody came to see it. I have three simultaneous videotapes of the show, shot by a young Seamus McGarvey, that have played around the world at exhibitions of Leigh's work. I've never watched the tapes myself.

1. Copi was Raúl Damonte Botana (1939-1988). The script of *The Homosexual* appears in Copi, *Plays, Vol. 1*, trans. by Anni Lee Taylor (London: John Calder, 1976). Laing's production of *The Homosexual* opened at the Tramway in Glasgow in June 1993, toured to the queerupnorth festival at Green Room, Manchester in September 1993, and closed at Bagley's Warehouse in King's Cross, London in November 1993.
2. According to the printed programme, his name is Max Sharp.
He played the character of General Pushkin. Riccardo Iacono played Captain Garbenko.

Opposite: Backstage photograph of Max Sharp and Adrian Howells from the run of *The Homosexual: Or, the Difficulty of Sexpressing Oneself*, performed at Tramway, Glasgow, 1993. Photo by Stewart Laing.

Overleaf: Backstage photograph of Leigh Bowery from the run of *The Homosexual: Or, the Difficulty of Sexpressing Oneself*, performed at Tramway, Glasgow, 1993. Photo by Stewart Laing.

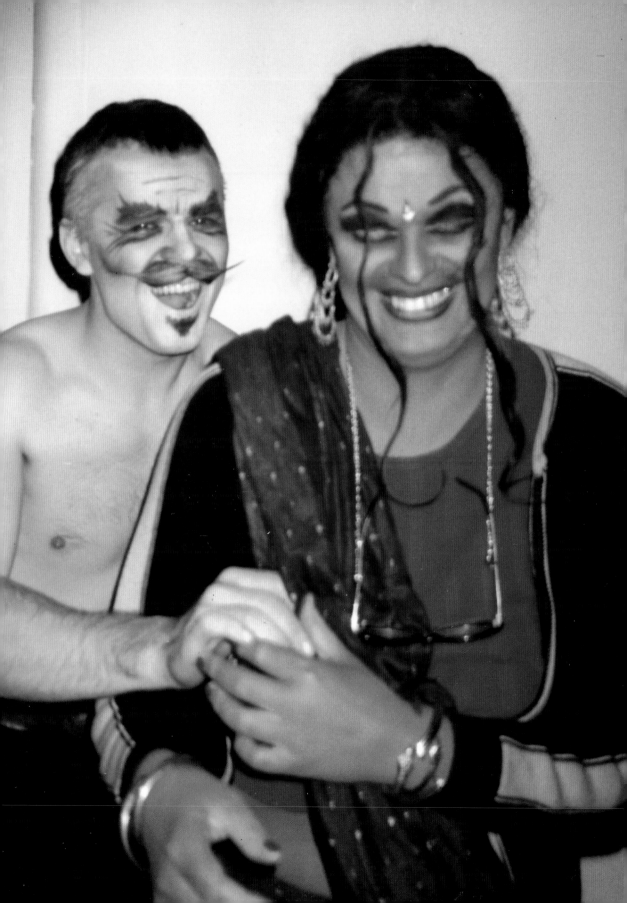

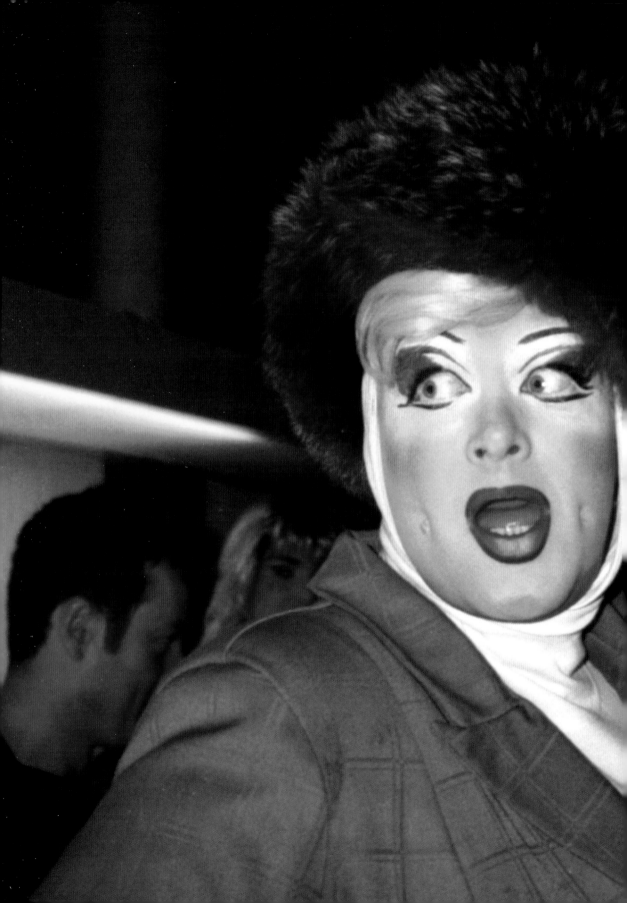

Adrian Howells on
The Homosexual

Dominic Johnson

The following is excerpted from a longer interview – reproduced earlier in this book – that was originally published in full in Dominic Johnson's book The Art of Living: An Oral History of Performance Art. *This section in which Howells recalls his performance in a production of Copi's* The Homosexual *has been excerpted here to complement Stewart Laing's reflections on the project. Howells also briefly discusses the long-term implications of this collaboration, specifically in terms of the continuing relevance of sex and sexuality in his later one-to-one performances.*

Dominic Johnson: *You performed in Stewart Laing's production of Copi's* The Homosexual, or The Difficulty of Sexpressing Oneself *(1993). Can you tell me about the production?*

Adrian Howells: *The Homosexual* was hugely important to me. We did it first at Bagley's Studio, behind King's Cross Station, and we toured it to Manchester and Glasgow [in 1993].[1] When I was at college [at Bretton Hall, Leeds, 1980-84], I was a born-again Christian – indeed I was president of the Christian Union. I was incredibly cautious about what I would get involved in, in terms of productions – I guess I didn't want to offend the Lord! I met Stewart Laing, and he showed me the script of Copi's play. I thought it was the most radical thing I had ever encountered. He offered me the role of the Madre, and told me he was going to ask Leigh Bowery to play Madame Garbo. I'm not sure I really knew who Leigh Bowery was at that time, other than a vague awareness of Taboo, and the 'Blitz Kids' scene.[2] I really like the fact that Stewart wanted to cast Leigh – with his excessive approach to performance; me, from what I call the 'Dora Bryan School of Performance';[3] and Ivan Cartwright, who used to do Myra Hindley drag and get beer cans thrown

Opposite: Adrian Howells in performance in *The Homosexual: Or, the Difficulty of Sexpressing Oneself,* performed at Tramway, Glasgow, 1993. Photo by Eileen Heraghty, courtesy of Stewart Laing.

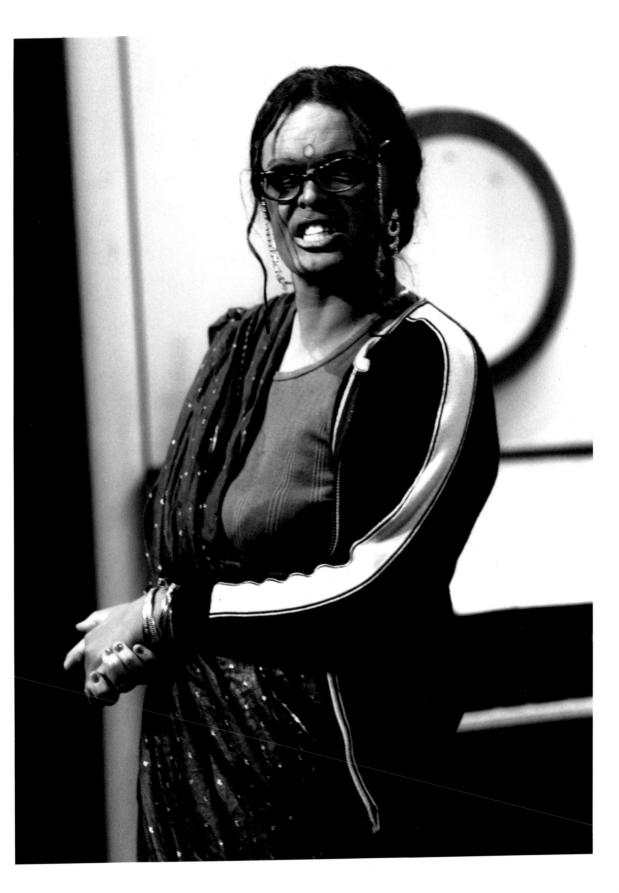

at him by enraged queens at the Two Brewers.[4] Ivan had a scandalous show where he'd come out onto the stage covered in leprous sores, ringing a bell to the sound of Donna Summers's *Love's Unkind* – because she said AIDS was a punishment from God. I thought Ivan was fantastic. It was really inspired of Stewart to get the three of us together to do Copi's disgusting play.

The process was really satisfying. For the first three days of the rehearsal periods we sat and read the play together, and put every single word and line under the microscope. Leigh was fucking clever – I don't know if people realise that about him. It was a joy for us to discuss and argue over our readings of the play. Leigh and I fell in love with each other. I was the epitome of old school Danny La Rue camp, and I'd never come across someone as brilliantly radical as Leigh. We gelled. He worked very hard, and I respected that. Even after a long day we would sit and go over lines together, and laugh and laugh. It was a marriage made in heaven.[5]

I could say what I wanted. The whole experience was new to me. Before that, particularly working with the Citizens Theatre [as Assistant Director, 1990-2000] – with Philip Prowse, Giles Havergal, and Robert David MacDonald – my experience had been of working with powerful but incredibly intimidating people. Philip in particular could be an acerbic queen, and as an actor you could sometimes feel ridiculed for your ideas. I never felt like that working with Leigh, even though he *certainly* had a reputation that preceded him. And Stewart [Laing] was completely liberating, too. He loved that I could be camp, and ridiculous, and tasteless. I learnt to celebrate queerdom. We were radical queers, and I learnt that about myself being involved in that show, and particularly from spending all that time with Leigh. *Time Out* called our production 'a hymn to tastelessness', and we all enjoyed that very much.[6] I can't remember if they meant it kindly or not, but it did sum up our process. We'd ask how tasteless and offensive we could be, and go for it. *It gave me license to go beyond myself.*

The play opens with Irina [played by Ivan Cartwright] and myself on a sofa. I was blacked-up, and I played the Madre as an Asian transsexual on speed. I guess you couldn't get away with that anymore. Leigh applied my body make-up every night, and I wore a sari, tracksuit top and trainers. I had a *Carry On Up the Khyber* cockney accent. Ivan played Irina as a complete slut, who gets banged by soldiers on the steps of the Russian Palace, in a mini skirt that was practically a belt, with platform shoes, and an amazing cleavage. In the opening of the play, I give Irina an abortion, and out comes a skinned rabbit wrapped in cling film, attached to an umbilical cord. People were appalled, and it was very funny. Leigh would walk in wearing 36 fox furs stitched together as a huge coat – he'd see the aborted rabbit-foetus, and barf a load of vegetable soup onto the floor.[7] It was all really distasteful. I loved it. It brought out violent reactions in people. Copi is too much to begin with – his plays are rarely staged in the UK – and Stewart took it to another level of offensiveness.

It was all very liberating, and my permission to 'go there' was initiated by working with Stewart, Leigh, and Ivan. I think a lot of people, nowadays, think I'm too 'pure'. There is that side to me, and to what I choose to do in performance. But, at times, I want to get my hands dirty. I am drawn to the darker, seedier side of things, to impropriety. I still choose to get my hands dirty, not just artistically, but in terms of going places in my imagination, my fucked up relationships, and my research.

DJ: *Sexuality and sexual identity are central to Copi's play, from the title to the text and performed images, and the working relationships you've described. How important is sexuality to your own practice?*

AH: I've been thinking about doing a performative walk, which will look at night-time experiences of sexual contact that I've had. Some of them have been hilarious. It feels important for me, now, to remind everyone – and myself – that I'm a gay man. I don't feel that it's necessary to do so in *Foot Washing for the Sole* [2008-12], or *The Pleasure of Being: Washing/Feeding/Holding* [2010-11], but it still comes up. After *Garden of Adrian* [2009], for example, after we spooned, a straight guy commented that he'd never had an intimate experience with a gay man before, and he was surprised I didn't 'come on' to him.[8] I don't want to get too carried away by saying this, but I think it's important that I'm a gay man – not a straight man, in case you didn't know this about me [*we laugh*] – saying we can have experiences of intimacy, and *tenderisation*. I feel pride that I can own the responsibility for doing that.

1. Howells misremembers the details of the touring of the production. Stewart Laing recalls the correct timeline of the tour: 'we started at Tramway, Glasgow, as part of an *Into the Blue* season curated by Valerie Edmond [a short run from 23 June 1993]. Then we did queerupnorth [in September]. Bagley's Warehouse (rather than Studio) came last – dates 9-25 November 1993'. Stewart Laing, email to Deirdre Heddon and Dominic Johnson, 23 June 2015.

2. The Blitz Kids were a loose group of artists, pop musicians, and club creatures, whose nightlife appearances and social antics centred on the Blitz in Covent Garden, London, from 1979 to 1980 (and other clubs and nights such as Taboo and Kinky Gerlinky, throughout the 1980s and early 1990s). Bowery was a central figure in the group, alongside Boy George, Marilyn, Steve Strange, Princess Julia, Martin Degville, Philip Salon, and others.

3. Dora Bryan was an actress in Ealing comedies of the 1950s, in which she invariably played fruity characters including fallen women.

4. The Two Brewers is a long-running, traditional drag club in Clapham, South London.

5. Leigh Bowery died of an AIDS-related illness on 31 December 1994, just over a year after the play ended its tour.

6. See James Christopher, 'Review: *The Homosexual*, Bagley's Warehouse', *Time Out*, 17 November 1993. The review is preserved in Stewart Laing's personal archive as a clipping without page numbers.

7. The coat was designed and constructed by Lee Benjamin and John Harkins, to be worn over a fur-trimmed leather jacket, with a wimple, blonde wig, and fur hat. See Tilley, *Leigh Bowery*, p. 208.

8. *The Garden of Adrian* was performed in June 2009 at the University of Glasgow. In each half-hour encounter, the artist led participants through a garden (designed by Minty Donald), and engaged in a series of contemplative interactions, including a scenario in which the audience-participant is 'spooned' – hugged from behind – for some time while laying together on a patch of turfed grass.

From Talking to Silence: A Confessional Journey

Deirdre Heddon and Adrian Howells

From 2006 to 2009, Adrian Howells held an Arts and Humanities Research Council Fellowship in the Creative and Performing Arts at the University of Glasgow. For the three years of his Fellowship, Adrian explored risk and intimacy in performance. Dee Heddon was Adrian's academic mentor for the duration. To mark the culmination of the Fellowship they co-authored an article, 'From Talking to Silence: A Confessional Journey'. This article is reproduced below, with only minor revisions. The editors have chosen to retain the present tense of that act of co-authoring because whilst Dee's text could be amended to past tense, with all the significance that revision would signal, Adrian's text cannot be so easily amended. In retaining the present tense, we recognise too that this act of collaboration was undertaken at a particular time, and presents a perspective of and from that time. Time inevitably moves on while writing stands still. There is a certain comfort in the 'stillness', the still-there-ness of writing.

Dee: Introducing Adrian Howells

Our culture is saturated with confessional opportunities, ranging from chat shows to 'reality TV', from Internet blogs to social networking sites such as Facebook. It seems that wherever you turn people are more than willing to engage with an unburdening of their deepest and darkest secrets. This proliferation of confessional technologies has been mirrored by an evolving genre of autobiographical, confessional live performance. In the UK, a considerable body of work based on the sharing of personal material has been created by artists such as Mem Morrison, Bobby Baker, Ursula Martinez, Curious, and Third Angel, to name just a few.[1]

Over the past ten years, performance artist Adrian Howells has made a significant contribution to this confessional performance landscape, creating and touring performances in which he confides in strangers hoping, in turn, that they will share details with him. Adrian structures his performances around dual notions of 'transaction' and 'transformation', with exchange anchored in the dialogic: the oral/aural, the spoken and the heard. Most recently, Adrian's work has tended to be performed for a single spectator at a time. In this form of performance practice – intimate, personal and interactive – the boundary between performer

and spectator dissolves in the process of exchange, an exchange that asks for a very committed and at times vulnerable sort of spectatorship.

How does this performance work sit alongside – or in resistance to – the glut of mass-mediated confessions? For the past three years, in his role as a Creative Fellow at the University of Glasgow (funded by the Arts and Humanities Research Council), Adrian has been exploring further the nature of risk and intimacy in performance, asking what sorts of confessions might take place in a secular culture, and with what effects. My own long-standing interest in performances that use autobiographical material has allowed me to act as an 'academic mentor' to Adrian – a 'critical friend' and an informed interlocutor – for the duration of his fellowship. I have had the privilege of seeing first-hand how he works. I have also had the opportunity to participate in the work itself and to offer feedback from the inside, prompting shifts in the practice as it has developed.

Three years offers a considerable – and unusual – amount of time and space for an artist to pursue a self-defined 'problem': in this instance, the place of confession in live performance. Time and space affords the opportunity (too often considered a costly luxury) to reflect, to question, to challenge, and to revise. Prompted by the personal frame of Adrian's work, in the following pages we offer personal, reflective accounts of the research journey: Adrian's from the perspective of the artist; mine from the perspective of the spectator. What both accounts reveal is the entirely unexpected shift from a form of performance that places talking at its heart, as a prompt for and signal of 'intimacy', to the use of silence as a way to structure other types of intimacy and 'confession'. Adrian's three-year journey saw him not only drop his drag performance-mask of 'Adrienne', but also, more radically perhaps, what we came to recognise as the mask provided by 'talking'. In shared silence, Adrian found a different mode of risk taking, communication and transformation.

Adrian: Introducing 'Adrienne' (The Confessing Animal)

Whilst the ontology of theatre is one of communal experience, my work has been motivated by the sense that in this age of mass-mediation and technological advancement there is a necessity to prioritise opportunities for audiences to have intimate face-to-face, one-to-one encounters in real time with real people. My work prioritises interpersonal connectedness and what I refer to as an authentic experience between two people (though the question of 'authenticity' in the field of performance is always vexed). My presumptions about confessional exchange have been predicated on an entrenched, perhaps cultural belief in the therapeutic benefits of confession, it being akin to a 'talking cure'. Indeed, my own oft-repeated mantra is 'a burdened shared is a burden halved'. Through my performance experience, I intuited that I needed to confess in order to give permission to and put at ease the audience-participant, encouraging them to do the same. So, the exchange was consistently dialogic, predominantly both an oricular (spoken) and auricular (heard) experience, performed within a wider cultural context of the mass-mediation of the personal and private made public.

For the six years prior to embarking on my fellowship, I adopted a performance persona, 'Adrienne'. For *Adrienne's Dirty Laundry Experience* (2003), performed at The Arches in Glasgow as part of the queer festival, Glasgay!, I transformed a bland basement room of a theatre space into a launderette-cum-living room, complete with plumbed-in washing machine, installed tumble dryer and washing lines; all the other paraphernalia that you would usually find in a launderette was added. Audience-participants were invited to bring me their dirty laundry to wash and for the time it took the wash cycle to run its course, I would get them to share their metaphorical dirty laundry over a cup of tea and a biscuit. I liked the fact that people left the space with a tangible, literal bag of clean laundry, but also that they might feel that their 'souls' had been cleansed a little.

Embracing the idea of exchange, an entire wall of the 'laundry' was covered with a whole display of photos of me, friends and family from childhood through teenage years and into adulthood, depicting various looks and styles I had adopted, as well as states of drag. This was a photographic representation of my own dirty laundry of the past forty years. In addition, just as the space had been transformed, so had I – into 'Adrienne'. Adrienne is less a drag queen than another version of me; a man wearing thick make-up and rather unglamorous, woman-next-door clothes. Adrienne is someone you can lean on and trust.

Adrienne: The Great Depression (2004) was performed at the Great Eastern Hotel in London. For a week, I inhabited one of their rooms and lived with(in) several self-devised rules: I could not leave the room at any time for the duration of the week; I could not draw the heavy curtains so that I would never know whether it was day or night; every piece of crockery that was delivered by room service had to stay; and finally, that having put Adrienne's elaborate make-up on at the beginning of the week, I would never remove it, or indeed wash, shower or shave.

During the week I mounted all the usual photographs, but these took on a much more poignant aspect when framed by the knowledge of a recent bout of severe depression. I also wrote a 'stream of consciousness' text, which I cut up and pasted around the room. My time with the audience-participant was committed to talking openly and honestly about the suffering of my depression and confiding very private details of attempted suicide, self-loathing, pain and despair. I hoped that this gesture of openness would encourage my guests to share their moments of darkness too, lightening them in the process.

Lulu Le Vay, of the *Guardian* newspaper, booked in for the last slot of the performance at the very end of my week's stay. I had seen people on the hour, every hour, for the previous 48 hours. Her visceral account captures the decomposition of both the room and me: 'Darkness tumbled from the room, as did a rank, BO riddled musty smell. [...] Adrienne was sprawled across the bed in a dramatic woeful fashion. [...] Her red blouse was stained, makeup swampy, and

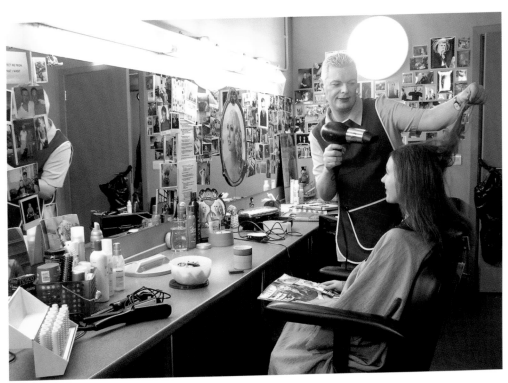

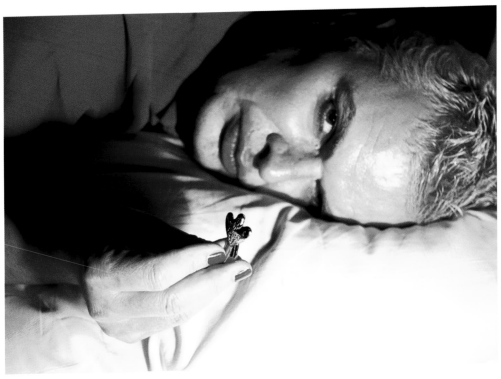

135

every spare inch of floor, dressing table, beside table was drowned in overspilling ashtrays, dirty cups, glasses, discarded newspapers and infinite trays of mould-encrusted plates harbouring half eaten food. [...] The scene of a wallowing depressee unfolded'.[2]

Salon Adrienne (2005-7), meanwhile, presented in a hairdressing salon in Glasgow, was lighter in tone but nevertheless prompted both me and the participants to engage with the inevitability of aging, using the mirrored surfaces of the salon as a space for literal and metaphorical reflection.

As suggested by these examples, my Adrienne performances were located in familiar, frequently domesticated spaces. These matched my equally 'domesticated' persona, both intended to reassure the audience-participant, engendering a sense of safety, familiarity and security.

Dee: Meeting Adrian/Adrienne

I book in for an hour-long appointment at Comerford Hairdressing, Glasgow. This is my first experience of Adrian's work. I have no idea what to expect. When I arrive I am met by a very friendly 'Adrienne', a heavily made-up, peroxide-blonde man dressed in a blue tabard, a pink blouse and denim skirt. Welcome to *Salon Adrienne*. For the next hour, I experience the caring hands of Adrienne, as she tenderly washes my hair; at the same time, I experience her gentle confessional prompting, as she asks me about the last time someone washed my hair for me. I tell her about those childhood baths, when I inherited the dirty water left over from the person before, and my mum used a kitchen jug to rinse off the shampoo. From a distance of some 35 years, I can still recall the persistently soapy smell of that white, deeply scratched, plastic jug. Adrienne tells me she had a jug that smelled just like that too.

Ensconced safely in the seat in front of the mirror, I sip tea and eat biscuits. Adrienne reveals her dislike for her naked, aging body, the trepidation of standing in front of a mirror. 'I'd like you to take a long, hard look in the mirror and tell me what you see there', she instructs me. I see a woman who is not much younger than her mum was when she died of cancer. Though the woman in the mirror looking back at me carries some lines marking her age, she does not look old; not old enough to die anyway. I feel OK about getting older, looking older. I also see Adrienne, standing behind me, protectively, encouragingly. She gently takes my head in her hands and begins to tenderly massage my scalp. We have talked a lot, sharing reflections. For this final moment we share, instead, a companionable silence. I am glad of it and let the weight of my head, filled with thoughts, rest in her hands and simply be held.

Whilst the difference at the heart of every 'repeat' performance is a truism, every performance of *Salon Adrienne* is necessarily different. Whilst there is a skilful dramaturgical structure, which ensures different degrees of intimacy/ revelation and different textures, atmospheres or moods, there is also an element of improvisation since Adrian cannot script the conversation in advance. He remains attentive to the moment, responding to and feeding off what is being said

by his co-creator. The performance of *Salon Adrienne* that I am participating in, then, is made just for me because it is made with and by me, albeit in the capable, experienced hands of Adrian. I am put at ease. I am solicited, courted, consulted, included, engaged, heard, responded to, attended to... This is bespoke theatre, and as I leave the Salon I feel really special. I have learnt about Adrian, but I have also learnt about myself. This is the value of exchange.

Adrian: *Held* (2006)

Beginning my Fellowship in 2006, I was keen to extend my explorations into risk, intimacy and confession by engaging questions of physical intimacy, rather than just conversational intimacy. *Held*, staged in three different spaces of an apartment, tested different degrees of physical intimacy with individual spectators, each gesture reflecting the room that we were situated in. We held hands across the kitchen table, talking about handholding, about what it means culturally and personal memories of handholding. In the living room, we sat side-by-side on a sofa and talked about music and memories for 15 minutes. In the bedroom, I spooned into the audience-participant, on a bed, for half an hour. Given a choice, participants opted for silence rather than talking.

This final action unexpectedly revealed to me the potential for bodily or non-verbal exchange: the way the body lying beside me was maintained (tense or relaxed), shifts in tensions, the rhythms of breathing and depths of breath. During a performance at Fierce Festival in Birmingham in May 2007, a Nigerian, born-again Christian woman offered up her spoken confession to me in the first two stages – revealing that she had never been properly touched or held by anyone. Her disciplined and formal Christian background meant that she had to kneel to speak to her parents if they were already themselves seated. In the final stage of *Held*, 'spooning' into her on a bed in silence, I felt every sinew and muscle of her body relax and let go over the course of that half hour. In the context of what had taken place in the previous two stages this felt very much like a bodily confession and, for me, a different way of listening.

Dee: Being Held

It is Adrian's first research performance, *Held*. I enter a flat in the West End of Glasgow and am met by Adrian at the door. There is no 'Adrienne', just Adrian, but I am surprised how little that seems to matter. He sounds and acts just the same. Adrian welcomes me and ushers me into the kitchen where he makes us a pot of tea and offers me a plate of cakes as we sit at the kitchen table. Taking hold of my hands in his, I tell him I have always held the hands of my lovers, though when I first became a lesbian it signalled a proud, public announcement of sexuality as much as an act of intimacy between two people. I also, though, admit to a painful self-consciousness about my hands, which are always hot and sweaty. I recall that as a six-year-old schoolgirl, I was persistently in trouble because my pencil marks would smudge on the page, due to the sweat. The solution was a pair of surgical gloves provided by my mum (a nurse). This was an act of love on her part. Adrian holds my hands reassuringly, tightly, warmly.

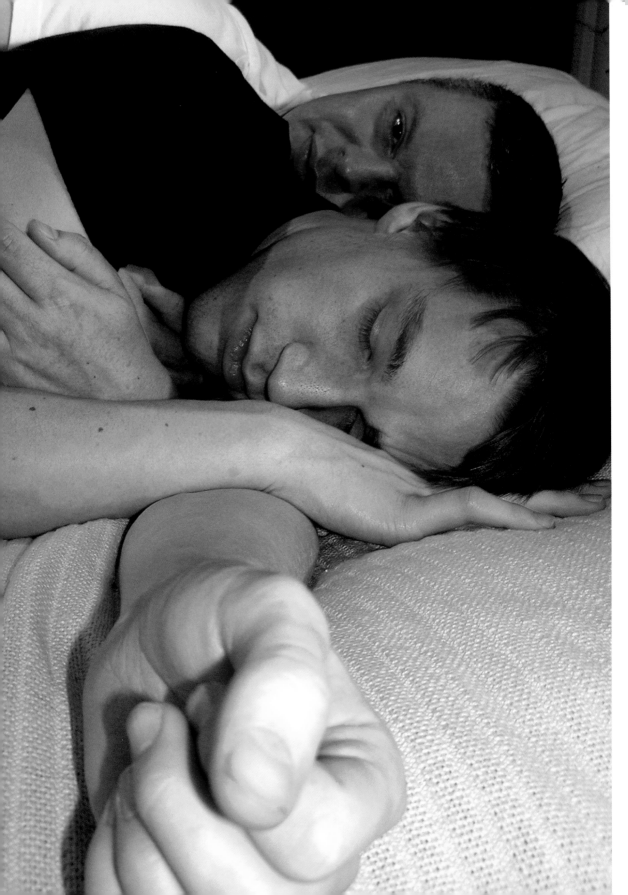

In the living room, sitting side by side on a couch, with Adrian's arm draped around me, I am invited to select a track from an eclectic range of CDs (ranging from Joni Mitchell to Abba) and to talk about why I have chosen it. I choose an Eagles song, *Hotel California*, because it reminds me of Moira, a girl I knew when I was a teenager. She loved this song. I lost touch with Moira when I was 15 and doubt I've heard this song since then.

In the final stage, the bedroom, Adrian explains that we are going to spoon into each other. I can have a pillow placed between us if I wish, and we can talk or simply be silent. I choose not to have a pillow and not to talk. We simply lie together for 30 minutes. I am extremely conscious of the weight of Adrian's arm embracing me, and the size of his body next to mine, which feels so different to that of my partner. I never realised till this moment how much my body had absorbed and remembered her particular shape, and the shape we make together. I lie very still next to Adrian, the silence allowing my mind to wander: What sort of intimacy is this? Can one be intimate with a stranger?

My reflections resonate with others':

> The experience itself was fairly challenging but not uncomfortable. I felt that Adrian and I went through a sort of accelerated friendship and we ended up sharing the sort of moments that I haven't even shared with many of my closest friends and family. [Participant, *Held*, Cork][3]

> It was moments of nostalgia, all those times that I've been held in different ways and for different reasons. It was personal confessions from Adrian that [made] me sympathise with him, whilst being comforted by him. It was an exchange of stories, and exchange of intimacy. It has left me reminiscing of times when I've been held. And when I'm in similar positions of intimacy with others I'm transported back to the performance. It made me appreciate being held. [Participant, *Held*, Birmingham]

Adrian: *Foot Washing for the Sole* (2008)

Thematically and conceptually this attention to body language was significantly developed in my next research-led performance, *Foot Washing for the Sole*. I sought to explore further the opportunity for an audience-participant to experience an internalised, silent response to a physical and sensorial stimulation. Could there be a dialogic exchange between two bodies in close proximity that was not dependent on the oral/aural? Is 'body language' confessional? The phrase 'listening to our bodies' is commonplace but what is it to listen to the body of another?

Having attended a foot washing service at St Columba's Church in Glasgow, in connection with another project, I was struck by the intimacy of this act – an intimacy often structured between strangers and framed as an act of 'giving'. Reading the account of Jesus washing the feet of the disciples at the Last Supper

Opposite: Adrian Howells in a studio shoot for publicity images towards *Held*, which were first used in the version performed at Fierce Festival, Birmingham, 2007. Photo by Niall Walker.

in St John's Gospel I was struck by the words he uttered as he performed this task: 'What I do for you now, go and do for one another'. Foot washing was framed as a generative act.

For *Foot Washing for the Sole* I knelt on the floor at the feet of a single audience member, and performed the simple tasks of washing the feet, drying the feet, anointing the feet in frankincense and sweet almond oil, massaging the feet and finally kissing the feet (if permission was granted). My intention was that during the foot washing and drying I would facilitate a minimal, spoken exchange; during the massage, however, there would be an opportunity for silence and a bodily 'conversation' between my hands and their feet. This silent time was also intended to provide opportunity for internal contemplation, self-reflection and even revelation and transformation. I sought to shift the focus and attention away from the experience being about me and my inclination – or habit – to perform as one of Michel Foucault's 'confessing animals'.[4] I asked seven questions during the foot washing stage that ensured the focus remained on the participant and would simultaneously allow for a body-memory connection and either a verbalised or an internalised confession. These seven questions were:

1. What is your relationship with your feet?
2. Do you ever give your feet a treat like having a pedicure or a foot massage?
3. How is it for you to have me kneel here washing your feet for you?
4. Has anyone else ever washed your feet for you?
5. Could you wash somebody else's feet for them?
6. Would you be prepared to wash a total stranger's feet?
7. Not in a literal, physical sense, but do you think your feet are capable of picking things up and leaving things behind?

Dee: Points of Connection

I am in a warm room, bathed in red. I sit in a large chair, with Adrian at my feet. I close my eyes, and together we inhale seven times. Adrian then takes the weight of my feet in his hands and begins washing away their tiredness. I don't remember anyone ever washing my feet for me, other than when I had a foot massage in Thailand. 'Could you wash somebody else's feet for them? Would you be prepared to wash a total stranger's feet?' Given the intimacy involved in washing another's feet, what I am actually being invited to 'pass on' is the performance of intimacy, of holding another, of taking care of another, of attending to another.

But perhaps Adrian also washes away the gap between us. Like the points of connection he seeks to activate between my feet and my body, his actions serve to connect us. Conducting this part of the performance in silence, my eyes closed, I am keenly attuned to my other senses: to the smell of the oils; to the warmth in the room; to the touch of fingers between my toes; to my smooth, wet skin, in contact with another's skin. My primary sense is haptic, touching, an acute awareness of myself in combination with another. Laura Marks writes,

In a haptic relationship our self rushes up to the surface to interact with another surface. When this happens there is a concomitant loss of depth – we become amoeba-like, lacking a centre, changing as the surface to which we cling changes. We cannot help but be changed in the process of interacting.[5]

Where does his body end and mine begin? I give myself up to this touching and being touched. I wonder if Marks's loss of depth can be equated with an extension of self?

Whilst the connection is between these two bodies, his and mine, here and now, the wider political agenda is made explicit in the final action. Taking my right foot first, Adrian kisses it gently, saying '*Shalom*' (Peace), following this with a kiss to my left foot, and the phrase '*Salaam Alaikum*' (Peace be with you).[6]

> A generous act connecting two human beings profoundly in one space at one time. [...] I will take this in every step, knowing that everybody and every country are joined in some way.
> [Participant, *Foot Washing for the Sole*, Glasgow]

Adrian: *The Garden of Adrian* (2009)

My final research project, *The Garden of Adrian*, again taking a cue from religious frames, placed the bodily, performer/participant exchange and the potential for individual contemplation and internal dialogue/revelation within a garden environment. This garden was built inside a theatre (Gilmorehill, University of Glasgow) that had, appropriately, originally been a church. The constructed garden contained real plants, trees, growing grass and other materials, which I hoped would conjure calm, stillness and silence. Developing out of *Foot Washing*, in this performance I privileged the idea of experiential knowledge and sensorial experience over the cerebral or intellectual.[7] I was also determined that this final project should further explore ways of prompting particular kinds of silence (silences that are reflective, perceptive, focused, wandering), recognising too that silence is not just an absence of sound, but might be a space carved out from the contemporary culture of particularly cacophonous noise (a noise to which that mass-media confession contributes).

In reflecting on my practice over the three years, I realised that I had used 'talking' as a mask, something to hide behind. Removing my incessant speaking in the previous pieces had, in fact, felt more risky. It has also concentrated my attention on the spectator-participant. In *The Garden of Adrian* exchange became a more solitary and internalised monologue – an exchange with/for the self. I remained, though, a catalyst for the participant's silent journey. The devising of structures for bodily exchanges prompted body-memories (for example, I washed the hands and forearms of audience-participants in a bird bath; I rested my head on their

Overleaf: Adrian Howells, *The Garden of Adrian*, performed at Gilmorehill, University of Glasgow, 2009. Photo by Hamish Barton. Howells washes an audience-participant's hands and forearms in one of seven 'stations'.

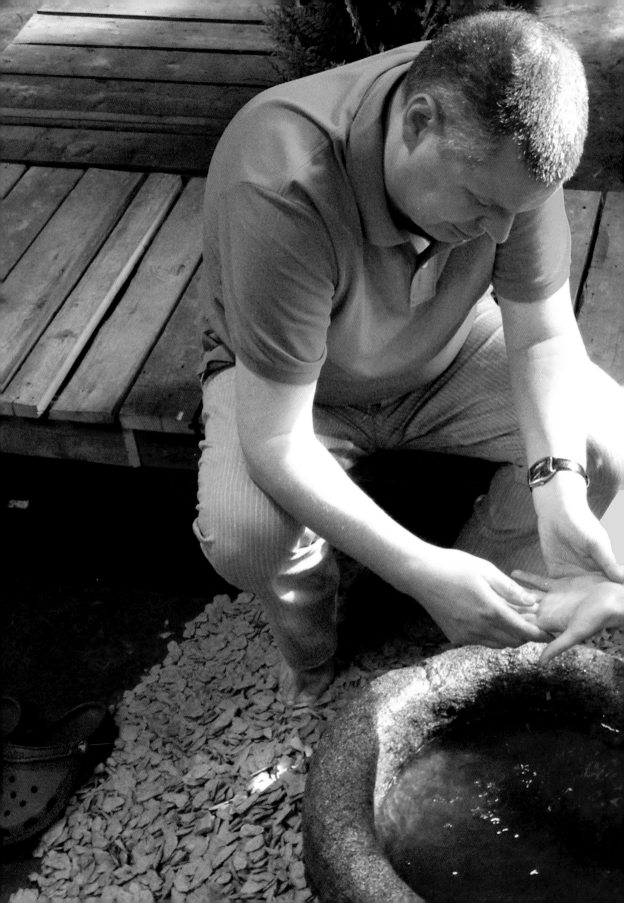

lap as they sat on a rock; I fed them strawberries, from my fingers to their mouth). Such acts often triggered strong autobiographical associations. Feedback also highlighted that it was the environment itself that served to transport participants to another world, another time and place. This 'internal journeying', mirroring the journey through the physical garden environment, was facilitated by a sense of time slowing down, an escape from the hustle and bustle of daily life that took place just outside. The garden provided an oasis where there was plenty of time, space and stillness in and around each interactive 'station' of the garden to allow for contemplation.

Dee: Garden of Delights

I sit in a deck chair, inside a well-worn garden shed and remove my socks and shoes, as instructed by a notice, putting on a pair of flip-flops left there just for me. There is a flask of tea and some shortbread in a Tupperware box, which I am invited to help myself to. The light seeping through the wooden slats of the shed attracts me like a moth. I try and peer through the tiny gaps but can see nothing. A sign on the door in front of me teasingly asks 'What are you looking for?' I can't see what's outside, but I can hear the sounds of bird song. Hearing Adrian gently calling me my name, I open the door of the shed and look down onto a beautiful garden, the garden of Adrian.

Looking up at me with a generous smile, Adrian invites me to join him and takes my hand. Over the next forty or so minutes, he leads me to five different places in his indoor garden. We take off our flip-flops and stand, bare footed, in the cool, smooth soil. I realise, with some regret, that it is many years since the soles of my feet felt this particular texture. We spend many minutes looking, in detail, at a freesia planted in the soil. I gingerly pluck strawberries from Adrian's fingers, letting the juice dribble down my chin, marvelling at the depth of the flavours. I sit on a large rock, feet resting on cold smooth stones, cradling Adrian's head that rests in my lap. Adrian gently washes my hands and arms with cool, sparkling water. I stand barefoot on buoyant grass, its blades peeking up between my toes, remembering summers in my gran's garden. Adrian and I will lie together on a check blanket laid out on the grass square. I drift off, a million miles away.

For the duration of my time in Adrian's garden, I speak less than 20 words, and he only speaks to tell me what is going to happen next and check I am OK with that. In *The Garden of Adrian*, the final performance of Adrian's three-year research fellowship, the 'babble' of confession has been exchanged for silent contemplation. My physical and literal journey through the internal garden is matched by an internal reflection that carries me on a journey through childhood reminiscences, remembering tastes, smells, sounds, and textures. We tarry long enough in this space for me to encounter other versions of my self on this journey, slowing down, allowing details to rush in, and then staying with them so that the information they carry is revealed to me, is re-inhabited, re-lived, re-encountered, re-membered, re-stored, re-storied, and then carefully re-turned.

Adrian has said almost nothing. I have said almost nothing – or at least not aloud. But I have had a full dialogue with my selves, prompted by Adrian's careful actions and instructions: look, taste, hold, touch, feel, smell, be...

My final action, before I leave Adrian's garden, is to take a little seedling with me, leaving in its place a plastic label carrying my name. When I get home, I transplant my seedling to the window box outside my kitchen. For the rest of the summer, I watch as it grows and strengthens and finally blooms into a riot of deep purple. And I remember Adrian's garden and my journey through it, the things I saw, felt, tasted, touched, smelt, heard and thought.

Adrian: Towards Silence

Three years ago, my performances were filled with talking, mostly my own. My motivation for making confessional work was the sense that within mass-media culture, what people sought was a genuine connection. I still believe this, but my sense of where that connection might be found has shifted. At the end of this first post-millennial decade, swamped by the mass-mediatisation of confession and the proliferation of such manifestations of it as occurs in 'reality TV' shows, it occurs to me that what people perhaps really crave are opportunities to escape from this version of synthetic 'real life'. Rather than contributing to the deafening 'white noise', an alternative performance strategy might be to carve out other spaces, modes of connection other than the spoken exchange, other forms of the dialogic. In a noisy culture like mine, silence rings out loudly, offering another place to 'be' or to become: to reflect, to imagine, to project, to re-connect – with self and others and other selves – through the unique relationship of a quiet, considered, one-to-one encounter. I feel that this is a place I might stay, at least for a while, even though it is not where I anticipated arriving.

> Blessed, soothed, approved, loved, without a word.
> (Participant, *Garden of Adrian*)

1. See Deirdre Heddon, *Autobiography and Performance* (Basingstoke: London, 2008).

2. In the original version of this essay, no citation was given. The editors have been unable to trace the source of the quote.

3. Howells was invited to show his performances at a number of festivals. At each event, he either collected feedback in a post-show book, or via questionnaires emailed to participants. Many of these documents are now stored in the Adrian Howells Collection, Scottish Theatre Archive, University of Glasgow.

4. Michel Foucault, *The History of Sexuality, Volume 1: An Introduction*, trans. by Robert Hurley (1978 rpt. New York: Vintage Books 1990), p. 56.

5. Laura U. Marks, *Touch: Sensuous Theory and Multisensory Media* (Minneapolis: Minnesota University Press, 2002), p. xvi.

6. Howells subsequently performed this piece in Tel Aviv and Nazareth, to both Israeli Arabs and Israeli Jews.

7. There was an intention for the interactive garden to emulate a Five Senses Meditation, which I had encountered on a yoga and meditation retreat on the Holy Isle, off the west coast of Scotland, conducted by an elderly Tibetan Buddhist monk in the Mandala Gardens.

My Audiences with Adrian: Performance, Photography and Writing the Intimate Encounter

Jon Cairns

In one of the story-telling segments mid-way through Adrian Howells' *An Audience with Adrienne* (2006-10), entitled 'Course you Can Malcolm!', Howells clutched a framed photograph of 'Malcolm', to reminisce about the crush he once had on the grammar school 'hunk' who had been two years above him. Howells told his audience how he schemed to become friends with Malcolm by acting on his knowledge of Malcolm's attraction to a girl at the school – one Debbie Rush, we discover – and how he played the role of matchmaker between them. The strategy was a success and the tale unfolded further as Howells recounted his developing friendship with the older boy, which included sleepovers and intimate conversations in Malcolm's bedroom, during which Adrian would invent pornographically detailed stories of encounters between Malcolm and Debbie. But even as, in accord with adolescent male ritual, their attentions turned to sex, Howells recalled how he dared not reveal his own erotic secret – the desire for Malcolm that had motivated his actions.

At 'Station 9' of his one-to-one performance piece *The 14 Stations of the Life and History of Adrian Howells* (2007-8), the autobiographical protagonist – the artist – instructed me to read a two-page letter mounted on the wall. From 'Jim', it offered an excoriating indictment of Howells' treatment of his former friend, documenting the latter's unrequited love for, and callous betrayal by, Howells, who stood by as I read. A 'happy' snap of Adrian and Jim posing in front of a Christmas tree, arms around each other's shoulders, hands clasped together, sat starkly, almost accusingly, *outside* the dark frames that pulled the letter into the field of my attention.[1]

Both works under discussion here were typical of Howells' practice from about 2002, when he branched from a conventional theatrical career to begin his own work as a solo performer, instituting his feminine persona with *Adrienne's*

Upper: Photograph of 'Malcolm' used in the 'Course you Can Malcolm!' segment in various performances of Adrian Howells, *An Audience with Adrienne* (2006-10). Photo likely by Adrian Howells. *Lower:* Photograph of 'Jim' used in Station 9 ('He Falls from his Pedestal') of *The 14 Stations in the Life and History of Adrian Howells* (2007-8). Photographer unknown.

Living Room. The Adrienne character was instrumental throughout this period, but by 2007 he had also begun performing as 'himself' in *The 14 Stations* and in *Held* (2006). This latter performance signalled a new development in Howells' practice, towards an emphasis on care of the audience-participant and away from his own confessional input.[2]

An Audience and *The 14 Stations* engaged the audience as participant, confessor and accomplice in Howells' presentation of autobiographical episodes. Crucially, the life narrated was not simply consumed as spectacle, but produced through mutual interaction and exchange as the audience was encouraged to speak back, interpret, judge, empathise. The risks entailed in inviting such intimate dialogue were an explicit part of Howells' project. Indeed, the effect on me as an audience member and participant in these works was to trigger a plurality of responses, partly to do with not knowing quite how to react, amidst doubts about the veracity of what I felt.

I will explore some of the performative, narrative and affective functions of intimacy in the scene of Howells' confessional work, paying attention to the felt ambivalences in the encounter, as well as to the critical difficulty this presents in re-visiting the scene of such a complex encounter at a later date. I want here to ponder the effects – and affects – of Howells' reliance on the details of his intimate relations, the intimate 'personal' archive he drew upon and allowed us, his public audience, such apparently privileged access to. His public staging of intimate interaction worked to problematise our understanding of it and what it is that we *feel* as a result. When it comes to considering affect in a work of art, particularly a performance, it is not always easy, desirable, or within one's control to be precise or definitive, either about what was felt, or how this is put into discourse. What happens, for example, when a performer cries, or reveals a dirty secret, or takes your hand – as Howells did variously in his works? These actions might provoke conflicting emotions and thoughts, which, while theorisable, also exceed theoretical containment. In turn I am interested in how I might *write* the complex contingencies of such interactions.

In both *An Audience* and *The 14 Stations,* personal photographs and effects had an integral role in Howells' enactment of self as this was constructed across the space and duration of his interactions with the audience. The works depended on a series of identifications between represented self-image and live performance to build an embodied autobiographical subject across a number of forms – oral, visual, and theatrical. The persona that Howells presented, already notionally doubled with Adrienne, acknowledged the multiplicity of a 'self' fictively constructed where verbal narrative and bodily affect met.

In both pieces, photographic portrait snaps were 'performed', animated as part of the performance as a whole, rather than as visual adjunct, supplement or illustration. The picture of Malcolm, for example, was pulled off the wall of the performance space and shown to the audience as Howells brought the

boy into this episode of his life-story. The photographs – not only of Howells himself, but also his parents, his friends and lovers, who all featured heavily in his autobiographical tales – were made to *do* the work of identity construction in building a self-portrait that foregrounded his complex relationships with others. These pictures of intimate others were mobilised to structure a representation of Howells in our encounter with him. They were not simply vehicles for Howells' narrative, nor stand-ins for the absent characters, but came to be significant focal points for interactions between Howells and his audience, in a way that exceeded their conventional appearance as either stage props or representational ciphers. The 'naive' sincerity of the album snapshot and the confessional candour of Howells' stories were both instrumental in the establishment of intimate exchange between audience members and performer in the works, whether this was in a group situation, as in *An Audience*, or with an audience of one, in the case of *The 14 Stations*. As Linda Haverty Rugg has shown, we persist in a desire to believe in autobiographical and photographic truth, in spite of our 'sophisticated' knowledge of their historical and cultural construction.[3] In this respect, critical ambivalence becomes moot in addressing the skilfully structured paradox of Howells' staged authenticity. The photographs were integral to his attempt to secure some of the generically recognisable conditions for intimate exchange. Alongside the semi-scripted confidences, these 'revealing' photographs seemed to offer immediate recognition of something given to be true, but I knew they were also distant from the dramas claimed for them. Indeed, Howells' adeptness at the deployment of intimacy tactics piqued my critical curiosity immediately.

For Lauren Berlant – in her book *The Female Complaint* – intimacy is a *genre*, a set of cultural conventions, which arguably belong to the realm of those practices and fantasies of social belonging that can be tracked across various commodified cultural forms, including, she writes, 'Oprah-esque chat-shows and chick-lit', and to which we might add the varieties of domestic photography that most of us cleave to.[4] Indeed, in Howells' many popular culture references, including the sentimental pop ballads he sang in the two works I examine here, our already-established relationships to intimate public culture were brought to the scene of performance – as fans, guilty viewers, as producers *and* consumers. This cultural imaginary was never detached from its relations to reality in Howells' practice, which acknowledged that the 'reality' of intimacy is, significantly, a fantasised relation, mediated through cultural forms, rather than an unproblematic emanation of physical proximity and direct bodily affect. In this respect, Berlant's model of intimacy is a useful touchstone for examining what Howells did. This model expresses both a desire for a better life – fuller, more connected and meaningful – after the styles of the mainstream sentimental cultures she explores, and yet acknowledges that the resolutions of closeness and love are contingent, provisional, changeable, and difficult. While Howells may have decried the lack of intimate social contact and personal connection in contemporary life, as well as his own, he knew very well how hard-won and difficult to sustain these

dynamics were, and that they required constant attention and work, as his various tales of love and rejection attested.[5]

In exploring these issues the role of ambivalence has come to the fore – psychologically, socially, and, importantly, hermeneutically. Ambivalence about the commodified conventions of intimate belonging and the values it promotes – which are heavily drawn on by Howells – produces a range of emotional as well as intellectual responses, especially concerning place and behaviour in the performance scenario, as well as upon later reflection. In respect of Howells' work, I am concerned not only to record such responses as they occurred in the event, but also to attempt to invest the writing of my own ambivalence with their affective range. In so doing, I am wary of turning the productive and mobile tensions of the performances into a definitive account and paradoxically fixing the claims of such ambivalence. Ambivalence allows for uncertainty: it avoids or defers fixity and position(-taking). But, if we take a cue from Eve Kosofsky Sedgwick, we must attend to the shifting manoeuvres of any theoretical claim. In a well-known essay on the subject, she examines 'strong' theory on the one hand, which she characterises as critically paranoid and teleological, widely applicable and general, in contrast to 'weak' theory, on the other, which is reparative and attentive to localised affects. She emphasises the benefits of examining the push and pull of weak and strong theoretical tacks as the interaction of different motives within 'the ecology of knowing'.[6] My approach permits me to play with ambivalence as a structuring theoretical term, but, following Jane Gallop, I give it over to the anecdotal moment of my involvement with Howells to offset a potentially unifying trope, with an emphasis on the contingent value of my specific and localised responses.[7]

Family Intimacies?

An Audience with Adrienne was characterised by its small scale and intimate setting, in both the 2007 and 2010 versions I attended. The audience never comprised more than 25 people, seated in a set designed to resemble a stereotypically dated version of a British living room, with intimations of the middle-class parental home Howells grew up in. This was arrayed with an assortment of kitsch paraphernalia, vintage teen posters, gay scene ephemera and record album sleeves from the 1970s and early 1980s – which brought his bedroom into the set – as well as a collection of photographs of family and friends.

This became the scenario in which Howells, as Adrienne, his homely feminine persona for the piece, welcomed his audience, dressed in his trademark housewife's (or housecleaner's) tabard, slacks and tacky jewellery. By offering sweets or ice lollies, striking up warm banter, and getting to know everyone's names (which he rather impressively remembered for the rest of the performance), Howells settled us in for an evening of participation, and confessional tale-telling focused on his life. This included team-building party-style games, for which the audience was divided into groups, such as a

sand-castle building competition, or making a paper collage of a grotesque character cut out from gossip magazines, the results of which were humorously judged – as happened in the *Summertime Special* (2007) and the *Seaside Summertime Special* (2010), two versions of *An Audience with Adrienne*, in London and Brighton respectively. But the central element of the piece revolved around items on laminated menus, à la British seaside café, such as 'See Thru Fru-Fru', 'Barry Stacey's Kitchen Table' and 'Austrian National Costume', from which the audience was invited to choose. These items, including the one featuring Malcolm, prompted an autobiographical anecdote from Adrienne, drawn from Howells' childhood, teenage years and early adulthood, each one simultaneously funny and touching. These were invariably, and usually *comically*, scenes of queer longing, teenage awkwardness and emotional pain, but also of triumph over adversity.

Indeed, there were several emotional registers within *An Audience*, in the context of confessional sharing and its quasi-therapeutic ambience. However, the shifts in mood were unified by an ethos of exposure and self-disclosure. This might be hysterically funny, as in the 'Black Hole of Catalonia' story, chosen from the menu, in which Howells campily described taking the skin off his fingers to frantically squeeze through a tiny hole in a wall – without the aid of a lubricant – to escape a situation in which he found himself caught *in flagrante* with a Spanish clergyman by the latter's ancient parents. Or, it might be seriously poignant, as when he recounted how his brother Julian had stood up for him against homophobic bullying at school, a story that led to audience tales about similar victimisation.

At another point Howells gave a nostalgic rendition of one of the sad 1970s pop ballads he admitted to incessantly playing, extracting and re-living a morose and lonely pleasure. But he also buoyed it up with 'The Slosh', a dance learnt at a holiday camp in his childhood. This dance, performed while Howells related a tale of entering a talent competition at a Pontins holiday resort, itself conjured up family album images. Indeed, we later saw pictures in the autobiographical slide show that ended the piece, and which could very well have been taken at the resort, alongside other snapshots marking holidays and special occasions. Our viewing of this selection of 'private' images hovered between illicit voyeurism and familial privilege. We saw a gallery of images of Howells in various guises throughout his life: as a child at the seaside, as a garish party teenager, as a cringingly coiffed gay son, and as a seriously casual university student. The album shots showed many Adrians, *some* aspects of which may have been recognisable to the audience as compatible with the confessional self-portrait that Howells built up over the preceding course of the performance, but not all.[8] The banal familiarity of the images made them recognisable and allowed the audience to not only reflect on real points of

Overleaf: Adrian Howells, *An Audience with Adrienne: Her Summertime Special,* performed at Drill Hall, London, 2007. Photo by Robert Day.

identification and similarity, where their lives and stories touched his, but also on the fact that no amount of revelatory confidences and personal images was going to present the 'full' picture.

In the meantime, Howells adeptly exploited this basic duality – that photography is both self-sufficient and transparent on the one hand, and, on the other, in need of narrative embellishment to return to it the meaning it cannot speak on its own.[9] Patricia Holland, writing on the family album, encourages critical caution and argues for the need to hold on to its 'dangerous ambiguities' in order to avoid supporting exclusionary and homogenising structures of understanding its images.[10] 'Malcolm' did not 'tell' us the tale that we heard – as recounted in the opening of this chapter – but arguably Howells' intimate recollection brought to bear what might easily be forgotten in the normalising impulse of the narratives extending from the boy's pose to camera. We might ask, with Holland, '[f]or whom is this image so carefully, so spontaneously manufactured?', as she flags the self-regulatory function of the album snap. While personal and private, the photograph is staged for the imagined 'critical scrutiny' of 'outsiders' constituting a normative public.[11] Howells' response to the question of 'for whom', in the case of Malcolm, produced a resolutely queer reading, giving his album picture to an audience, moving from the 'private' realm to the 'public' domain of performance in such a way that collapsed those regulatory distinctions. Howells' queer fabulations and autobiographical narratives, spun out from selected images, were not about fabrication, but constituted a fictive development of the image that insists on *the act of telling* as a significant locus of the truth of the photograph.[12]

The use of the photo as narrative prop was central to the video interludes that punctuated the performance, which we watched on a TV screen, temporarily transmuted into a family gathered round the box. The programmes consisted of interviews Howells conducted with his ageing parents, other family members and friends about his burgeoning gay sexuality, its effects on his childhood and how those close to him dealt with it. These were largely staged around family snaps, clearly edited into the sequences, and which we pored over with the family as they reminisced on screen. These TV interludes again encouraged audience contributions, as participants were eased into a kind of familial scenario in which the personal photograph became instrumental in the presentation of an intimate live portrait. Small, static black-and-white images were (re-)articulated and extended into theatrical dialogue and confessional exchange, as in the video section, 'Fatally Attracted to Colourful and Glittery Things', which featured pictures of Howells as a toddler, including one in which he is fascinated by his own reflection in a mirror compact. In the same film, cross-dressing emerged as a theme, as Howells revealed that in response to a school project, which asked the children in his class to draw a picture of what they wanted to be when they grew up, he came up with a picture of Danny La Rue, a well-known female impersonator in Britain in the 1960s and 1970s. In the 2010 performance of *An Audience with Adrienne*, these nostalgic segues

across familiar genres of photography and storytelling, elicited some serious and moving responses from audience members in one of the show's turns towards more melancholic reflection.

Intimate Strangers

An Audience certainly put its audience into a scene of intimacy in a number of ways, not least through shared imagery, but this was an *ambivalent* intimacy. My doubled feeling about my own intimate engagement with Howells in part stems from the audience address being both personal and impersonal – the classic mode of interpellation. As an audience member, I recognised myself as object of address, saw myself in many of the images, yet also understood the performance to be addressed to others: those assembled in the space with me, as well as those indefinite others who might attend a repeat performance or view a recording; or, in more dispersed fashion, the wider publics that might be addressed as the work entered into discursive circulation. Its function as an open public spectacle, a 'performance piece', intervened in and pervaded the cosier 'closed' therapeutic group, or family circle reminiscing through the photo album.[13]

While we were encouraged to get familiar, ambivalence crept into the scene, in part because the performance produced intimacy as a 'relation among strangers', one of the normative conditions of a modern public as Michael Warner describes it in *Publics and Counterpublics*.[14] Howells demonstrated an ardent desire to get to know his 'public', encouraging interaction and sharing between the audience in an attempt, at least temporarily, to transform them into a coterie, a family, a set of intimates, or confidantes. In this sense he might be seen to have shored up conventions of intimacy as a psychologically, and physically 'private' and 'close' experience. He used a repertoire of forms and devices to do this: direct address, for example, particularly by remembering individuals' names; the sharing of personal images and effects; conversational performance; and physical proximity of audience members to each other, as well as to the performer. These were undoubtedly theatrical conceits, part of the seduction into the confessional scene, aided by the domestic ease of intimacy as cosy living room chat.[15] In some ways, the affective community provisionally forged in Howells' work tapped into an awareness that our culture more widely is not thinkable without stranger interaction, as Warner reminds us. The putative privacy of our intimacies is psychically staged in relation to an internalised public of unknown others. But in spite of our understanding that there is a 'dependence on the co-presence of strangers in our innermost activity', as Warner puts it, we may feel strangerhood and intimacy to be incompatible in certain situations, even within the relatively permissive public context of performance art and live art.[16]

At the June-July 2007 *Summertime Special* run of *An Audience*, I certainly felt ambivalent about the risks of opening up to people I didn't know, when I made one of my own disclosures, and was drawn into Howells' intimate scene.

Above: Photographs from the author's holiday with friends in Nice, France in 1990.
Photos by Jon Cairns.

Intimate interactions are usually regulated, but which regulations apply in such a hybrid form, where performance art or live art meets therapy workshop? The parameters of intimacy were stretched riskily between theatrical entertainment, on the one hand, and private therapeutic reflection, on the other, so knowing whether, and how, to divulge something of myself became enmeshed in questions of propriety, despite – or perhaps because of – the licence encapsulated in Adrienne's catchphrase: 'It's all allowed!' The flyer (had I seen it) for the performance would have prompted me to select 'a childhood/teenage holiday snapshot' that I was 'happy to share with others'. Unaware of such a request for the evening, having had the tickets booked on my behalf, I nevertheless managed to contrive, quite coincidentally, to take something that fulfilled the requirement. Earlier that day I had received, in my pigeonhole at work, a package containing a set of discoloured photographic prints. There was no note, no indication of who had sent them, no negatives. I assumed that the film had only been recently rediscovered and developed, hence the degraded state of the images, by one of the people in the photos, with whom I had long lost touch. They were souvenirs of a holiday I had taken in Nice with friends in 1990.

My theory is that it was the rather fit and attractive dark-haired young man in the images who had sent them – to me, rather than to his now ex-girlfriend, who is also pictured. Was this simply because it had been easier to track my place of work, to ensure their receipt? Or had he remembered me ogling his body on the trip – secretly, I'd imagined – at a time when I was still sorting my own sexuality out, and thought I might have been a more appreciative audience?

When I recounted the story during the performance, Howells was amazed by the coincidence of my receiving the prints that day. The photographs were passed around, and I entered the performance in a way I hadn't anticipated, in part because no one else had brought any images, which meant I was centre-stage for a while. But here, now, I'm ambivalent about the use value of extending the interaction, however notionally, to a reader. Is this because I've made my own libidinal admission about my former friend, one that, beyond the confines of theatrical disclosure, he now might happen to read? Or that I still can't show his ex, who is a close friend, the naked pictures he sent me? Or is it something less circumspect, more self-reflexive as I entertain misgivings about a moment of self-indulgence, complete with pictures of me that I show you here, as I might display them, unsolicited, on Facebook? Is this the awful slippage from performative writing to confessional self-indulgence? How far can I write myself into the scene without risking critical credibility? Of course, others have run such a risk before me. Marianne Hirsch engages the ethical problem of 'exposure' when showing her family images, seeking to retain a sense of her autobiographical investment in them, even while exposing them – and herself – to the 'public scrutiny of academic writing'.[17] Jane Gallop explores the complex of vanity and shame in staking a claim for the value of subjective experience as knowledge. She plays out the narcissistic implications and troubling specificity of writing from the position of the photographed

subject, 'the position from which it [may be] most difficult to claim valid general insights'.[18] Gallop knowingly marshals Roland Barthes for critical support for her 'bragging' and 'unsightly narcissism' concerning pictures of her with her son, while accusing him of similar vanity when he rejects photographs of himself he doesn't like on the basis that his image is not coincident with his 'profound' self.[19] And here, I proffer a critical provenance that mires me more deeply in a writerly conundrum. I seek the legitimising effect of citation but in this case it does not allow me out of the problem, especially given that Gallop's self-reflexivity in particular refuses to simply rise above the troublesome aspects of subjective voice. So, retroactively 'allowed' by Adrienne, and taking my cue from Gallop and Hirsch, I enjoy the ambivalent risk and cringe of solipsism, and like them, flirt with paranoid self-reflection, if only to avoid a binaristic dismissal of confession as antithetical to critique.

Mixed Feelings

In *The 14 Stations of the Life and History of Adrian Howells,* at the Battersea Arts Centre in 2008, Howells again staged an intimate self-portrait, this time as a one-to-one experience, although the roughly chronological organisation of the narrative was more conventionally theatricalised than *An Audience.* There were frequent points of audience interaction, but on the whole the piece did not afford the same degree of reciprocity as the earlier work, with participation more carefully scripted into the encounter, as opposed to the relatively spontaneous discursive forays of *An Audience.*

The 14 Stations also presented a more self-abased version of the artist by gradually exposing what Howells considered his 'dislikeable' traits, such as selfishness, narcissism, manipulativeness and arrogance, through a series of 14 performance vignettes. Howells successively led the participant to different locations in the performance venue, some of which were semi-public, such as a lobby or canteen, where others were closed off to public view. Each point was a 'Station', at which Howells, like Christ *en route* to the crucifixion, was humiliated and scourged, before being redeemed. He narrated his sufferings, sometimes pathetically, but he also scripted his self-flagellation, by showing how he was often party to his own disgrace. Early on, for example, he told how, as a 13-year-old, he had lied and feigned distress to inveigle his way into the inner circle of an attractive, charismatic teacher (Station 3: 'He Falls From Grace').

As such tales accumulated, Howells solicited ambivalent feelings from the audience-participant, and at the nadir of his journey, actual punishment from them. After revealing the profoundly careless and wounding effects of his actions on 'Jim', the close friend we met in Station 9, he asked the participant to hand him a glass of vinegar to drink (Station 10: 'He Is Stripped of His Garments') before silently requesting a dousing with ice-cold water as he crouched naked in a child's paddling pool at Station 11 ('He is Made to Suffer'). I obliged, but such an obvious desire on the part of the performer to

suffer, and at the hands of another, may have inclined other participants to draw back from the invitation.

In *The 14 Stations*, Howells' intimate confessions arguably built to engender a more confused and judgemental response. As in *An Audience with Adrienne*, this was aided by the exhibition of personal archive photographs and film footage. The photographs, like the one of Jim, appeared mute, small and insufficient, and seemed to lack any agency of their own. Yet they were also vivified in providing the link between the somatic affect of the one-to-one encounter and its increasingly difficult turns as Howells' narratives became ever more craven and self-lacerating. As if to mark this somatic power, in turn, the represented body of Jim and its pain, as I construed it, was brought into contact with Howells' body, via mine. The photograph performed its small yet viciously effective role alongside Howells' testimony and the accusing text of the letter in 'setting me up' to act in the space.

My relish at throwing the bucket of water over Howells was met with my almost immediate regret – not simply that I had given him such a bodily shock, but that I had unthinkingly done his bidding. In fact, though, resisting the urge to inundate him might have been more spiteful, possibly denying him the redemptive humiliation scripted into the piece.[20] In going along with the dousing, did I become Howells' accomplice? Was I duped by him, or by the small picture of Jim? The photograph, so adeptly sewn into the intimate revelation of Adrian's hard-hearted act of rejection is not a false picture of conventional 'good times'. The tangible memory of genuine friendship that this image actively anticipates and constructs in the moment of the pose to camera has been overwritten with sad irony as an authentic relic of a ruined relationship. Perhaps that innocent photograph was the real accomplice to this whole tale, and my credulity at what it signified culminated ironically in my one moment of decisiveness. But what happened in that moment? I imagine a set of photographs in my memory: Adrian pathetically crouching; a series of freeze-frames of water caught mid-hurl. Yet there are no photographs of this event, and certainly not of me in the act: nothing to prove the certainty of a belief that what I did was justified. But then, nothing shows I was not simply licensed to act on a desire to be naughty either.

And this is where ambivalence about what photographs show meets my critical ambivalence at being so sentimentally manipulated in *The 14 Stations*. So, while talking myself into the nostalgic truth-value of the photo, I fell hook, line and sinker for Howells' theatrical ruse and found myself sadistically impelled to participate in a scene of dramatic intimacy. The photograph of Jim became a knot into which the effects and affects of the performance were tied. In writing this knot I admit to the 'subjectivity' of the interpretive act and in so doing make public its intimate machinations, putting them into an accountable context.[21]

Overleaf: Adrian Howells, *Adrienne's Dirty Laundry Experience,* performed at The Arches, Glasgow, as part of Glasgay!, 2003. Photo by Niall Walker.

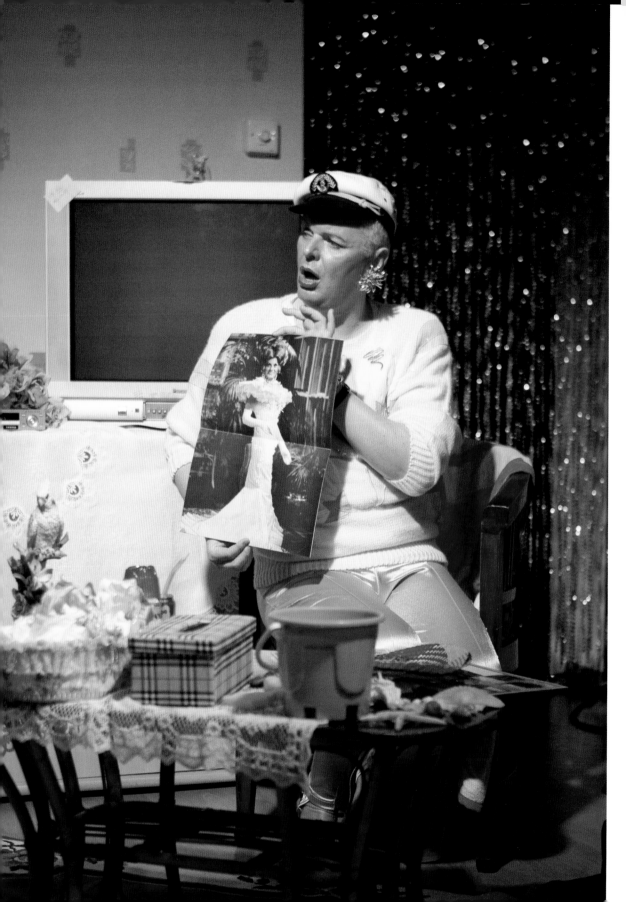

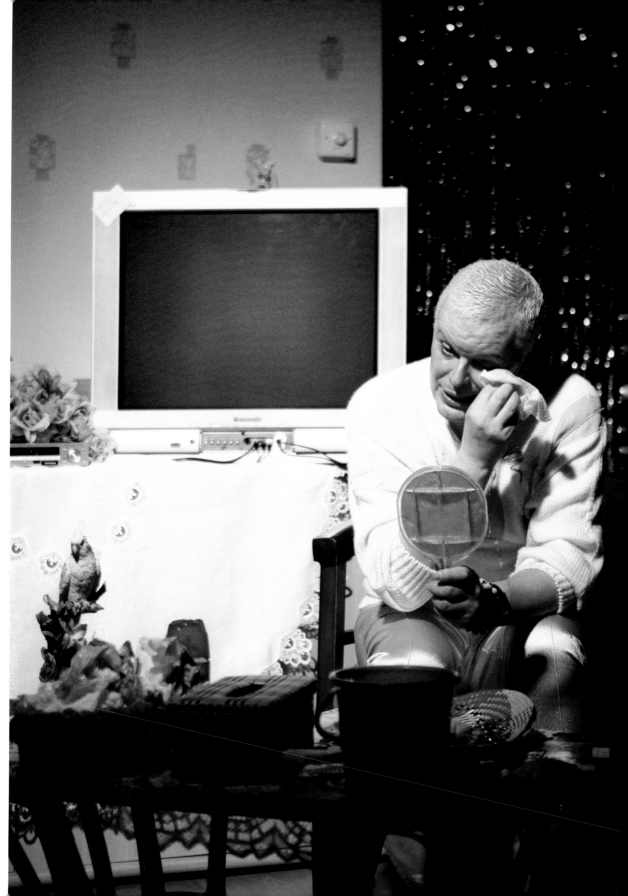

As a point of overdetermination, the mental image of me throwing the cold water crystallises a number of things about my participation and how to represent it. I was locked into an embarrassed yet committed engagement with the artist: self-conscious, yet completely drawn in. At that moment during *The 14 Stations* I crossed over into Howells' story and the action, the scene of *his* performance, became all about *me*. The too much-ness of the overdetermined autobiographical take is perhaps a necessary stand-in for the never-enough of the representation of the affective event.

The images are caught in the dynamic ambivalence between 'too much' and 'not enough' as Howells strives towards intimate closeness and the desire for authentic dialogue. When I sluiced the icy water over him, was I paying Howells too much attention in a potentially abusive gesture? Should I have 'abandoned' him – or at least his cathartic script?[22] Whichever way, my intimate moments with Howells were, at the same time, too excessively 'real' and believable, as well as too 'staged'.

Lauren Berlant has noted that 'therapy saturates the scene of intimacy' in contemporary culture, 'from psychoanalysis to twelve-step groups to girl talk, talk shows, and other witnessing genres'. She looks specifically at how women's intimate publics negotiate normativity and conventionality through 'affective knowledge'. Howells' performances derived in large part from what is familiar and recognisable to us in the broader culture of intimacy (that is Berlant's field of inquiry), in which fictionalising and story-telling become alternative ways of coding counterpublic address, to figure possibilities for social transformation along empathic lines.[23] The story about Malcolm in *An Audience with Adrienne* ended with an anecdote about Malcolm's acceptance of Howells' homosexuality when the latter came out to him, and Howells wondered what it cost him – the popular, sporty boy depicted in the snapshot – to be friends with the fey 'poofter' whose effeminate leanings and campy high-jinks the audience became acquainted with during the piece. Howells' performances adhered to and reaffirmed a range of normative representational practices and familiar strategies but also departed from them, as he re-deployed and re-aligned them in ways that signalled uses and configurations that weren't straightforwardly 'oppositional' or anti-conventional.[24] His work showed us how he managed disappointment with the realities of love, desire and happiness, found the agency with which to 'get by', and strove towards conformity while knowing he didn't quite fit. Our relationship to the norms and codes of belonging, signified so strongly in the domestic photograph, are always imprecise, uneven, damaged, *ambivalent*, as Berlant argues.[25]

Howells encouraged his audience to consider its complicated relationship to the norms we inhabit so ambivalently: recall the faulty attempt to fit into the heteronormative strictures of homosocial bonding in the improvised porn stories with Malcolm. In the case of Jim, conventions of friendship were shown to be a minefield of sensitivities. From humour, we turned to bleakness and the performance of misery, sometimes both at the same time: I smiled when

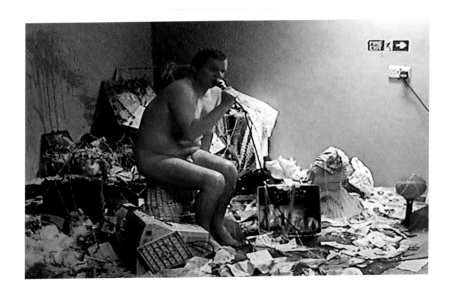

Howells sat shivering on a pile of rubbish after his punitive drenching, and listened as he croaked a pathetic version of Eric Carmen's *All By Myself* (1975). But I also remembered the promise of happier times: the picture of Adrian and Jim may have taken us to an irretrievable past but it also looked forward to an alternative future.

Both *An Audience* and *The 14 Stations* played out momentary fantasies of collectivity, connection and intimate care within the live performance scene. During the performances there was a sharing of strategies and stories about how to negotiate the dominant conventions and intersections of gender, sexuality, and class in the building of self-representation, especially where our interpellation into the normative schemas for these identifications does not work, even if we want it to. Of course, there is anxiety in such ambivalence about dominant conventions and values, but also pleasure – indeed Howells and his audience enjoyed, even relished this dual affect. José Esteban Muñoz's notion of 'disidentification' is helpful with regard to the difficulties of specifically queer forms of social belonging and their cultural manifestations.[26] This recasts habitual identifications with normative structures in a doubled formulation, which emphasises the queer subject's troubled yet transforming relation to them.

Admittedly, part of my anxiety in this writing is related to preventing ambivalence from falling into mere indecision and wanting instead to stress its hermeneutic value in relation to a troublesome *undecidability*. As Howells' performances moved in and out of 'easy' entertainment and 'difficult' reflection, it became increasingly important that the disidentificatory work they did with normative forms such as the album photograph and family

Above: Still from video documentation of Adrian Howells singing on a pile of rubbish in Station 10 ('He is Stripped of his Garments') of *The 14 Stations in the Life and History of Adrian Howells*, performed at the Arches, Glasgow as part of Arches Live, 2007.

anecdote, with popular song and audience chat was recognised and replayed in the modalities of my interpretation. My critical ambivalence takes its lead from his faceted playfulness, with its joyously confessional candour and sometimes-paranoid turns, forging intimacies and breaking them. His adept manipulation of intimacy's repertoire always placed his audiences within and between the binaries of public/private, stranger/confidante, impersonal/personal, distance/closeness.

Rhetorical ambivalence joins with the felt ambivalence at the heart of the intimate encounter and becomes a useful way to 'hold open' the structure of the performances, to 'meet' their provisionality, spontaneity, and the uncertainties of their public intimacy.[27] These may have been scripted in some respects, but were unpredictable to the extent that they relied on audience response, which was bound to be different in each reprisal. The autobiographical subject was never finalised or definitive, as Howells and his audience were produced anew in the intimate sociality of each set of interactions. In homage to this performative mobility, I have strived to let the anecdotal evidence push back against decisive accounting.

Hopefully my wavering becomes a way to catch the variety of ambivalences dispersed across these complex performances, both to mark the general structural effect of undecidability within the intimate scene *and* the localised feel of my own uncertainty at the specific scenes of performance. Correspondingly, I waver here, at the scene of writing, between the decisiveness of sluicing freezing water over Howells and doubt about the ethical and affective motivations for my action. I 'bare all' in sharing my old pictures and private tales, but my embarrassment at my exhibitionism is tempered - not only by excitement, but also by loss. While his death sadly forces yet another temporality of engagement, Adrian, even now, gives me permission to put myself on the line, in an intimate push and pull that gestures to the lasting affective power of his work.

1. These scenes and their accompanying photographs are drawn from two of Howells' live works. *An Audience with Adrienne* was first performed in 2006 and subsequently toured throughout the UK and internationally. *The 14 Stations of the Life and History of Adrian Howells,* a one-to-one piece, was first performed at The Arches in Glasgow in 2007, and subsequently at the Battersea Arts Centre in London in 2008. Research for this paper was drawn specifically from productions of *An Audience with Adrienne* at the Drill Hall, London, 27 June-8 July 2007 (*Her Summertime Special*); the Nightingale Theatre, Brighton, 8-11 May 2010 (*A Seaside Summertime Special*); and a recording of the production for Glasgay! at The Arches, Glasgow, 7-12 November 2006 (*A Lifetime of Servicing Others*); for *The 14 Stations of the Life and History of Adrian Howells*, from the production for the Burst Festival at Battersea Arts Centre, London, 14-17 May 2008; and a recording of the production at The Arches, Glasgow, 26-28 September 2007.

2. For his own account of his performances as Adrienne see Howells, 'The Art of Being Adrienne' (2005), <http://www.cascpp.lancs.ac.uk/documents/beingadrienne.pdf> [accessed 19 May 2011]. For discussion of his subsequent work 2006-10, see Deirdre Heddon and Adrian Howells, 'From Talking to Silence: A Confessional Journey', *PAJ: A Journal of Performance and Art, PAJ* 97, 33.1 (January 2011), 1-12.

3. Linda Haverty Rugg, *Picturing Ourselves: Photography and Autobiography* (Chicago and London: University of Chicago Press, 1997), p. 10.

4. Lauren Berlant, *The Female Complaint: The Unfinished Business of Sentimentality in American Culture* (Durham and London: Duke University Press, 2007), p. xi.

5. The 'back to nurture' adage of Howells' works after 2007 indicated something of the affective labour needed to maintain such intimate care (rather than relying on a simplistic appeal to our better natures). I derive this phrase from Howells' lecture, 'Back to Nurture: An Illustrated Talk about Intimacy and One-to-One Performance', Central Saint Martins, London, 13 June 2013. See Deirdre Heddon and Adrian Howells, 'From Talking to Silence: A Confessional Journey', *PAJ: A Journal of Performance and Art, PAJ* 97, 33.1 (January 2011), 1-12. This essay is reproduced in full in the present publication. Howells speaks of the importance of experiential connection and physical tenderness in Dominic Johnson, 'Held: An Interview with Adrian Howells', in *The Art of Living: An Oral History of Performance Art* (Basingstoke and New York: Palgrave Macmillan, 2015), pp. 262-85 (p. 269). A revised version is reproduced in the present publication.

6. See Eve Kosofsky Sedgwick, 'Paranoid Reading and Reparative Reading, or, You're So Paranoid, You Probably Think This Essay is About You', in *Touching Feeling: Affect, Pedagogy, Performativity* (Durham and London: Duke University Press, 2003), pp. 123-151 (p. 145).

7. Jane Gallop, *Anecdotal Theory* (Durham and London: Duke University Press, 2002).

8. See Paul John Eakin, 'Talking About Ourselves: The Rules of the Game', in *Living Autobiographically: How We Create Identity in Narrative* (Ithaca and London: Cornell University Press 2008), pp. 1-59. There is an intriguing interplay between the unified, coherent subject who can be detected and traced through the various guises, and the discontinuous performance that can be narratively linked to forge a self.

9. Marianne Hirsch explicitly frames the problem of family photography's visual truth value. In *Family Frames: Photography, Narrative and Postmemory* (Cambridge and London: Harvard University Press, 1997), Hirsch writes of the various interpretive discourses that circulate family photography, but complains that what it divulges about the *subjects* depicted remains 'masked by an opaque screen of familiality' (p. 106). There is a resistance to theoretical explanation that compels Hirsch to introduce subjectivity through the specifics of autobiography.

10. Patricia Holland, 'Introduction: History, Memory, and the Family Album', in *Family Snaps: The Meanings of Domestic Photography* ed. by Patricia Holland and Jo Spence (London: Virago, 1991), pp. 1-14 (p. 13).

11. Ibid., p. 7.

12. Carol Mavor has developed this approach to historical photographic material – moving from close reading to the more speculative and subjective. In *Becoming: The Photographs of Clementina, Viscountess Hawarden* (Durham and London: Duke University Press, 1999), she weaves between the persistence of the photograph as historical record and the demands of the contingent moment of interpretation via Roland Barthes' notion of the photograph – and writing – as bodily inscription.

13. In this way it might be a part of the intimate public culture that Berlant alludes to in *The Female Complaint*, in its *imagined* sense of shared generality (even while it is actually being staged as a social scene).

14. Michael Warner, *Publics and Counterpublics* (New York: Zone Books 2002), p. 74.

15. Howells acknowledged the shifts between awareness of the performance of intimacy and the experience of intimate exchange regardless of staged context, which involved a certain risk on the part of the audience member: '[O]f course, these [live and felt] moments are sometimes delineated by being within the consciously-held performance mode and sometimes within the "real", and unconsciously-held, non-performed mode'. Howells in Rachel Zerihan, *Live Art Development Agency Study Room Guide on One to One Performance*, <http://www.thisisliveart.co.uk> [accessed 19 May 2011] (p. 36).

16. Warner, *Publics*, p. 76. Public sex, which Warner, with Berlant, also discusses, provides a very different context for thinking through this assumption, as well as grounds for deconstructing the public/private binary. See also: Michael Warner, *The Trouble with Normal: Sex, Politics, and the Ethics of Queer Life* (Cambridge, Massachusetts: Harvard University Press, 2000), particularly the fourth chapter, 'Zoning Out Sex' (pp. 149-93).

17. Hirsch, *Family Frames*, p. 107. Hirsch contents herself with the idea that 'any real exposure [is] impossible' because subjective familial relations resist understanding (pp. 107-8).

18. Jane Gallop, 'Observations of a Mother' (with photos by Dick Blau) in *The Familial Gaze*, ed. by Marianne Hirsch (Hanover and London: Dartmouth College/University Press of New England, 1999), pp. 67-84 (p. 68).

19. Ibid., pp. 70-71. She quotes Roland Barthes' *Camera Lucida* and, like Carol Mavor, takes Barthes' lead in figuring a 'subjective' and 'anecdotal' hermeneutic.

20. Howells would pour the water over himself if the participant refused (Johnson, 'Held', p. 276). See Jennifer Doyle's account of the same moment in *Hold it Against Me: Difficulty and Emotion in Contemporary Art* (Durham and London: Duke University Press, 2013), pp. 109-10.

21. Erica Rand writes about the importance of paying attention to the accumulation of meanings which knot around an object in ways that neither over-privilege the object itself nor favour its theoretical contexts as the only touchstones of interpretation. See Erica Rand, *The Ellis Island Snow Globe* (Durham and London: Duke University Press, 2005), pp. 19-20.

22. See Dominic Johnson on intimacy as 'bounded by destitution' in a continuum between abandonment and abuse: 'Ecstatic Intervals: Performance in a Continuum of Intimacy', in *Intimacy Across Visceral and Digital Performance*, ed. by Maria Chatzichristodoulou and Rachel Zerihan (Basingstoke and New York: Palgrave Macmillan, 2012), pp. 89-101 (p. 90).

23. Lauren Berlant, 'Intimacy: A Special Issue', *Critical Inquiry* 24 (1998), 281-82; and *The Female Complaint*, p. 2.

24. Berlant's concept of the 'juxtapolitical' has informed my reading of Howells' practice in this regard: it implies an openness to the political, but remains outside of it. *The Female Complaint*, pp. 10-11, 267.

25. Ibid, p. 9 ff.

26. José Esteban Muñoz, *Disidentifications: Queers of Color and the Performance of Politics* (Minneapolis and London: University of Minnesota Press, 1999). He describes 'disidentification' as 'an ambivalent structure of feeling that works to retain the problematic object and tap into the energies that are produced by contradictions and ambivalences' (p. 71).

27. I am grateful to Kate Love for the notion of writing to 'meet' affect. She is specifically concerned with the antagonistic affect of experience as both in language, and not, simultaneously. See Kate Love, *Who Did Not Specially Want it to Happen: Experience and Writing* (Bristol: Intellect, 2016).

You and I: On Theatre and Audience (With a Nod to Adrian Howells)

Caridad Svich

I'd like to say you are here. I'd like to say you will be here soon. But you are not here, outside of the here of memory, the here of your touch, the here of your laughter, the here of mischief and provocation that was central to the radical intimacy of your work – with us, here, those of us known as the audience or spectators.

I'd like to say we were kin, but we are not. We lived miles away from each other, across an ocean, and our paths crossed through the work and reflections of mutual colleagues and friends, who always said with a smile, 'Ah, Adrian'.

But we met once. In a café at a theatre in New York City. Again, through a friend. His name is Carl. We both knew him. Carl is still a friend. And later through Andy and Tim. Also friends. Always with a smile. Always a gleam in the eye. Always the cheeky wink and delicious remark.

Sadness was not something I thought of when I thought of you. Although yes, I was told it was something you carried, as many of us do – perhaps with greater weight, and as we now know, with a stare into the hollow of its despair.

But that's not what I think about when I think about your work, and its lessons. Still felt today. Still resonating across the fragile membrane of performance.

When I think about you, I think about the audience. I think about being with the bodies in a room or a pool or a hair salon (when you were also Adrienne) and sometimes just the one body, yours. The essential, stripped down you and I, where the shared act of making something breathes. I also think about nakedness and touch, and light and dark. And candles and perfume. And how we can be here for each other and one another. Just here. And how often we forget this. Because we are always doing other things.

I think about the way you held people, the way you made spaces for their vulnerability to be recognized as well as yours.

And so, what follows are some words. Inspired by your legacy. An imagined performance on the canvas of the page.

This is not for you.[1]
You never came into my mind when
I was making this.
To be honest, I was thinking of someone
else entirely.

So, you can only imagine how shocking
it is to see you there
staring at me, listening to me, thinking
all sorts of things.
I am not sure how to behave.
Because, I don't know you. At all.

Are you sure you are supposed to be here?

Maybe you wandered in by mistake.
Maybe you thought something else
was going to happen.

Listen, I'm sorry.
Because, even though we're strangers,
It's clear that someone must have invited you
Or asked you to come

Not that it changes anything.
I mean, I still made this without
thinking about you
But you know what I mean

I want you to feel welcome
Because
Well, you showed up
And no one else did

Really, I'm quite taken
With your taking the time to come
all this way
There are so many things to do in a day

that you have chosen (somehow) to have
come here is...
flattering

Even if I do find it a little odd

Because really I wanted someone else
to show up
Someone else entirely

Not you

I'm a little hurt, actually
Maybe even a bit angry
That it's you

And not this other person
That has made it here

Because it's much harder with strangers
Much harder to be intimate –
At least for me
And this is ... well ... intimate
And a bit, you know, dark

I'm not going to lie
It's a bit uncomfortable
To see you there
And know that all this
Is now meant for you

When it wasn't
For you
In the first place

...

I am just being honest here
I hope you don't mind

It's a bit embarrassing to pretend we're friends

I mean, we haven't even said hello.
Haven't even broken bread together.

This is all quite unnatural

Although a friend of mine says most
everything we do is

...

You seem impatient
Maybe you're getting upset
Or bored
When we were children, we never had
time to get bored, my grandparents say

I'm not sure I know what they mean
Almost everyone I know gets bored
quite easily
Just like you're doing now
Glancing at your phone

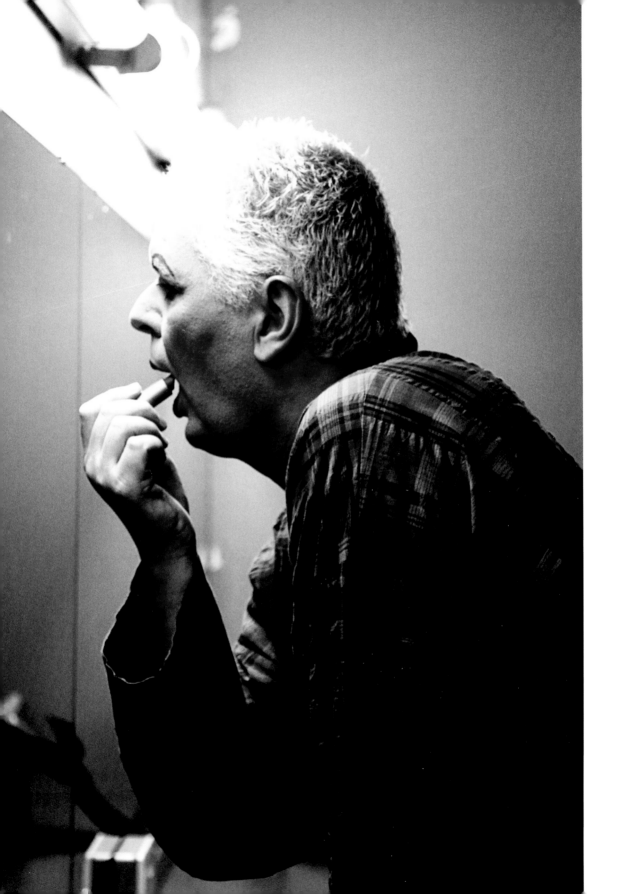

Cradling its vibrations
I understand

Listen, I have been where you are, too
I know what it's like to be a stranger
In a strange place
Where people behave in peculiar ways
And expect you to suddenly be friends
As if they'd known you for years

I know what it's like to walk in
And know, deep down, that you never
thought of me
And were perhaps even contemptuous of me
And saw me as some sort of project you
had to work on
Or task you had to fulfill

Listen, you can ignore me
It's okay

I would rather you did
Because, well, this being intimate thing

Is

I'm not sure I'm good at it either
Not these days

Because, I do get bored quite easily
And rather like looking at my phone
And really, my mind is...
So cluttered with...

So, for you to ignore me
Is great

It's probably the best thing you could do

Because really, I walked in by mistake
I didn't even know what I came here for
I had the wrong day
And
You weren't even on my mind either
And what we have here is

Not even a real thing

So

Really

You can carry on
Pretend I'm not here
Pretend it's all some sort of show
And that what we're doing is
A perfectly natural thing

I won't tell anybody
After all, I don't know anybody who goes to...

...

What?
You want to actually shake my hand?
Say hello?
Share some food and drink?

You want to talk to me?

What if I do/say the wrong thing?

It's all allowed?

Really?
Okay.
Let's begin, then: you and I.

1. A version of the remainder of this reflection was initially written for the 2015 Theatre Communications Group's *Audience (R)Evolution* blog salon, for which the author also served as curator. TCG is one of the US's largest arts service organisations. It supports, documents, grants, publishes and advocates for theatres at the administrative and artistic levels nation-wide. In the spring of 2015, TCG asked me to curate a blog salon in conjunction with the *Audience (R)Evolution Convening* event in Kansas City. The salon invited practitioners and producers in the field to speak to issues related to spectatorship and the ethical engagement among art workers, artists and audiences. See <http://www.tcgcircle.org/2015/03/you-and-i-on-theatre-and-audience-with-a-nod-to-adrian-howells/> [accessed 5 October 2015].

Opposite: Adrian Howells applies his makeup backstage before a performance of *An Audience with Adrienne: A Lifetime of Servicing Others*, at The Arches, Glasgow, as part of Glasgay!, 2006. Photographer unknown.

Come Closer: Confessions of Intimate Spectators in One-to-One Performance

Deirdre Heddon, Helen Iball and Rachel Zerihan

We have licked and plucked the ripe red strawberries held gently between his fingers, feeling the juice dribble down our chins.

'One-to-one', 'one-on-one' or 'audience-of-one' are all terms used to describe performances that invite one audience member to experience the piece *on their own*. In practical terms, the spectator books a performance slot during which they alone encounter the work. This formal shift in the traditional performer/spectator divide can, quite radically, reallocate the audience's role into one that receives, responds and, to varying degrees restores their part in the shared performance experience. In place of the metaphorical or imaginary dialogism that pertains to all acts of theatre (the spectator is always in some sort of relationship with what is seen), in one-to-one performance the spectator is actively solicited, and engendered as a participant.

Demanding a more explicit and overt relational exchange, the performances of Adrian Howells are part of a wider group of UK-based Live Art and performance practitioners including Sam Rose, Kira O'Reilly, Franko B and Oreet Ashery who have been drawn to utilising the form in their practices. In the last few years, early-career artists can also be seen experimenting with the seemingly intimate at Live Art festivals and at the Edinburgh International Fringe Festival too. The Battersea Arts Centre in London has now hosted two 'One-on-One' festivals. Notably, one of the latest – namely the *One on One Festival* at Battersea Arts Centre, London, in April 2011 – presents spectators with a number of 'set menus', inviting them to make individual choices of what to see, according to – or framed by – appeals to personal taste: from the 'mind-

bending' Menu 1 (for those with 'strong stomachs'), to the 'personal' Menu 2 (which offers a 'spicy main with subtle nostalgia inducing sides'). One-to-one performance is employed as a tool for claiming and proclaiming individuality.

The authors of this chapter are well-practiced participants in the circuit of exchange and desire that functions as the architecture for one-to-one performance. Our collective attendance at a symposium, *i confess...* (University of Glasgow, June 2009), provided a forum for us to participate in the same one-to-one performances and then to share our experiences of that participation. Practice-as-Research (PaR) is normally about making performance but, given that one-to-one is usually participatory, here the practice is located in the experiential processes of reception: PaR becomes SPaR (Spectator-Participation-as-Research). This acronym intentionally signals the relational dynamic embedded in the one-to-one form, a dynamic – or enfolding – that we unfold here.

i confess... was the culminating event of a three-year creative arts fellowship held by Adrian Howells at the University of Glasgow between 2006-09 (funded by the Arts and Humanities Research Council). Howells' research project had practically explored the use of intimacy and risk in solo performance. *i confess...* afforded the opportunity to invite academic researchers (including Dominic Johnson, Roberta Mock, Yvette Hutchison, Helen Iball and Geraldine Harris) and performance practitioners (including Oreet Ashery, Owen Parry, Sam Rose and Martina Von Holn) to engage in discussion and debate around the use of intimate and confessional forms in performance. Reflecting on our participation in Howells' *Garden of Adrian* (2009), in this chapter we individually and collectively explore the shifting dynamics of subject/object, gift/demand, performer/spectator and authenticity/performance, revealing the complexity inherent in playing the role of an intimate spectator. The intimacy of our individual encounters with Howells' work is remembered as at times excruciating and at other times very moving. We begin to recognise here the ways in which these differences map onto acculturated expectations, and relate to personality traits and personal histories.

Jacques Rancière argues in *The Emancipated Spectator* that all spectators are active irrespective of the form of performance being witnessed.[1] Yet the prevalence of the one-to-one form and its particular dramaturgical-spectatorial structure prompts interrogation into what it means to be a literally performing spectator. The generic term 'one-to-one' risks erasing the diversity of ways in and degrees to which this work actively constructs participant-spectators, engendering different participant-spectator roles and the experiences that arise from playing them. As we suggest, in creating a space within the work for the spectator to become a participant, the perceived value of this form of performance hinges on the seeming authenticity of exchange, on the engendering of a relationship between performer and performer-spectator. This

Overleaf: Adrian Howells, *The Garden of Adrian*, performed at Gilmorehill, University of Glasgow, 2009. Photos by Minty Donald.

relationship – this performance of the *between* one and another – is intertwined with and inseparable from the sensitive, generous and demanding work of collaboration; collaboration makes the work. Claims of authenticity, though, are tricky to define in an environment of roles and masks, of script and improvisation, of being a performer and playing at being one. As we suggest, alongside the 'parts' created for us by performers are other habitual, sticky roles, including that *of* spectator. What is it to collaborate *as* a spectator? And how does the collaborating spectator evaluate the – and their – performance? What and whose performance are we judging?

One-to-one performance proposes a dialogic and collaborative encounter, though identifying and claiming the success of those encounters is not straightforward either. Our discussion also strategically staged another dialogic and collaborative encounter, as in writing this chapter we devised a collaborative writing process. We spent four days together in a rented apartment, reflecting on our experiences, allocating writing tasks, reading aloud and sharing our draft writing and then agreeing a structure. In this iteration, we consciously retain both the dialogue and the collaboration that took place between us as we sought to make sense of what had taken place between us and Howells.

The Garden of Adrian

Dee Heddon: *In* The Garden of Adrian *I am led gently and carefully by Adrian Howells through a woman-made garden (designed by Minty Donald), built inside a converted church that is now a theatre. Leading me by my hand, Howells softly tells me that if there's anything I don't want to do, I shouldn't do it. Over the next hour or so, I will place my bare feet into cool soil; gingerly pluck strawberries from Howells' fingers, letting the juice dribble down my chin; cradle Howells' head in my lap, holding him like a lover, like a mother; have my hands and arms tenderly washed, each one in turn; and lie on a blanket atop a perfect square of green grass, Howells spooning into me. Engaging with the five senses, I will travel through childhood reminiscences, prompted by tastes, smells, sounds, and textures.*

Rachel Zerihan: *My dad, who I would do almost anything for, once tried to tempt me with a freshly picked ripe one on a trip to a 'pick your own' farm when I was a child. I squirmed and whinged until he reluctantly accepted my refusal. More recently my boyfriend brought a punnet of them onto a romantic picnic break. He sought to edge them into an erotic sphere of sensual delight, but my disdain for their hairy skins and mushy middles meant he eventually ate them all, my mouth remaining dry and berry-free. The twenty years or so in-between, I'd even tried to coax myself to eat a whole one yet failed each time, nibbling only a hamster's portion with winced eyes and screwed up-face.*

I don't like strawberries, yet I ate one for Adrian Howells. Moreover, I ate two.

Howells' welcome hug was warm and inviting and it was a relief to see him after being stuck in the shed so long; a reward, it felt, for my time in isolation. We had not long left the first stage of the journey, the visual feast of looking at a beautiful white flower whilst

wriggling fresh earth beneath our feet, when I saw the full punnet waiting for me at the next station. Howells held my hand as we walked towards the bench and gently led me to take my place.

I don't like strawberries. 'I don't like strawberries' was all I needed to say. He asks me if I like them and I lie, 'yes', though my eyes plead 'no'. Why lie? My will to please has followed me throughout my life, from asking my mother each night whether I had 'been a good girl' and only accepting her affirmation as license to sleep with ease (this lasted for years), to more recent decisions I've made to behave, do good, please others. My role as dutiful spectator in Howells' garden was led by my desire to please even though he had explicitly told me that I would not have to do anything I felt uncomfortable with shortly after the hug that marked my entrance to the garden space.

The sensation of tasting the strawberry, quite clearly, was intended to be a pleasurable one and I remember trying to fake enjoyment. Like receiving an unwelcome lover, I feigned delight and satisfaction.

One-to-one performance is an art form that both relishes and can be interrupted by autobiographical fragments. In other art forms this is the case for *reception*. One-to-one is unusual in that the artist's moments of *production* are inevitably affected by – entwined with – the participant's life experiences and senses of self. In its processes of signification, one-to-one performance presents as inevitably and unpredictably dirty; it is revealing to consider how readily participants protect the performance from the 'clutter' of personal baggage. The more we reflected on our spectator-participation at *i confess...* the more it became evident how, as spectator-participants, we so easily (though, often, not willingly, as you will see from the examples that follow) adopt what Sidonie Smith and Julia Watson call 'ready-made narrative templates to structure experiential history', and thus 'take up culturally designated subjectivities'.[2]

Indeed, one-to-one often piggybacks on everyday autobiographical practices. These provide a useful shortcut in behavioural acclimatisation, given that 'recitations of our personal narratives' are 'embedded in specific organisational settings and in the midst of specific institutional routines or operations: religious confession goes to church, psychological trauma goes to the counsellor's office or the analyst's couch' and so on.[3] We are aware that 'only certain kinds of stories need to be told in each narrative locale' and 'in this way, the institution writes the personal profile, so to speak, before the person enacts and experiences it as "personal"' and thus 'in everyday life, autobiographical narratives are part of a frame-up'.[4] Invited to offer some reflections at the *i confess...* symposium, Helen Iball recognised spectatorship as a process of conventionalised 'self-presentation and composition' that is 'largely unreflective',[5] an impulse that she identified as 'giving good audience', where there is a compulsion to participate in the normative assumptions that are a pitfall of one-to-one performance. So it is that coercion becomes a much more problematic issue than it might seem: it goes beyond the intentionally manipulative, because there is a (danger) zone where practitioner's assumptions meet the participant's desire to 'give good audience'.

Rachel has assumed her response to strawberries is too insignificant in terms of the hierarchies of experience that experiential performance proffers; invoking the notion of an 'ideal audience-participant' perhaps. That Rachel had agreed to have her experience filmed for the archive probably heightened her sense of responsibility for the piece of performance to be realised. In fact, and for such reasons as Rachel *pretending herself*,[6] intimate spectatorship agitates for recognition that, as Helen has written elsewhere, 'to a greater extent than in other forms, no response is easily dismissed as inappropriate, over-sensitive or shallow because there can be no grounds to be frustrated with audience response'.[7]

In discussing our experiences of *The Garden of Adrian*, we talked a lot about Rachel consenting to eat the two strawberries. As Rachel has described above, she chooses to suffer this course of action in response to Howells' request because she believes she should be good. This is the sort of dogged observance of once prescribed and now habitual behaviours carried by us all: it is called introjection. Commitment to our 'introjects' ('I should be, I must be, I ought...') can be so strong that they often have the power to override our interest in our own wellbeing. Clarkson and Mackewn explain that introjection interrupts 'the individual's holistic functioning' because she is 'internally split between the original impulse' and the ensuing action or resolution.[8]

Rachel: *I don't like strawberries*

Helen: - *'and the introject':*

Rachel: *I must be a good girl to please others.*

Rachel described how this introject interrupted her experience of *The Garden of Adrian*. Her dialogue with Howells at this point is based on habitual rather than honest responses.

The processes of Gestalt psychotherapy, such as this notion of introjection – along with perspectives from, for example, psychology and applied ethics – suggest themselves as useful ways of attending to responses that other critical methods might dismiss as incidental digressions. Using existing formulations of behavioural processes such as introjection enables the expression of blocks and digressions. These are part of the autobiography of the participant-spectator, as much as (maybe rarer, elusive) moments of meaningful one-to-one contact and dialogue.

Rachel: *Strawberries aside, in the response that I wrote immediately after the event, I gushed at length about the need for everyone (not just the participants of the i confess... symposium) - and particularly vulnerable or dejected people - to be offered such a rewarding, nourishing and life-affirming experience. This intense response was caused by cumulative qualities including Howells' phenomenally caring presence, the Zen-like environment, the opportunities for sensual experiences and the natural materials used in constructing the garden path, yet most profoundly for me, was an action of cleansing that made me both incredibly sad and, quite simply, touched.*

There's not much to say of the action involved – after asking me to roll up my sleeves Howells led each of my arms closer to a pool of water and gently dropped cool water over my hands, then my wrists, then onto my forearms. I've recounted the effect of this gesture and it seems out of proportion to the simple, solitary action but my response to Howells' gesture made me think about others: others in my life who deserve such careful attention, others I don't know who surely do too, others who are somebody's others, others who feel they have no other; re-connecting one with the human through contact is a skill Howells embodies in many of his one-to-one works and is something he does with an openness that is often infectious. The selfless act of refreshing, cooling, bathing my lower arms inexplicably triggered a sense of gratitude that overwhelmed and moved me. If the camera hadn't been there I'm pretty sure I would have spilled tears.

The current preoccupation with performances of intimacy is arguably contextually related to wider cultural concerns around inter-subjectivity, and anxieties over how – in a world of inter-racial and inter-ethnic conflict and global inequalities and injustices – we might live together, better. Performances of intimacy, in their very staging, seem to demand performances of trust, mutual responsibility, mutual openness and mutual receptiveness. In this, they correlate with a critical understanding of subjectivity, of 'being' as 'being-together'.[9] The subjective is always intersubjective, depending on identifying with the other *as* a subject. Understanding subjectivity as in process, our encounters with others have the potential to affect our selves and vice versa. Hélène Cixous, figuring this process of intersubjectivity, writes that 'When I say identification, I do not say loss of self. I become, I inhabit. I enter. Inhabiting someone at that moment I can feel myself traversed by that person's initiatives and actions'.[10] Cixous' insights frame the duality of identification - a problematic process, perhaps, in that the other becomes transformed as much as the self. But what is clear, here, is that the self *is* transformed.

Sara Ahmed also underlines the extension of self that results from empathetic identification. As she writes, 'Identification is the desire to take a place where one is not yet. As such, *identification expands the space of the subject.* [...] Identification involves *making likeness* rather than being alike'.[11] This expansion of the space of the subject is arguably enabled by the creation of a space *for* intersubjectivity; a place for showing what Adriana Cavarero might call *who one is* – or, more simply, that one *is* one – to another *who is* and who is a singular one too (that is, unique and irreplaceable).[12] This creation of particular (one-to-one) inter-subjective space could be considered a site for 'resingularization', set against 'mass-media manufacture' of homogenous subjectivity.[13] So one-to-one might fit Lauren Berlant and Michael Warner's account of 'queer social practices like sex and theory' that 'try to unsettle the garbled but powerful' project of 'normalisation that has

Overleaf: Adrian Howells, The Garden of Adrian, performed at Gilmorehill, University of Glasgow, 2009. The image shows the full Japanese-style garden in which Howells encountered audience-participants, designed by Minty Donald and lit by Mike Brookes. Photo by Minty Donald.

made heterosexuality hegemonic';[14] performance might, then, be situated as a 'counterpublic'[15] – a way of 'rethinking intimacy'.[16]

Rachel finds herself moved by Howells' gentle, giving gesture. Ahmed, in her critical revalorisation of the emotion of being moved, writes evocatively and usefully: '[m]oving here is not about "moving on" or about "using" emotions to move away, but moving and being moved as a form of labour or work, which opens up different kinds of attachments to others'.[17] Berlant and Warner recognise that non-standard 'border intimacies' can 'give people tremendous pleasure'.[18] Howells' performance operates in ways that accord with such 'border intimacies', dismantling some of the 'conventionally based forms of social division' such as male and female, friend and lover, hetero and homo and also, by creating a personal encounter in a performance space, some of the 'taken-for-grantedness of spatial taxonomies like public and private'.[19] By such means, Howells consciously disentangles the intimate from the sexual. In his use of physical intimacy, Howells engages a process of identification, using touch as a means to impress the other into/onto Rachel, bridging the space(s) between. Howells moved Rachel beyond the space of their personal interaction into a wider social realm: is this perhaps to reconfigure the one-to-one as one-to-two-to-three, foregrounding social engagement through its 'rethinking' of intimacy, in contrast to the hegemonic model of intimate life sited in the '*elsewhere*' of political public discourse, a promised haven' that 'consoles' citizens 'for the damaged humanity of mass society'.[20]

Howells is a very experienced, professional practitioner. We are disarmed by him. His performance of authenticity, of being unmasked, encourages us to similarly unmask ourselves, to give ourselves to him and the performance, to actually be seduced without knowing it. So we are unmasked while Howells *performs* (pretends) an unmasking. His performance is structured, crafted, and repeated, but his skill is to disguise that skill, to try and persuade us that this is not performance. Whilst Howells might function as a 'context provider' rather than a 'content provider', his skill and professionalism provide him with security, a script of sorts that he has constructed. The spectator, however, has no such safety net. We have not done this before. We know not what we do, what we might do, what we will come to wish we had not done. Howells' beguiling tone is not easy to resist. Just as collaboration does not guarantee equality, so we must be careful not to confuse action and activity, or participation, with agency.

Rachel: *I don't like strawberries. 'I don't like strawberries' was all I needed to say. He asks me if I like them and I lie, 'yes', though my eyes plead 'no'.*

Helen Freshwater notes that 'academic theatre studies continues to engage with hypothetical models of spectatorship', and her book *Theatre & Audience* asks some uncomfortable questions of that practice.[21] There is an interesting paradox in one-to-one: that the survey can cover 100% of the audience, and yet the data is always partial and subjective and significantly incomplete. And that whilst the academic commentator might, for once, reasonably speak for the whole audience that is only

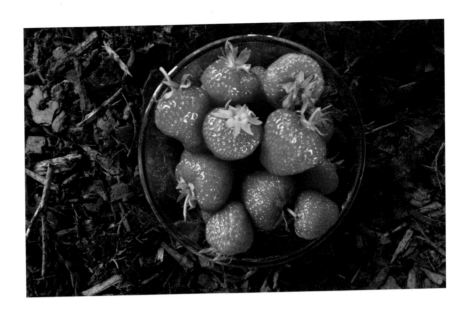

because she *was* the whole audience and this makes it impossible not to confront the narrowness of that perspective and the inevitability of a spectrum of other responses, many of them very different from her own (because that range is part of the point of the form and its popularity).

The Spectator-Participation-as-Research that we have applied in this chapter has begun to reveal the usefulness of comparative study, based in phenomenological description and reflection and personal revelation between the three of us having experienced the same three performances, sometimes very differently. As a result of this research method, it has become apparent that personal insecurities and digressions have the potential to produce *more* intimate connections to the 'integrity of experience', through 'immediacy', 'relationship', 'awareness' and 'attention',[22] if we are able to sidestep the autobiographical subjectivities that we feel bound to (re-) produce. What is also revealed, in our eagerness to compare notes and discuss individual experiences, is our desire to know 'what it was like for you'; in the fragmented, singularised and often insecure space engendered by one-to-one, this shared desire is surely bound up with needing reassurance: 'That's what I did too'. It has not slipped our notice that our conscious collaboration between three has returned the 'individual' experience towards the 'collective'.

Above: Bowl of strawberries used by Adrian Howells in one station of *The Garden of Adrian*, performed at Gilmorehill, University of Glasgow, 2009. Photo by Minty Donald.

1. Jacques Rancière, *The Emancipated Spectator*, trans. by Gregory Elliot (London and New York: Verso, 2009).

2. Sidonie Smith and Julia Watson, 'Introduction', in *Getting a Life: Everyday Uses of Autobiography*, ed. by Sidonie Smith and Julia Watson (Minneapolis: University of Minnesota Press, 1996), pp. 1-24 (p. 9).

3. Ibid., p. 10.

4. Ibid., p. 11.

5. Ibid., p. 17.

6. This phrase is borrowed from 'the character Adrian', played by Adrian Howells, a scripted 'audience member' in Tim Crouch's *The Author* (Royal Court Theatre London, 2009), who declares: 'I saw a play last year. And I remember thinking, "that writer has imagined me". I've been imagined! Poorly imagined! The audience has been badly written! We're all going to have to pretend ourselves!' See Tim Crouch, *The Author* (London: Oberon, 2009), p. 20.

7. Helen Iball, 'My Sites Set On You: Site-Specificity and Subjectivity in "Intimate Theatre"', in *Performing Site-Specific Theatre: Politics, Place, Practice*, ed. by Anna Birch and Joanne Tompkins (London: Palgrave Macmillan, 2012), pp. 201-18 (p. 202).

8. Petruska Clarkson and Jennifer Mackewn, *Fritz Perls* (London: Sage, 2007), p. 73.

9. See Jean-Luc Nancy, *Being Singular Plural*, trans. by Robert D. Richardson and Anne E. O'Byrne (Stanford: Stanford University Press, 2000).

10. Hélène Cixous and Catherine Clément, *The Newly Born Woman*, trans. by Betsy Wing (Minneapolis: University of Minnesota Press, 1975), p. 148.

11. Sara Ahmed, *The Cultural Politics of Emotions* (Edinburgh: Edinburgh University Press, 2004), p. 126.

12. See Adriana Cavarero, *Relating Narratives: Storytelling and Selfhood*, trans. by Paul A. Kottman (London and New York: Routledge, 2000).

13. See Felix Guattari, *The Three Ecologies*, trans. by Ian Pindar and Paul Sutton (London and New York: Continuum, 2008).

14. Lauren Berlant and Michael Warner 'Sex in Public' in *Intimacy*, ed. by Lauren Berlant (Chicago and London: University of Chicago Press, 2000), pp. 311-30 (p. 312).

15. Ibid., p. 322.

16. Lauren Berlant, 'Introduction', *Intimacy* (Chicago and London: University of Chicago Press, 2000), pp. 1-8 (p. 6).

17. Ahmed, *The Cultural Politics of Emotions*, p. 201.

18. Berlant and Warner, 'Sex in Public', p. 324.

19. See Berlant, 'Introduction', p. 3.

20. Berlant and Warner, 'Sex in Public' p. 317.

21. Helen Freshwater, *Theatre & Audience* (Basingstoke: Palgrave Macmillan, 2009), p. 29.

22. Petruska Clarkson, *Gestalt Counselling in Action* (London: Sage, 2004), pp. 30, 181. In these terms, Clarkson draws direct comparison between the concerns of Gestalt counselling and those of qualitative research. She adds that, qualitative research is concerned with 'the examination of practice' and 'research into the qualities of [...] subjects, subjective experience, the phenomenological quality of experience unique and inimical as it is. So is Gestalt' (pp. 182-5).

He Washed the Colour Out of My New Pyjamas, He Did.

Marcia Farquhar

> Clarence, u were the wind beneath MY wings as well as your own Tuesday pm! It was totally gorge-of-the-arses to see u and I honestly LOVED our time together and your emphatic company and conversation was JUST what the consultant psychiatrist would have ordered! Today has been a cheese sandwich kinda day, thank God! Who knew??!! SOO much love to u! Adrian xxx
>
> P.S. I've started an online petition to secure Olive first dibs as the Angel Gabriel for next year's nativity!

From: Marcia Farquhar
Date: Friday, 19 December 2014 07:36
To: Dominic Johnson
Subject: Re: Invitation to contribute to a book on Adrian Howells

It is the strangest coincidence that the day you, Dominic, sent me the invitation to be part of a book of Adrian was a year to the day of my last meeting with the darling: 17 December 2013. We met in Glasgow and I'd just heard the news that Olive, my granddaughter, had been robbed of her chance to be a donkey in the nativity play. I told Adrian that the poor little girl was inconsolable and hated being a townsperson. She had been so proud of her part as a donkey. We think she was demoted because of arse-y behaviour, which Adrian and I agreed was a perfect disposition for the donkey – an ass by any other name.

Today I have just come back from this year's play, where she was an angel and had a line that she delivered very shyly and brightly. I thought of Adrian with such love and of course a streak of utter selfish fury that he wasn't around in this dimension to tell. He had been a total life force when Olive was born three months early and lived in an incubator in Govan for what seemed an eternity.

Adrian gave the most wonderful support. His art and life was full of a love that was real – and that is something marvellous.

I loved that Samuel Beckett believed in kindness and I have always loved Ben Vautier and others of an existential understanding who haven't distanced themselves from this often-awkward impulse. I think if I were to write something it would be about true love, Agape, in the life and work of Adrian. Of being in love, and not (and deeply not in his case) of being romantically in lurve, but the other... Sorry, I am rushing and gushing this, but I will get it clearer. I just wanted to write something to you as proof of my delight and enthusiasm.

Another point in his text message, from this time last year, which I wish to annotate is his reference to a 'cheese sandwich'. I had told him that I always thought of Albert Camus saying that on many a day it was, for him, a choice between suicide and a cheese sandwich, and that he opted for the latter as someone who believed in being happy despite the utter bleakness. When I mentioned this to Dee, after Adrian's death, she said maybe he'd just got fed up with cheese sandwiches – and that made me smile and weep.

So yes, yes, YES – and just let me know when, etc.

Excuse rush typos and bad punc

I can, and will, do better.

———

Left: Adrian Howells, *Adrienne's Dirty Laundry Experience*, performed at The Arches, Glasgow, as part of Glasgay!, 2003. Photo by Niall Walker. *Right:* Adrian Howells, *Adrienne's Dirty Laundry Experience*, performed at Home Live Art, Camberwell, London, 2005. Photo by Manuel Vason.

And now, here, for better or worse, is the something:

The idea of taking my dirty washing and thoughts to be addressed by a drag queen filled me with dread.[1] I took my new pyjamas. I wasn't taking anything with a possible stain to be decoded by some performing stranger. Getting intimate over Rich Tea and dirty linen in a so-called 'one-to-one performance' was/is my idea of hell.

My daughter Ella had invited me and spoke of integrity, humour and something beyond words that compelled her and – she assured me – would compel me too. Unconvinced, but touched by her heartfelt enthusiasm, I went along. I was unprepared for the welcome, which bowled me over and into another dimension. It was love at first sight. The greasy makeup, nylon overall, and tragi-comedic pose made an impact, but something else knocked me and my prejudice off course. Here was actually one of the loveliest human beings I'd ever encountered. Adrian/Adrienne was going through the motions of performance patter – rituals of hospitality, explaining the cycle of a wash – and through all the chatter I heard the voice of a Jean Genet saint, a truly beautiful battered soul in the process of living through pain and giving his/her all.

I didn't know I'd fall in love with Adrian but I did and from then on his art/his heart was and is a treasure. I can only remember him and his art using that piece of my mind that he reached, my heart.

We all have our begrudgers, but of all the people I have ever met Adrian was the least defended against being unloved – and yet this did nothing to deter him from the risky business of offering love unconditionally in his work and in his life, again and again. To those who called him self-indulgent I can only say 'if only he *had* been'.

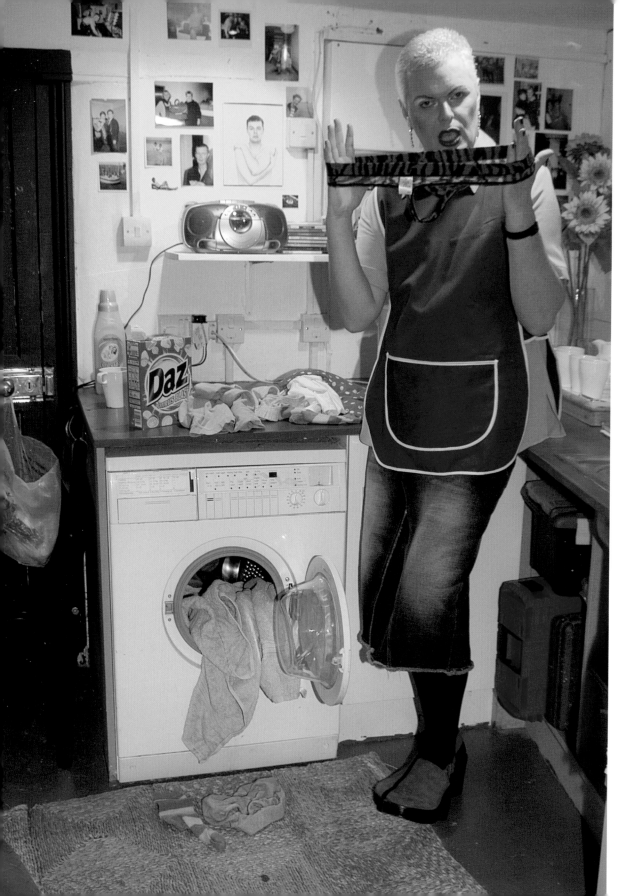

So many bang on successfully about failure: it's a theoretical industry for some and a real pain for others. *A real shame.* The best existential jokes are often made by those truly afflicted with the wisdom of knowing how dark it gets. Adrian's ability to cause mirth was nothing short of genius.

Genius was a contested term when I came of age in the seventies. The attack seemed timely – and yet, so many years later, I reflect on the term and on the notion of intuition, guiding spirits, innate dispositions and talents. I reflect and rage that so many endowed with such generous singularity are made to feel wrong by those for whom the apparently rational is not simply an intellectually safer page – a page on which to reference all sorts of misfitting desires, and the only page allowed. Despite his oft-quoted instruction, 'it's all allowed', Adrian was not quite so generous with himself.

My new Californian pyjamas were ruined. Pop apple green, the background on which sushi images had so recently dazzled in bright black and orange, had vanished. I saw instead a dingy pea colour on which pale shades of prawn and empty faded charcoal shapes floated, and I screeched, 'What have you done?' I ramped up the camp to mask a shamefully real outrage and dismay.

Of course he heard *the real* and looked close to tears of remorse – and so began a history of reassurance between two people terrified by ordinary disappointment. It was a strange bonding that began that day, when the little exchanges of intimacies paled like the pyjamas into a much deeper understanding.

'It's a poor sort of memory that only works backwards', as the White Queen said to Alice. I am so happy that this book will be a way of remembering Adrian into the future – and a way, too, to *bugger the begrudgers.*

Couldn't start, can't stop.

CURTAINS

Lights Up.

1. The performance referred to is Adrian Howells' *Adrienne's Dirty Laundry Experience*, Home Live Art, Camberwell, London, 2005.

Opposite: Adrian Howells, *Adrienne's Dirty Laundry Experience*, performed at Home Live Art, Camberwell, London, 2005. Photo by Manuel Vason.

Foot Washing for the Sole

Adrian Howells

... during the final stage of spooning into her on the bed ... I felt every muscle and sinew of her body relax and let go ... our bodies constantly negotiating to accommodate each other's tiny shifts and movements ... a silent, non-verbalized conversation between our bodies ... a bodily dialogue ...

Unexpectedly I had discovered, through the performance of my one-to-one piece, *Held* (2006), that confessional information can be communicated non-verbally. Two bodies in close, physical and touching proximity have the potential to engage in an often self-revelatory, but silent, conversation. So, I wanted to explore specifically whether my hands could be 'in dialogue' with another's feet.

In preparation I attended the traditional Maundy Thursday footwashing ceremony in a Roman Catholic church in Glasgow.

... I felt cheated ... the priest didn't really wash the feet of the twelve people from the congregation. He only concerned himself with one bare foot ... merely poured a trickle of water on it and then dabbed it with a 'napkin' handed to him by an attendant ...

More useful was the scene I located in St. John's Gospel about Jesus washing the feet of his disciples at The Last Supper.

> Then he poured water into a basin and began to wash the disciples' feet and to wipe them with the towel that was wrapped around him [...]. When he had washed their feet and put on his outer garments and resumed his place, he said to them, 'Do you understand what I have done to you? You call me Teacher and Lord, and you are right, for so I am. If I then, your Lord and Teacher, have washed your feet, you also ought to wash one another's feet. For I have given you an example, that you also should do just as I have done to you.
> (John 13:5, 12-15)

I read up about foot-washing and purification rituals in other religions and cultures. Furthermore, being familiar with the Western and Christian idea that 'the eyes are the window to the soul', I was fascinated by the assertions of reflexologists that it is in fact the soles of the feet that provide a clearer 'view' of individuals' internal lives.

In an interview with Mona Siddiqui, Professor of Islamic Studies at the University of Glasgow, she informed me that the 'wudu' ablutions are a necessary ritual preparation to render a Muslim pure before going to prayer (whether that be privately or in a mosque). She said that during ablutions Muslims should be focusing on the preparation to pray to Allah: to purify their hearts and minds and avoid rendering their ablutions invalid by profanation. The latter can be caused by not just impure thoughts but also interruptions to their ablutions: touching something that is impure, passing wind, and so on.

Ann McGuinness, a complementary therapist and Reiki master, told me frankincense oil would be a perfect oil to use for a foot massage and that she would recommend mixing it with a good base oil like sweet almond oil. She said not only was it great for hard and damaged skin but it also soothed and calmed the mind, slowing down and deepening breathing, and was excellent for use when meditating. It was also non-toxic and non-irritant and can be used by most people. Frankincense originated in the Middle East. It was used by the ancient Egyptians as an offering to the gods, and the Hebrews valued it highly. In St. Matthew's Gospel gold, frankincense and myrrh were among the gifts brought to honour Jesus's birth (2:11).

In the one-on-one performance piece that ensued, I simply washed, dried, anointed with oils, massaged and kissed the participant's feet. Intimacy was engendered not only through the touching of the feet but also through the silence and stillness that surrounded the performance, as well as through my supposed 'act of servility'. For many, it was a deeply profound and moving experience that often triggered specific memories associated with the experience of the foot. In the meantime I have performed the work in many different countries and cultures – from the UK to Israel to Japan – and it has been fascinating to discover significant variations of attitude towards and acceptance of the ritual. The experience seemed to help participants to connect with humility. It seemed to 'earth' them in a particular way, although the soles of their feet were in fact temporarily raised off the ground. As facilitator, however, rather than discovering a bodily conversation through touch, I found I was afforded the opportunity to become more in 'touch' with myself.

Towards an Ethics of Intimate Audiences

Helen Iball

In working towards an ethics of intimate audiences in performance, Adrian Howells' *Foot Washing for the Sole* (2009) provides a paradigmatic example.[1] Firstly, *Foot Washing for the Sole* invites critical engagement with journalistic perceptions of a burgeoning trend for audience participation in twenty-first-century UK theatre practice. This participatory form is marked by its direct engagement with individual audience members as a one-to-one relationship. With particular reference to the Edinburgh Festival Fringe, *Guardian* theatre critic Lyn Gardner has been voluble in identifying this audience-participatory practice in terms of its newly 'widespread' availability and by ascribing the label 'intimate theatre'.[2] Secondly, whilst perceptions of a recent gamut of interactive and seemingly personalised theatre experiences might be cause to celebrate the rejuvenation of 'audience participation' from its traditional associations with embarrassment and entertainment at a fellow spectator's expense, it is also an apposite moment to consider the ethical implications, recognising that this trend is associated with reported complications, some of which I discuss later.

I follow through on Gardner's recognition that so-called 'intimate theatre' places 'audiences in situations they would never encounter in a traditional theatre', which raises 'ethical issues – both for those making and watching the work'.[3] It is in this context that the second reason for proposing *Foot Washing* as paradigmatic arises from particular circumstances surrounding the piece's inception. *Foot Washing* was produced during Howells' AHRC Creative Fellowship at the University of Glasgow (2006–09) and thus his work was subject to scrutiny using established processes of ethical review. Under such circumstances, assuming that ticket purchase implies consent – as one critic wrote, 'after a week at the Edinburgh Festival, I should have known that the purchase of a ticket here on the Fringe can contractually bind you to almost any sort of audience participation' – such agreements are destabilized, and theatre-making gets reframed as an experiment involving 'human participants'.[4]

In defining 'intimate theatre', Gardner cautions that, when audience participation is employed as an integral component of a performance, it 'signals to the audience that its presence matters' and, if audience presence 'really does matter, it changes the contract between artists and audiences'.[5] I prefer 'intimate audience' to 'intimate theatre', as it implies the need for a code of practice given the direct involvement of an audience through personalisation. An ethics of intimate audience might be viewed as a search for points of balance along a continuum from *could* to *should*, in an audience-participant's encounter with a performance 'that pushes at the edges of our expectations of what theatre could be' – in the words of Lois Keidan and Daniel Brine.[6]

Using *Foot Washing* as a case study, I propose ethical review as fundamental to creative processes in work whose project is intimacy with an audience, whilst also evidencing that the process cannot contain every eventuality. Indeed, some obvious risks are challenging to overcome, and there may be a risk of succumbing to a false sense of security because ethical review has taken place.[7] I suggest Nel Noddings' care theory as a mode of discourse with the capacity to illuminate the nuances of engagement with *Foot Washing*. Care theory has provided a discursive framework for investigating the complicated nature of practitioner–participant interaction. In *Caring: A Feminine Approach to Ethics and Moral Education* (1984), Noddings proposes that caring, 'rooted in receptivity, relatedness, and responsiveness', is a preferable approach to ethics than 'justice-based approaches'.[8] As I will go on to investigate, by means of Noddings' model, to work towards an ethics of intimate audience is to consider reciprocity, receptivity, reversibility and benevolence as much as it is to assess beneficence through established procedures of ethical review.

Workshopping Ethics

A three-day interdisciplinary research workshop that I organised, *Theatre Personal*. at the Workshop Theatre, University of Leeds (14–16 May 2010), provided an opportunity for a practical evaluation of recommendations from the initial ethical review that *Foot Washing* received at the University of Glasgow. The research workshop was the first time that the performance involved a second layer of 'audience' beyond Howells and his solo audience-participant; usually the intimacy is private, a one-to-one encounter. Indeed, it is unsettling to look at the video footage of the workshop and see witnesses observing the performance with notebooks and pens in hand.

During the research workshops, I invited Howells to perform *Foot Washing* twice consecutively, each time with a different audience-participant and in front of a small group of 'expert witnesses' and postgraduate student theatre-makers. The group was composed of five postgraduate and postdoctoral student audience-participants and four witnesses, bringing expertise from applied ethics and psychology, with myself as the fifth witness, from theatre studies. The witnesses from ethics and psychology were invited because one-to-one theatre involves interpersonal relations that, in analogous professional situations, have a code of ethics and specific requirements regarding training

and supervision, including procedures for dealing with potential harm. This becomes even more evident where there is a blurring of habitual distinctions between social and aesthetic practices, such as in cases, including Howells', where there are similarities between intimate audience and confessional, spiritual and/or counselling experiences.[9] One of the two psychologists had significant research experience in the professional ethics of counselling and psychotherapy.

As a practitioner, Howells works with integrity, insight and sensitivity. There were many instances during the workshop weekend, and subsequently, of awareness that my understanding and insights into practice were playing catch-up with Howells' own. Nevertheless, there is not equivalency in terms of support for Howells as there is for professionals in one-to-one occupations such as therapy and counselling, particularly in terms of strategies of closure, self-support, professionally accredited supervision and support mechanisms that could be called upon if needed. Such dynamics are relatively new territory for venues, and lack of experience is heightened by the pressured economics of programming for limited audience numbers. The additional layer of spectatorship in the *Foot Washing* performances during the workshop introduced a level of inauthenticity to the research method in the sense of disturbing the intended dynamic although, as will be discussed later, this disturbance produced some illuminating responses from all parties.[10] Subsequently, and as is evident from an example discussed later in this chapter, the opportunity to evaluate findings and recommendations from the workshops in the light of audience-participant experience arose from the Battersea Art Centre (BAC)'s first One-on-One Festival (6–18 July 2010).

The intrusiveness that had been anticipated as a consequence of opening a one-to-one performance to witnesses dispersed as *Foot Washing* got underway. This was facilitated to a significant extent by the techniques that Howells had in place to prepare himself and his audience-participant. These techniques are documented online: they include a meditative sequence of seven breaths along with the verbal information and instructions that Howells gives at the beginning of the piece; these strategies recognise informed consent as a key component in facilitating ethical participation. Indeed, one of the psychologists at the research workshop observed that 'the same performance piece could have very different ethical qualities depending on the extent to which the performer has prepared themselves and the audience'. Howells responded to questions on this topic during the workshop by describing how the advance publicity for *Foot Washing* lists each stage of the performance for prospective audience-participants:

An audience member is given this experience as part of a festival. They will normally have read about it on the Internet or in a brochure and it clearly says exactly what I will do […]. I will wash your feet, I will anoint your feet […]. [I]t even says, which I am not happy about, that I will ask your permission to kiss your feet. Now, I've left that in because the ethics committee at Glasgow University insisted that I did. I wouldn't normally do this in the professional theatre world, but I've left that in for them because that is what the ethics committee insisted that I made transparent when I did this as part of my research.

The Glasgow committee's insistence upon informed consent was reiterated by ethicists and psychologists in the workshop and, at points, the student theatre-makers, Howells and I struggled with this recommendation. Our struggle was most evident in relation to the 'liquorice' performance.[11] There is evidence of Howells' struggle in the quotation given above. In the arts, advance information about what happens is often accompanied by a 'spoiler alert'. With the 'liquorice' performance there was a big difference between the artist's intention and a psychologist's concerns about how the piece might be experienced by the participant, with the recommendation that an explanation of the piece be presented at the outset, rather at the end of the performance as the artist had planned. On reflection, it seems that intimate experiences of an audience have the potential to take the participant on a journey of a different order, because the quality of 'surprise' is relocated to the unpredictability inherent in a one-off interface between practitioner/artwork and the participant's individual experience. Indeed, assumptions, misunderstandings and anxieties on the part of the participant are as potentially detrimental – though this may be itself interesting and amusing – to the piece as are 'spoilers'. Thus, informed consent may well support and facilitate a fuller reception of the work.

As is evident from the series of video clips documented online, Howells' actions in *Foot Washing* are also explained carefully at each stage during the performance.[12] This helps to address the inequality that Howells recognizes as occurring in the relational dynamic because 'the practitioner has the map'. Noddings names the two parties in the caring relationship: the 'first member is the "one-caring" and the second is the "cared-for"', and it is the inequality in this dynamic that some commentators have found problematic.[13] Sarah Lucia Hoagland critiques the ethics of Noddings' model, concerned by the reliance on 'giver' and 'taker' roles (parent and child, teacher and student), which invoke dependency and dominance.[14] This dynamic is, in fact, not so clear cut in Noddings' model – and neither is it clear cut in *Foot Washing*, as I will go on to explore.

Watching the extracts from the first audience-participant's experience of *Foot Washing*, one example shows an example where participants may be reluctant, concerned, uncertain or resistant. The carefulness and ritual of the process

is emphasized by Howells getting into a comfortable, cross-legged position. He holds the meditative pose for a few moments, seemingly to make sure he is ready. This recalls the breathing of the seven breaths preparing both Howells and his participant for the experience at the outset in one extract; the meditative pose probably also signals this reminder to the audience-participant. In an extract, the uncertainty of whether to put both feet in the bowl is acknowledged in the sharing of a small glance and laugh by Howells and the audience-participant. On watching the video, I notice that eye contact seems to function in this sequence both as reassurance and as the prompt for the participant to express a reaction. So, for example, once Howells has lathered the liquid soap in his hands he looks up at his participant and in response she half-giggles and covers her face with her hands. For a while, both gazes are concentrated on the foot that is being soaped. Then Howells looks up – a 'checking' with his participant – and her response to their eye contact is a louder giggle, or laugh, than before. As Howells gently dries her foot, an experience both felt and observed by the participant, she begins to cry and covers her face with her hands.

Howells looks at his participant several times, gauging her process, before beginning to wash her second foot. This sequence may be recognised as exemplifying the fundamental components of caring as proposed by Noddings: engrossment, motivational displacement and recognition. Noddings identifies engrossment as a requirement for caring, describing it as 'receptivity' to the needs of the other.[15] She goes on to say that engrossment must be paired with motivational displacement: where the one-caring's behaviour is determined largely by the needs of the cared-for. Howells 'checks' again as he prepares the soap, looking once and then looking again, at which point eye contact is established and the participant smiles and exhales audibly. Noddings states that caring requires recognition of the caring by the cared-for. When this happens, where the cared-for responds to the caring, Noddings describes it as 'completed in the other'.[16]

The video cuts to a conversation instigated by two questions from Howells: firstly, he asks whether the participant has had her feet washed by anyone before and, secondly, whether she has ever washed anyone else's feet. A little later, when Howells asks, 'How is it for you to have me doing this for you?' the participant's tears return. She says that it is 'quite humbling'. Her hands again go to her face, cover her eyes and wipe tears. 'I suppose it […] makes me wish that the world was better. So it is kind of good but at the same time a little bit sad'. The participant then asks, 'Can I ask you something? How is it for you washing my feet?', to which Howells replies that it 'absolutely feels like a privilege. And I am not bullshitting you, as I've washed over six hundred pairs of feet and it feels every time like something important, something special'. In response to Howells asking whether she could do the same for other people, the participant says that 'it feels like it is connected to goodness, so [I] would push through the reservations [she would feel] to give someone the experience'.

Noddings suggests that people build an 'ethical ideal, an image of the kind of person that they want to be' and it is in this context that she distinguishes between natural caring, which arises as a response based in 'love or natural inclination' and ethical caring: that is, the difference between wanting to care and feeling that one must.[17] She goes on to claim that ethical caring is based on, and depends upon, natural caring because the 'foundation of ethical response' is in 'the memory of caring and being cared for'.[18] By applying these concepts, *Foot Washing*'s 'particular intimacy' – Eve Kosofsky Sedgwick's phrase – may usefully be charted.[19] The next section explores the 'particular intimacy' of practitioner and audience-participant, with reference to some of the constraints and conventions of performance.

Accelerated Friendship, Repetition and Care

One of the witnesses from applied ethics described his response to observing *Foot Washing* at the research workshop in terms of being 'moved' by 'how getting right into the middle of someone's life' had 'happened so quickly'. This is concordant with Howells' description of his practice as inducing 'an accelerated friendship/ relationship between two initial strangers'.[20] During *Foot Washing* the intimate experience of sensual and careful treatment, of being anointed, soothed and cleansed, is employed by Howells as a means of initiating closeness and openness – intimacy – in a concentrated time period. The ticketed slots at public performances are sometimes 20 and sometimes 40 minutes long, depending on the venue's programming requirements. Howells' performance evidences Alphonso Lingis' assertion that 'the sensorial is a medium in which any point turns into a pivot, any edge into a level, any surface into a plane, any space between things into a path'.[21] The possibility of intimate engagement occurs in the connection between Howells' questions about his participant's relationship with their feet and his washing and massaging of their feet. He employs the familiar social form of massage therapy to chaperone the encounter. As is evident from the *Foot Washing* video clips, the 'accelerated friendship/relationship'[22] expressed so intensely in this example is facilitated by the 'particular intimacy' that 'seems to subsist between textures and emotions'.[23]

The title of *Foot Washing for the Sole* plays on the homophone 'sole/soul'. In a concordant realm, the recognition that underpins Eve Sedgwick's book *Touching Feeling* is that 'the same double meaning, tactile plus emotional, is already there in the single word "touching", equally it is internal to the word "feeling"'.[24] The potential for meaningful contact in *Foot Washing* operates primarily at the level of 'touching feeling'. However, this is also a site of particular vulnerability: not everyone likes, or wants, or responds well to such contact under these conditions, and even when/if they do, that intimacy can be fragile and susceptible to rupture. Furthermore, in the ethical review during the *Foot Washing* research workshops, an unexpected risk became evident.

Opposite: Adrian Howells, *Foot Washing for the Sole*, performed for camera at Gilmorehill, University of Glasgow, 2008. The foot belongs to Peter McMaster. Photo © Hamish Barton.

At the centre of the piece is a monologue during which the content becomes overtly political in referring to the Israeli–Palestinian conflict. Howells acknowledged that this had caused discomfort, particularly amongst some of his Jewish participants, in response to the opinion of a psychologist at the workshop who articulated how:

> [*Foot Washing*] changed for me into something different, from the foot washing of the participant into a political message that took me aback and I felt more uncomfortable with that. […] I'm getting a political message that I don't think you can assume – I'm sure you don't assume – that the person will agree with. That's what I feel a bit uncomfortable about and what I don't think is communicated at the start.

It is not only the range of possible responses that make attentiveness a crucial component of one-to-one theatre; it is also the temporality of performance as a medium. Particular issues arise in the challenges of time allocation, the convention of repetition and, indeed, expectations about the 'accuracy' and 'authenticity' of repeat performances.

Certainly, ethical issues might easily be anticipated to arise from the conjunction of repetition with 'accelerated' intimacy.[25] Temporality is a realm of intimate audience where performance conventions wrangle with the quality of engagement; performance repetition is a particular instance where Noddings' concept of the ethical self is required and, perhaps expected, anticipated, accepted and investigated, as I will consider.

During stints at theatre festivals, as Howells explained to me in an email, he usually did 'ten performances in a day, but [he has] done sixteen, and [has] also done six' and he usually does 'three or four' before he takes a break.[26] The form might be decried as unethical – and even elitist in its limited availability – because it is to some extent unsustainable and, on this basis, potentially discriminatory and exploitative of performer and audience alike. The practitioner responds to the demands of, and the demand for, repetition by complying with the 'script' s/he has created with the aim of achieving parity in the quality of the experience for participants, regardless of whether their allocated timeslot occurs early or late in the day. The practitioner is vulnerable to exhaustion, to the pressures imposed by self-regulation, by the contract with the venue and an awareness of audience expectations. During workshop discussions, Howells recognised that:

> The repetition is problematical. For example, in Brighton, to do 16 performances a day, because I get really tired and although on the one hand I want to work with the real, and what is happening in that space at that time, I also want to ensure that that person has a qualitative experience and so if I really allow myself to be as tired as I am, that does impair their experience and so it becomes about discipline and it becomes about a discipline of performing.

Whilst repetition is understood and expected by participants, there are inevitable discrepancies between freshness and tiredness. In worst-case scenarios, the freshness of expectation and heightened anticipation on the part of the audience-participant collides with the strain of repetition for a performer who has done the performance several times already that day.

As well as being the first occasion *Foot Washing* was performed in front of an 'audience', the *Theatre Personal* workshop also created a situation in which the participant in the first performance was able to see another participant taking part in what she had just experienced, and where the same witnesses were present for both performances. The research method caused a shift in perspective, which brought to light potential consequences that might otherwise remain concealed. A key example of this during the performances of *Foot Washing* was Howells' awareness that observers were hearing him make the same claims twice. What the participants and observers experienced were two different responses and two different interpersonal dynamics in response to the same basic scripted structure. What Howells experienced was his repetition:

> Doing *Foot Washing* a second time, I became so aware of you all spectating, while I was speaking about humility and what have you. I was so conscious of the fact that I had already said this, and that you would be thinking 'he is such a cheat'. I was conscious of that more so than I was engaging with the participant, and that has quite upset me actually, because I was not really there and present in the moment for the participant - because I was so aware that I had already said those words and you had heard them.

Howells' concern was contested by one of the witnesses, an ethicist, who said that 'it never crossed my mind that there was some kind of inauthentic representation in what you were doing'. It was also contested by the first participant's response to seeing *Foot Washing* performed a second time. These responses were both akin to Noddings' understanding of the importance of how care is being received:

> [Howells'] integrity is what makes it authentic for me. [...] Clearly it did connect with me very strongly. I think that I moved in and out [of connection with the performance] because, in my own response, I became very suspicious at various points. I thought there was something in the drink [of water] and I had to smell the drink [*laughter in room*] and I think it is because of my own vulnerability – because I'd been vulnerable. So that was all going on for me and I got a little bit paranoid at points, and so [when I was] watching you [the second person to participate in *Foot Washing*] it was much easier for me to accept that Adrian was being genuine. Watching him, he was very in that moment – although he said that it was a very different experience because people are watching – [*to Howells:*] you looked engaged to me,

and that was very reassuring having been on the other side of it because I think there's this huge trust issue.

Whilst there may be concerns that repetition is perceived as false or deceptive (and indeed this is an ethical grey area for which, it seems from the workshop discussion, the benefits usually outweigh the risks) there is an expectation that such structures are in place, as is clear in the first participant's recognition that 'my expectation was that this was a performance. Adrian will have things that he wants to do, things that he repeats'.

From the evidence of the first *Foot Washing*, the variation – which 'personalises' – is with the audience-participant. She acknowledged her experience as one that became separated from Howells' input, because 'at the end I just felt a bit overwhelmed and shell-shocked because of *my* journey, in a sense regardless of Adrian's journey'. It is the predominance of touch in the performance that, with a receptive audience-participant, has the capacity to facilitate this private time for personal reflection. In the instructions to the performance, Howells states, 'I need to get to the soles of your feet. […] This is an opportunity for us both to be silent; and perhaps my hands and your feet will have their own conversation'.

'Ethical Selves' as Obstacles

The notion of ethical care as defined by Noddings already has a performative component at its core: the need to invoke the ethical self – 'the image of ourselves at our caring best' – to which we resort when there is 'one thought too many'.[27] That is, 'when we are too tired to care or when the one cared-for proves difficult':

> There are times, of course, when we do not feel like caring, and then I've said we have to draw on our 'ethical ideal' – our history of caring and the high value we place on ourselves as carers. In this approach, care theorists are close to virtue ethicists who depend heavily on the character of moral agents. Our priority, however, is on natural caring, and our efforts at ethical care are meant to establish or re-establish the more dependable conditions under which caring relations thrive.[28]

This idea is one that offers a particular slant on the term 'virtuosity' in theatre practice, and this model is one that resonates for me in terms of the contracting and code of practice that might be most appropriate for engaging an intimate audience. What emerges is a theatrical virtuosity that is capable of sustaining the practitioner in the face of competing pressures (time limits, repetition, tiredness, hostility, resistance) that are also a result of – and subject to – the 'perform or else' mentality of theatre culture and its paying audience that allows little room for deliberate compromise, postponement or withdrawal.[29] *Foot Washing* passes on the baton of care to its participants and here a direct link might be drawn with the ethical self. However, as Noddings acknowledges and as is evidenced in the next section:

> Ethical caring, as necessary as it is, is always risky because the ethical agent's attention is diverted from the cared-for to his or her ethical self [...] If the cared-for sees this and calls us on it – 'you don't really care' – relations are likely to become even more difficult.[30]

In relation to his 'most radical project to date', *The Pleasure of Being: Washing/Feeding/Holding* (2010-11), in which he invites his participant to be 'bathed naked, cradled and fed', Howells admitted he was 'really pushing the form' of one-to-one performance, and emphasizes that 'the audience member will be able to stop the performance if they are uncomfortable'.[31] In conversation with me in November 2010, Howells described how he had come to recognise the value of preparing the participant in a vestibule outside the performance space as a direct result of the *Theatre Personal* workshop practice and discussions. This understanding also resulted in the consensual instructions being delivered by an usher possessing a detailed understanding of the piece; because Howells had learnt that by giving this information himself, audience-participants' concerns that their responses might sabotage Howells' artwork tended to increase.

One-to-one performances create a particular kind of loop where the audience-participant is observant to the way that her/his response is received by the practitioner, with the practitioner becoming an audience to the way that her/his work is received. Borrowing again from care theory, sometimes it is the case that 'the one-to-be-cared-for turns about and responds to the needs of the one-caring' and Noddings discusses how this might 'diminish the ethical ideal' yet might also be 'ethical heroism'.[32] These are eventualities that map onto the *Foot Washing* workshops and, more broadly, to other examples of intimate audience experience. An audience-participant's concern to 'give good audience' appears to be widespread.[33] Howells acknowledges that:

> It's really important that they [audience-participants] have agency, because even more in a One to One show people feel that they have to go along with things in case they sabotage the piece. It's about creating a safe space.[34]

However, being instructed to stop the performance if you are uncomfortable and feeling able to put that instruction into practice are very different things.

This question of the status of care for an intimate audience also functions on a formal level. Reflecting with me on their witness to the *Foot Washing* workshops, the ethicists questioned whether performance repetition is a form of deception and whether there is a 'sort of deception in leading people to believe they are special'. And yet, resonating with Noddings' concept of engrossment, Adam Phillips and Barbara Taylor write: 'Kindness is a way of knowing people beyond our understanding of them. By involving us with strangers [...] as well as with intimates, it is potentially far more promiscuous than sexuality'.[35] This powerful claim is one that casts as intensely meaningful the phrasing 'friendship/relationship' that Howells describes his practice as inducing.[36]

Phillips and Taylor continue to observe that kindness 'is a risk precisely because it mingles our needs and desires with the needs and desires of others'.[37] The ethicists wondered if *Foot Washing*'s constructed special attention becomes unethical because it makes the participant even more vulnerable to the feeling that this connection is short lived, fickle and therefore bogus. Yet, as they went on to acknowledge, some may prefer the knowledge of repetition as a cushion to make the intimacy – and being the focus of attention – more bearable.

Intimate audience is about getting close to us and inviting us to be open, and the dynamic is a fragile one that depends on the contingency of a meeting of 'ethical selves'. The imbalance between the anticipation of a one-off experience and the frequency of the activity for the practitioner differentiates intimacy in theatre from the (aspirant) qualities of intimacy in daily personal relationships. At the same time, there is a recognisable alignment of one-to-one performance with therapeutic, medical and pastoral dynamics, where what is unusual or loaded for the participant may be a more regularized and habituated daily occurrence for the professionals involved. A theatre dynamic, with the practitioner holding the 'map', is one that suggests Noddings' model of 'inherently unequal relations' where one person 'bears the major responsibility for caring' such as 'parent–child, physician–patient and teacher–student'.[38] However, the two performances of *Foot Washing* during the research workshops – in addition to other evidence gathered from my own one-to-one experiences and anecdotal evidence from fellow theatregoers – suggest that there are aspirations for the dynamic as one of 'mature, equal relations' where the carer and the cared-for 'exchange places regularly'.[39] Indeed, this is a shifting dynamic that *Foot Washing* asks audience-participants to consider. As one of the workshop witnesses from applied ethics observed, the areas for ethical review in Howells' theatre practice are tangible and participants 'have themselves exposed in [a] very intimate and explicitly clear way' where there are 'obvious risks' and 'obvious potential goods'. Under such circumstances, a practitioner's virtuosity or, indeed, *virtue*-osity, might be understood as a combination of being good, in both senses – of high performance proficiency and moral virtue – and of being careful.

Overleaf: Adrian Howells, *Pool Attendant*, performed as part of Home Live Art's event *Back to School at the Pool*, Camberwell Baths, London, 2005. Photo by Andrew Whittuck, courtesy of Home Live Art.

1. I thank the artists, participants and witnesses in the *Theatre Personal* pilot workshops in 2010, and to the students of *Making Spectators* in 2011 at the University of Leeds. I am grateful to the British Academy for financial support, both for this research and towards the broader project *Theatre Personal: Audiences with Intimacy*.

2. Lyn Gardner, 'How Intimate Theatre Won Our Hearts', *Guardian*, 11 August 2009, <http://www.theguardian.com/culture/2009/aug/11/intimate-theatre-edinburgh> [accessed 17 July 2015].

3. Ibid.

4. Tom Lamont, 'Edinburgh Fringe Theatre Roundup', *Observer*, 14 August 2011, p. 26.

5. Lyn Gardner, 'Wisdom of the Crowd: Interactive Theatre is Where it's at', *Guardian*, 2 March 2010, <http://www.guardian.co.uk/stage/theatreblog/2010/feb/28/interactive-theatre-connected-coney-lift> [accessed 20 August 2011].

6. Lois Keidan and Daniel Brine, 'Introduction' in *Programme Notes: Case Studies For Locating Experimental Theatre*, ed. by Lois Keidan and Daniel Brine (London: Live Art Development Agency), p. 6.

7. Adrian Howells, 'Adrian Howells: Research Ethics Processes', *YouTube*, <http://www.youtube.com/watch?v=CHhVITDzE1g> [accessed 4 January 2011].

8. Nel Noddings, *Caring: A Feminine Approach to Ethics and Moral Education* (Berkeley: University of California Press 1984), p. 2.

9. See Helen Iball, 'My Sites Set on You: Site-Specificity and Subjectivity in "Intimate Theatre"' in *Performing Site-Specific: Politics, Place, Practice*, ed. by Anna Birch and Joanne Tompkins (Basingstoke: Palgrave Macmillan, 2012), pp. 201-15.

10. Throughout, unless otherwise stated, all quotations are transcribed from *Theatre Personal* workshop discussions.

11. See Helen Iball, '*Theatre Personal* workshop: Adrian Howells', 2011 <http://theatrepersonal.co.uk/workshops/with-adrian-howells/> [accessed 1 July 2011].

12. Ibid.

13. Noddings, *Caring*, p. 4.

14. Sarah Lucia Hoagland, 'Some Concerns About Nel Noddings' *Caring*', *Hypatia*, 5.1 (1990), 109-14.

15. Noddings, *Caring*, p. 30.

16. Ibid., p. 4.

17. Ibid., p. 5.

18. Ibid., p. 1.

19. Eve Kosofsky Sedgwick, *Touching Feeling: Affect, Pedagogy, Performativity* (Durham and London: Duke University Press, 2003), p. 17.

20. Adrian Howells, 'The Burning Question #3: What's it Like Washing Feet Every Day?', *Fest*, 16 August 2009, <http://www.theskinny.co.uk/festivals/edinburgh-fringe/fest-magazine/the-burning-question-adrian-howells> [accessed 11 November 2015].

21. Alphonso Lingis, *The Imperative* (Bloomington and Indianapolis: Indiana University Press, 1998), p. 30.

22. Howells, 'The Burning Question #3'.

23. Sedgwick, *Touching Feeling*, p. 17.

24. Ibid.

25. Howells, 'The Burning Question #3'.

26. Adrian Howells, personal correspondence with the author (6 October 2011).

27. Nel Noddings, 'Care as Relation and Virtue in Teaching', in *Working Virtue: Virtue Ethics and Contemporary Moral Problems*, ed. by R. L. Walker and P. J. Ivanhoe (Oxford: Oxford University Press, 2007), pp. 41-60 (p. 49).

28. Nel Noddings, *Caring: A Feminine Approach to Ethics and Moral Education*, 2nd edn (Berkeley: University of California Press, 2003), p. xv.

29. See Jon McKenzie, *Perform or Else: From Discipline to Performance* (London: Routledge, 2001).

30. Noddings, *Caring*, 2nd edn, p. xv.

31. Howells in Susan Mansfield, 'Interview: Adrian Howells, Theatrical Producer', *Scotsman*, 18 May 2010, <http://www.scotsman.com/news/interview-adrian-howells-theatrical-producer-1-476044> [accessed 17 July 2015].

32. Noddings, *Caring*, p. 77.

33. See Deirdre Heddon, Helen Iball and Rachel Zerihan 'Come Closer: Confession of Intimate Spectators', *Contemporary Theatre Review*, 22.1 (2010), 120-33. A revised version is reproduced in the present publication.

34. Howells in Mansfield, 'Interview'.

35. Adam Phillips and Barbara Taylor, *On Kindness* (London: Penguin, 2009), p. 12.

36. Howells, 'The Burning Question #3'.

37. Phillips and Taylor, *On Kindness*, p. 12.

38. Noddings, 'Care as Relation and Virtue in Teaching', p. 42.

39. Ibid.

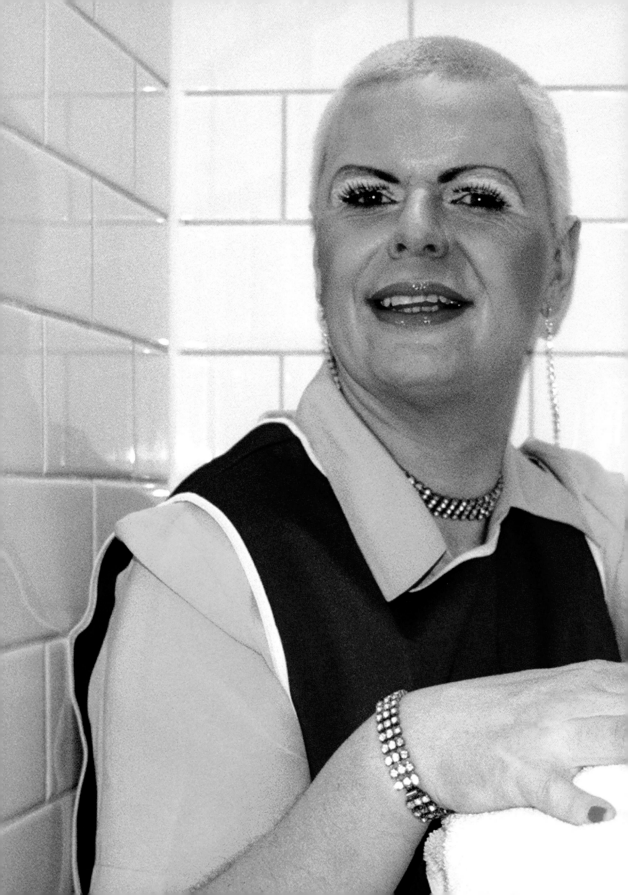

Sole History: The Grammar of the Feet in *Foot Washing for the Sole*

Kathleen M. Gough

I wanted to explore specifically whether my hands could be 'in dialogue' with another's feet.
– Adrian Howells[1]

The value of my training can be said to begin and end with the feet.
– Tadashi Suzuki[2]

Adrian Howells had a way of getting me to try things that I had decided in advance would not be particularly interesting. He took intense emotional risks in his performance practice and then discussed certain poignant moments that had taken place with anonymous participants. This always left my ever-so-slightly cynical self to wonder whom these people were who showed up to sit in a room with a stranger in a performance context and confess secrets or divulge non-verbal information about their history, their person and their bodies. Clearly, there were many people out there who had no residual memories of growing up Catholic. Yet, by early 2009 I had discussed and experienced enough of Adrian's performance work to understand that compassion expanded in the room when he was in it. It was, to me, his greatest gift to the planet – as ineffable as grace. So when he asked several of his friends to volunteer to participate in *Foot Washing for the Sole* in April 2009, in preparation for the British Council Showcase at the Edinburgh Fringe Festival that summer, I didn't flinch.

Three spaces in Glasgow were used to workshop the performance: the Gilmorehill Centre (home to the University of Glasgow's Theatre, Film and Television Studies subject groups, where I was working at the time), Balance Yoga Studio in the West End of Glasgow, and St. Aloysius Catholic Church in the city centre. When I asked which venue I should go to at the allotted time, I was told to go to St. Aloysius Church (cue my eye roll here).

So I made my way to the church in the centre of Glasgow that shares the name of the parish church of my childhood in Southern Maryland in the US. I don't have particularly fond memories of growing up Catholic in my parish church, except for during Easter season. Ash Wednesday was particularly intriguing, as it heralded in the Lenten season and I remember my excitement of observing

people going about their work with ashes on their forehead throughout the day (a little theatricality went a long way with me even at eight, nine, and ten years old). My absolute favourite day in the Lenten calendar was Holy Thursday. This is when regular community members would sit in chairs in front of the altar with their shoes and socks off and have their feet washed as part of the liturgical service. I should say that Southern Maryland is not a place where people relish performative, theatrical, or emotive displays (unless they are on the baseball field with a can of Bud). This foot-washing ceremony seemed magical to me. It was a time for play in the most expansive sense of that word. Through these rituals I came to understand what it was to make oneself vulnerable as a public act of faith. I would not have articulated that at the time, but it gave me pause each year for over a decade. The act of foot-washing bound us together as humans across time and space – in the church, or temple, or mosque, or meditation centre, or yoga studio, or black box theatre.

When I was sitting in a pew near the altar at St. Aloysius in Glasgow waiting for my allotted slot with Adrian, I was thinking back to my childhood attendance at these foot-washing ceremonies as part of the Holy Thursday Catholic service. I no longer remember whether I was hearing the sound of Adrian at the back of the church replacing the water in the basin where participants placed their feet, or the sound of the water in the basin in front of the altar at that other St. Aloysius Church 3000 miles away and what seems like several lifetimes ago. Adrian, the sound of the water splashing, the site of the performance, and I were placed somewhere precariously between ritual and theatre, between the here and now and once upon a time. This church in Glasgow, my childhood church in Maryland and *The* Church were like a single melody of an arpeggiated chord, where the notes are not played together but spread out over time. Together they operate like an audio loop where ritualised behaviour collapses time, space and architecture in a way that becomes both iterative and cumulative.

In many respects St. Aloysius Church was just the occasion to think about the manner in which ritualised behaviour often operates like a sound loop. Nevertheless, it also underscores and highlights a rich and complex performance genealogy for Howells' work that has remained surprisingly absent in performance criticism: its inextricable connection to religious and spiritual performatives. Exploring *Foot Washing for the Sole* in the context of late Byzantine (eastern Mediterranean) and medieval (Western European) monastic art and culture (ca. 950-1450 A. D.) illuminates an alternative genealogy for intimate and immersive theatre – one that *Foot Washing* best exemplifies but which is by no means anomalous in contemporary art and performance practice. In *Medieval Modern: Art Out of Time* (2012), Alexander Nagel explores how 'contemporary art has put pre-Enlightenment modalities back into operation'.[3] In recent performance criticism this is, perhaps, nowhere

Overleaf: Adrian Howells, *Foot Washing for the Sole*, performed for camera at Gilmorehill, University of Glasgow, 2008. Photo © Hamish Barton.

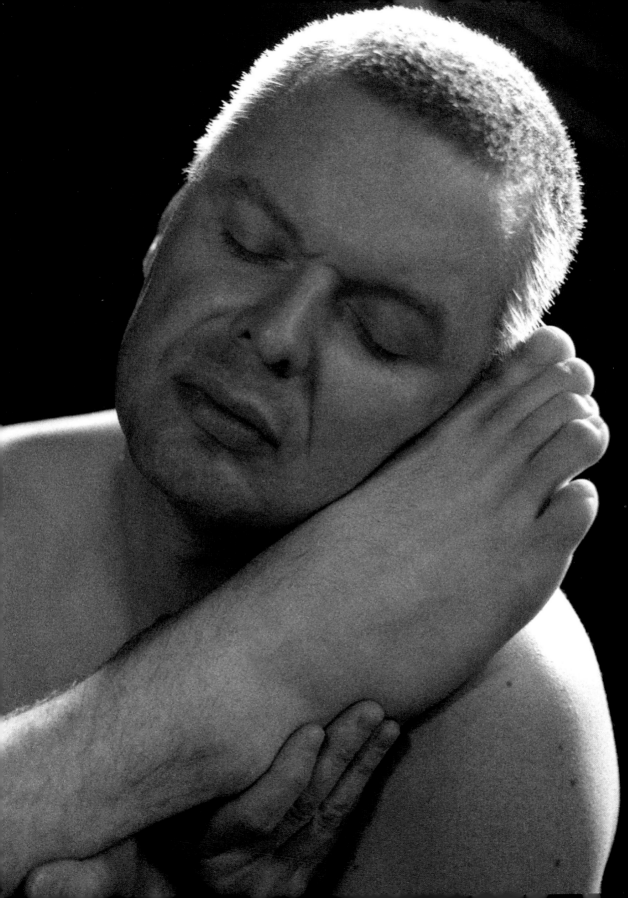

more evident than in Marla Carlson's *Performing Bodies in Pain: Medieval and Post-Modern Martyrs, Mystics and Artists* (2010) where she uses the conceit of bodies in pain to read recent dramatizations of torture and self-inflicted pain in performance art against late medieval saints' plays.[4]

While Carlson reads particular medieval and contemporary plays and performances by comparing thematic similarities, I am suggesting here that Howells' *Foot Washing* is far more than a thematic variation on an ancient theme. Instead, this performance shares key features with pre-Enlightenment foot-washing rituals – not the least of which is its desire to dissolve boundaries between ritual, theatre, religious practice and everyday life. Locating Howells' *Foot Washing* within a longer history of foot-washing practices affords a different conceptual point of departure for understanding the loop between pre-modern and postdramatic performance – one that asks us to take seriously how religious and spiritual performatives continue to animate contemporary experimental theatre.[5]

Many religious cultures around the world do, of course, share foot-washing as a ritual practice, and Howells 'read up about foot-washing and purification rituals in other religions and cultures'.[6] However, his preparation for this particular piece began by reading the Bible, specifically, the Gospel of John where Jesus washes the feet of his disciples during the Last Supper on the eve of his crucifixion.[7] The following is the passage from the Gospel of John that helps to lay the foundation for exploring the loop between religious and spiritual performatives and postdramatic performances like *Foot Washing*:

> [He] got up from the meal, took off his outer clothing, and wrapped a towel around his waist. After that, he poured water into a basin and began to wash his disciples' feet, drying them with the towel that was wrapped around him. [...] When he had finished washing their feet, he put on his clothes and returned to his place. 'Do you understand what I have done for you?' he asked them. 'You call me "Teacher" and "Lord," and rightly so, for that is what I am. Now that I, your Lord and Teacher, have washed your feet, you also should wash one another's feet. I have set you an example that you should do as I have done for you'. (John 13.5)

In an interview for the British Council in 2010, Howells recalls how, upon reading this, he thought to himself, 'this is a fantastic humanitarian challenge: to do for somebody who might be a stranger, a neighbour or a perceived enemy'.[8] He then took up this challenge, creating *Foot Washing* specifically to travel first to Israel where he washed the feet of both Israelis and Palestinians.

There is no denying the ways this performance is a contemporary iteration of ancient religious and spiritual practices of foot-washing. Explaining the power of performative speech acts, Judith Butler uses the language associated with the aural dimensions of looping – such as echo and repetition – in her discussion. 'If a performative provisionally succeeds', she writes, it is 'because that action

echoes prior actions, and *accumulates the force of authority through the repetition or citation of a prior and authoritative set of practices*.[9] In other words, 'It is not simply that the speech act takes place *within* a practice, but that the act is itself a ritualised practice'.[10] Ultimately what this means 'is that a performative "works" to the extent that it draws on and covers over the constitutive conventions by which it is mobilised'.[11]

The performative 'utterance' at the centre of the 'ritualised practice' in *Foot Washing* is located in the grammar of the feet: it is the presence of feet being displayed for washing, and then being washed, that not only dissolves the boundary between the historical and contemporary, but the entire idea of medium specificity. In *Foot Washing*, the genre, the being-in-a-medium of aesthetic performance, dissolves the moment that participants place their feet in the basin of water in front of Howells' kneeling body, and take their place as iterations in a ritualised practice that has always and everywhere been genre-dissolving.

Nowhere is the genre-dissolving quality of this ritual more pronounced than in Byzantine and medieval monastic art and culture – milieux that I have come to understand as ground zero for considering alternative genealogies of contemporary postdramatic performance.[12] In order to hear the pattern of this ritualised behavioural loop – where the feet sometimes sound religious, at other times royal, at one moment pedestrian, at another moment lifesaving, and almost always postdramatic – I first want to listen to the grammar of our feet in Howells' hands. Then it might be possible to hold Byzantine and medieval feet as they walk back and forth across mediums without the slightest concern for specificity. These feet tell us about the performance history of the future that begins (again) with immersive, one-to-one performances that Howells' own practice helped to bring (back) into existence.

Sole/Soul Histories

Foot Washing for the Sole is a one-to-one performance that takes place over a period of 30 minutes and is – quite literally – a foot-washing experience. It begins when the participant enters the space, sits in a chair with Howells poised at his or her feet, and is invited to inhale and exhale seven times. In Howells' own words, he then:

> simply washed, dried, anointed with oils, massaged and kissed the participant's feet. Intimacy was engendered not only through the touching of the feet but also through the silence and stillness that surrounded the performance, as well as through supposed 'acts of servility'.[13]

The foot massage is performed in complete silence, where the 'dialogue' is simply between Howells' hands and a participant's feet. In contrast, while he is washing and drying the participant's feet, there is a minimal spoken exchange that is intended to 'allow for a body-memory connection and either a verbalized or internalized confession'.[14] In order to prompt this exchange (or

'confession' as he calls it), Howells asks each participant seven questions:

1. What is your relationship with your feet?
2. Do you ever give your feet a treat like having a pedicure or a foot massage?
3. How is it for you to have me kneel here washing your feet for you?
4. Has anyone else ever washed your feet for you?
5. Could you wash somebody else's feet for them?
6. Would you be prepared to wash a total stranger's feet?
7. Do you think your feet are capable of picking things up and leaving things behind (beyond the literal, physical sense)?[15]

The dramaturgy of this performance – as it works its way back and forth between the aural/oral dialogue and the silent dialogue of touch – slowly dissolves the boundary between an aesthetic experience of performance and play (that is, 'Do you ever give your feet a treat like a pedicure?'), and the ethical gesture to which this particular practice is directed (namely, 'Would you be prepared to wash a total stranger's feet?').

In James Hillman's *Healing Fiction* he asks the question, 'What does historicizing do for the soul?'[16] This question allows Hillman to interrogate the false distinction between a case history (which is often considered the *real*, literal facts of someone's life), versus a soul history (our internal narratives that are often relegated to the realm of pure imagination, as something *not real*). According to Hillman, one of the things that historicising does for the soul is to bring the supposedly imaginary narratives that we have internalised about ourselves and the world into history. Historicising also puts events into another genre: 'neither here and now, nor once upon a time, but halfway between'.[17]

While Hillman's intent is to historicise the soul, Howells' intent is, in many respects, to historicise the *sole* – to imagine the sole's history as a personal confessional case history. When Howells says that a minimal spoken exchange is intended to 'allow for a body-memory connection and either a verbalized or internalized confession', there is an assumption that this dialogic exchange, in tandem with the washing and drying of the participant's feet, will *produce* something ('a verbalized or internalized confession').[18] I suggest that it is not autobiographical, psychological (soul/sole) history that is triggered in this performance, or at least not in the way we typically understand this idea. Rather, participants inhabit both first-time-ness and repetition. In Richard Schechner's theory of the restoration of behaviour – defined as 'twice behaved behaviour' – he highlights this process by discussing how 'social actions' and 'cultural performances', defined as 'events whose origins can't be located in individuals, if they can be located at all' are, when acted out, 'linked in a feedback loop with the actions of individuals'.[19]

In *Foot Washing* and in Howells' other one-to-one works, the locus of attention (both by Howells and performance critics) is focused almost exclusively on

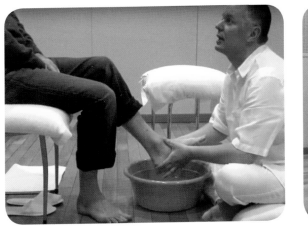

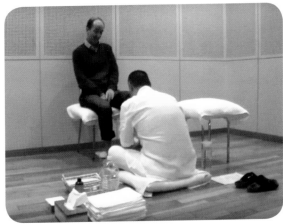

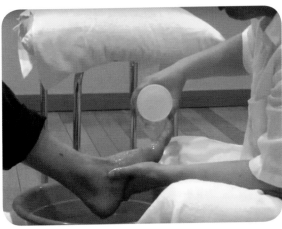

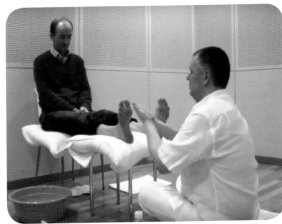

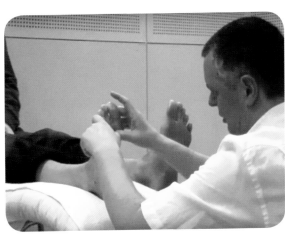

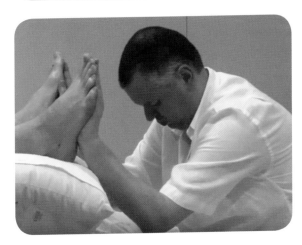

Above: Stills from video documentation of Adrian Howells, *Foot Washing for the Sole*, performed at Tokyo Performing Arts Market, Tokyo, Japan, 2010, as part of Connected Festival, supported by British Council. Video by Kazuomi Furuya and Miho Nitta.

the artist's intentions and the agency and affect of the participants.[20] The one thing that is never explicitly discussed is how this one-to-one performance is, itself, a performative utterance: the degree to which the performance 'works' has to do with 'the extent that it draws on and covers over the constitutive conventions by which it is mobilised'.[21] Instead, the themes that animate criticism are focused on how this one-to-one confessional performance work (a genre that Howells' practice helped to invent) is best understood using the language of immersion, intimacy, risk, confession, complicity and participation as these tropes have come to define experimental performance practice in the early twenty-first century. It is important for this discussion to note that all of these concepts listed here are typically associated with individual interiority and individual intention.

Considering that Howells' solo performance work has its roots in autobiographical, dialogic exchange, recourse to this paradigm is not surprising. In Howells' interview with Dan Prichard in 2010, he says he wanted to move away from one-to-one performance because he was concerned that the work was too focused on individualism (at the expense of the community and the collective experience).[22] Paradoxically, in moving from the autobiographical model of performance for small groups of people, to the silent performance-for-one, his practice actually moved away from the small 'I' of individual autobiography with its attendant traumas, joys, injuries, and ironies. In turn, it moved into a space that could hold the stories that the small 'I' likes to tell itself in a far more vast and mysterious framework of touch and silence.

Foot Washing does not necessarily produce anything outside of the labour associated with the performance itself. As part of a ritualised behavioural loop, historical referents for this practice are not separate from the action performed in the present tense. There is simply a continuous loop where each exchange between performer and participant might strike a different chord, but where the grammar of individual feet expresses no *fundamental* difference from other feet that have participated in this performative ritual throughout its long history. It is not personal, or not in the way we typically associate the personal with the unique, the original and the individual. Neither is this practice representational in the way we typically associate that concept with theatre.

In this postdramatic world, contemporary expressions of mimesis, as this conceit is understood in *Foot Washing*, might best be described in the way the medieval Byzantine world understood mimesis: as presence, as performance. As Bissera Pentcheva explains, 'what the Byzantine offers us today is an access to a culture that defined the process of image-making not as an artistic modelling of representational mimesis, but as a sensually saturated experience of the divine accessible to both actors (that is, singers) and audience (that is, congregation)'.[23] A consideration of the 'divine' of postdramatic performance as those aspects of the work where we can create the conditions but cannot control outcomes and intentions (those moments where we might understand how we are powerless) might allow us to see how the ritual, gestural practice

of *Foot Washing* is also a process of image-making – 'a sensually saturated experience' where Byzantine, medieval and postdramatic feet are heard on a loop as arpeggiated counter melodies. These melodies are not played at exactly the same time, but are spread out in order to create a kind of rhythmic interest across mediums.

The Medieval Grammar of the Feet

Exploring the relationship between medieval and Byzantine foot-washing practices and Howells' contemporary postdramatic manifestation as arpeggiated counter melodies is a way of understanding the circuitous interaction between the pre- and post- dramatic. The capacity of foot-washing practices to jump mediums and dissolve genres so readily is, in part, how spiritual and religious performatives help to constitute one genealogical strand of postdramatic performance practice.

In order to clarify how concepts such as looping, dissolution of genres, and aural/oral (as opposed to visual) culture – which are so prevalent in postdramatic performance – operate within Byzantine and medieval culture let us return to the foot-washing scene in the Gospel of John. 'The ritual inspired by this passage called *mandatum* in the Latin West and *nipter* in the Greek East', writes William Tronzo, 'was one of the most widely diffused and enduring ceremonies of the entire Middle Ages'.[24] Tronzo suggests that this was 'due to the breadth and complexity of the subject, which combined themes of water and purification, humility and charity'.[25] While the origins of the Church practice of *mandatum* are obscure, in the British Isles the 'centrality of the monastic foot-washing was stressed as early as the eighth century in Bede's *Vita prosaica*, the Life of St. Cuthbert' and was bound to both biblical referents and the Judaic custom of hospitality where one washed the feet of guests after a long journey.[26]

A common sense approach to understanding how images of foot-washing appear in Byzantine and medieval monastic art is to imagine that the images depicted are pictorial representations of the biblical story; they are an imitation of form. However, as Pentcheva argues, 'Byzantine *mimesis* is the imitation of presence'.[27] In other words, the foot-washing scenes are not Platonic depictions where an artistic rendering is modelled on an essence, or ideal image, but are based on rituals happening in real time-space. This theory also holds true for Western monastic practices at this time where 'footwashing scenes are multiplied in monastic art and adapted to mirror foot-washings that were a part of the monk's daily life'.[28] As Susan Von Daum Tholl writes, 'Such image manipulation is striking in the early part of the fourteenth-century Peterborough Psalter, where a scene of St. Benedict washing the feet of a poor man is incorporated into a series of Scripture-related footwashings'.[29] This refashioning of a biblical event – the manner in which monastic practices of foot-washing are used as the 'origins' for pictorial representations of the biblical story and not vice versa – are echoed by Tronzo who examines how the subject of foot-washing is depicted in Byzantine church mosaics in the Greek East:

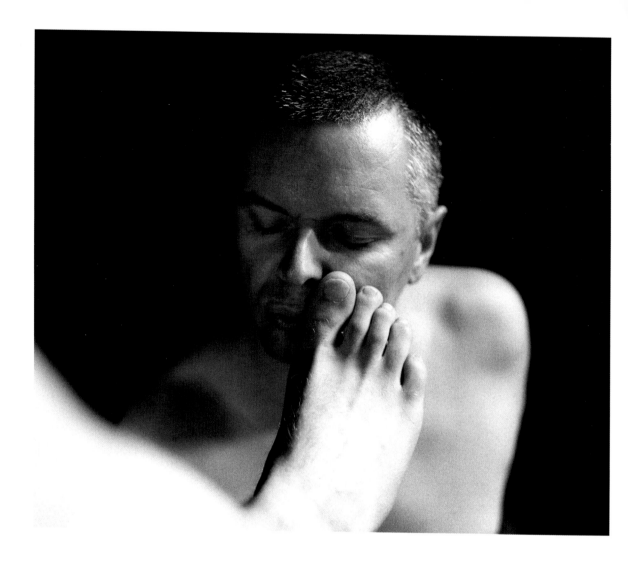

'it was the ritualized Gospel text that gave rise to an image that was meant to stand as a perfect and complete model and prototype, embracing both the visual and the verbal, for the re-enactment of the event in real life; sacred past and liturgical present thus met'.[30] In this particular arpeggiated counter melody, the Biblical story is the paradigm for the single images, and the single images are a paradigm for the Biblical story. They are on a loop.

These foot-washing ceremonies – particularly the way they brought together themes of humility and charity – not only proliferated throughout Byzantine and medieval monastic culture, they were simultaneously being played out (so to speak) in the high courts of Byzantine emperors and medieval royalty. As early as the eleventh century, there is evidence that the wife of King Henry I of England, Matilda, 'wore a hair shirt under her clothes when she invited lepers to her private chamber where she washed their feet and kissed their hands'.[31] In addition, in a 'fourteenth-century treatise on Imperial ceremonies attributed to an author known as Pseudo-Kodinos, a ceremony is described for Holy Thursday in which the emperor washed the feet of twelve paupers of Constantinople'.[32] These accounts illustrate some of the ways images of foot-washing were simultaneously thought of as sensually saturated experiences: what we think of as images of foot-washing were, in fact, never about the past but about contemporary enactments performed by countless actors amidst innumerable audience members. The grammar of the feet suggests ways that past, present and possible future coexist.

This conceit recalls Sharon Aronson-Lehavi's discussion of the characters in medieval mystery plays that are 'like molds that can be filled by different performers even within the same performance'.[33] One of the most elaborate illustrations of this theory as it pertains to nonreligious foot-washing practices is found in the 'Order of the Maundy' in Queen Elizabeth's court written down by William Lambarde in 1572. The description of this royal ritual takes us through the spiritual performative echoed in monastic practices, to the hyper-theatricality of life at Elizabeth's court. It highlights how the shape-shifting historical contexts for this practice appear as arpeggiated counter melodies where the sensual content changes its formal configuration, but where the ethical gesture remains intact. Because this thick description reads like an alternative genealogy for immersive, intimate postdramatic performances like *Foot Washing*, I quote it at length:

> First, the hall was prepared with a long table on each side, and forms set by them; on the edges of which tables, and under those forms, were layed carpets, and cushions for her majesty to kneel, when she would wash them (the poor). There was also another table laid across the upper end of the hall, somewhat above the foot pace [a platform immediately before an altar] for the Chaplain to stand at. A little beneath the midst

Opposite: Adrian Howells, *Foot Washing for the Sole*, performed for camera at Gilmorehill, University of Glasgow, 2008. Photo © Hamish Barton.

whereof, and beneath the foot pace, a stool and cushion of estate was pitched, for her majesty to kneel at during service time. This done, the holy water, basins, alms, and other things, being brought into the hall; and the chaplain and poor folks having their said places, the yeoman of the laundry, armed with a fair towel, and taking a silver basin filled with warm water and sweet flowers, washed their feet, all, one after another, wiped the same with his towel, and so, making a cross a little above the toes, kissed them. After him, within a while followed the sub-almoner, doing likewise, and after him the almoner himself also; then lastly, her majesty came into the hall, and, after some singing and prayers made, and the gospel of Christ's washing his disciples feet read, thirty-nine ladies and gentlewomen, (for so many were the poor folks, according to the number of the years complete of her majesty's age), addressed themselves with aprons and towels to wait upon her majesty; and she, kneeling down upon the cushions and carpets under the feet of the poor women, first washed one foot of every of them in so many several basins of warm water and sweet flowers, brought to her severally by the said ladies and gentlewomen, then wiped, crossed, and kissed them, as the almoner and others had done before.[34]

What is striking here is that despite the fact that this is happening in Elizabeth's court, she is not the sole subject of the piece. She is one of four actors washing the feet along with the Yeoman, Sub-Almoner and Almoner; all of them are performers sharing a single performative 'mold'. Similarly, the 39 recipients also share the single mould of grateful paupers. While there is minimal spoken language to this practice (it is not a performance driven by narrative even if some language is spoken, similar to the use of language in *Foot Washing*) the image that it creates is steeped in sensual, sensorial detail: the 'fair towels', 'silver basins filled with warm water and sweet flowers', the cross above the toes, the kisses, the singing, prayers, lush carpets and cushions transport us to a world between ritual and theatre – a world, one might add, that shares uncanny similarities with Howells' *mise en scène* in *Foot Washing*. It is this world between ritual and theatre that begins to tell us about the performance history of *Foot Washing* as surely as *Foot Washing* begins to illuminate the postdramatic routes of pre-dramatic performance.

Our Feet in His Hands

In March 2015, on the eve of the first anniversary of Adrian's death, I had been living in Burlington, Vermont for eight months. Having recently returned to the US after almost a decade in Scotland, which had brought me in contact with the precarious reality of multiple deaths and departures, I had a dream. In this dream I was at the Glasgow Film Theatre in the city centre. This cinema is also located just down the street from St. Aloysius Church, the site of my own foot-washing experience with Adrian in 2009.

In March 2014 I was supposed to meet Adrian at this cinema to watch *The Grand Budapest Hotel*. Earlier that day he cancelled our date for the evening

and was unreachable by mobile phone. This was an unprecedented experience in our friendship and for two days it left me uncharacteristically anxious, weepy and troubled for reasons that made no sense to me. On the second day of my despair, when I thought I was going crazy but still did not understand the nature of my feelings, I would find out that Adrian left his body that evening.

In the dream I had in March 2015, I was queuing at the Glasgow Film Theatre for Adrian's *Foot Washing*. I was so excited to see him again, but I was confused by the hundreds of people sitting in the cinema waiting for their turn in the performance. I thought about how Adrian would never have time to wash all of their feet and wondered if something had gone wrong with the ticketing for the event. At one point, still standing just inside the doorway to the cinema, Adrian passed in front of me. It had been so long since I last saw him, that I could hardly contain my excitement. He looked busy so I decided not to keep him from his preparations. I just hoped that he was not going to be too busy to see me again.

At some point in this dream, as I waited in the queue, the visual image of Adrian faded and he started to speak to me in a disembodied voice. He was confused as to why I thought he was in the cinema and wanted me to explain. I broke down in a flood of tears and told him I had forgotten – I had forgotten that he was not here anymore. I felt devastated (and still do recalling this dream). He then told me he had not come back to wash people's feet, but to run a workshop to teach others how to perform the practice so that they could pass it on. I woke up crying and did not stop crying that day. To me, the dream was an iteration of the spiritual performative loop that I did not anticipate. This, I began to understand, is not only a genre-dissolving practice, but one where a worldly sole history does co-mingle with our soul's history. It was personal, but not in the way I had imagined it would be.

I know of no other performer who could do this work with Adrian's integrity and discipline. Paradoxically, what allowed the work to travel far and wide with such success *as* performance (*Foot Washing* was performed around the UK, Ireland, Israel, Singapore, Germany, Canada and Japan) is that the performance had little to do with Adrian. On some level, Adrian knew this. He had some difficulties in his performance work after *Foot Washing*. When he returned to autobiographical material in 2011 he got very ill. Returning to the small 'I' of autobiography was, for Adrian, another kind of restored behaviour – one where there was a law of diminishing returns. In Adrian's autobiographical work, his Christ consciousness too easily mingled with crucifixion complex.[35] In the end, it was the simple grammar of our feet in his hands – not as symbolic act, not as representational practice, but as presence, as ethical gesture, and as a collaborative promise that would go on long after we left the performance. The resonance of our brief encounter with Adrian continues to linger in the language of that final kiss: *love*.

1. Adrian Howells, 'Foot Washing for the Sole', *Performance Research*, 'On Foot', 17.2 (2012), 128-31 (p. 128). This essay is reproduced in full in the present publication.

2. Tadashi Suzuki, *The Way of Acting: The Theatrical Writing of Tadashi Suzuki* (New York: Theatre Communications Group, 1993), p. 21. In 'The Grammar of the Feet', a chapter in Tadashi Suzuki's *The Way of Acting*, he discusses the central significance of feet in his performance training by weaving together a discourse that incorporates the physiological, the anthropological, the architectural, the spiritual and the theatrical. It is this attention to how medium specificity dissolves in discussions of the feet to which this essay directs its attention.

3. Alexander Nagel, *Medieval Modern: Art Out of Time* (London and New York: Thames & Hudson, 2012), p. 9.

4. Marla Carlson, *Performing Bodies in Pain: Medieval and Post-Modern Martyrs, Mystics and Artists* (Basingstoke: Palgrave, 2010).

5. The term 'postdramatic' was first used by Richard Schechner to describe Happenings as a 'new theatre [that] lacks human intentionality', in *Performance Theory* (1977 rpt. London and New York: Routledge, 1988), p. 23. For Hans-Thies Lehmann, whose *Postdramatic Theatre* was translated from the German to the English in 2006, while dramatic theatre is defined by a sense of 'wholeness' and serves as the '*model for the real*', *postdramatic* theatre comes into existence when these elements are no longer the regulating principle, but one variant among many: see *Postdramatic Theatre* (London and New York: Routledge, 2006). The features that best describe intimate postdramatic immersive performances like *Foot Washing for the Sole* – where genres are dissolved, where there are no traditional characters, where text does not drive a 'plot', where the main focus is the interaction of audience and performer, and where presence and process replace a fixed representational 'meaning' and authorial intent – are also key features of pre-dramatic rituals of the Byzantine (Eastern European) and medieval (Western European) Christian worlds.

6. Howells, 'Foot Washing for the Sole', pp. 130-1.

7. Ibid., p. 129.

8. Dan Prichard, British Council Arts Interview with Adrian Howells, April 2010, <https://www.youtube.com/watch?v=C7btf8Tdg_s> [accessed 25 May 2015].

9. Judith Butler, 'Burning Acts – Injurious Speech', in *Performativity and Performance*, ed. by Andrew Parker and Eve Kosofsky Sedgwick (London and New York: Routledge, 1995), pp. 197-227 (p. 205). Emphasis in original.

10. Ibid.

11. Ibid.

12. See Kathleen M. Gough, 'The Art of the Loop: Analogy, Aurality, History, Performance', *TDR: The Drama Review* (2016), where I argue that the dramaturgical aesthetic of recent postdramatic performance practice returns to medieval modes of representation.

13. Howells, 'Foot Washing for the Sole', p. 131.

14. Deirdre Heddon and Adrian Howells, 'From Talking to Silence: A Confessional Journey', *PAJ: A Journal of Performance and Art*, 33.1 (January 2011), 1-12 (p. 7). This essay is reproduced in full in the present publication.

15. Ibid., p. 9.

16. James Hillman, *Healing Fiction* (Barrytown: Station Hill Press, 1998), p. 43.

17. Ibid., p. 44.

18. Heddon and Howells, 'From Talking to Silence', p. 7.

19. Richard Schechner, *Between Theatre and Anthropology* (Philadelphia: University of Pennsylvania Press, 1985), p. 37.

20. For insightful critical essays that engage these concerns in relation to *Foot Washing*, see Heddon and Howells, 'From Talking to Silence'; Howells, 'Foot Washing for the Sole'; Helen Iball, 'Towards an Ethics of Intimate Audience', *Performing Ethos*, 3.1 (2012), 41-57; and Fintan Walsh, 'Touching, Flirting, Whispering: Performing Intimacy in Public', *TDR: The Drama Review*, 58.4 (Winter 2014), 56-67. A revised version of Iball's essay is reproduced in the present publication.

21. Butler, 'Burning Acts – Injurious Speech', p. 205.

22. Prichard, British Council Arts Interview with Adrian Howells.

23. Bissera V. Pentcheva, 'Performing the Sacred in Byzantium: Image, Breath, Sound', *Performance Research*, 19.3 (June 2014), 120-8 (p. 120).

24. William Tronzo, 'Mimesis in Byzantium: Notes toward a History of the Function of the Image', *RES: Anthropology and Aesthetics*, 25 (Spring 1994), 61-76 (p. 62).

25. Ibid.

26. Susan E. Von Daum Tholl, 'Life According to the Rule: A Monastic Modification of Mandatum Imagery in the Peterborough Psalter', *Gesta*, 33.2 (1994), 151-58 (p. 154-5).

27. Bissera V. Pentcheva, 'The Performative Icon', *Art Bulletin*, 88.4 (December 2006), 631-55 (p. 632).

28. Von Daum Tholl, 'Life According to the Rule', p. 151.

29. Ibid.

30. Tronzo, 'Mimesis in Byzantium', p. 67.

31. Virginia A. Cole, 'Ritual Charity and Royal Children in 13th-Century England', in *Medieval and Early Modern Ritual: Formalized Behavior in Europe, China and Japan*, ed. by Joëlle Rollo-Koster (Boston and Koln: Leiden, 2002), pp. 221-43, (p. 225).

32. Tronzo, 'Mimesis in Byzantium', p. 62.

33. Sharon Aronson-Lehavi, *Street Scenes: Late Medieval Acting and Performance* (Basingstoke: Palgrave, 2011), p. 101.

34. William Lambarde, 'The Order of the Maundy at Greenwich, March 19, 1572', *Archaeologia*, 1.1 (January 1779), 7-9 (pp. 7-8).

35. Howells acknowledged these elements in his work, which were influenced perhaps by his period as a 'born-again' Christian at university in the 1980s. More recently, however, in an interview with Dominic Johnson, Howells says, 'I think I have had a tendency – not on a conscious level – to *play the martyr*. I guess I've been comfortable with that, as it's all I've ever known. Now I'm conscious of it, I don't want to play the martyr anymore'. See Dominic Johnson, 'Held: An Interview with Adrian Howells', in *The Art of Living: An Oral History of Performance Art* (Basingstoke and New York, 2015), pp. 262-85 (p. 282). Emphasis in original. A revised version is reproduced in the present publication.

The Pedagogy of Adrian Howells

Robert Walton

Teaching and workshops constituted a large part of Adrian Howells' professional practice. In the last decade of his life he gave workshops on his signature approach to intimate one-to-one performance across the UK, as well as in Canada, Israel, Finland, Singapore and Australia. Communities of like-minded artists were formed through the shared experience of Howells' affecting workshops. The approach to work that he imparted opened a new paradigm for artists seeking, as Howells put it, 'to foster genuine exchange with each audience participant'.[1] At the time of his death Howells was internationally recognised as a leading authority in intimate, autobiographical and one-to-one performance.

All of Howells' later practice might be viewed through the lens of pedagogy. His performance works often took place within carefully constructed learning environments where the audience might practise, or even rehearse, versions of themselves. Furthermore, the tactile aspects of the performances included his touch, which had an instructive force that effected new insights and experiences. Ultimately, in all of his intimate performances there was an aspect of Howells leading by example and modelling, as a teacher might, a brave new kind of behaviour. In the earlier speech-based works, such as *An Audience with Adrienne* (2007-10) and *Salon Adrienne* (2005-7), we became brave enough to share our confessions with him. In the later sensory-immersion works, including *Foot Washing for the Sole* (2008-12) and *The Pleasure of Being: Washing/Feeding/Holding* (2010-11), we became brave enough to occupy long periods of silence and bodily intimacy with him. What a privilege for audience members to be taught by Howells during the years that his extraordinary practice transformed.

In tandem with the rapid development that took place in Howells' approach to making performance over the last decade of his life came a new, explicitly pedagogical focus for his workshops with students and independent artists. The notes, lesson plans and correspondence from Howells' archive reveals a marked journey from his millennial 'Beyond the Comfort Zone' workshops;[2] through experiments with confessional workshops from 2007;[3] to the later performance workshops on intimacy and one-to-one that he led around the world from about 2010 onwards.[4] All of the workshops across this timespan are unified by the theme of moving beyond and shedding the constraints of the everyday in order to find more direct and urgent ways to communicate. There are also recurring images of one body being held by another, the common use of blindfolds, extreme physical intimacy, and the role of Howells as provocateur, reassuring participants that a search for the 'beyond' is absolutely *allowed*.

Howells' work with the dancer and choreographer Nigel Charnock greatly influenced his approach to creating 'Beyond the Comfort Zone' as a workshop for actors which explored the state of physical exhaustion and its effect on the authenticity of spoken text. In his preparatory notes, Howells outlined introductory caveats that framed these workshops:

> I will push you, but with TLC place of discovery.
> Be prepared to challenge yourselves, to embrace the
> uncomfortable – physically, emotionally, psychologically
> OPPORTUNITY to push back boundaries, to go beyond
> your comfort zone.[5]

The workshop drew upon fragments of text drawn from the actors' experiences of past relationships that were then manipulated through a series of gruelling physical exercises. Howells planned these experiences very carefully and used high-energy dance music to further heighten the working environment. The workshop explored rapture and the ecstatic body in performance, quivering and exhausted, *in extremis*, beyond the everyday.

As Howells' performance works became quieter and more meditative, so too did his workshops. From about 2010 onwards the workshops were less energetic and declamatory and created more space for discussion and introspection. Howells had also moved from a predominantly theatre-based context, where workshop participants would normally be actors, to a broader field of live art where his students came from a diverse range of backgrounds, including those from disciplines other than performance. There was a greater emphasis placed on students creating their own experimental, intimate one-to-one performance through a longer workshop period. The exercises in the new workshops remained challenging, asking participants to work

Opposite: Adrian Howells performed for camera with a series of invited audience-participants – here with Susan Yip – to produce images to accompany lectures by the artist. Gilmorehill Theatre, University of Glasgow, 2008. Photo © Hamish Barton.

Above: Stills from video documentation of Adrian Howells and participants in a three-day workshop for the HATCHLab series at Harbourfront Centre Theatre, Toronto, Canada, 2011. The workshop was organised in association with the School of the Arts, Media, Performance and Design at York University; and the Rhubarb Festival at Buddies in Bad Times, Toronto.

in extreme physical proximity, to transgress interpersonal taboos and share intimate experiences. However, Howells was now focused on creating what he considered to be safe and ethical frameworks which would 'hold' his workshops by promoting mindfulness and concern for others.

While Howells' notes for these workshops stated his aim for the exercises to 'promote ideas of intimacy and risk-taking' there is also a new focus on 'gift-exchange' and 'creating an environment and atmosphere of openness, honesty and trust'.[6] In fact, his increased awareness of the ethical dimension and responsibilities of his developing performance practice fed directly into the workshops, which by 2011 always included discussion of:

1. Ethical considerations with one-to-one and intimate work
2. Empowering audience-participants
3. The idea of pre and post performance care
4. Questions of how much/what information is given in pre-performance publicity materials.[7]

The later documents in the archive reveal Howells' increased clarity and specificity within his pedagogy. Here he introduces himself as being 'interested in work that deeply nurtures and nourishes individuals', as well as 'promot[ing] intimacy and vulnerability in a safe environment'.[8] In order to foster genuine exchange with audiences he was able to articulate three linked themes within his work: intimacy and one-to-one performance; risk and vulnerability; and autobiography and confession.

At this stage in his work Howells was able to deftly align the concerns of his performance practice very closely with his pedagogical approach, as he outlined at the beginning of his 2011 workshop in Toronto:

> [I am] interested in [a] really qualitative examination of the dynamics of a shared experience, putting it under a microscope, slowing everything down, paying attention to detail, looking at the minutiae of an exchange between 2 people, looking at very simple actions/gestures, making a real connection, being 'in the moment', presence, stillness and silence.[9]

The archive reveals how Howells refined his workshops across each iteration. Reading the notes left behind, it is possible to glimpse the workings of a teacher searching for the best way to create spaces to disseminate this most sensitive and ephemeral of practices. He created exercises to promote 'tactile and tender exchange', 'non-verbal communication' and 'ideas of presence, stillness and silence' that included washing a partner's face and hands, feeding one another, 'spooning and holding each other in a prolonged embrace'.[10] Though conducted quietly and with great care, these exercises still radically transgressed taboos of physical and emotional intimacy with strangers, and challenged participants to explore where their own body ends and another begins. Howells' aim was to dissolve the edges of self in order to rediscover the notion of 'gift' and 'service' that he identified at the core of performance.

The pedagogical practice of Adrian Howells affected many practitioners and is worthy of greater attention and fuller analysis than is possible in the space of this short contribution. In any case, to really understand Howells' work it must be done, it must be enacted. So I invite you to 'do an Adrian' wherever and whenever you can. Despite his conspicuous loquaciousness, he believed that actions speak louder than words.

1. Adrian Howells, artist's notes for MA workshop at Royal Scottish Academy of Music and Drama, Adrian Howells Collection, Scottish Theatre Archive, University of Glasgow, Box 29.

2. 'Beyond the Comfort Zone' (2003-08) was presented at: Lancaster University; Glasgow University; De Montfort University, Leicester; Warwick University, Coventry; Glasgow School of Art; Royal Scottish Academy of Music and Drama (RSAMD), Glasgow; Royal Welsh College of Music and Drama, Cardiff; Dundee Rep Theatre; Helsinki Theatre Academy; The Jaffa School, Tel Aviv; and Holon Theatre Academy, Israel.

3. 'I Confess' (2007-11) was presented at: Royal Conservatoire of Scotland, Glasgow; HatchLab, Harbourfront Centre, Toronto; York St. John and Ripon University; Warwick University; Laban, London; RSAMD; Israeli Stage Centre, Tel Aviv; Glasgow University; and in Haifa, Israel.

4. These included: 'I Wanna Get Next To You – Intimate and One-to-One Performance' (2011-12) as part of 'Small Encounters' R&D week at Midland Arts Centre, Birmingham; York University, Toronto; and HatchLab, Harbourfront Centre, Toronto; 'Making Day: Intimacy and One-to-One Performance' (2010) at Forest Fringe, Edinburgh Fringe Festival; and 'Intimacy and One-to-One Performance' (2010-11) at Royal Conservatoire of Scotland; Leeds University; Trinity Laban; Warwick University; and Queen Mary University of London.

5. Adrian Howells, artist's notes for Workshop at Dundee Rep Theatre, Adrian Howells Collection, Box 29.

6. Adrian Howells, artist's notes for 'Small Encounters Workshop and Sharing', Adrian Howells Collection, Box 29.

7. Ibid.

8. Howells, artist's notes for MA Workshop at RSAMD.

9. Adrian Howells, artist's notes for 'Intimacy and One-on-One Performance Workshop' at York University, Toronto, 2011, Adrian Howells Papers, Box 29.

10. Howells, artist's notes for 'Small Encounters Workshop and Sharing'.

Touching Laughing

Rosana Cade

Adrian and I held hands on many occasions. It was an important part of our relationship. We became particularly close in early 2012 when he mentored me during the process of developing my workshop for *Walking:Holding*, a performance where one audience member at a time goes on a walk through a city and holds hands with different local people. Adrian and I sat huddled up together on a sofa in the 78, a busy bar in Glasgow, and chatted for a long time about the importance of touch and physical intimacy. He helped me to develop my understanding of this element of the performance. I had been focusing on it as an exploration of being in public – of queer visibility – rather than considering the intimacy between the audience and the performers as a vital element of the work. We spoke about the relationship between touch and emotion, about physical touch as a language, and about the nourishing experience that sharing touch with another human being can offer.

In December 2013 we took the train down to London together for Christmas. Adrian was on his way to the hospital to visit his mum, who was in a critical condition. We sat and held hands in silence for most of the four-and-a-half-hour journey, and I thought about our conversation in the 78 and how much it had meant to me. On that day, physical touch was the only language that was needed.

Adrian came to *Walking:Holding* as an audience member in Edinburgh and we strode down Leith Walk in the sun, holding hands and swinging our arms. We paused to look at our reflection in the window of a wig shop and I asked him what he thought people would think our relationship was. He was dressed smartly, wearing a long beige coat and a scarf flung over one shoulder. I had a shaved head, and wore a leather jacket and big black Dr Martens boots.

Overleaf: Adrian Howells, *An Audience with Adrienne: A Night at the Opera*, performed in the *Under Construction* series, at the Bavarian State Opera (Bayerische Staatsoper) Festival, National Theatre, Munich, Germany, 2009. Directed by Ben Wright. Photographer unknown. In press materials describing the performance, Adrienne 'invites the audience into the rehearsal rooms at the National Theater, where day-in, day-out, people work on the creation of the enchanting and intoxicating world of opera'.

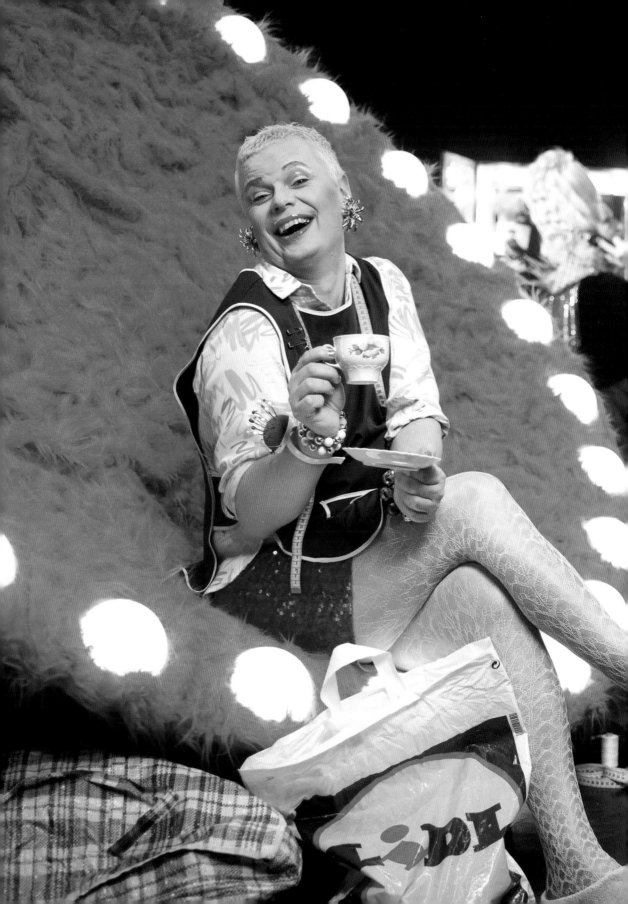

He said, 'I think it looks like I'm a wealthy gentleman and you're my rent boy'. And we laughed, and enjoyed this imagined situation as we continued down the street.

Many people know of Adrian's appreciation of touch and intimacy. But his deviant imagination and dark sense of humour were also important parts of our relationship, and part of what made him such a brilliant mentor and facilitator for me. He created a space where I felt like I could get away with saying almost anything. I appreciated hugely working with someone whose boundaries around what was acceptable were even wider than mine. When Adrian came to work with my class on the Contemporary Performance Practice Course at the Royal Conservatoire of Scotland for a week on autobiographical performance in 2009, it was like everybody was able to let go of something that had been holding them back. Though he facilitated with a lot of love and care for the people he was working with, he also had a refreshing disregard for social norms – norms that tie us up in knots trying to do the right thing. Adrian was naughty and loved naughtiness, and for a group of students trying to understand '*how to* make performance' this naughtiness – this pushing against the norms of acceptability – was a vital lesson. People felt safe, the atmosphere was playful, and because of that we were able to work with deep and difficult material. People in my class made some of their most interesting and personal work during that week with Adrian.

In the last piece that we worked on together, *A Gay in a Manger*, for Christmas at The Arches in 2013 (with Laurie Brown, Jessica Bennet and Eilidh MacAskill), we spoke at length about the seriousness of this dark play, this queer deviant humour and the need to create spaces for it within artistic practice. Unfortunately, due to his mother's deteriorating health and his need to visit her, Adrian wasn't able to perform in the show. However, his intention had been to play a perverted old woman in a wheelchair called 'Grandma', who would sit and eat brandy butter out of a giant vat, and touch herself regularly. On entrance to the stage we were to ask her 'What have you been up to Grandma?', and she would reply, in a deep, gravelly voice, 'I've been fist-fucking an orphaned Filipino tsunami survivor'. Drawing on some of his earlier performance experiences, working with the likes of Leigh Bowery, Adrian taught us that you can make fake sick by holding vegetable soup in your mouth, and fake poo by slightly melting a Mars bar.

We were creating this performance as an antidote; an antidote to insipid Christmas entertainment, to the heteronormative values that are intrinsic to this entertainment, to 'dreams coming true' through capitalist marketing strategies. I don't know if Adrian's Grandma – or this version of her – would have made it into the final show. But our rehearsal room was full of laughter, deep dark laughter, the process of our making an opportunity for a group of queers who often feel excluded or unrepresented to unleash some of their frustrations and their fantasies together.

It is important to find queer role models, and Adrian was definitely one of mine. Previously I have tended to compartmentalise my practice into 'serious work' and 'silly work', but Adrian encouraged me to see integrity within all my different approaches to queer performance-making. From small, gentle intimate actions between two people, to big brash personae on a stage in front of a hundred people, to facilitating groups of participants across the world, the experiences Adrian shared with me, and the care he showed towards me, were vital to my development as an artist at the beginning of my career. Someone with such a tender and considered approach to intimacy and vulnerability, who also has a huge capacity for queer deviant behaviour, is a rare thing.

Above: Adrian Howells in a contact sheet from a studio shoot for Nigel Charnock + Company, ca. 1996-97. Photos and contact sheet by Hugo Glendinning.

On Generous Performance

Fintan Walsh

What do we mean when we talk about a generous performance, or more specifically, a generous performer? For rarely do we discuss generosity within a cultural context without referring back to an individual, in a way that blurs distinctions between performance, performer and person. As critical praise or affirmation, the term 'generosity' is typically deployed to account for performers who give audiences what seems like more than they needed to, or more than we expected. These figures surpass their professional mandates, by appearing to surrender something extra of themselves in performance – intangible though palpable transmissions; professionally crafted and mediated, though seemingly also subjectively rooted. In so doing, they offer audiences a rare insight, feeling or experience that neither skill can offer easily nor money guarantee. The performer may get paid, and the audience may return its appreciation with thanks, but with the generous performer there persists a sense that we can never fully return the offering. In the performer's excessive sharing, there runs a risk too of self-depletion or sacrifice. The aura of abundance that we often associate with generosity in performance sometimes looks and feels a lot like virtuosity – the rapturous spell of mastery. But whereas virtuosity is typically understood to belong to the domain of artistic accomplishment, generosity is more commonly associated with the realm of personal virtue.

'Generosity' is a word that followed Adrian Howells around during his professional life, and more publicly perhaps, in the days following his death. It chased him through newspapers, blogs, status updates, tweets and

Opposite: Adrian Howells in *Salon Adrienne*, performed at The Arches, Glasgow, as part of Glasgay!, 2005. Photographer unknown.

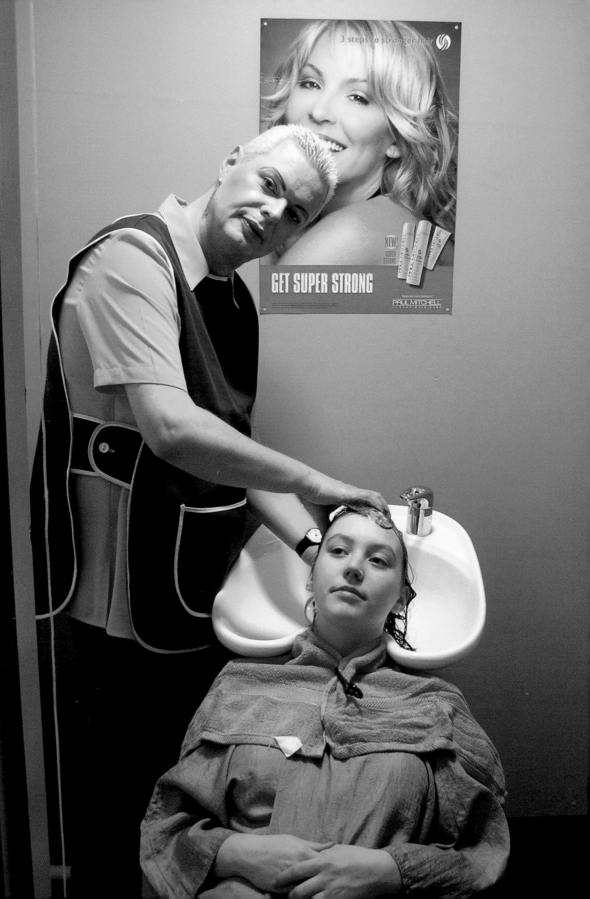

conversations, as if struggling to embrace him one last time, in the way that he had so often embraced us. For instance, writing in the *Guardian*, Andy Field reflected, 'More than any artist I've ever met, Adrian managed to create performances of generous, courageous honesty'.[1] In her obituary for *The Scotsman*, Joyce McMillan lauded Howells' 'boundless emotional generosity'.[2] Reporting the performer's death online, the Live Art Development Agency remembered 'a generous, brave, and honest artist, with a generous, brave, and honest soul'.[3] And in *The List*, Gareth K. Vile wrote of Howells that 'the generosity of his performance ensured that it was neither selfish nor self-indulgent'.[4]

In previous writing I've considered how Howells' performance intersected with therapeutic practices and theories, using confession and touch to involve audiences in (quasi-) cathartic rites and rituals.[5] I've also explored how his work tested physical and emotional boundaries between performers and participants, even pressuring us to graft hard in order to sustain the show.[6] As I reflect on Howells' work now, including on some of my own thinking around it, I feel wary of subjecting individual performances to the kind of analysis that might hinder other nuances and resonances from insinuating themselves in future. Instead, what interests me presently is the abiding sense of generosity that suffuses and surrounds the practice. It is a sense, I believe, that encourages us to consider not only what Howells' work was 'about', but more broadly how we might gauge or determine value in the performance of work, and work as a kind of performance.

The word 'generosity' has roots in the Latin *generōsitās*, meaning 'good breeding' or 'nobility of stock'.[7] The generous person gives up 'more than is strictly necessary or expected'.[8] As this definition indicates, generosity describes a kind of gift-giving that does not demand return, resembling Jacques Derrida's formulation that 'for there to be a gift, there must be no reciprocity, return, exchange, countergift, or debt'.[9] Generosity is a key tenet of many religious faiths too, most obviously embedded in the Christian virtue of *caritas,* meaning both charity and love in Latin.[10] It is perhaps no surprise, therefore, that Howells' work was replete with religious customs and echoes; indeed he was a born-again Christian while at university.[11] *Caritas* emphasises the importance of fostering supportive social relations, crucially against the divisive effects of market economics: giving freely to others, after all, is not readily compatible with a commercialist society. As Adam Phillips and Barbara Taylor elaborate in their book *On Kindness* (2009), with the rise of capitalism in the sixteenth century, 'the Christian rule "love thy neighbour" came under increasing attack from competitive individualism'.[12] In Book IV of *Nicomachean Ethics* (350 BC) Aristotle discusses generosity (*eleutheriotēs*) as an important character virtue, the careful balancing of wastefulness and stinginess.[13] In the thirteenth century, Aristotle's ideas were revisited by Thomas Aquinas, who claimed that generosity (*liberalitas*) is allied to justice, based on the conviction that the capacity to give people more than you owe

them, requires an initial sense of what is owed.[14] Much more recently still, in the wake of the global financial crisis, Pope Benedict XVI's encyclical 'Caritas in Veritate: On Integral Human Development in Charity and Truth' (2009) reasserted *caritas* as the 'extraordinary force' necessary for the 'common good' of our times.[15] *Caritas*, in this document, is deemed necessary for combating the negative social impacts of everything from globalisation to economic privatisation, towards promoting 'social conscience and responsibility'.[16]

In this chapter I focus on what generosity might mean in the context of performance practice and phenomenology, and more pointedly in relation to Howells' unique mode. I do so by discussing what can be counted as the generous aspects of Howells' approach to performance, by exploring how these resonated within the service work contexts that his practice explicitly engaged: cleaning clothes in established and makeshift laundrettes; tending hair in a salon; bathing in hotels; and washing feet in a range of venues (mine, in a room above a sixteenth-century tavern). Generosity is understood here as both a practice (something 'extra' done or given) and a sense (a feeling, affect or disposition towards giving), that straddles and scrambles definitions of virtue as moral excellence and virtuosity as masterful skill, typically associated with the solo performing artist. Howells' practice evoked and upset these categories by staging power and diffusing it; holding privilege and displacing it; ultimately striving to dignify all human interactions within the service milieux he presented. This complication, I offer here, is a gift that Howells' performance work keeps on giving.

Receptive Criticism

While generosity as a performance feature has not received substantive attention in theatre and performance scholarship, the subject of 'critical generosity' has been addressed by David Román and Jill Dolan. With different degrees of nuance, both scholars use the term to argue for the importance of broad contextual sensitivity when assessing a production's merits. In *Acts of Intervention: Performance, Gay Culture, and AIDS* (1998), Román introduces the term to describe the behaviour of audiences responding to Tony Kushner's two-part play *Angels in America* (1993) in the wake of the AIDS crisis, many of whom had lost friends and loved ones, some of whom were ill themselves.[17] Román observes a kind of critical generosity among these people, apparent in the way they lovingly cared for each other during the shows. As he saw it, these responses were rooted in the generosity of AIDS activism, and therefore needed to be recognised in evaluating the production. Accordingly, Román calls for an expansion of the criteria by which criticism is determined, informed by the sense that because language is ideologically fashioned and prejudiced, we can also mobilise it to be constructive and reparative. As he puts it, '[c]ritical generosity understands that criticism is much more than simply a procedure of critique or means of qualitative analysis. Criticism can also be a cooperative endeavor and collaborative engagement with a larger social mission'.[18]

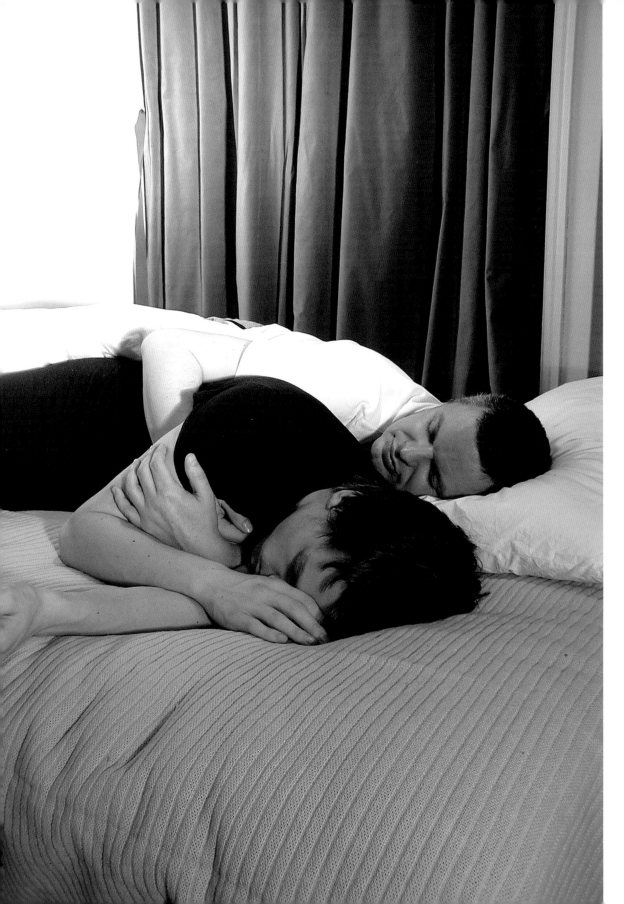

Jill Dolan has taken up Román's interest in critical generosity, to assert the value of critics and academics giving back to the often-fragile performance cultures about which we write. She posits, '[c]ritical generosity can be useful for those of us committed to the arts as social engagement, with deep beliefs in its ability to reach people, change minds, affirm alternate visions of how we live in the world, and deliver hope in the potential of a different, more universally equitable future'.[19] For Dolan, critical generosity allows performance cultures and communities to flourish beyond the performance event: 'it allows us to think specifically beyond the present of reception into the near future of potential activism and engagement. Generous criticism, then, also considers how we imagine the afterlife of performance'.[20] Crucially, for Román and Dolan, generosity is something that an audience may practice, manifest in a kind of open receptivity that allows performance cultures to grow and survive; a disposition all the more important when connected to marginal groups that desperately need support. But what of the kind of generosity that seems to come from the performer rather than the audience? How might we account for the generosity that we associate with a performer or performance markedly invested in its audience's experience? Is this generosity just a sign of an exceptionally accomplished artist, the authentic enactment of selflessness, something in between, or something different altogether? How, if at all, can we know? Or, as I will continue to explore in the case of Howells' practice, might there be a form of generosity in performance that productively confuses these delineations.

Performing Work

My email inbox contains several lengthy messages from Howells about his work, suggestive of great personal and professional generosity. But the kind I want to highlight here is more specifically associated with invested, attentive and careful performing *for* audiences. It is the sort that makes individual audience members feel like the performance they are witnessing is for them alone, for example, and in Howells' one-to-one work, this was often literally the case. As a practice and a sense, this generosity seems all the more significant when we track how Howells' work typically took place in a wide range of service contexts, that exist in almost every neighbourhood, where labour, commerce and sociability intersect: laundrettes, salons, hotels and bars. In the worlds Howells conjured, or dipped in to, the differences between performer and audience, employer and worker, service provider and service user tended to dissolve, as participants oscillated between positions of power and privilege, including Howells himself.

As the named performer, Howells was always in one very important sense in charge. However, within these encounters he frequently assumed a position of service – he was the one who cleaned our clothes, who washed our hair, who scrubbed and anointed our feet, who held us, who bathed us, who listened

Opposite: Adrian Howells in a studio shoot for publicity images towards *Held*, which were first used in the version performed at Fierce Festival, Birmingham, 2007. Photo by Niall Walker.

to us, who looked us in the eye for assurance. With remarkable degrees of commitment, Howells elevated these ordinary tasks and situations, saturating them with a typically unnoticed or disregarded dignity. What might seem like the most menial duties in a service-driven economy were given special significance in Howells' conscientious ministrations. His work refused to accept that we are just cogs in a machine, or even the machine itself, pointing to how and where we might offer or access value other than as capital profit.[21]

In *Adrienne's Dirty Laundry Experience* (2003), Howells' eponymous drag alter ego turned a space into a functioning launderette. Soaking material with metaphor, participants were invited to bring their 'dirty linen', and as clothes were washed in real-time, secrets were shared over tea and biscuits. As Howells himself reflected on the experience, 'I liked the fact that people left the space with a tangible, literal bag of clean laundry, but also that they might feel that their "souls" had been cleansed a little'.[22] More cleaning took place in *Salon Adrienne* (2005-7), as the performer washed our hair, and transformed a mundane manual task into something altogether more interesting via his cross-dressed persona. More importantly, perhaps, via exacting touch and sincere conversation, as we faced each other in a mirror, Howells prompted us to reflect upon our self-image and perceptions on ageing. Perhaps ironically for a performer, Howells seemed acutely aware of the difficulties of being seen in public, protectively reducing the universe to two people.

These partial touches became full-bodied embraces in *Held* (2006), in which Howells not only grasped our hands and sat next to us, but spooned us in bed. With these forms of intimate contact his practice brushed the borders between performance and sex work. *Held* laid the ground for much more immersive and exposing experiences of shared bathing, as took place in a bath for *The Pleasure of Being: Washing/Feeding/Holding* (2010-11).[23] And in *Foot Washing for the Sole* (2008-12), Howells meticulously cleaned and anointed our feet, explicitly asking us what we think about service and care: Where does the power lie? Are we inferior if we serve? (A friend who also attended the performance told me Howells said he had the most beautiful feet he had ever seen; someone was lying, or someone was being exceptionally generous.) In this performance encounter, as in many others, Howells was ostensibly leading but he also placed himself in a relationship of service – as a performing artist, but also in terms of the tasks he undertook. On occasion, audiences occupied multiple roles too. And while it is impossible to tell the precise difference between these relations, Howells repeatedly staged work on the seesawing positions of power and service, prompting us to reflect upon their relationship too. Despite all this ambiguity, however, I always felt as if Howells was trying to elevate generous service – as social investment, attention and care, rather than any kind of forced subjection - as something we should experience and exercise. As the performance examples I have just described also indicate, Howells' work was awash with water: cleaning water; buoying water; eventually, inevitably, some murky water too.

Working Performance

Let us step outside these performances of service work, to think about how service is performed in some 'real' workplaces: the kind that Howells' work represented, and in a certain sense, also were. Despite the greed that unmistakably motors contemporary iterations of capitalism, public demonstrations of generosity are not unusual. For generosity can also collude with profiteering, entrenching and fixing servility in the most insidious ways. Two seemingly contrasting scenes expose generosity as a particularly obscene spectacle of our times: a phenomenon that Howells' performances can be taken to subtly intercept.

Ellen DeGeneres is best known for her syndicated television show, *The Ellen DeGeneres Show*, which has been running since 2003. Akin to a tactic spearheaded by Oprah Winfrey on the *Oprah Winfrey Show* (1986-2011), one of Ellen's distinctive trademarks as a presenter is her capacity to deftly work-up and manipulate her mainly female audience's emotional reactions – one minute laughing hysterically, the next crying hysterically, but always in captive awe. As was also the case with Oprah, the audience's emotional labour is sometimes rewarded with lavish presents. While Oprah's signature was gifting the entire audience – in 2004, in the first show of her nineteenth season, every member received a car – Ellen is better known for bringing down-on-their-luck individuals onto her show to reward them. On 18 October 2013, in the segment 'An Inspiring Waitress Gets an Amazing Surprise', 22-year-old single mother and waitress Sarah Hoidahl came on set to talk about her own good deed: namely, the day she bought lunch for National Guard soldiers, walking away from her shift with only 8 dollars. Impressed by the waitress' generosity, Ellen gives her a 50-inch screen television, and a check for $10,000. On a follow-up show aired on 8 November 2013, in the segment 'Ellen's Favorite Waitress Gets a Car', a production crew visits the woman's workplace to give her a new Hyundai family vehicle. Cue everyone hysterically laughing, everyone hysterically crying. What kind of generosity is on display here, and how does it function? The waitress performs an act of generosity in work, only to have it trumped and effectively invalidated by Ellen on television. Generosity that matters, we might deduce, is something that only the wealthiest can enact, securing the hierarchy it claims to otherwise intervene in. The worker's generosity, we are led to apprehend, is nothing next to such spectacles of capital. Moreover, generosity that can be 'paid for' like this is hardly generosity at all. Ellen turns generosity into capital profit for the waitress, but more so, for her and her show.

Another perverse scene involves the unusually generous workers at the restaurant chain Pret A Manger. This cohort came under scrutiny in 2013 when it was revealed they were specifically instructed to enact 'Pret behaviours' to achieve this effect of ostentatious generosity, and were poorly

Overleaf: Adrian Howells in *Salon Adrienne*, performed at The Arches, Glasgow, as part of Glasgay!, 2005. Photographer unknown.

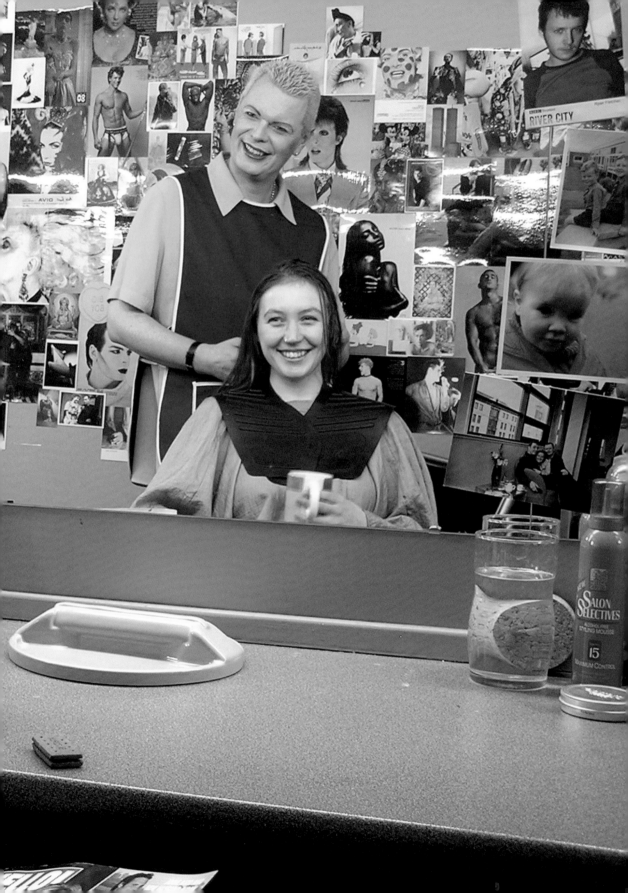

paid for doing so. In a sense, this kind of scenario is nothing new. In the post-Fordist workplace, capital flows not just through objects, but via the circulation of services and affects.[24] However, largely following an exposé by Paul Myerscough in *London Review of Books*, it was reported that staff at this global chain were subjected to a particularly strident regime, and required to follow a 17-point behaviour plan. Some of the rules, then listed on the company website, included that staff were instructed to be 'charming', to 'have presence', to 'care about other people's happiness'. Unwelcome traits included being 'moody or bad-tempered', or just doing the job 'for the money'.[25] Two years later, in 2015, CEO Clive Schlee confirmed that employees were permitted to give away a certain amount of free food and drink to customers they liked.[26] Undoubtedly a cunning PR corrective to the 2013 controversy, here the worker's exploited emotional labour was masked and downgraded, by framing the customer as the servile figure who needs to please before being generously rewarded. The pressured affective toil of worker and customer suppresses the possibility of any kind of spontaneous human interaction or feeling, in the service of Pret A Manger's economic gain. And as both examples help illuminate, the workers' (and even audiences' and customers') generosity is regulated as a compulsory affect of immaterial labour, manufactured for corporate profit. It is not simply the case that workers cannot afford to be generous in action or disposition, but rather that they are not afforded the opportunity to exert agency in this way: bodies, behaviours and emotions are equally managed.

Virtue and Virtuosity

Howells' practice explicitly drew connections between this kind of service work, and the work of the performing artist, encouraging us to pay attention to axes of power and privilege in art and life. It explored ways that generosity might expand and enhance our daily lives, and flourish outside of a compulsory logic of capital exchange. These issues can be considered further by examining how Howells' practice represented a particularly rich meeting of different definitions of the virtuoso, as conceptualised within artistic and Italian autonomist or *operaismo* traditions.[27] The word 'virtuosity' has roots in the Latin *virtus*, meaning skill, virtue or manliness.[28] In sixteenth- and seventeenth-century Italy, the word 'virtuosity' was used to describe someone of great artistic or intellectual aptitude. In the eighteenth century, it became more often associated with musicians, and in particular soloists. Joseph Roach unearths how ideas about acting changed with the rise of celebrity culture in the seventeenth century. Roach describes how 'generosity of soul' was considered a feature of effective performance in the theatrical theory of Pierre Rémond de Sainte-Albine, as outlined in his manual *Mémoire sur le laminage du plomb* (1731).[29] In his study of Romanticism and music in eighteenth-century Britain, Gillen D'Arcy Wood reveals how the emergent virtuoso musician was feared to embody 'the lure and threat of gratuitous, non-productive labour', in the developing industrialised order, and 'a dangerous residue of aristocratic uselessness'.[30] The virtuoso was in danger of sacrificing

interior depth to exterior show, you could say, or compromising personal virtue for professional virtuosity. Some of these associations persist into the contemporary era, with solo performers treading a line between being seen as distinctively interesting and engaging, on the one hand, and self-absorbed and apart on the other. While in one sense Howells belonged to a solo performance tradition, he differed from it in placing interactive relationships with audiences at the heart of his work, and also in his distinctly anti-masterful approach: his work was typically gentle and dialogic, in a way that undercut any accusations of virtuosity in its conventional artistic sense.

For autonomist philosopher Paulo Virno, the virtuosic is no longer a category confined to individual artistic excellence. Instead, he suggests that the term defines the kind of immaterial labour characteristic of proliferative service work. In Virno's thinking, any job which does not have as its conclusion a physical end product, and therefore is valued for a particular kind of performance, falls into the category of the virtuosic. It also describes 'an activity which requires the presence of others, which exists only in the presence of an audience'.[31] This emphasis on services does not mean that we no longer produce commodities, but that 'for an ever increasing number of professional tasks, the fulfilment of an action is internal to the action itself'.[32] For Virno, this kind of immaterial labour represents the subsumption of labour under capital: 'nobody is as poor as those who see their own relation to the presence of others, that is to say, their own communicative faculty, their own possession of a language, reduced to wage labour'.[33] Virno argues that historically this 'servile virtuosity'[34] was the terrain of non-productive personal services such as those of a butler, but now it has become the very paradigm of productive work itself. 'Ellen's Favorite Waitress', the Pret A Manger workers, and laundrette, salon and hotel staff would all fall into this category, as well as the performing artist, and maybe even his audience. In Virno's reading, the emotional climate of post-Fordism is ambivalent, characterised by states of 'opportunism, cynicism, social integration, inexhaustible recanting [and] cheerful resignation'.[35] He offers intemperance as a model of non-servile virtuosity with the capacity to transform this culture. Operating as a kind of anti-virtue (temperance being a cardinal virtue in much western thought, including Greek philosophy and Christianity), the intemperance of which Virno speaks might be exercised in disobedience and withdrawal from the state or industrial discipline. With intemperance, negative sentiments are freed-up and mobilised to stage an opposition to the established order.

One of the ways performance practice can critique service work, according to Nicholas Ridout, is by making it more obvious, even while also commodifying it: 'Far from being the paradigm of authentic self-expression, performance reveals itself as exemplary commodity (it commodifies action, not just things) and as the site for a critique of its own commodifying processes'.[36] Howells' work certainly made service visible and in need of our attention: by theatricalising scenes of service; by framing artistic performance as a kind of service too; and by creating opportunities for participants – including himself

– to experience different roles and power positions within this performative economy, thus unsettling presumed boundaries and hierarchies. He challenged the virtuosity of the solo performing artist as masterful, and the worker as simply servile, by practising a kind of generous immersion with each other *in* work (against Virno's intemperance) as a way to enrich and humanise the interactions he curated and indexed. It is hard for most of us to accept a call to generous service as a politically benign invitation, let alone an artistically gratifying one, though in Howells' swapping of roles and identifications, with and among his audiences, this appeal is no less for generous authority. And this was one of Howells' most persistent interests, I believe, and something his work sought to explore: that a generosity of investment, attention and care might be a way to relieve us from the disaffecting pressures of our everyday lives.

Affirming Service

José Esteban Muñoz detects the queer potential of Virno's formulation of work in *Cruising Utopia: The Then and There of Queer Futurity* (2009). In a discussion of the influence of Jack Smith on US performers including Dynasty Handbag and the collective My Barbarian, Muñoz highlights how, despite the threat of commodification, the worker's and performer's shared virtuosity 'offers a potential for a certain escape', by debunking 'production-based systems of value that make work and even cultural production drudgery and alienated debasement'.[37] Muñoz is especially interested in the potential for 'anticommunal affect stances' such as 'cynicism, opportunism, depression, and bitchiness' to collapse experiences of isolation and the general 'tonality of hopelessness', leading to 'new modes of collectivity, belonging in difference and dissent'.[38] Inversely, I think, Howells' work advanced the idea that there may be more obviously affirmative practices and senses capable of achieving a similar effect.

Layered with questions of intimacy, confession, sexuality and embodiment, Howells' work vibrated within a queer register too. But this queer sense also emanated from the generous actions and affects that concerned and encircled the practice: the way Howells physically gave his body to us in instances of touching, seeing, talking, listening – and invited us to do the same; and the atmosphere of investment, attention and care he attempted to cultivate. Generosity, in this context, might even be taken to approximate the aestheticised practice of what is sometimes metaphorically described as a giving of oneself to others; a sort of creative self-dissemination, which Leo Bersani has proposed as a distinctively queer ethic.[39] Viewed with the help of Muñoz and Bersani, we might even say that Howells' performance work presses us to conceive of generosity as a particularly queer ethic: a dissemination of self and work, or selves in and at work together.

Two questions preoccupied my thinking during Howells' performances: What does he want of me? And what am I supposed to do? I've never been able to answer these questions fully. However, another question insinuates itself now, as it so often does in the wake of loss: What are we supposed to do with what

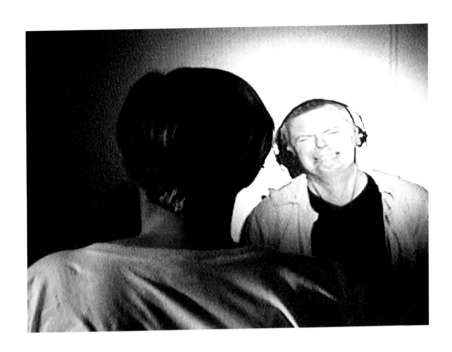

we have been left with? As I've attempted to show in this chapter, Howells' performance practice immersed us in complex exchanges of work and feeling, in a range of service contexts, playing with the locus of power and privilege, subverting roles and responsibilities. I do not think his practice supplied easy answers to the dilemmas of exploitation and alienation that define contemporary capitalism, or that it was even ethically unambiguous itself, but I've never not believed in the integrity of what he was trying to do: to create a space where generosity might precipitate intimacy, where intimacy might vitalise our encounters with performance in work and work in performance, and where these encounters have the potential to saturate and soften the hard edges and cold surfaces of our daily lives. Howells' work took generosity off its cardinal pedestal, and tried to find a place for it in the service encounters of everyday life. Above all else, his work asserted the urgency of investing in each other, paying attention, caring. It highlighted the value of giving a bit more of ourselves without diminishing our own resources. In a subtle but audacious way, it hinted at how this just might enhance the quality of our lives, and the lives of those we meet, including fleeting encounters in the launderette, the salon, the hotel, the theatre, maybe even between pages such as these, and hopefully beyond.

Above: Still from video documentation of Adrian Howells crying while listening to music on earphones in Station 6 ('Jordan Makes Him Weep') of *The 14 Stations in the Life and History of Adrian Howells*, performed at The Arches, Glasgow as part of Arches Live, 2007. Howells describes this scene on p. 112. The audience-participant is Dee Heddon.

1. Andy Field, 'Adrian Howells: "He Created Performances of Courageous Honesty,"' *The Guardian*, 19 March 2014, <http://www.theguardian.com/stage/2014/mar/19/adrian-howells-performance-artist-theatre-tribute> [accessed 2 June 2015].

2. Joyce McMillan, 'Obituary of Acclaimed Theatre-Maker Adrian Howells, *Scotsman*, 20 March 2014, <http://www.scotsman.com/what-s-on/theatre-comedy-dance/obituary-of-acclaimed-theatre-maker-adrian-howells-1-3346849> [accessed 2 June 2015].

3. Editorial, 'Adrian Howells – A Generous, Brave, and Honest Artist', Live Art Development Agency website, 20 March 2014, <http://www.thisisliveart.co.uk/blog/adrian-howells-a-generous-brave-and-honest-artist/> [accessed 2 June 2015].

4. Gareth K. Vile, 'Adrian Howells: An Appreciation of the Talented Theatremaker', *The List*, 20 March 2014, <https://www.list.co.uk/article/59549-adrian-howells-an-appreciation-of-the-talented-theatremaker/> [accessed 2 June 2015].

5. Fintan Walsh, *Theatre & Therapy* (Basingstoke and New York: Palgrave Macmillan, 2013), pp. 62-6.

6. Fintan Walsh, 'Touching, Flirting, Whispering: Performing Intimacy in Public', *TDR: The Drama Review*, 58.4 (2014), 56-67.

7. Taken from the *Oxford English Dictionary* definition.

8. Ibid.

9. Jacques Derrida, *Given Time: 1. Counterfeit Money*, trans. by Peggy Kamuf (Chicago: The University of Chicago Press, 1992), p. 12.

10. Taken from the *Oxford English Dictionary* definition.

11. Howells in Dominic Johnson, 'Held: An Interview with Adrian Howells', *The Art of Living: An Oral History of Performance Art* (Basingstoke and New York: Palgrave Macmillan, 2015), pp. 262-85 (p. 279). A revised version is reproduced in the present publication.

12. Adam Phillips and Barbara Taylor, *On Kindness* (London: Penguin Books, 2009), p. 5.

13. Aristotle, *Nicomachean Ethics*, trans. by Terence Irwin, with introduction, notes and glossary (Indianapolis: Hackett Publishing Company, 1999), pp. 49-52.

14. See the discussion of Aquinas' thinking on generosity in *The Ethics of Aquinas*, ed. by Stephen J. Pope (Washington: Georgetown University Press, 2002), p. 124.

15. Pope Benedict XVI, 'Caritas in Veritate: On Integral Human Development in Charity and Truth', 29 June 2009, <http://w2.vatican.va/content/benedict-xvi/en/encyclicals/documents/hf_ben-xvi_enc_20090629_caritas-in-veritate.html> [accessed 2 June 2015].

16. Ibid. I should add that this paragraph of references only captures some broad shifts in ethical and religious understandings of generosity, and is obviously not a complete history.

17. David Román, *Acts of Intervention: Performance, Gay Culture, and AIDS* (Bloomington: Indiana University Press, 1998), p. xxvi.

18. Ibid., pp. xxvi-xxvii.

19. Jill Dolan, 'Critical Generosity', *Public: A Journal of Imagining America*, 1.1-2 (2013),

<http://public.imaginingamerica.org/blog/article/critical-generosity-2/> [accessed 26 June 2015].

20. Ibid.

21. While in Marxist economic thinking, surplus value ('*mehrwert*') refers to return on capital, Howells' 'generous' performance explores a different register of values, especially by centralising human experience and interaction. See Karl Marx, *Capital, Volume I* [1867], trans. by Ben Fowkes (1976 rpt. London: Penguin Classics, 1990), especially chapter 9, pp. 330-39.

22. Adrian Howells in Deirdre Heddon and Adrian Howells, 'From Talking to Silence: A Confessional Journey', *PAJ: A Journal of Performance and Art*, 33.1 (2011), 1-12 (p. 3). This essay is reproduced in full in the present publication.

23. In *Held* and *The Pleasure of Being*, the difference between art and sex work also seemed unclear. In a 2011 interview with Karl James, Howells describes paying for sex with a man himself, and the scene he sets is remarkably like that in *The Pleasure of Being*: 'Prepared to Love', *The Dialogue Project Podcasts*, published 10 March 2011, <https://itunes.apple.com/gb/podcast/2-2-5-the-dialogue-project/id423791414> [accessed 8 October 2015].

24. The term 'post-Fordism' is used to describe late-twentieth-century modes of industrial production and consumption, including the kinds of service work that feature in Howells' performances, and in this chapter.

25. Paul Myerscough, 'Short Cuts', *London Review of Books*, 35.1 (3 January 2013), 25 (p. 25).

26. The statement was widely published across the media, including in the *Guardian*. See Jessica Elgot and Esther Adley, 'Pret Staff's Free Coffee for People they Like: Discrimination or a Nice Gesture?', *Guardian*, 22 April 2015, <http://www.theguardian.com/uk-news/2015/apr/22/pret-free-coffee-people-they-like-discrimination-or-nice-gesture> [accessed 2 June 2015].

27. Autonomism and *operaismo* refer to the social and political movements and theories of Italian workerist rights, which emerged in the 1960s. Inflected by Marxist thinking, the intellectual dimension is associated with figures including Antoni Negri and Paolo Virno, among others.

28. Taken from the *Oxford English Dictionary* definition.

29. Joseph R. Roach, *The Player's Passion: Studies in the Science of Acting* (Ann Arbor: University of Michigan Press, 1985), p. 98.

30. Gillen D'Arcy Wood, *Romanticism and Music Culture in Britain, 1770-1840: Virtue and Virtuosity* (Cambridge: Cambridge University Press, 2010), p. 4.

31. Paolo Virno, *A Grammar of the Multitude*, trans. by Isabella Bertoletti, James Cascaito and Andrea Cason (Los Angeles and New York: Semiotext(e), 2004), p. 52.

32. Ibid., pp. 61-2.

33. Ibid., p. 63.

34. Ibid., p. 68.

35. Ibid., p. 84.

36. Nicholas Ridout, 'Performance in the Service Economy' in *Double Agent*, ed. by Claire Bishop and Silvia Tramontana (London: Institute of Contemporary Arts, 2008), pp. 127-31 (p. 131).

37. José Esteban Muñoz, *Cruising Utopia: The Then and There of Queer Futurity* (New York: New York University Press, 2009), p. 178.

38. Ibid., pp. 176-7.

39. In *Intimacies*, written as a dialogue between Leo Bersani and Adam Phillips, queerness is largely aligned with the pleasure/pain of destruction, traceable in everything from bareback sex to self-shattering encounters with the aesthetic. But at one point, Bersani aligns queerness with 'ego dissemination rather than ego annihilation', which in its open-ended orientation, seems to resonate with Howells' work. See Bersani in Leo Bersani and Adam Phillips, *Intimacies* (Chicago and London: University of Chicago Press, 2008), p. 56.

Tea and Footprints

Lucy Gaizely, Gary Gardiner and Ian Johnston

It is September 2013 and we are sitting watching Adrian iron shirts and tuxedos in a changing room at The Arches. Ian is sleepy as he listens contentedly to the gossip passed back and forth between Adrian, Gary and Lucy. Adrian is telling us about the Pippa Dee parties his mother used to throw in the 1970s. We have heard the story many times before but it is always hilarious and Ian particularly loves the bit where Adrian says that all he wanted at the age of nine was a 'Pippa Dee two-piece dress arrangement'.[1]

It is 2015 and we are in Aberdeen, sitting in a changing room whilst Lucy irons shirts and tuxedos. Lucy asks Ian what Adrian would be saying right now. Ian says: 'He would be calling me and Gary his boys. He always called us that'. We are currently touring *Dancer* (2013-), a show made in collaboration with Adrian, Gary, Ian and Lucy as a result of an artistic residency between Sense Scotland and The Arches.

Adrian's remit in the collaboration was to work with adults with complex communication needs to explore touch, communication and intimacy. Over two years, Adrian worked in a variety of ways with individuals from TouchBase (Sense Scotland) but was particularly drawn to Ian. Lucy asks Ian why he and Adrian got on so well and he says: 'We had a good laugh and we both really loved dancing for an audience'. Lucy asks Ian if this is why they made a show together. Ian thinks for a while and nods: 'He saw my show *Home* and said I danced like Mick Jagger; Lucy and Adrian thought Gary should work with us because he dances like that too'.

Overleaf: Ian Johnston in a press image for *Dancer* (2013), created by Ian Johnston in collaboration with Lucy Gaizely, Gary Gardiner and Adrian Howells, and performed at The Arches, Glasgow, supported by Sense Scotland, TouchBase and The Arches. Photo by Niall Walker.

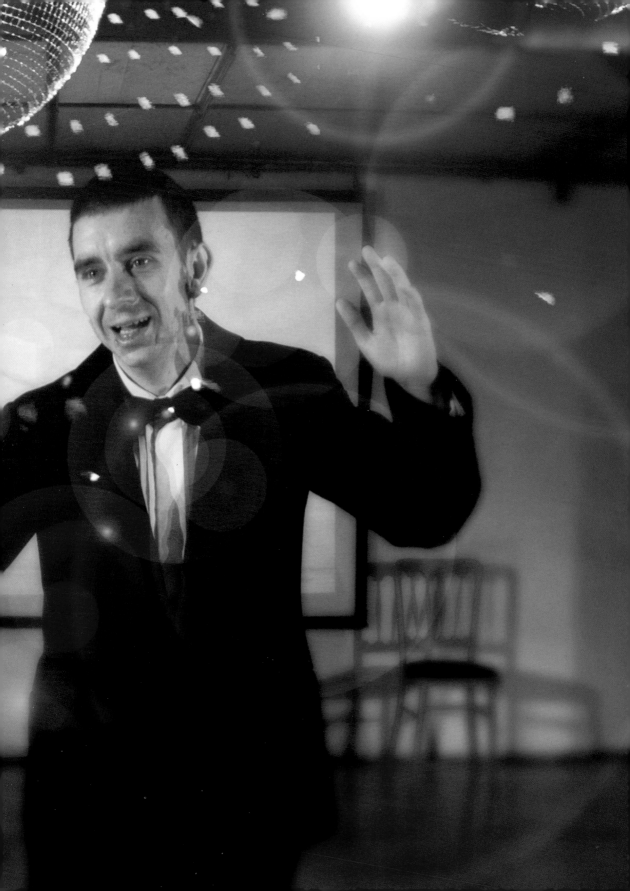

Dancer was made over a period of 15 months and was first performed in September 2013 at The Arches; it has since been performed at Southbank, Battersea Arts Centre, Fierce, People's Dancing Festival, Behaviour (at The Arches), Bounce Festival, Dance Live and No Limits Berlin. The work was developed further by a commission from Unlimited, which supports the work of disabled artists. Adrian sadly passed away before we learned the outcome of the application to develop it further at Unlimited.

As we talk about collaborating with Adrian, Ian remembers that Adrian phoned his Dad frequently during the process of making *Dancer*. 'He talked to my Dad, he checked everything was ok with my Dad. We went clubbing with my sisters too. He liked them and he liked Jac Arnold [Ian's support worker]. He always gave people hugs'.

Lucy asks Gary about his experiences of working with Adrian on *Dancer*:

> Adrian was like a social lubricant, he created the optimum working conditions for all of us. Every artist could do with an Adrian in the room. He consciously offered generosity and praise to all collaborators, creating a genuine space of wellbeing. You can't help but to excel in this situation.

Gary describes the dynamic of working with Ian and Adrian:

> We played often with ideas based around Ian's autobiography and our collective love of dancing. Until after Adrian's death we had a motif in the work which was about 'finding your spark'. The metaphor wasn't quite right but we knew we needed this sort of sentiment. We started re-working the show after Adrian died and we discovered that Adrian's ghost – his footprint – was of course embedded in the work. It exists now in an overt way, a line of text, a lighting choice, etc., and it's like he never left us. Ian and I realised that this was the motif we needed for the work, so we began to explore the notion of footprints rather than sparks, because Adrian had left his all over the place.

This feeling is echoed by Lucy. Having produced Adrian's residency in TouchBase and worked on the development of *Dancer*, Lucy observed first-hand the gusto of his social lubrication. Adrian brought people together. His work at TouchBase was as much about talking and being with people over a cup of tea as it was working in a rehearsal space. He didn't limit his time in TouchBase to spending it with service users; he also developed meaningful relationships with the staff, using his particular skill of valuing all the expertise in a room.

> Adrian was nervous about how to share his work with Sense Scotland. He was challenged by the dynamics of an institution that doesn't rely on spoken word as its primary communication and felt like he wasn't experienced enough to work with individuals there. Adrian

was liberated from these insecurities when he understood that the arts tutors in TouchBase were excited by his practice, and that this is all they would expect him to offer. As I observed his growing comfort in this environment I understood that his arts practice was deeply embedded in the idea of wellbeing and intimacy. Engaging with people who have deafblindness or other sensory impairments and who thus know about physical intimacy as a functional part of communication could well have been one of the greatest challenges Adrian faced in his work. I think Adrian had to really look at what intimacy meant to him and to question whether it was the same for someone who relies day-to-day on intimate touch as communication.

Lucy asks Ian what Adrian did to work through some of these challenges and he says, 'have a cup of tea and a biscuit' (which he did by the bucket load). He was also open with us in admitting to what scared him. We all suffer a little of the 'imposter syndrome', which generates feelings of inadequacy; Adrian had it in abundance and it was this vulnerability which endeared him to everyone. He was able to establish a space without pressure – which developed into such a meaningful, creative relationship with Ian.

It is 2015. Ian, Gary and Lucy are sitting having a cup of tea and chatting about the next piece of work that Gary and Ian intend to make together over the coming months. We consider what aspect of Adrian we will carry with us into this new collaboration and agree that he offered us the best etiquette for any process: Team Dancer will always strive to make our collaborators feel like they are truly fantastic. That is Adrian's legacy.

Lucy asks Ian what he thinks it will be like without Adrian collaborating with us. He looks pensive for a while and answers: 'Quiet'.

1. Pippa Dee parties were staged as a form of direct selling, with social events hosted by a Pippa Dee agent to sell Pippa Dee products – a range of women's and girl's clothing.

Duty of Care:
Producing Adrian Howells

Shelley Hastings and Jackie Wylie

Battersea Arts Centre (BAC) in London and The Arches in Glasgow worked together for ten years to support artists. Adrian Howells was one of the most important artists that both venues worked with, commissioning a number of his performances since 2003.

Shelley Hastings (Senior Producer, Battersea Arts Centre)

I first met Adrian Howells when I was starting out as a producer ten years ago, and I went to see *Adrienne's Room Service* at The Great Eastern Hotel in Liverpool Street in June 2005. You booked an hour in a beautiful hotel and Adrian – as Adrienne – came in dressed as a chambermaid with a tea trolley of snacks and old photo albums and sat on the bed. I had been instructed to make myself comfortable so I was wrapped up in the hotel dressing gown, wearing the hotel slippers. We ate biscuits together, listened to music and relaxed into a hazy nostalgia for distant family. It was a beautiful, generous, intimate exchange. I felt cushioned and amazed at how easy it was to get that feeling of intimacy with a stranger.

Soon after that experience I asked Adrian to present *Salon Adrienne* as part of BAC's BURST festival (2005). It was an important show for the organisation and one that we highlighted in the festival's press release. Adrian was based in Ocean hairdressers on Lavender Hill in South London. The piece was a one-to-one encounter, where Adrian washed your hair and made you tea and then you had a conversation about what you felt when you looked in the mirror. The work carefully accessed a very vulnerable place but Adrian's care and generosity, his ability to wrap the conversation in the theatre of the everyday and in his own camp confessions, allowed his audience to feel safe enough to open up. I can remember audiences, staff and other artists during that festival coming back up the hill and being overwhelmed with what had happened and giggling nervously at what they had revealed to Adrian, but also to themselves. The work became the talking point of that year's festival, and even if you were unable to get a ticket you could see Adrienne framed by the salon window every day, gently subverting the ordinary and bringing something completely different to your walk to the station.

Adrian went on to present many of his works in BAC's major festivals, including: *A Xmas with Adrienne* (2005); *The 14 Stations of the Life and History of Adrian Howells* (2008); *Won't Somebody Dance with Me?* (2008); *Foot Washing for the Sole* (2009); *The Pleasure of Being: Washing/Feeding/Holding* (2010-11); and, most recently, he remounted *Salon Adrienne* and presented *Unburden: Saying the Unsaid* (2013). Adrian was incredible at nurturing relationships with everyone in the building at BAC. Everybody knew who he was – and even if they were unsure about his work they were brave enough to experience it; the performances became something we all talked about as a staff team. The generosity of his practice extended to connecting to every department, and he often ended up working with our technicians or design assistants on projects unattached to BAC.

His process and approach to each piece was meticulous. He could certainly be difficult if things didn't meet his expectations, which would prompt him to send one of his famous emails outlining what needed improving – always signing off with how 'GORGE-ARSE' we all were and how he knew we would get it sorted. Adrian had high expectations but I was prepared to meet his demands as far as was possible, because I knew that in return he would deliver something extraordinary, original and beautiful. I also knew that he had an uncompromising duty of care to his audiences, and that was partly why the spaces he created for performances needed to be *just so*. Creating a safe space in which difficult emotions could sit or be held was paramount to his practice. For *14 Stations* we transformed many spaces across the building, including our archive where we created a huge pile of rubble that Adrian sat on top of, naked, singing *All by Myself*. For *The Pleasure of Being* we arranged for a roll top bath to be plumbed into the middle of our mezzanine room, ensuring space and light for the work.

In 2010, BAC staged its first festival of intimate work – the One-on-One Festival. This new venture may never have happened without Adrian's influence. He presented *The Pleasure of Being* as part of this festival, and it was a critical success, prompting articles about the impact of intimate work in newspapers ranging from the *Guardian* to *The New York Times*.[1]

In a society where we are increasingly isolated from each other or our interaction is mediated though technology and social media, Adrian's work seemed to be perceived by many as an oasis. His presence, humour, patience, empathy and ability to really listen and sense what his audience needed meant he was constantly changing lives, and I don't say that lightly. At BAC, working with him over many years, we have been witness to many incredible stories of audience members who, through Adrian's work, were able to open themselves up to their darkest fears, were able to allow themselves to be vulnerable, were able to understand themselves better, or who were simply changed by the openness he was offering. Adrian seemed to be touching our deepest needs as human beings to be heard, touched, loved and understood.

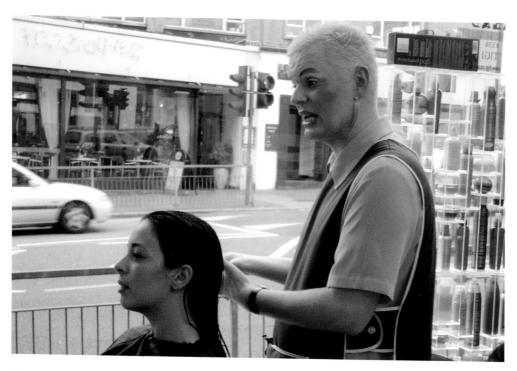

One audience member of *The Pleasure of Being* told us her mother had recently fallen very ill. She had been bathing her mother and she wanted to feel what it was like to be bathed herself. Another audience member came to this work having never undressed in front of anyone nor been seen naked as an adult. She was bathed and held by Adrian. A young woman from our Agency Programme experienced *Salon Adrienne*, and was overwhelmed with its possibility.[2] She went on to transform her idea of opening a pop-up local hairdressers into a 'wellness' salon that supported emotional health as well as new hairstyles.

I worked with Adrian for nearly ten years, producing his work at BAC alongside another producer, Richard Dufty. In the frenetic, angry, demanding reality of everyday life, there is a gaping hole where Adrian used to be. Adrian's work, his heart, his energy and his generosity are missed every day – that space where 'it's all allowed'. I wish it were. Now, more than ever, I miss that precious space and power that Adrian carved out for his audiences, me amongst them.

The last time I saw Adrian was in a performance of *Unburden* at BAC as part of our 2013 autumn season. I went to see the show in the middle of a hectic working day and so I wasn't prepared for what happened. I walked into a large wooden room filled with hundreds of candles and the smell of pine and there was Adrian sitting quietly at the far end of the space, on his own. There was a walkway through the candles and a chair so that you could join him. We sat very quietly and still and bathed in candlelight he gently took my hands. He then quoted Edward Bach and talked about the need to acknowledge our mistakes without dwelling on them, as well as understanding when we are blameless and have done our best. He then carefully asked me to think about how I would choose to live if I had only three months left, who I would see, where I would go, what I would do. The way he expressed this was without fanfare or drama, he was just asking me very simply and directly to consider who and what really mattered. In the warmth of that room, and held by his confident gaze, we went on to have a conversation that I feel changed my life. It was his most powerful, transformative work for me and that day I was ready to receive it. Just as the conversation is drawing to a close you share a drink with Adrian and a candle is lit and you are asked to place it in the room. It was only then I realized that we were surrounded by candles that held the residue of the last few months of everyone who had experienced the work. The room was charged with the final wishes of everyone Adrian had encountered during the work. I hope he knew how powerful an act of love this was.

Jackie Wylie (former Artistic Director, The Arches)

Adrian Howells didn't come into The Arches' office like any other artist. He announced his own arrival with such enthusiasm and disregard for the

Opposite: Upper: Adrian Howells in *Salon Adrienne*, performed at Ocean salon, Lavender Hill, London in association with Battersea Arts Centre, London, 2005. Photographer unknown. Lower: Adrian Howells, *An Xmas with Adrienne*, performed at Battersea Arts Centre, London, 2005. Photo by Shelley Hastings.

conventions of professionalism as to simultaneously parody and celebrate the entire relationship between artistic institution and resident creative. He loved self-reflexive performativity and the blurring of the distinction between performance persona and everyday Adrian (if indeed it is useful or even possible to make such distinctions). His use of confessional autobiography was as much a social as an artistic tool. Coming back from touring or trips away he would sashay into the middle of the office: 'I KNOW you are all busy doing whatever IMPORTANT things you all do but I HAVE to tell you what that Shelley said ...'. These moments were little gifts amongst the frantic pace and everyday stresses, where we all downed tools together and reconnected.

Adrian was The Arches Artist in Residence from 2011 onwards and he loved all the small marks of belonging that came with this. At press launches he would publically brandish his key fob, delighting in his special privilege to access all areas. He took his ambassadorial role very seriously. In 2012 he was invited to perform *Foot Washing for the Sole* at the Pazz Festival in Oldenburg, Germany and on request I posted out to him a set of Arches business cards in order that he would have the tangible legitimacy of an institution that he loved so much and was affiliated with. He was a brilliant (if unofficial) programming collaborator, providing incredibly detailed debriefs on the work that he had seen, the other international presenters that had come to his work and how they had responded – and, of course, all the gossip from the festival bar. It was at Pazz that he met the Canadian company Mammalian Diving Reflex. His passionate response to their show *The Best Sex I've Ever Had* sowed the seeds for their later collaboration, *All The Sex I've Ever Had: Glasgow,* which was led by Lucy Gaizely (The Arches Creative Learning Programmer who was a huge influence, mentor and support to him). Mammalian Diving Reflex also presented *The Children's Choice Awards* at Pazz, in which Adrian received an award for best use of feet from the children's jury, who had experienced *Foot Washing*.

One of the relationships that he relished most was with Jeanette Stirling, the legendary cleaner at The Arches. Adrian's first show at The Arches was *Adrienne's Dirty Laundry Experience* as part of Glasgay! (2003). It took place in an eight-metre-square room that housed the washing machine generally used for theatre costumes and the sweaty towels of visiting DJs. Adrian was surprised to come in on the morning of the first night to find that the dirty laundry that formed part of his stage design had been washed and folded – the cleaning team had been perplexed and appalled to find a mysterious set of smalls cluttering their space. From there a great friendship grew with Adrian always taking time for a cuppa and natter in their office.

Adrian was a perfectionist when it came to the aesthetics of each work. On several occasions over the years I would look over nervously from my desk, half pretending not to notice, as he took a variety of staff members and project volunteers through an exacting list of the props and materials required for each show. Yet a few hours later I would walk into the office to see them delighting together in the softness of the towels that had been selected for *The Pleasure*

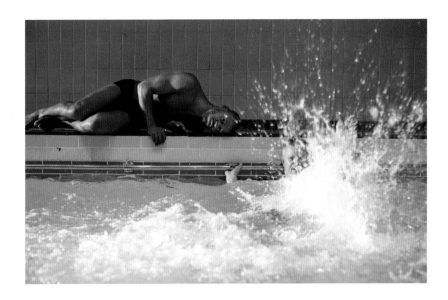

of Being: Washing/Feeding/Holding (Edinburgh Fringe Festival, 2011) or the specific colour of the balloons that had been uncovered in the pound shop for *Won't Somebody Dance With Me?* (Behaviour Festival, Arches, 2010).

Adrian was able to get what he wanted. He treated everyone as equals and the warmth of his manner meant that more than with any other artist all the staff went out of their way to help. He presented *Foot Washing for the Sole* in The Arches LIVE festival in 2008 and I remember going down into the basement and realising to my surprise that he had created it in a room in the building that I didn't even know existed. Space was a hotly debated commodity in The Arches and he had charmed the technical team into letting him use their production office, which would usually have been kept under firm territorial control. In *The 14 Stations of the Life and History of Adrian Howells* (Arches Live, 2007), one audience member at a time had a promenade experience across the foyer, down into the restaurant, through to several of the rehearsal rooms and out of the back café bar corridor where staff travelled up and down constantly with jangling keys and crates of supplies. He commanded such good will that he was able to integrate this seamlessly with the day-to-day operations of the building.

He was a unifying force across the different staff teams, a model for the potential organisational change that a residency can achieve. In 2010 Adrian launched a new strand of activity at The Arches, our invited artists' makeovers of the restaurant, creating *Adrienne's Bar and Grill*. He worked with Niall Walker, the Design and Marketing Manager at The Arches, to install gaudy

Above: Adrian Howells, *Lifeguard*, performed at Govanhill Baths, Glasgow, 2012. Co-produced by National Theatre of Scotland, The Arches and Govanhill Baths Community Trust. Ira Mandela Siobhan lies beside the pool and Howells performs in the water. Photo by Simon Murphy, courtesy of National Theatre of Scotland.

1970s furniture, brash, colourful ornaments, fairy lights and images of 1970s pop stars mixed with his own family photo albums. The set was incongruous to the otherwise sleek, urban decor of the rest of the café bar. It can be difficult to merge the commercial and creative elements of an arts venue but Adrian created a template for this. He devised a special retro menu and in full drag teetered around the tables with his drinks trolley, serving up camp quips and unrestrained tales about his life, often just sitting to join the unsuspecting diners who were also given opportunities to confess their own stories across the dinner table. The beauty of the makeover was that while many of the guests were there intentionally for the performance, others had just popped in for a bite to eat. Adrienne would often refer to the images and objects around her whilst chatting to guests, who now were convinced they had made a new best friend. Adrian's restaurant makeover was so popular it stayed up for three months, with some tinsel and baubles added for an extra festive feel in December.

After the last customers had left the restaurant I sat with Adrian in the subterranean, unglamorous dressing rooms. I loved watching him take off his makeup, the meticulous way he would wipe away the lipstick and heavy eye shadow. Both of us sat looking into the mirror at his face while we chatted about the shows I was thinking of programming in the festivals, artists that we were both excited about and of course what we *really* thought of the work that we had recently seen.

I am finishing writing some of my memories of Adrian two months after The Arches has closed. Yesterday, as part of an archiving process, I went through my old Arches notebooks, stretching back over 11 years. The person who is a continuous presence on page after page is Adrian. In one notebook there is a page that is blank except for Adrian's name, followed by a large dash, then the word TENDERNESS, with a messy circle scrawled round it. I don't recall if this was to remind me to tell him that was how I felt during a show, or the start of an unfinished presentation or conversation. As part of the organisation's national lottery-funded refurbishment in 2001, engravings of the names of staff members and key performance moments were added to the glass doors and windows of the buildings. After Adrian died, we decided to add a Perspex image of Adrienne to the doors that the audience would pass through to go down to the theatre. I'm glad we marked the impact he had on all of us: Adrian caught in a moment at the top of the long corridor, forever looking us all in the eyes, listening carefully with that serious nod of the head in encouragement: 'Come on, you can do it'.

1. See Lyn Gardner, 'Wisdom of the Crowd: Interactive Theatre is Where it's at', *Guardian*, 2 March 2010 <http://www.guardian.co.uk/stage/theatreblog/2010/feb/28/interactive-theatre-connected-coney-lift> [accessed 17 July 2015]; and Matt Wolf, 'Actor's Skill, in Delivery and Dexterity, Redeems *La Bête*', *New York Times*, 13 July 2010, <http://www.nytimes.com/2010/07/14/arts/14iht-LON14.html?_r=0> [accessed 17 July 2015].
2. The Agency Programme is a collaboration with Contact, Manchester, supporting people aged 18-25 to develop local projects, businesses and events. See <https://www.bac.org.uk/content/20400/create_with_us/the_agency> [accessed 21 July 2015]

Opposite: Adrian Howells, *Adrienne's Bar and Grill*, performed at The Arches, 2010. Photo by Niall Walker.

What Money Can't Buy: The Economies of Adrian Howells

Stephen Greer

Adrian Howells kept his receipts. He kept his receipts, his professional contracts and his bank statements, and he kept them carefully. I am trying to make sense of these records, and the trace of value that they describe in Howells' life and practice. This is not an easy task, in part because he seems to have kept nearly everything but also – paradoxically – because his archive is a partial one.[1] His records for 2010, for example, are ordered in identical, hand-labelled brown envelopes in the following categories: travel, laundry and repairs, theatre and cinema tickets, stage clothes, lessons, training and studio hire, periodicals and trade publications, food and meals working away from home, hotel, accommodation, B&B and business meals, postage, stationary, equipment, charity donations, hairdressing and makeup, cash withdrawal receipts, miscellaneous, and subscriptions. There is no sense of hierarchy in which one form of transaction is privileged over another, only thousands of pieces of paper whose preservation appears both pragmatic – directed towards end of year settlement with his accountant, to whom he would write effusive and apologetic letters – and a way of attending to the detail of life as it was lived. These documents record Howells' tastes, habits and movements with a kind of granular and oftentimes mundane detail: ticket stubs for plays, performances and films; printed emails from Amazon marking the purchase of books and DVDs; boarding passes for international flights to arts festivals, and train tickets between Glasgow and London; receipts for fresh fruit and candles. This trail has an uncertain intimacy: I can tell you everywhere Adrian ate when he visited Singapore and what he ordered from the menu, though not if he enjoyed the food.

Though the range of materials held in Howells' uncatalogued papers in the University of Glasgow's Scottish Theatre Archive are concerned partly with the development and staging of Howells' one-to-one performances, the public, professional and private spheres of his life are not readily separated. Receipts

Opposite: Photos of some of the 35 uncatalogued boxes of papers and artefacts in the Adrian Howells Collection, Scottish Theatre Archive, University of Glasgow. Photos by David Caines.

that are generic to the point of anonymity also mark Howells' idiosyncratic choices, and many legal documents have the status of private correspondence through the force of social convention, if not copyright law. Records of 'training' – yoga, massage therapy – describe Howells' efforts to attend to his own body while also invoking the kinds of corporeal labour he would undertake for his audience: forms of deliberate stillness, touch and presence. They reflect the deliberate choices of an artist developing his practice and, at the same time, the commonplace necessity of a self-employed worker who will claim the expenses of his labour against tax: a blurring of life and work even as formal structures of accounting require their notional separation. It is an archive of affect in several different ways: a text whose meaning is dependent upon the cultural practices which surrounded its production and my reception of it as much as its literal contents and, concurrently, a record of the forms of affective labour which took place within and in the act of producing Howells' performances.[2] There is also a kind of dead-pan humour to the rigour of Howells' book-keeping. The 'miscellaneous' folder which contains his TV license, details of a donation to the Pakistan flood appeal and a ticket stub for a trip to Berlin's Der Hauptstadt zoo also contains a receipt for a box of Quality Street. If Howells' refrain was 'it's all allowed', his records seem to add 'and it's all important'.

Accounts of affective labour as a form of postmodern immaterial labour developed through the work of Maurizio Lazzarato, Antonio Negri and Michael Hardt emphasise the intangible quality of its products, even as the act of producing them 'remains corporeal and intellectual'.[3] Performance and cultural studies scholarship has sought to assert the political significance of artistic labour as a material practice. Seeking to avoid 'misrecognizing the ontological immateriality of performance, its ephemerality and disappearance' with an inherent resistance of commodification, Bojana Cvejić and Ana Vujanović have argued for the need to treat performance as 'a material artefact, being a product and commodity of the institutional market of the performing arts'.[4] In turn, in their introduction to 'On Labour and Performance' (a special issue of *Performance Research*), Gabriele Klein and Bojana Kunst argue that any claim about the capacity of performance to 'directly challenge the practices of value-circulation and production of subjectivity in contemporary capitalism' requires the critical contemplation of the proximity between performance and contemporary modes of labour.[5] Howells' archived papers may serve both enquiries in describing the dominant conditions within which the affective labour of contemporary performance-making takes place. Though contemporary art's workforce may consist 'largely of people who, despite working constantly, do not correspond to any traditional image of labor', the contracts and agreements within Howells' archive demonstrate how such exertion is nonetheless acknowledged, ordered and allocated the status of work within a wider capitalist economy.[6] At the same time, the record of Howells' specific and distinctively *generous* labour describes a resistance of hegemonic logics of exchange – manifest not through a claim on the autonomy of art,

but in oftentimes pragmatic negotiations within dominant infrastructures of performance. If the radical potential of affective labour rests in its capacity to produce 'social networks, forms of community [and] biopower', Howells' practice and the archival documents which trace its operation describe the kinds of effort such a project may involve: negotiations between labouring for others and working for oneself, between commodity and gift.[7]

I begin, though, by offering an account of the ways in which Howells' labour was most often commissioned during a highly prolific period of his career, not with the intention of asserting the primacy of a commercial logic but to better understand his practice as an intervention in a culture dominated by the material and emotional logics of capital.[8] As a self-employed artist throughout his professional life, Howells signed many, many contracts: in notionally working for himself, he worked for a great number of institutions, companies and other individuals as a performer, teacher, mentor and facilitator. One stack of paperwork tells me that in 2008, Howells was employed by Goldsmiths, University of London, the University of Warwick, the University of Roehampton, The Royal Conservatoire of Scotland (formerly the Royal Scottish Academy of Music and Drama), the Battersea Arts Centre (BAC), The Arches, Fierce Festival, the Royal National Theatre on London's South Bank, and the Holon Theatre and British Council in Israel. This was not a particularly unusual year. For these and other organisations, Howells was employed through short-term contracts in which his labour was given for a fixed fee (rather than any share of profit from the public presentation of his work). I have found no indication in the archive as to whether Howells sought these terms, and I am mindful that the precarious income of a box-office split may not have been any more desirable. Howells' fee was occasionally delineated within a contract as production costs alongside an 'artist's fee' but more commonly appears as a single sum to be paid in instalments on submission of invoice. Agreements to present work at venues or festivals outside of London and Glasgow contain provisions for travel expenses and accommodation, sometimes booked in advance on Howells' behalf but, again, more often requiring him to invoice for the costs after the fact.

Though Howells' records reveal that his work was primarily commissioned by UK venues – most frequently The Arches, Glasgow and BAC and Drill Hall, London – they also indicate that it was more widely staged, not least in international arts festivals.[9] At the same time as he performed and created new work, Howells taught and lectured across the length of the country.[10] Nearly all of this work involved the unmarked effort of travel and a great bulk of Howells' financial archive is taken up with train ticket stubs and airline confirmations. In each instance of employment, a contract was issued setting out the terms of Howells' labour – teaching on a particular course for a university, mentoring another artist, a commission to produce a new work or an engagement to perform an existing one – and each contract required one or more invoices to secure payment. Howells is repeatedly reminded in the

formal terms of his contracts that as a self-employed worker he is personally liable for his own payment of tax and national insurance and, in the case of at least one university employer, required to prove his eligibility in accordance with the Asylum and Immigration Act 1996 to work in the UK. He is 'not governed by, or entitled to, any standard conditions of employment', and obliged to provide his own tools and equipment unless otherwise agreed. As an independent contractor, Howells was required to manage and administer his labour so that it might become intelligible as work, and to do so over and over again. This labour is unmarked but – like travel – represents time and effort required of Howells in formally accounting for hours worked so that he might be recompensed.

While the patterns of labour described by Howells' records may characterise the precarious, neoliberal terms of employment exemplified by the artist whose livelihood is constituted through 'a variety of flexible and temporary workshops, festivals and residencies', there is nonetheless a persistent, rhythmic quality to the relationships that they trace.[11] Names and institutions repeat, not least in the form of Howells' three-year Creative Fellowship funded by the Arts and Humanities Research Council (AHRC) in the department of Theatre Studies at the University of Glasgow from 2006 to 2009 (and thereafter an Honorary Research Fellow – an unpaid position) and his role as The Arches Artist in Residence from 2011. Though the development of these longer-term relationships may mark the mitigation of precarity, they do not describe security – pointing instead towards the affective labour required in cultivating professional networks of support (whose resilience may, in turn, be precariously dependent on research or arts council funding, and the caprice of local governance). There is, perhaps, a form of structural amnesia at play, the product of a regulatory regime in which formal recognition of extended periods of temporary labour might eventually invoke the legal privileges (and, for the employer, obligations) of permanent employment.

Most often identified as the singular-plural 'Company', hired to produce his own performances and other works of creative labour as an actor, and in teaching and mentoring other artists, the language of Howells' employment contracts nonetheless capture a broader economy of professional practice which identifies formal roles in order to allocate responsibility, risk and reward.[12] While Howells' agreement to appear as 'Adrian' in the original production of Tim Crouch's *The Author* at the Royal Court in 2009 appears straightforward in describing Equity standard rates of pay and conditions of employment as an actor, the paper trail of his collaborative projects has left a more oblique trace of labour which can be only partially reconstructed through the partial archive of contract and invoice. Howells' work with choreographer and dancer Nigel Charnock, for example, appears fleetingly as payments for dancing in the ensemble *Stupid Men* (2007), invoices for rehearsals and performances

Opposite: Adrian Howells, An Audience with *Adrienne: Her Summertime Special*, performed at Drill Hall, London, 2007. Photo by Robert Day.

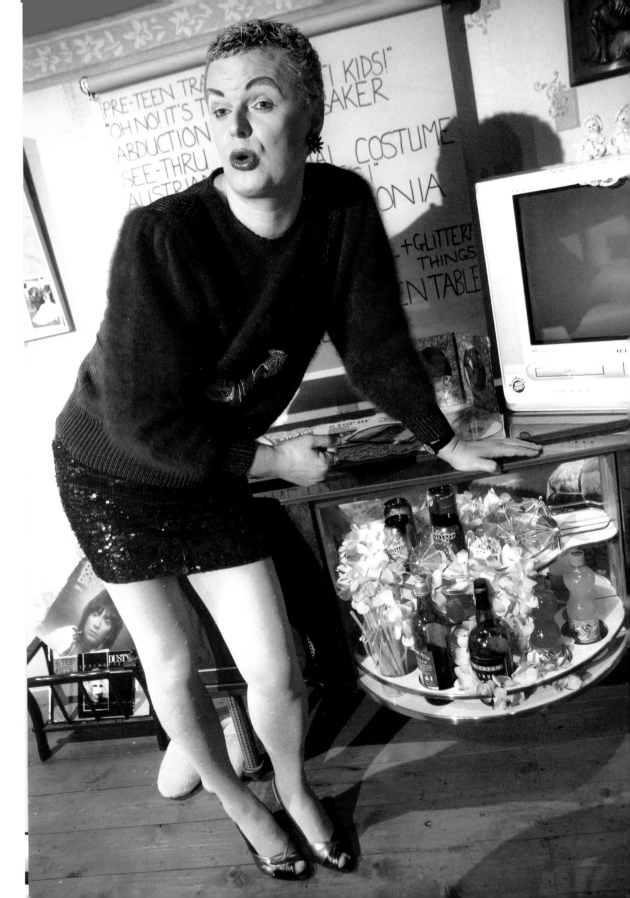

of *Gorgeous* (2007) at the Drill Hall and fees paid by the National Theatre Studio for a research and development week that would see the latter show re-staged as *Charnock and Howells* (2008). In turn, Howells' contribution to what would eventually become the National Theatre of Scotland (NTS) show *Lifeguard* (2012) first appears in his records as invoices to The Arches for work in co-facilitating meetings with the Govanhill Baths Community Trust in Spring 2011, followed only later by a pair of contracts with NTS itself: the first to commission the work, and the second to hire Howells as performer and director. In isolation, neither set of records suggests the highly collaborative nature of the project staged in Govanhill Baths, even though (as NTS' formal credits for the production make plain) the show was a co-production between NTS and The Arches, and that Howells worked alongside Mike Brookes, Minty Donald, Rob Drummond, Jane Mason, Nick Millar and Nichola Scrutton, artists and friends with whom Howells had worked before. Elsewhere, collaboration frames Howells as the employer of others – with payments from the British Council Singapore passing to Theo Clinkard and Euan Maybank for their work on *An Audience With Adrienne*, along with a royalty to the show's original director, John Hardwick, and the filmmaker, Ben Wright.

The language of Howells' commissioning contracts also routinely describes claims on the future development of his work, and projects the possibility of value beyond the labour immediately at hand. These terms do not appear as bespoke conditions, unique to Howells' work, but rather as the standard terms of arts industry practice. A contract notionally concerned with a single scratch performance might also contain detailed language concerning the London, British or international premiere of future finished work. While the artist might retain ownership and copyright of a work, the contract – as in the case of one major London arts venue – might simultaneously grant exclusive rights of first refusal to present the production at the next stage of its development, a claim on a negotiable percentage of the box office receipts from any future tour of a finished work, and a royalty 'to be negotiated in good faith', and payable in the event of broadcast on UK or international media. While many of these clauses appear intended to be invoked only in breach of contract or exceptional circumstance – including but not limited to acts of god – they nonetheless describe a discursive field in which value is produced through a kind of anticipatory constraint.[13] That process not only dictates where and when a performance must take place but also often forbids repeat performances within a particular radius of the venue for a given period of time, stretching before and after the engagement. While variations in these spatial and temporal restrictions suggest different scales of creative economy (a city venue might demand an exclusion zone of 25 or 30 miles, while a smaller town or festival dictate only ten) they describe an implicit common logic: that in order for an artist's work to acquire and retain its value, it must be rarefied.

In other words, the conditions dictated by these contracts describe how the value of the live might be produced and regulated through the economic logic

of scarcity. Though intimate performance has been singularly criticised as a 'decadent' art form that represents a poor investment of limited resources – a claim which itself requires the internalisation of a particular austere logic of 'value for money' – we might well recognise that mechanisms of limited supply do not run counter to the ontology of performance but strongly complement popular and scholarly beliefs about what gives theatre its unique value.[14] Consequently, if the logic of scarcity marks an unwelcome capitalist appropriation of live performance's claim on the idea 'that a limited number of people in a specific time/space can have an experience of value which leaves no visible trace afterwards', then the economically unsustainable investment of time and effort involved in the production of one-to-one performances may present an alternative, critical means of 'costing' labour.[15] That critique emerges not through the refusal of scarcity but in its excessive application, an over-commitment to the notion of the live as irreproducible.

At the very least, Howells was himself highly conscious that the particular practical demands of presenting one-to-one work had economic consequences that required an acknowledgment of non-monetary orders of value. Interviewed in March 2013, Howells acknowledged the status of his one-to-one work as a 'loss-leader' in that festivals understood that they would not 'break even' by presenting it:

> But the festival accepts that it's culturally important that the work is part of the programme, as it has another 'currency' that will not necessarily translate into making money. What is an issue is that because of that fact [the show not making money], a festival will sometimes argue that they don't need to pay me a going rate in terms of what the festival pays other artists – and that isn't good enough. They'll sometimes try to persuade me to do a lot more performances to help them break even.[16]

Howells' assertion of the economic value of his labour, even in recognising its non-financial 'currency', suggests a canny, contrary form of resistance. If a promoter is going to trade on the cultural capital of his work, they must relinquish their claim on its commercial value by, perversely, paying Howells 'more' than a calculation based on ticket-sales alone might rationalize as economically viable. Howells' resistance is simultaneously economic and ethical, appropriating the discourse of profit to force recognition of the unethical demands (lower fees, more performances) required to sustain it, an interruption to the logic of neoliberalism which demands ever greater efficiency.

Such material negotiations cannot be considered as separate to the relational dynamics at stake within Howells' performances, but should be seen as part of the work's discursive production. A number of agreements concerned with stagings of *Foot Washing for the Sole*, for example, contain detailed technical riders for the performance that go beyond a minimal description of spatial

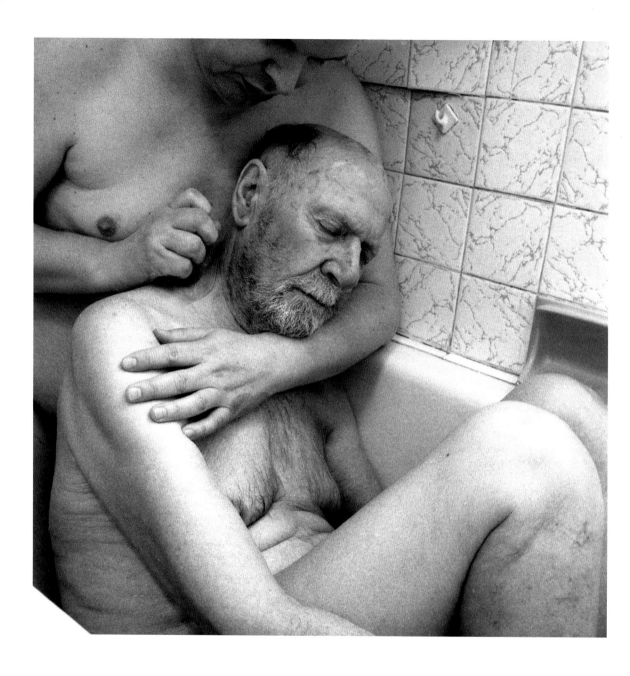

Above: Adrian Howells performing for camera with an audience-participant to support the development of *The Pleasure of Being: Washing/Feeding/Holding*. © Hamish Barton.

requirements in order to implicate the producer in Howells' economy of care. At these moments, the pragmatic detail of production asserts its own field of value that is oriented to the welfare of the audience-participant: the contract partner is formally obliged to provide a chair which 'should be comfortable, but not squishy and allows people to sit upright', and the foot stool 'MUST be [the] same height as seat of chair'; the towels which will be used to dry the audience-participant's feet must be 'pristine white', and washed and dried at the end of each day of performances.

In turn, the production of the agreement for the first staging of *The Pleasure of Being: Washing/Feeding/Holding* at BAC identifies the visual scheme of the space that will be converted into a bathroom – 'white, clinical, but with a Japanese theme' – as well as its emotional register – 'General feel of the room – warm, glowing and womb-like'. Howells will provide towels and bathrobes but a note from the technical manager 'recognises that the same number of towels and bath mats might be needed, because when one gets out of the bath it's nice to have a dry mat'. The conduct of this caretaking is not Howells' labour alone but takes the form of a shared responsibility, and is given the legal status of a binding duty. In a contract for a presentation of *Foot Washing for the Sole* at a large European arts festival, the presence of Howells' values is more directly assertive. After describing at length the 'standard artiste' protocols 'not to transmit or allow the transmission or reproduction by cinematic video, television, wireless, recording apparatus or any other means of any part of the Production', the agreement invites the artist to give permission for unrestricted use of photographic, audio and video-recording of the production for publicity purposes during the festival. Howells' hand-written, all-capitals amendment grants consent, albeit with clear admonishments:

> ON THE PROVISO THAT THE AUDIENCE-PARTICIPANT
> IS A SPECIALLY SELECTED AND BRIEFED VOLUNTEER
> (PREFERABLY FROM THE FESTIVAL STAFF TEAM) THAT
> IS HAPPY AND COMFORTABLE WITH THIS PRIVATE,
> CONFIDENTIAL AND INTIMATE EXPERIENCE BEING
> 'PUBLICISED' AND MASS-CONSUMED IN THIS MANNER!
> IT SHOULD NOT BE A PAYING MEMBER OF THE GENERAL
> PUBLIC WHO IS APPROACHED TO DO THIS!

Howells' clause, counter-signed by his employer, forces a distinction between the kind of transaction marked by buying a ticket and the broader logic of commodity, with the consent typically inferred by participation in a capitalist economy sharply demarcated from the form of transaction sought within the performance itself.

If Howells' contractual intervention on behalf of his audience asserts its own field of value – centred on a distinction between public and private forms of exchange – it also begins to indicate the works of labour which he required

from those who participated in his practice. In interview, Howells asserted the primacy of active consent within one-to-one performance encounters alongside the particular value of audience-participants whose choice to take part was highly informed, 'knowing/understanding all the risks and implications (or not!) inherent in an encounter with (very often) a total stranger'.[17] Consent here extends beyond simple agreement to take part to involve acknowledgement of a risk which could not be anticipated in full. The 'or not!' marks how Howells' insistence upon 'the spontaneous, a flexible structure and on non-scripted, improvised exchange' necessarily involved an exposure to unpredictable, if not unknowable consequences on both sides of the exchange.[18] That said, the terms of possible risk were not evenly split: what was likely a wholly new encounter for a participant was for Howells an expression of many years of professional experience. While the value of Howells' work to a festival might not readily 'translate' into money, so too might an audience member's financial commitment, evident in the purchase of a ticket, be exceeded by a cost to the individual measured 'far more than just in monetary terms'.[19] Here, 'cost' may be understood as the subjective emotional and psychic consequences and effort involved in exposing oneself to and through the moment of exchange, either in verbal confession or through the body in acts of 'shared breathing rhythms', silence and literal nakedness.[20]

Yet Howells' pursuit of active involvement was also mediated by a consciousness of how an open, participatory exchange might be subsumed by a commitment to the 'event' of the performance, and a cultural logic of commodity. Interviewed in 2009, Howells articulated his concern that involvement in one-to-one work might produce a sense of complicity in which an audience-participant would seek to avoid 'ruining' a work of art by 'just agreeing, going along' and in doing so surrender 'their power and their control over their lives when they come through the threshold of a performance space with me'.[21] Howells' instructions to audience-participants taking part in *The Pleasure of Being* staged as part of BAC's One-On-One Festival in April 2010 would seem explicitly designed to counter any impulse to 'go along with things' in directing participants to exercise a very specific form of personal agency and self-care. If the wider economic and structural conditions of performance 'militate against the "spontaneous" and "unique" intimate experience', we might recognise Howells' conscious attempt to preserve the possibility of an unrehearsed exchange.[22] Presented on laminated white card and included in the archive alongside the commissioning contract, Howells' guidelines read:

> • Before you join me in the bathroom, I would like you to carefully read the following guidelines to help you get the most out of the experience:

> • For 30 minutes I would like to deeply nurture and nourish you. I hope you will feel able to surrender yourself to this experience of total care.

• It is very important that you tell me if there is ANYTHING I am doing that you feel uncomfortable with, and this might especially be to do with touching or washing a particular part of your body. PLEASE DO NOT FEEL YOU HAVE TO BE POLITE AND GO ALONG WITH EVERYTHING I AM DOING! [...]

• I have absolutely no expectations of what you choose to do or say during your time with me. You can either talk as and when you would like to – especially if you wish to share something with me, like a memory that the experience may trigger for you, for example – or you may choose to remain silent. It is entirely up to you!

Contrary to Claire Bishop's claim that socially engaged art most often finds self-sacrifice 'triumphant', with authorial presence renounced in order to allow participants to speak, Howells' instructions assert his presence in marking out the field of labour which requires his audience-participants to negotiate between seemingly contradictory impulses.[23] It is, perhaps, ethical for this very reason – in Howells' apparent refusal to absent his own desires from the exchange ahead.

While accounts of Howells' work often conceive of his labour as a gift to his participant, I am keen to recognise the forms of obligation that may be invoked by gift-giving itself. Marcel Mauss' anthropological study *The Gift*, first published in 1950, suggests that contemporary societies draw a sharp distinction between 'obligations and services that are not given free, on the one hand, and gifts on the other'.[24] Yet in Mauss' account there is no such thing as a free gift, only 'personal incentives for collaborating in the pattern of exchanges' which serve to articulate dominant social institutions.[25] Conversely, Lewis Hyde emphasises the transient, relational quality of the gift as something which must always move to another – that 'whatever we have been given [as a gift] is supposed to be given away again, not kept'.[26] In contrast to the exchange of consumer goods – whose logic serves to keep buyer and seller in balance without further relationship – Hyde suggests that gifts are characterised by a momentum which shifts weight 'from body to body'.[27] Howells' work, I suggest, articulates and troubles these distinctions by offering the possibility of exchanges which might resist dominant economic and cultural imperatives governing reciprocity while simultaneously asserting the relational labour required of both parties to sustain alternatives. Howells asks that he be allowed to attend to the person who takes part in his work, a request which requires that person actively to gift him a measure of their personal, physical autonomy so that he might 'nurture and nourish' them. At the same time, the request for a participant's willingness to 'come on board' involves an active resistance of the desire to please Howells – or, perhaps, to resist placing Howells' pleasure or happiness above their own. If – as in Theodor Adorno's formulation – 'real' giving has its joy 'in imagining the joy of the receiver [...] choosing, expending

time, going out of one's way', that gift may nonetheless place demands on the one who receives it.[28] Though Howells suggests that he has 'no expectations', the guidelines clearly imagine a particular kind of exchange in which an audience-participant must both consider the appeal to relinquish control (to 'surrender') while simultaneously retaining a sense of their own agency ('It is very important that you tell me if there is ANYTHING...').

The kinds of complex labour invited – if not demanded – by Howells may not have been readily intelligible within the broader discursive frame of the festival's marketing which constructed audience members as adventurous explorers, empowered to pick and choose the kinds of affect that they might desire. A single ticket – starting at £17.50 – allowed an audience member to 'select their own journey' from a menu of artists and companies, with the festival's box office acting as tour guide: 'No two expeditions are alike. Tickets are strictly limited. [...] Safe, curious, intimate, scary? Call us to shape your future'.[29] Centred on the promise of a bespoke experience 'unlike anything you've ever done', the rhetoric of marketing may frame the possibility of exchange as – in Jen Harvie's account – an opportunity 'to be expressive, to be empowered, to claim agency in the making of art and performance', and to do so without offering anything in return beyond the price of a ticket.[30] While one-to-one performances may, for Deborah Pearson, 'supply a demand for intimacy between audience member and performer, albeit in an economically unsustainable fashion', it may also be involved in sustaining that desire.[31]

Affective labour works to reproduce itself, giving form to and materializing needs in products which, as Lazzarato maintains, themselves become 'powerful producers of needs, images, and tastes'.[32] Here, that 'need' is to think of oneself as brave, adventurous, a connoisseur of new experiences who risks transformation to stand apart from the crowd. The product, in other words, is a sense of individualism. I do not suggest here that the representations of marketing might wholly define the experience of (or motivation for) participating in BAC's festival or describe the full intentions of the festival's organisers, but rather that such language reflects a dominant cultural discourse in which consumer habits are framed as the signs of personal distinction. Though Howells' relationships with his audience-participants may not have taken first form as a financial transaction – insofar, as noted above, he was engaged for a fixed fee rather than a share of box-office income – that does not mean that audience-participants' relationships to his work in return were not shaped by the price of the ticket or the act of purchasing it.

Reflecting on his own experience of *Foot Washing for the Sole* in 2010, Fintan Walsh has suggested that Howells' model of non-hierarchical service might be considered more ethically complicated when understood as a service that has been paid for, 'so that any emotional or affective transaction is predicated upon

Opposite: Adrian Howells, *Adrienne's Room Service*, performed at Great Eastern Hotel, London, 2005. Photo by Marko Waschke.

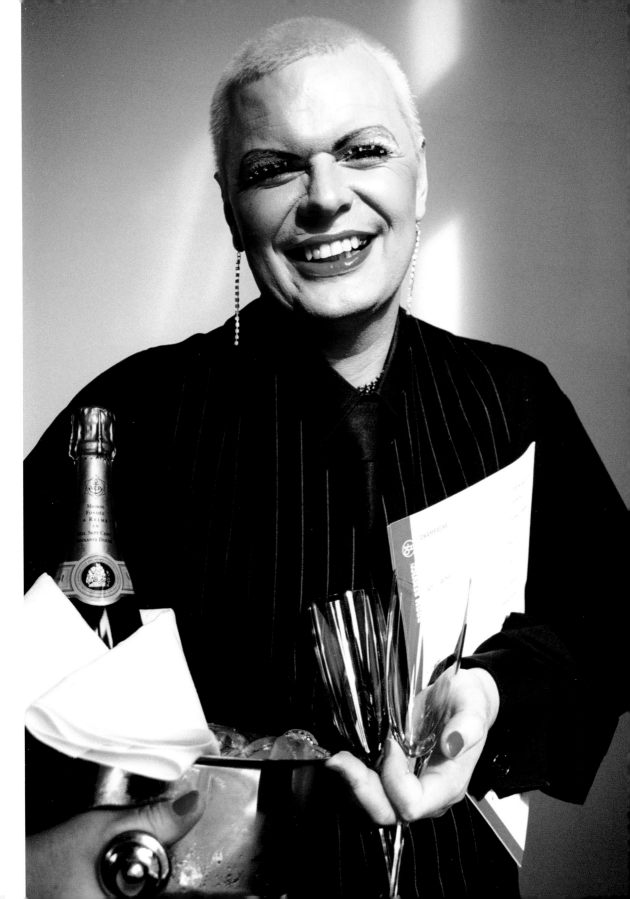

monetary exchange'.[33] Walsh's observation, I suggest, rests less on the idea that the forms of exchange within Howells' practice might be wholly determined by the logic of capitalist transaction than on acknowledgment of how the act of buying a ticket may invoke particular, habitually assumed logics for value itself. The cultural training of capitalism is such that the logic of price permeates and structures other logics of value, acting as a universal point of reference through which experiences might be compared and ranked. Despite ourselves, we understand we have access to a rarefied experience only because we have paid for it and that even if we reject a merely financial valuation, part of the value of that experience is reflected in its price.[34] Moreover, the logic of exchange may mark a psychic field in which 'doing nothing' exposes one to the ungovernable generosity of the other.

To return to Mauss, we may even experience a gift as a debt, such as that we find ourselves 'sold' to the gift-giver until recompense has been offered for a gift received.[35] When we do not perform by taking part in an exchange of gifts, we raise an affective debt that becomes intelligible through the logic of capital; as Walsh observes, the 'economy of service' in which 'we pay to be touched' is also one in which we 'even feel an obligation to be touched [...], to feel or at least to appear moved; in other words, to *act*'.[36] Such a feeling of obligation may not be directed exclusively towards Howells (a desire not to ruin *his* work) but reflects our own internalized sense of how value is given meaning within a commodity culture. It marks a form of cathecting to a dominant logic of exchange, practiced in order to make wider sense of our own emotional labour, and in place of the myth of free exchange, we find ourselves in a situation in which, in Lazzarato's formulation, 'one *has* to express oneself, one *has* to speak, communicate, cooperate, and so forth'.[37] From the perspective of a paranoid critique that – following Eve Sedgwick's analysis – places its faith in the exposure of hidden patterns of hegemonic social relations, Howells' practice might direct us to better acknowledge our own complicity in sustaining neoliberalism's regime of affective value.[38] But understood as a reparative intervention centred on the amelioration of that regime, as an acknowledgment of dominant logics of exchange without granting them the status of inviolable truth, Howells' affective labour might unburden us of the *demand* for reciprocity. We do not owe him anything though we might join him, if we like.

Interviewed ahead of his residency at The Arches in partnership with Sense Scotland's TouchBase centre, where he would work with socially isolated adults with complex learning needs, Howells voiced concern that his work was circulating within 'very particular times' in which:

Opposite: Adrian Howells performs naked with a series of clothed invited audience-participants – here with audience-participants Katy Baird (left) and Susan Yip (right) – in images produced to accompany lectures by the artist. Gilmorehill Theatre, University of Glasgow, 2008. Photo © Hamish Barton.

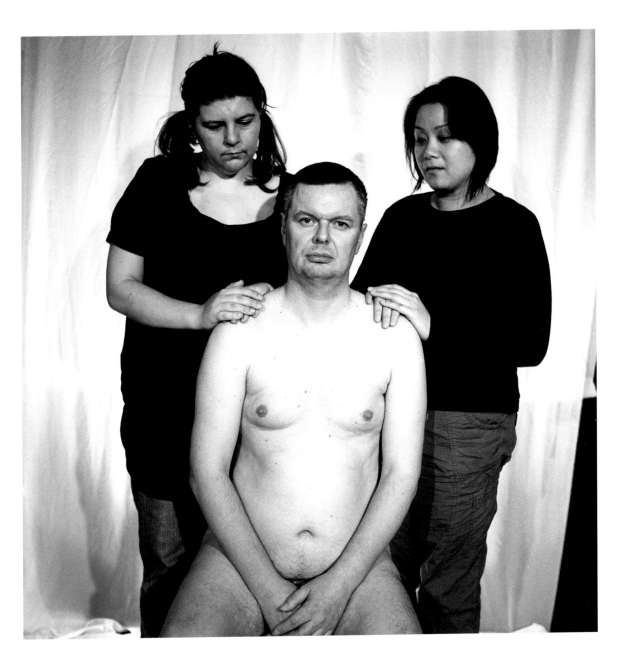

the phone-hacking scandal; the way that people have been seriously abused by those in authority and power, all of this has been preying on my mind that it's coming from an individualist society where people are out for themselves. So I feel I need to return to the idea of community.[39]

If the development of Howells' practice during his AHRC Fellowship was marked by the shift from spoken confession to communicative silence, we might also recognise in that trajectory a pursuit of forms of generative exchange apart from the purely individual contract.[40] That phase of Howells' practice – traced in the archive through the commission for *May I Have The Pleasure...?* (2011), in hours invoiced as contributing artist to The Arches' production of Mammalian Diving Reflex's group autobiographical work *All The Sex I Ever Had* (2013) and in the early stages of collaboration with Ian Johnston and Gary Gardiner on the show that would become *Dancer* (2013) – did not mark a departure from intimacy, but rather an attempt to (re)discover intimacy's place within shared rituals of communal experience. While none of the works produced through the residency were one-to-one performances, Howells continued to refine that thread of his practice through *Unburden (Saying the Unsaid)* (2013), commissioned and developed at BAC. The scene of the individual confession was joined, in other words, with a social dramaturgy oriented on a wider network of possible exchanges.

This though, is the point at which my reading of the archival record of Howells' life and work finds its limit. While an ordered sequence of monthly invoices account for days he worked at The Arches and TouchBase, they tell me nothing about the relationships Howells developed with those he mentored, or the forms of care that he gave and may have received in kind. It seems fitting that Howells' archive might perform its own refusal of the attempt to qualify his affective labour, even as it offers evidence of the ways in which he worked.

The records for the last financial year of Howells' life are unsorted, a dense mass of receipts and ticket stubs whose materiality marks a life in progress – one cut short. As I work, I am conscious of the transactions that may appear elsewhere in the folds of his papers: exceptions to the patterns of production that I have sought to trace and relationships whose presence may have been intelligible to Adrian alone. There are intimacies of exchange that I cannot share here, in large part because they are not in my gift to give.

Overleaf: Adrian Howells applies his makeup backstage before a performance of *An Audience with Adrienne: A Lifetime of Servicing Others*, at the Arches, Glasgow, as part of Glasgay!, 2006. Photographer unknown.

1. This essay draws primary material from boxes 23, 24 and 29 of the Adrian Howells Collection, held as part of the Scottish Theatre Archive at the University of Glasgow. At the time of writing, these boxes contain a large number of uncatalogued receipts, invoices, contracts and bank statements, as well as personal and production ephemera, and are primarily dated between 2006 and late 2013 (although a few documents are drawn from earlier periods).

2. On the former sense of an 'affective archive', see Ann Cvetkovich, *An Archive of Feelings: Trauma, Sexuality and Lesbian Public Cultures* (Durham and London: Duke University Press, 2003), p. 7. On Howells' use of his own 'autobiographical archive' within his performances, see Jon Cairns, 'Ambivalent Intimacies: Performance and Domestic Photography in the Work of Adrian Howells', *Contemporary Theatre Review*, 22.3 (2012), 355-71.

3. Michael Hardt and Antonio Negri, *Commonwealth* (Cambridge: The Belknapp Press of Harvard University Press, 2009), p. 132. Also see Maurizio Lazzarato, 'Immaterial Labor' in *Radical Thought in Italy: A Potential Politics*, ed. by Paolo Virno and Michael Hardt (Minneapolis and London: University of Minnesota Press, 1996), pp. 133-47. For the wider field of discussion, see: *Being an Artist in Post-Fordist Times* ed. by Pascal Gielen and Paul De Bruyne (Rotterdam: NAi, 2009); *Are You Working Too Much? Post-Fordism, Precarity, and the Labor of Art* ed. by Julieta Aranda, Brian Kuan Wood and Anton Vidokle (Berlin: e-flux Sternberg, 2011); and Jen Harvie, *Fair Play: Art, Performance and Neoliberalism* (Houndmills: Palgrave Macmillan, 2013).

4. Jasbir Puar, Lauren Berlant, Judith Butler, Bojana Cvejić, Isabell Lorey and Ana Vujanović, 'Precarity Talk: A Virtual Roundtable with Lauren Berlant, Judith Butler, Bojana Cvejić, Isabell Lorey, Jasbir Puar, and Ana Vujanović', *TDR: The Drama Review*, 56.4 (Winter 2012), 163-77 (p. 175).

5. Gabriele Klein and Bojana Kunst, 'Introduction: Labour and Performance', *Performance Research*, 17.6 (2012), 1-3 (p. 2).

6. Hito Steyerl, 'Politics of Art: Contemporary Art and the Transition to Post-Democracy', *e-flux*, 21 (2010) <http://www.e-flux.com/journal/politics-of-art-contemporary-art-and-the-transition-to-post-democracy/> [accessed 18 May 2015]

7. Michael Hardt , 'Affective Labor', *boundary 2*, 26.2 (Summer 1999), 89-100 (p. 96).

8. I also do so because greater transparency in how contemporary performance is financed seems both ethically and politically desirable when the touring model appears increasingly precarious. For context, see Bryony Kimmings, 'You Show Me Yours..', <http://thebryonykimmings.tumblr.com/post/67660917680/you-show-me-yours> [accessed 2 May 2015].

9. Festivals which programmed Howells' work include Vancouver's PuSh, Glasgow's Behaviour and Glasgay!, Birmingham's Fierce Festival, Uovo in Milan, Ireland's Kilkenny Arts Festival, the Traverse Theatre for the Edinburgh Fringe Festival, the Belfast Festival at Queens, the Bavarian State Opera Festival in Munich and the Tokyo Performing Arts Market.

10. Institutions of Higher Education included the Royal Central School of Speech and Drama, York St. John University, Saint Martin's College of Arts and Design, Queen Mary University of London, Lancaster University and the University of Leeds.

11. Puar, Berlant, Butler, Cvejić, Lorey and Vujanović., 'Precarity Talk', p. 176.

12. Clauses are variously concerned with financial liability in the event of cancellation, the schedule of payments comprising the fee, responsibilities for personal public liability insurance, details of marketing and technical support (including whether a venue will supply administrators and technicians) as well as the material scope of the venue (number of seats, the provision of a lighting rig, sound system etc.).

13. The venue tenancy agreement relating to one staging of *An Audience with Adrienne*, for example, allowed the owner of the building to cancel the performance if they judged a work to be in breach of 'good taste' and likely to 'cause offence to a reasonable audience'.

14. See Charlotte Higgins, 'Is Intimate Theatre "Decadent"?', *Guardian* (9 August 2011)<http://www.theguardian.com/culture/charlottehigginsblog/2011/aug/09/edinburghfestival-edinburgh> [accessed 20 May 2015]

15. Peggy Phelan, *Unmarked: The Politics of Performance* (London and New York: Routledge, 2003), p. 149. On the 'baffling' economic logic of one-to-one performance, see Deborah Pearson, 'Unsustainable Acts of Love and Resistance: The Politics of Value and Cost in One-on-One Performances', *Canadian Theatre Review*, 162 (Spring 2015), pp. 63-67.

16. Howells in Dominic Johnson, 'Held: An Interview with Adrian Howells' in *The Art of Living: An Oral History of Performance Art* (Houndmills and New York: Palgrave Macmillan, 2015), p. 272. A version of this interview is reproduced in the present publication.

17. Howells in Rachel Zerihan, *One-to-One Performance Study Room Guide* (London: Live Art Development Agency, 2009), p. 35. Howells acknowledged that making his work 'transparent' and seeking the active consent of his participants was an outcome of working within a university setting with formal systems of ethics approval and risk management for research involving human participants. See Lyn Gardner, 'How Intimate Theatre Won Our Hearts', *Guardian* (11 Augsut 2009) < http://www.theguardian.com/culture/2009/aug/11/intimate-theatre-edinburgh> [accessed 8 July 2015].

18. Zerihan, *One-to-One Performance Study Room Guide*, p. 35.

19. Ibid.

20. Ibid, p. 36.

21. Dan Prichard, 'Interview with Adrian Howells Part 2' (Balcony Productions and British Council, 2009) < https://vimeo.com/18162810> [accessed 20 May 2015].

22. Rachel Gomme, 'Not-So-Close Encounters: Searching for Intimacy in One-to-One Performance', *Participations*, 22.1 (2015), 281-300 (p. 286).

23. Claire Bishop, 'The Social Turn: Collaboration and its Discontents', *Artforum International*, 44.6 (2006), 178-83 (p. 183).

24. Marcel Mauss, *The Gift: The Form and Reason for Exchange in Archaic Societies* (London and New York: Routledge, 2002), p. 61.

25. Mary Douglas, 'Foreword: No Free Gifts' in Mauss, *The Gift*, p. xvii.

26. Lewis Hyde, *The Gift: How The Creative Spirit Transforms the World* (Edinburgh: Canongate, 2007), p. 4.

27. Ibid, p. 9.

28. Theodor Adorno, *Minima Moralia: Reflections on a Damaged Life* (London: Verso, 2005), p. 42.

29. 'BAC One-On-One festival', *Battersea Arts Centre Digital Archive*, <http://www.bacarchive.org.uk/items/show/3402> [accessed 2 May 2015]. Festival advertising for the following year adopted the frame of a menu of 'tasty bite-size theatre' in which *Foot Washing* returned as a 'main course' of intimate performance. See 'One-On-One Festival Brochure', *Battersea Arts Centre* <http://issuu.com/battersea_arts_centre/docs/1on1_finalx_web/2> [accessed 2 May 2015].

30. Harvie, *Fair Play*, p. 28.

31. Pearson, 'Unsustainable Acts of Love and Resistance', p. 65.

32. Lazzarato, 'Immaterial Labor', p. 138.

33. Fintan Walsh, 'Touching, Flirting, Whispering: Performing Intimacy in Public', *TDR: The Drama Review*, 58.4 (Winter 2014), 56-67 (p. 59).

34. The free staging of intimate work – as in Glasgow's //BUZZCUT// festival – may describe the circumstances under which such presumptive, habitual logic is challenged, if not entirely resisted (noting that the festival makes use of 'pay what you want' collections after every performance and share the proceeds amongst all of the artists taking part).

35. Mauss, *The Gift*, p. 61.

36. Walsh, 'Touching, Flirting, Whispering', p. 59.

37. Lazzarato, 'Immaterial Labor', p. 135.

38. On paranoid and reparative thinking, see Eve Kosofsky Sedgwick, *Touching Feeling: Affect, Pedagogy, Performativity* (Durham and London: Duke University Press, 2003), pp. 123-51.

39. See Josephine Machon, 'Adrian Howells: The Epic in the Intimate' in *Immersive Theatres: Intimacy and Immediacy in Contemporary Performance* (Houndmills and New York: Palgrave Macmillan, 2013), pp. 261-2.

40. Deirdre Heddon and Adrian Howells, 'From Talking to Silence: A Confessional Journey', *PAJ: A Journal of Performance and Art*, 33.1 (2011), 1-12. This article is reproduced in the present volume.

The Character of Adrian in *The Author*

Tim Crouch

Adrian and I met in Edinburgh in August 2007. I took my two eldest children (then 15 and 17) to see *An Audience with Adrienne* at the Medical School. There seemed to be no division between Adrian and Adrienne – no adoption of a character distinct from the man. They were one and the same but Adrienne allowed Adrian to be even more 'Adrian'.[1] Adrienne showed photographs of himself as a boy and talked about his childhood. In the spirit of permission as embodied in his work, I remember revealing in that show to having occasionally worn my mum's clothes as a kid. I'd never told anyone that – let alone my mum, least of all my children. But with Adrian/Adrienne, that's what happened. It was all allowed.

That autumn I started to work on a commission for a play from the Royal Court. Looking back over my notes from that time I see Adrian's name appearing again and again. He had entered my subconscious (he will never leave). I began to hear his voice in the things I was writing. Initially, I tried to objectify that voice – steer it towards a fictional characterisation. But then I realised that Adrian *was* so many qualities of the character I was thinking about so I started to write for him. Or, rather, I wrote for an idea of him. I wrote for the qualities I perceived. He became my template for the character. Writing for Adrian fed my confidence to also write for myself – or an idea of myself. This slippage between person and persona was there in Adrian/Adrienne and it became a central idea in the play I was to write.

In August 2008 I wrote an email to Adrian that contained this:

> I have a confession to make: I've written a play and in the play there is a person called Adrian [...] The play is called *The Author* but it's about how the audience is the author and, in my play, Adrian IS the audience. [...] I would love you to be in it.[2]

In that email I describe what I had written as a 'play' but I describe the role of Adrian in that play as a 'person' – not a 'character'. With hindsight, it would

Opposite: Esther Smith (standing) and Adrian Howells (in glasses) seated in the audience during a performance of Tim Crouch's play *The Author*, performed at the Jerwood Theatre Upstairs, Royal Court Theatre, London, 23 September to 24 October 2009. Photo by Stephen Cummiskey, courtesy of Tim Crouch.

have been more clarifying for Adrian if I had written 'character' – but this identity-ambivalence is intentionally fluid in *The Author*. The play, like most plays, draws from real life but it isn't real. The actors, like most actors, are not playing themselves but 'versions' of themselves. The key difference is that I don't give these versions fictional names – no Adrienne to an Adrian. I play a character who's a playwright called Tim Crouch – but it's not me.

I have described the character of the 'audience member' in *The Author* – played by Adrian (as 'Adrian') at the Royal Court and then by Chris Goode (as 'Chris') on tour – as being 'theatre's worst enemy': someone who accepts a subjugated, uncritical role, idolizing actors, surrendering authority, blindly subscribing to everything that theatre programmes for them (including, in the play's thesis, abuse). This is not a description of Adrian Howells. I was interested in how the qualities of the real Adrian – his openness and trust – bisected with the qualities of his fictionalized version. I didn't explain this complexity in my email to Adrian (I doubt I was capable of articulating it in that early stage of development) but I attached a draft of the play and said that I'd love him to meet up with my co-directors, Andy Smith and Karl James. He replied and said he was flattered and interested and asked if he could think about it. In December 2008 I went to teach for Adrian at the University of Glasgow. Afterwards, I wrote to Andy and Karl:

> Every second spent with Adrian Howells this weekend reinforced the rightness of his presence in the show. […] He gave a talk at the university this year and the cleaners came because he had befriended them all. He is excited about working with us.[3]

So Adrian agreed to be Adrian in *The Author* (after an extensive joke about him being second choice to Alan Carr).

———

The Author company assembled in May 2009 for a week of research and development on the play that would go into rehearsal in September that year. The week ended with a staged reading in front of staff invited from all the departments at the Royal Court – including the cleaners. In an interview by Helen Iball in October 2010, Adrian said that during that time he felt 'comfortable':

> We always had the scripts there, so the security of that was huge, but I also felt that I had much more of a distinct and definite role in terms of interacting with the audience and in terms of looking after them. [...] Once rehearsals started, it seemed like the flexibility had gone.[4]

The read-through was scheduled to end in a discussion with the audience. That early draft of the script invited Adrian to 'heal the space' at the end – to gently initiate a chance for the audience to unpack what had happened in the staged reading. At the end of the read-through, however, neither actors nor audience felt able to talk. Adrian was in tears. In our company debrief, he spoke passionately about his concern for individual audience members who might come to see the play and not be in a position to deal with it; people on their own; people on the edge of something and who might be tipped over by it. He spoke as someone with personal experience of this vulnerability. He spoke of the danger of the play generating a hopelessness and despair. Andy, Karl and I met the following month to confront the responsibilities of the play in the light of what had happened in May. We engaged with the Royal Court about signage in the theatre alerting people to the nature of the show. We put in place mechanisms to make both the play and the space as attentive to the audience as possible. We did not, however, change the nature of the challenge *The Author* makes to its audience: that challenge is at the centre of the play. It is a challenge that calls upon the audience to recognise its own authority and responsibility in relation to an act of representation. Nor did we choose to explicitly clarify the distinction the play consciously fails to make between 'character' and 'person'.

––––––

Rehearsals began in September 2009. As Adrian stated to Helen Iball, this is where it started to get difficult for him. In my mind we were working on a play written by a writer – with lines spoken by characters. A play with the audience at the forefront of its thinking but a scripted text with an argument contained within its full and fictional span. Of the four actors in the play, the character of 'Adrian' is given most leeway with the script. The stage direction reads, 'There is freedom in Adrian's speech to improvise if needed'. No other character is given this capacity. I wanted Adrian to feel free with his language – responsive to the audience – in the knowledge that the play also had a specific destination connected to the story it was telling. He would be responsive to the audience but not responsible. This was like asking a bird not to fly. I was asking Adrian to control and ration his contract of care because the play was exploring a

different contract – a more traditional contract, I suppose, between a 'play' and its audience. Helen Iball describes this:

> [W]ith the character of 'Adrian' in *The Author*, Crouch writes Howells into a compromised position. [… T]he form of performance practice that Tim found so engaging when he participated in *An Audience With Adrienne* becomes the host in a way that is antithetical to Adrian's interests in working with audiences. The play is parasitic upon Howells' nurturing practices, using a confessional form to anchor an *apparently* confessional form.[5]

The idea of a character being 'parasitic' on an actor's quality is glaringly exposed in *The Author*. The character of 'Adrian' is not particularly likeable – and Adrian Howells needed to be liked.

> I don't want to be disapproved of and disliked. I feel that when I do my work, there's not any real reason to dislike me, because I'm really trying to be as caring and nurturing and as audience-focused as I can be – it is about that person. Whereas, in *The Author*, having to say those things, I was disliked and I wasn't a pleasant character.[6]

We would not expect an audience to conceive of the actor playing Macbeth, for example, as being a murderous person. In *The Author*, however, the distinction between character and actor is blurred. The character of Adrian in *The Author* is not like the real Adrian – as most fictional characters are unlike the actors who represent them. Adrian wanted to 'look after' the audience but that is not the role of the actors in *The Author*. The audience members have to look after

Above: Adrian Howells shares chocolates with an audience member during a performance of Tim Crouch's play *The Author*, performed at the Jerwood Theatre Upstairs, Royal Court Theatre, London, 23 September to 24 October 2009. Photo by Stephen Cummiskey, courtesy of Tim Crouch.

- Adrian
- 47
- A buyer at Peter Jones
- Lives in Chertsey
- Lives alone
- Has an ordered life
- Prone to having fits (brought on by flashing lights)
- Has had eye surgery cos of being beaten up

Fastidious

Assumes familiarity

Lonely

Obsessive

Romantic

Nervous/Anxious

Certainty/Doubt

Naivety

- Avid theatre-goer "I see everything I do"

- Hangs around stage doors

- Waits ages to see actors — Ralph Fiennes

- Collects press cuttings — a bit of an anorak

- An incurable romantic

- Loves the glamour of it

- Lives his life vicariously thro' the lives of others — actors + celebs

- Bragging about his relationship with Courtenay

Only 3 months after end of play — after I've been beaten up! |Character| |Costume|
Character conversation

Speaking lines → character (blurred when interacting with audience)
Not speaking lines → not character
cf. violinist in orchestra, not playing, but still part of piece, still violinist, just not playing at certain times

MULTI-FACETED 'AUDIENCE' CHARACTER/PERFORMER

|ADRIAN (PART OF REC AUDIENCE)| → |ADRIAN (PART OF CO. OF PERFORMERS)| → |ADRIAN (CHARACTER IN PLAY WITHIN PLAY)|

|Closure |Forgiveness| |Aloneness/Togetherness|

I do have licence to disagree with audience member — don't always have to be good + kind + positive.
|DISCIPLINE| of saying line which is a question + then driving on.
Elasticity in first speech, but not so much in rest of play (rules of play!)
Elasticity at end of play — |HONESTY| find myself anew at the end of play, each night
An imperfect act of love + hope!!
GOOD AUDIENCESHIP

|CONFIDENCE| |SAFETY| |HOPE|

PLAY MY PART IN THE STORY.
I'm no more special as an audience member than anyone else — about being human to be with and at beginning.
BEING!!! BEING REAL!!! BEING IN THE PRESENT!

① Notice something abt. audience — to bring them in!

② Much more certain abt. what I think!
Re: HOPE

③ Look at which questions are rhetorical + which I sincerely want answered.

④ Cut pause before "And the actors go out on . . ."

⑤ Can play with usher — they will have seen it every night!

⑥ Sounding too posh — use own voice!

⑦ Keep it really close to me — have faith in fact that people will come to meet me!

⑧ Give myself licence to 'play' with audience — people on their own/people in couples.

⑨ 'Are we all on our own?' — He's found a way of being on his own + being comfortable with it!

⑩ Once I've opened out — can go back in again + just be with people around me!

⑪ Think about when he's talking about himself — and the certainty — and when he's asking questions of and.

⑫ Gracious way of responding to question that isn't helpful / and when I want to move things on.
⑬ 15/6/5!

Upper left: A page of notes from Adrian Howells' journal during his preparation for Tim Crouch's play The Author, performed at the Jerwood Theatre Upstairs, Royal Court Theatre, London, 23 September to 24 October 2009.

Remaining images: Front and back of a number of pages of Howells' heavily annotated script for The Author. All from Adrian Howells Collection, Scottish Theatre Archive, University of Glasgow, Box 33.

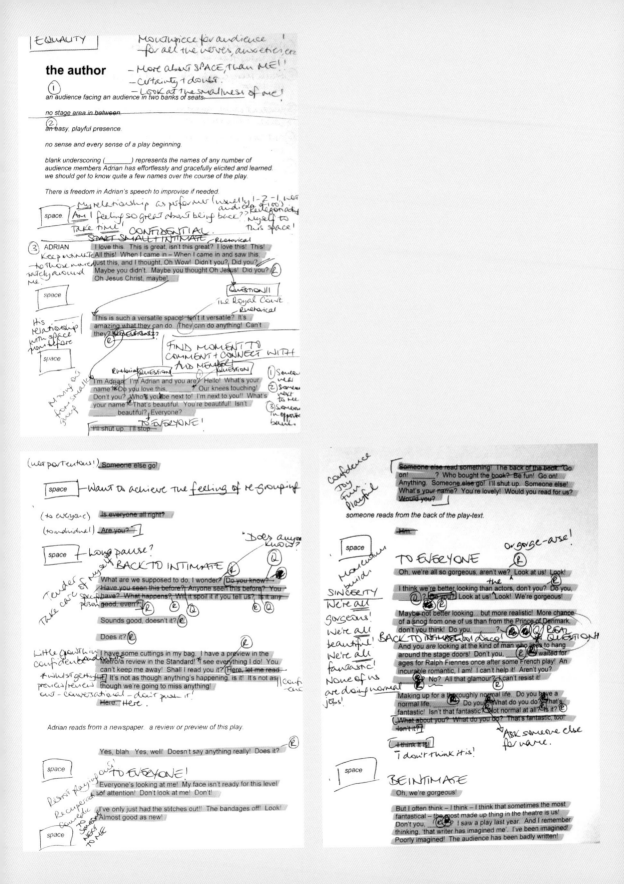

EQUALITY

handwritten: Mouthpiece for audience / for all the nerves, anxieties etc

the author

handwritten: — More about SPACE, than ME!!
handwritten: — Certainty + doubt.
handwritten: — LOOK at the smallness of one!

(1)

an audience facing an audience in two banks of seats.

no stage area in between.

(2)

an easy, playful presence.

no sense and every sense of a play beginning.

blank underscoring (_____) represents the names of any number of audience members Adrian has effortlessly and gracefully elicited and learned. we should get to know quite a few names over the course of the play.

There is freedom in Adrian's speech to improvise if needed.

space | *handwritten: My relationship as performer (usually 1 - 2 - 1, not and depersonalised) myself to this space / Am I feeling so great about being back?* *Take time. CONFIDENTIAL. START SMALL + INTIMATE — Rhetorical*

(3) ADRIAN *handwritten: Keep intimate to those immediately around me* I love this. This is great, isn't this great? I love this! This! All this! When I came in – When I came in and saw this – Just this, and I thought, Oh Wow! Didn't you?, Did you? Maybe you didn't. Maybe you thought Oh Jesus! Did you? (R) Oh Jesus Christ, maybe!

handwritten: QUESTION!! The Royal Court — Rhetorical

space

handwritten: His relationship with space from before This is such a versatile space! Isn't it versatile? It's amazing what they can do. They can do anything! Can't they? *handwritten illegible*

space

handwritten: FIND MOMENT TO COMMENT + CONNECT WITH AUD MEMBER

handwritten: Many anxious for smallest group *handwritten: Rhetorical QUESTION / QUESTION* I'm Adrian. I'm Adrian and you are? Hello! What's your name? Do you love this. Our knees touching! Don't you? Who you be next to! I'm next to you!! What's your name? That's beautiful. You're beautiful! Isn't beautiful? Everyone?

handwritten: 1) Someone near 2) Someone next to me 3) Someone in opposite bank.

handwritten: TO EVERYONE!
I'll shut up. I'll stop.

handwritten: (not portentous!) Someone else go!

space — *handwritten: Want to achieve the feeling of re-grouping*

(to everyone) Is everyone all right?

(to individual) Are you?

space — *handwritten: Long pause?* *handwritten: "Does anyone know?"*

handwritten: Tender of myself / Take care specifics *handwritten: BACK TO INTIMATE* *(R) (R)*
What are we supposed to do, I wonder? Do you know?
Have you seen this before? Anyone seen this before? You have? What happens? Will it spoil it if you tell us? Is it any good, even? *(R) (R) (R) (R) (R)*

Sounds good, doesn't it? *(R)*

Does it? *(R)*

handwritten: Little growth in confidence & must get it out. Previous/review conversational – don't push it! I have some cuttings in my bag. I have a preview in the Metro/a review in the Standard! I see everything I do! You can't keep me away! Shall I read you it? Here, let me read it. It's not as though anything's happening, is it! It's not as though we're going to miss anything! *handwritten: I can't...* Here. Here.

Adrian reads from a newspaper. a review or preview of this play.

Yes, blah. Yes, well! Doesn't say anything really! Does it? *(R)*

space *handwritten: Resist playing out! Recuperate Comedic smart seat to me* *handwritten: TO EVERYONE!*
Everyone's looking at me! My face isn't ready for this level of attention! Don't look at me! Don't!

I've only just had the stitches out!! The bandages off! Look! Almost good as new!

space

handwritten: Confidence Joy Fun Playful Someone else read something! The back of the book. Go on! _____? Who bought the book? Be fun! Go on! Anything. Someone else go! I'll shut up. Someone else! What's your name? You're lovely! Would you read for us? Would you?

someone reads from the back of the play-text.

Hm.

space *handwritten: Momentum build SINCERITY We're all gorgeous! We're all beautiful! We're all fantastic! None of us are doing normal* *handwritten: or gorge-arse!*

handwritten: TO EVERYONE *(R)*
Oh, we're all so gorgeous, aren't we? Look at us! Look! I think we're better looking than actors, don't you? Do you, _____? Look at us! Look! We're gorgeous! *(R)*

Maybe not better looking... but more realistic! More chance of a snog from one of us than from the Prince of Denmark, don't you think! Do you, _____? *(R) REAL QUESTION*
handwritten: BACK TO INTIMATE And you are looking at the kind of man who likes to hang around the stage doors! Don't you, _____ waited for ages for Ralph Fiennes once after some French play! An incurable romantic, I am! I can't help it! Aren't you? *(R)* No? All that glamour? I can't resist it!

Making up for a thoroughly normal life. Do you have a normal life, _____? Do you? What do you do? That's fantastic! Isn't that fantastic! Not normal at all – is it? What about you? What do you do? That's fantastic, too! Isn't it?

handwritten: ASK someone else for name.

handwritten: I think it is! I don't think it is!

space *handwritten: BE INTIMATE*
Oh, we're gorgeous!

But I often think – I think – I think that sometimes the most fantastical – the most made up thing in the theatre is us! Don't you, _____? I saw a play last year. And I remember thinking, 'that writer has imagined me'. I've been imagined! Poorly imagined! The audience has been badly written!

themselves. The actors are required to deliver their characters. The characters tell the story. The story is left with the audience. The play is difficult. It's difficult for everyone. Perhaps Adrian's solo practice was created to soften and ease the difficulty; *The Author* was written to identify it, inflame it and try to work out where some of it comes from. Talking to Helen Iball, Andy Smith (the co-director of *The Author*) said that an audience of 100 was 99 too many for Adrian.[7]

———

During the run at the Royal Court, Adrian did all he could to separate himself from the character.[8] The invitation to the actors in *The Author* is that they wear their own clothes for the show. Adrian, however, worked alongside the Court's wardrobe supervisor to develop a costume for himself – clothes that looked almost identical to those he usually wore but which weren't his. He would arrive at the theatre, wash and change into 'Adrian'. At the end of a performance, he would change back into Adrian. But the play did not support his reach for distinction between self and character. The play was pursuing a different course and Adrian felt compromised by it. In his life he had long since stopped considering himself an actor and, in *The Author,* he could never successfully separate himself from the character he was being asked to play:

I did feel very much like I was sacrificing what I am about as an artist, I was sacrificing that for the sake of this play and investing in this character that wasn't me. The character was quite unpleasant, was very obsessed with theatre and celebrity and the Royal Court and hanging around stage doors. It is very alien to me and there is no way I want to endorse that sort of behaviour. There's an arrogance to him [to 'Adrian'], assuming everybody feels like he does and then talking about those quite horrific things with such glee and relish.[9]

———

The Author is quite conventional in its demands to the actors. But Adrian was not an actor. He couldn't take his heart from his sleeve and hide it beneath a fiction. He was himself – in all his vulnerability – at all times. He couldn't dissociate in the way the play invited him to do – the way that, perhaps, might have made his experience in the play more bearable. I wish it had been easier for him.

A tour of *The Author* was being organised and, in January 2010, Adrian wrote to me with the news I was expecting to hear:

I'm afraid I don't want to do *The Author* again! I am SOOO bloody sorry […] Tim, I just know in the core of my being that it's not really MY world and I DID feel straight-jacketed having to learn and remember lines and felt constricted by the discipline of having to deliver

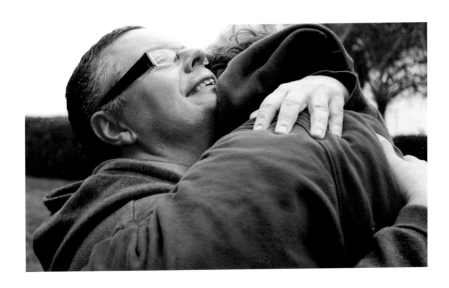

text and a performance in a particular way when we did it at the Royal Court. [...] To be absolutely honest and frank with you, Tim, I didn't particularly enjoy the performances and found the whole time a bit too stressful and anxious-making.[10]

———

In chemistry, there are such things as sacrificial anodes – highly active metals that are used to prevent less active metals from corroding. They absorb the bad stuff and sacrifice themselves for the benefit of others. You put them on boats, for example, under the waterline, and they attract the corrosive elements and are consumed in place of the metal they are protecting. I like to think Adrian Howells was a sacrificial anode, absorbing the suffering so we wouldn't have to. Those processes of self-exposure, love and sacrifice that he seemed to explore in his life became even more charged when he was working. The work didn't seem separate from him: it *was* him. He made the distancing of an actor's craft look glib and artificial. But I think it took its toll. We did all we could to help him through *The Author* but there was no way of stopping him from absorbing those negative ions.

1. Howells says, 'I'm really not interested in character and characterization. I'm interested in what is real'. See Dan Prichard, British Council Arts Interview with Adrian Howells, April 2010, <https://www.youtube.com/watch?v=C7btf8Tdg_s> [accessed 13 July 2015].

2. Tim Crouch, personal email to Adrian Howells, 28 August 2008.

3. Tim Crouch, personal email to Andy Smith and Karl James, 8 December 2008.

4. Helen Iball, 'Conversations with Adrian Howells', *Theatre Personal*, 2011, <http://theatrepersonal.co.uk/conversations/117-2/> [accessed 13 July 2015].

5. Helen Iball, 'A Mouth to Feed Me', *Contemporary Theatre Review*, 21.4 (2011), 431-44 (pp. 438-9). Emphasis in original.

6. Iball, 'Conversations with Adrian Howells'.

7. Ibid.

8. At the Royal Court, the play was performed at the Jerwood Theatre Upstairs, 23 September to 24 October 2009.

9. Iball, 'Conversations with Adrian Howells'.

10. Adrian Howells, personal email to the author, 13 January 2010.

Pillow Talk: The Legacy of Adrian Howells in Glasgow

Laura Bissell and Jess Thorpe with Nick Anderson,
Laura Bradshaw, Peter McMaster, Robert Softley Gale
and Murray Wason

pillow talk
noun
noun: pillow talk
intimate conversation in bed.

In 2004 Adrian Howells performed *Adrienne: The Great Depression* in Room 103 of the Brunswick Hotel in Glasgow's Merchant City.[1] This performance was an attempt to simulate a period of intense depression, similar to those that he experienced at various intervals through his life. Adrian/Adrienne inhabited Room 103 for one whole week, eating and sleeping in the same room, never washing, never shaving and never leaving. At the end of the week an audience was invited in small groups to join him on the bed, to talk about experiences of depression.

On 18 April 2015, seven of Adrian's friends – including performance-makers and academics – returned to the same room in the Brunswick Hotel, one year after his death, to engage in *pillow talk*: 'intimate conversations in bed' facilitated by Laura Bissell and Jess Thorpe. Adrian's work often explored intimacy in performance and the participants of this conversation gathered in (or rather, on) the bed to remember their experiences of the work of Adrian Howells, and the questions it raised in the wider ecology of the arts in Glasgow.

The Past

In the first stage of this conversation the participants were asked to reflect on their initial encounters with Adrian and to comment on how his work informed their own artistic practice. By inviting our peers to explore their personal relationships with Adrian and their engagement with his work, we hoped to reveal something of his influence on younger artists and the performance scene in Scotland, particularly in Glasgow where he lived permanently from 2006.

Laura Bissell: How did you meet Adrian?

Murray Wason: I met Adrian when I was in the Contemporary Theatre Practice programme [at the Royal Scottish Academy of Music and Drama (RSAMD)]. He was the mentor for the directing students in the fourth year, who were directing the first year cohort, of which I was a student. He was giving tutorials to us individually and also overseeing the performance work that we were making using a classic text – in this case, *The Tempest.* I wasn't being very well behaved or doing my homework, so I was getting into trouble quite a lot [*laughs*]. That was our relationship for several years I think, of him being in a position of authority. Little did I know that he himself was known for misbehaving.

Peter McMaster: I first met Adrian when I was in first year of the Contemporary Performance Practice (CPP) programme at the RSAMD.[2] I was in the toilet [*laughter*],and he sprung out of a cubicle and said 'Hello, are you Peter McMaster?', and I said yes. At that point I was experiencing a period of depression and he was as well. I think it was the time after he'd made *Adrienne: The Great Depression*, and he very quickly pulled his little silver angel out of his pocket and showed it to me. A woman had given it to him, a friend. He said it was his little guardian angel and that he carried that around with him. I don't know how he knew it was me in the loo, but he did leap out of the cubicle and introduce himself, and he wanted, in that moment, to bond with me very quickly, before I'd even met him, and to share his experience with me.

Jess Thorpe: I was aware of him in 2000 when he directed the year group above me [at the RSAMD] in a piece called *Mother of Mine*. After that he directed my year in *A Waste of Makeup* which was a piece about David Bowie. I wasn't in it but I was really jealous because it looked camp and so much fun. And then in 2004 he was 'gifted' to me as a mentor when I graduated from the RSAMD and I got my first teaching job on the CPP course. I was working with second year students to curate an international schools festival and he was the mentor allocated to help me figure out how to start teaching.

LBissell: I first met Adrian in Café Cherubini on Great Western Road in the West End of Glasgow. Adrian was looking for someone to stage-manage his piece *Salon Adrienne*, which was to take place in the basement of The Arches [in 2005]. Adrian gave me my first bit of paid work after I finished my degree and I always really appreciated that. After that meeting I went straight to Salon Services to try and borrow £5,000 worth of backwash equipment that I could install into The Arches dressing room (which I did). I remember finding Adrian to be very warm and it was the beginning of me working for him on a number of his shows over the years [*An Audience with Adrienne*, 2006, 2007, 2010; and *The Garden of Adrian*, 2009].

Robert Softley Gale: I first met him at the RSAMD when I was attending a student show. He came over and spoke about my work for about ten minutes

and I thought, 'this is great' [*laughter*]. Because he'd seen my piece the year before, and he just kept talking about it, and I was like: how does Adrian Howells know what I've done? And then about a year later I wrote to tell him I was working with disability and intimacy and asked him to come on board as a mentor. He replied to say he was willing to help, but that he wasn't an expert on disability. That wasn't an issue for me, as I am!

Nick Anderson: I think the first time that we properly met was on Argyle Street in Finnieston and we stopped and chatted in the street. I remember that conversation because he'd just come back from your house, Peter, he'd come to stay with you and Nic [Green] for a bit during another period of depression. I think this was around 2011 and he had a very specific take on where he was at that point in his life and how he was going to move forward. And he told me about it in the street. Immediately I was aware of his transparency and honesty about things like that.

Laura Bradshaw: My first meeting with Adrian was when he was the tutor for the directing students in the last module of my first year on the CPP programme. I remember having a conversation with Adrian because I found him to be quite an intimidating figure, a real presence in the room. I had a tutorial with him and I remember him saying to me that the director thought I was really lazy, and Adrian asked me if I thought that was true. And I remember thinking, 'that's what I'm coming across like', but at the time I felt insecure and angry. I think I was having a period of depression, and I thought, 'maybe you don't understand that'. But in later years I realised that he did and that he was perhaps just trying to tease it out of me.

JT: What have been some of your formative experiences of Adrian's work?

PM: I think it's a tough one to ask because Adrian probably wore the thinnest veil between a specific art piece and his life.

MW: I think my first experience of his work was probably *Adrienne: The Great Depression* which was in this very room in The Brunswick Hotel. I found it quite tough because I think he was very vulnerable. I didn't really know what I should or could do, and I had a feeling of wanting to help in some way. I remember divulging quite a lot in the performance. I found myself wrestling with that afterwards because I wasn't sure if I should've done that. So I found that quite edgeless in a way – what's part of the performance and what's not – which was tricky for me at that time, as I was still young.

JT: I met Adrian when he was still a director and then he moved to being a solo artist, and he created Adrienne, who we all thought looked a lot like Pat Butcher.

LBissell: 'Pat Couldn't-be-Butcher' [*laughter*].[3]

LBradshaw: I think the first thing I saw was *Adrienne's Dirty Laundry Experience* and I remember being quite challenged by it. I remember feeling shy

as a participant. I must only have been 20, and I went with a group of friends – maybe seven of us. Everyone had brought along their dirty laundry and I remember I didn't because I thought: I don't want to do that, I don't want to take along my dirty laundry, I don't know what might happen!

LBissell: What I really remember about the early work I encountered were the ideas of authenticity that he was trying to explore. Because I production-managed *An Audience with Adrienne* for a while, I began to ask: what is an experience if it's repeated again and again? And if you do two shows a day, are these really moments of authenticity, and do they create a real connection more profoundly than other kinds of performance might?

PM: It's complicated by knowing his intimate, personal story. He often made his work about this material, so technically everybody knew about it, but in the artwork you get presented with a formalised version of his story, for the purposes of viewing or for the purposes of experiencing it. I now feel that there was an impossibility that he always faced in placing his own story in his work, as if by making his work he might be fully healed by the process of creating it. But as we know, this was never to be the case. Because of this, I think I will always look at his work with a really different perspective to how I did when he was alive.

NA: The first thing I saw was *May I Have the Pleasure...?* (2011) He was speaking about loneliness, and being older and gay, and normative society not being appropriate for him, and I don't think I was ready to face that as a 23-year-old. That piece was *really* significant for me, even if my experience of it at the time was that I was quite bored and I felt like there wasn't something for me in the room. I now wonder if there was actually too much for me to deal with. It was too honest and I was guarding myself from it in some way.

RSG: The only work I saw live was *Lifeguard* (2012) with the National Theatre Scotland at Govanhill Baths, which I worked on, to help make it more accessible for those with a disability. For me it was about being in a room with a person, and creating a connection and intimacy in a unique way. There is a moment in the performance where everyone gets into the pool – it's a communal experience and I found that to be really powerful.

LBissell: What themes in Adrian's work do you feel are relevant to your work as an artist?

JT: He influenced me through his ability to encourage people to interact with each other in ways that were generous, exciting, fun. Those larger group pieces – like *An Audience with Adrienne* – were the influential ones for me, not the pieces where it was just him and me together.

Overleaf: Adrian Howells, *Adrienne: The Great Depression*, performed at Great Eastern Hotel, London, 2004. Photo by Marko Waschke.

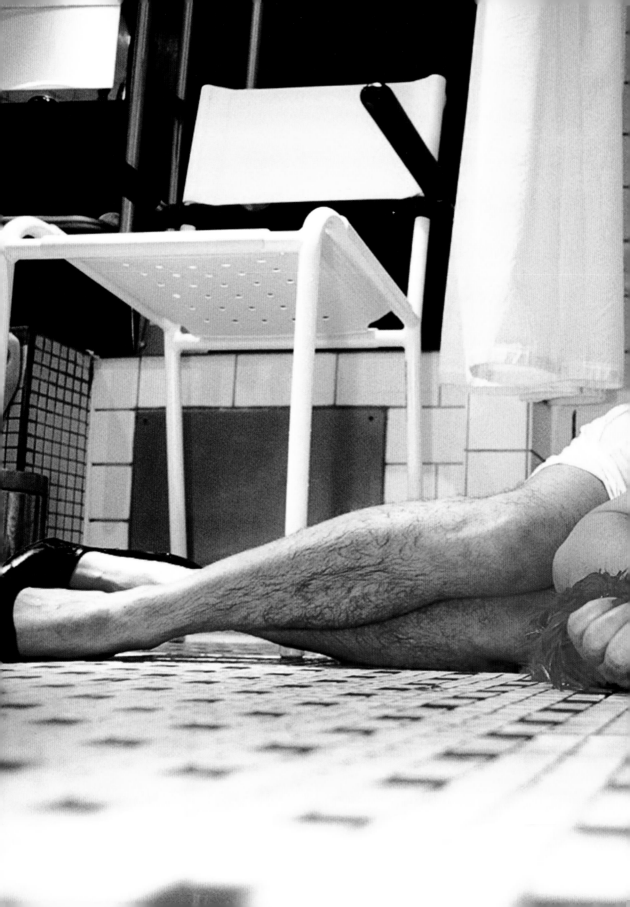

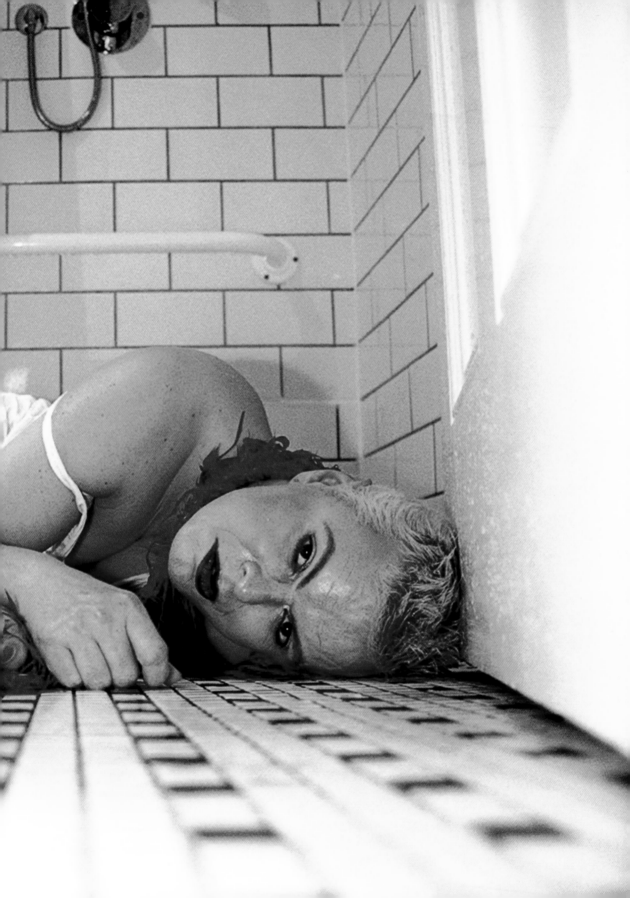

NA: Part of Adrian's contribution to //BUZZCUT// (the live art festival that I started with Rosana Cade in December 2011) was to advocate for the community aspect of the festival. If ever a decision was being made that was too in-service to a sector or the industry – he was our immediate voice. He'd argue that community was at the centre of what we do, and that our decisions should be directed by this. He would stress to us that creating an open, communal space within the festival was essential, as this was where audiences and artists would be talking to each other. Creating that kind of space would allow people to invest in each other and become fascinated by each other.

When Adrian was involved with //BUZZCUT// we started to have really developed chats about queer culture. We also talked about how the three of us – Adrian, Rosana, and me – could hang out together and the age difference would not feel relevant whatsoever. Age is a normative construct that tells you that you should be doing certain things at certain times in your life and that you should be hanging out with people your age, and that's something that we were all interested in challenging. Our conversations developed to define our friendships as political action, which was beautiful. But that conversation only happened because Adrian, as always, was asking the questions! [*laughter*].

LBissell: I found Adrian's work as an audience member a real challenge sometimes. For example, being asked to look in the mirror [in *Salon Adrienne*] was really useful for me to interrogate why I feel uncomfortable in those moments, and why I often struggle with one-to-one experiences in performance. I think his work has helped me to develop my understanding of what performance can be and to think about what the 'audience/performer' relationship is when you are both implicated in a one-to-one relationship.

PM: I think his most recent residency at TouchBase is a good reference point for me. He found a joy in that work. I think when I find my joy in the work I am making, maybe it's about learning how to stick with it.[4]

RSG: I think because he couldn't be Adrienne or 'Adrian-the-performer' at TouchBase, he just had to be in that room as himself with that person. That says something about how he always put up a front, but that he couldn't get away with it in that specific space.

The Present

Some of the themes of Adrian's work such as intimacy, confession and touch are being explored by younger artists who have been exposed to his work over the past few years, in particular students at the University of Glasgow and the RCS and those who encountered his work as Artist in Residence at The Arches. We asked the participants about the arts community in Glasgow in the present moment and how the repercussions of Adrian's work, life and death have affected contemporary performance making in this context.

LBissell: How do you think the arts community in Glasgow has responded to Adrian's death?

JT: I think there's a lot of sadness right now. For me, it's mainly from the point of view of friendship. We also lost the artist Ian Smith in the same year to the same illness.[5] I was friends with Adrian and Ian, and they both mentored me in different ways. In that year, I went to two funerals of two men of the same age, and it made me feel concerned about how, as an artist, you can remain feeling relevant and valued as you get older. It made me wonder about sustainable arts practices, and about safe emotional practices as well.

PM: Adrian was so good at putting himself on the line and making himself feel bad through the work he made. He was so good at exposing himself to the point where he couldn't rein it in and it led to performances like *Adrienne: The Great Depression* where he got depressed through doing it. I've had so many conversations with people about whether or not this has to be the case as a consequence of making your work. The invitation I gave to Nick Anderson when we started on the performance piece [27] was to look at these extreme emotional places we get ourselves into and these extreme experiences we have as young human beings, and what that can lead you to. The title refers to the age at which many artists and musicians have died.[6] But actually what we found – and maybe it's not a coincidence – is that although in the process we were looking at death, the work became about how to demonstrate being most fully alive. I think one thing I learnt from reflecting on Adrian's death is that my practice has to be life-giving. And as much as I think it shouldn't be the case that I learnt this most solidly through a friend dying, I admit that it is part of the legacy of Adrian's life and work for me.

JT: I found that I experienced a personal exhaustion after Adrian died. I think it just made me reflect on the effect of working practices on your wellbeing as an artist. And so it felt like maybe I needed to look at my own practice and ask: what is sustainable? What is real quality versus quantity? Why do I feel that I have to be making work all the time? Maybe it's better for me to do things in a smaller, more focussed way in order to experience them in a deeper way.

MW: For me, working with groups of younger people to devise work that becomes autobiographical, the lasting effect of Adrian's death has been to consider how to cushion that process. I was teaching a class the week that Adrian died and I decided to base the class on his work. I don't think I would have done that without his death. I based it on *Held* (2006) in particular, which allowed students to have intimate physical experiences with each other. I was thinking about the legacy of his work and I found this moment to be quite important for me, as a way to mark Adrian's work, or to see it again somehow. It was also about allowing younger people who were not familiar with Adrian's work to experience it – I didn't want his work to just go away. Perhaps there's a desire among us to solidify his work because he's not able to show it to us

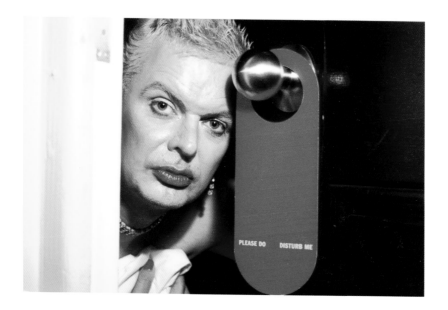

anymore. There is a strong desire in the arts scene to mark his legacy, but through action, I think, and not just through testimonial.

JT: When an artist is gone, they don't *need* their work to be shown anymore, so there has to be a good reason to continue sharing it. In terms of the ecology of the arts community in Glasgow, there is a reason his work has a resonance, because we stand on each other's shoulders, so to speak. Especially when we work with students, it's important that they know Adrian's work as a reference for intimacy, to share his 'attempts' somehow.

LBissell: Adrian's and Ian's deaths felt like traumas for the Glasgow arts scene and it really made me think about the individuals who make up the community, and that everyone plays a vital part in it. I've always known that our community exists but I think there's something about what happened last year that has made me think differently about it and acknowledge it or appreciate it more. It feels like quite a fragile and precious idea. I think people still feel very bruised by Adrian's death.

LBradshaw: Is there perhaps a sense of the absence of an older generation of artists in our community? Not just that it was made up of Ian and Adrian, but they were very significant figures in terms of the demographic of the community. I feel I've learned so much this year – I keep thinking about Adrian's memorial service in Glasgow and *how many* people were there. It made me reflect on the idea of care and how we can look after each other.

Above: Adrian Howells, *Adrienne: The Great Depression,* performed at Great Eastern Hotel, London, 2004. Photo by Marko Waschke.

The Future

Throughout the 'pillow talk' themes from Adrian's work such as intimacy, confession and community recurred constantly. In this final section the participants were asked to consider the legacy of Adrian's work. Participants responded in terms of their own practice but also reflected on how younger emerging artists might benefit from what Adrian's work has left behind in the wider arts community.

JT: We've talked about the past, and the present, and now we're going to talk about the future. Now that Adrian is gone, what will you carry with you?

LBradshaw: I was doing a big cleanout the other day and I found a card from Adrian to Murray – a birthday card. I'm sure everyone received a gushy card from Adrian at some point – he said loads of lovely things. When Peter mentioned earlier about the joy that Adrian carried with him, I was thinking that my encounters with Adrian often made me want to find the capacity to tell people how brilliant I thought they are. He was able to do that very easily, and it's something I often think about now in my encounters with people, particularly my encounters with friends, and with students. I really want to bolster them a lot, in the way that Adrian could.

JT: I think I'm going to carry a lot of laughter. We've talked a lot about heaviness but I want to remember the lightness of Adrian too, phrases like 'having a tilly top-up', or his funny little jokes, and his ability to break into an eighties dance move. It's just so important sometimes to not be too serious about life. I'm going to carry that because I laugh a lot when I think about Adrian.

PM: He had such a wicked sense of humour – and my god, so naughty.

LBradshaw: I always remember this time when we working together and he hid from us in one of the rooms at the conservatoire thinking we were all going to be back in about five minutes. But then we took ages coming back and then he was like, 'I've been hiding from you for half an hour!' [*laughter*].

PM: You can just imagine him hiding behind the curtain.

JT: And I guess that humour was, in some ways, a political act, an act of generosity in terms of his relationships with other people.

RSG: He could also keep a joke going for *so* long. I mean like *too* long. You're talking about the prism through which Adrian saw the world, and that's what I think I'll carry. I always think: what would Adrian have thought if he was with you?

NA: Before I'd met him I remember I'd sort of half-asked him to do *Five Minutes to Move Me*.[7] I never followed it up. I don't know why. And he challenged me about it later. What I'll take from that is: be reliable, work hard, be nice, remember that people are sensitive, and if you say something then someone could be holding onto that, so be genuine.

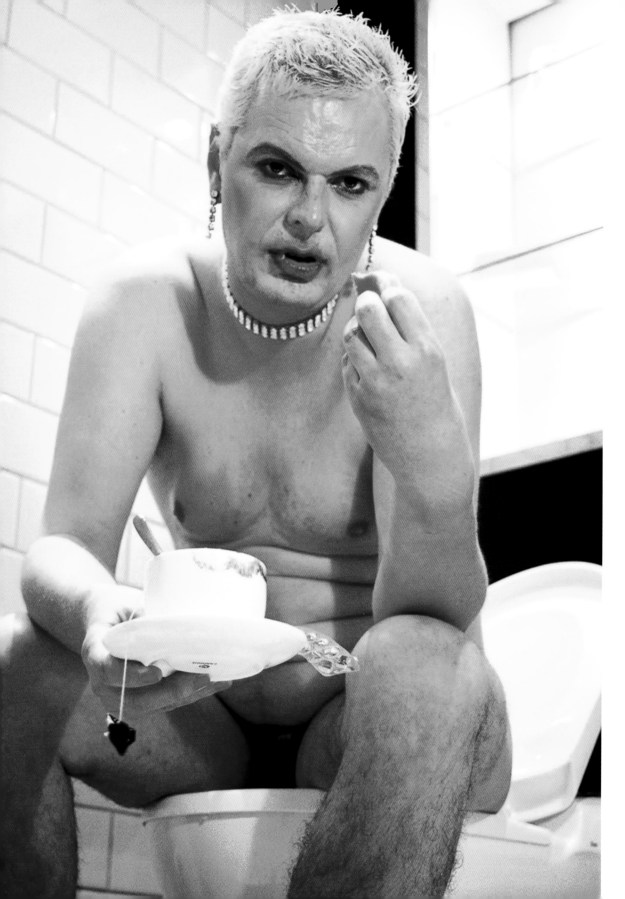

JT: The last question is: what is Adrian's legacy for the community?

LBissell: I think from the conversations we've been having it's been great to hear other people's experiences of Adrian and to think about the politicised way in which Adrian was working, in terms of his humour, his acknowledgement of his position as an older artist in a predominately younger arts community and his honesty about his illness. I'm thinking of Adrian's idea of 'it's all allowed' and the question: how can we – as a community – hold everybody? How *can* it be 'all allowed'? How can we continue to have a diverse community that is accepting of older artists and emerging artists, and artists who are working in different fields?

RSG: There's something for me about the fact that there's a hole in the community of people. Adrian left that hole – it's exactly his shape and that is just as much a part of what constitutes the community as the people left in it.

NA: The community just irrevocably changes and grows. It doesn't return to anything, it has to move on. It has to evolve.

PM: This taps into the notion of acceptance, perhaps. We have to accept that he has passed and there's this Adrian-shaped hole. We have to accept that no one else can fill it. I also think he made an effort to really accept everybody for who they were – again, 'it's all allowed'. Maybe we'll make less assumptions and more space, that would be good, wouldn't it?

NA: That would be good.

PM: Maybe we already are.

MW: I don't really like him actually [*laughter*].

1. *Adrienne: The Great Depression* was first performed at the Great Eastern Hotel in London (2004).

2. In 2009 the course, Contemporary Theatre Practice, was revised and renamed as Contemporary Performance Practice (CPP). In 2011, the Royal Scottish Academy of Music and Drama was renamed the Royal Conservatoire of Scotland (RCS).

3. Pat Butcher was a character in the British TV soap opera *EastEnders*.

4. TouchBase is part of Sense Scotland based in Glasgow and offers support and services for people who are deafblind and with sensory impairments. Howells worked with TouchBase participants prior to his death when he was Artist in Residence at The Arches.

5. Ian Smith was a Glasgow-based artist who formed the performance company Mischief-la-bas. He committed suicide on 1 August 2014, aged 55. See Robert Dawson Scott, 'Obituary: Ian Smith', *Scotsman*, 12 August 2014 <http://www.scotsman.com/news/obituaries/obituary-ian-smith-1-3506168> [accessed 14 July 15].

6. Peter McMaster collaborated with Nick Anderson on *27*, which was performed at In Between Time in Bristol in February 2015 and as part of the Behaviour festival at The Arches, April 2015.

7. *Five Minutes to Move Me* is a series of five-minute performances devised by //BUZZCUT// in 2012 and has been performed at Tramway, The Arches and Summerhall.

Opposite: Adrian Howells, *Adrienne: The Great Depression,* performed at Great Eastern Hotel, London, 2004. Photo by Marko Waschke.

Legacies of Darkness and Light

Nic Green

We find beauty not in the thing itself but in the patterns of shadows,
the light and the darkness, that one thing against another creates [...].
Were it not for shadows, there would be no beauty.

Jun'ichiro Tanizaki[1]

I am writing this from Kanazawa. Knowing that Adrian also visited Japan, in my mind's eye I keep imagining him. I picture him throwing himself into every opportunity, without a hint of British embarrassment or disbelief. I wonder when he would have cried because something was just too beautiful and I imagine moments when he might have veered into a knowing inappropriateness, causing a room of strangers to explode into fits of giggles. I imagine he loved the ceremoniousness of this place: the washing of the hands and mouth before entering a Buddhist temple; the humility of the mutual bow; the naked, communal bathing; the delicacy of the incense and tea ceremonies.

It strikes me that I am reminded of Adrian far more in spaces of civic or spiritual ritual than in any theatre. Experiencing the customs and practices here prompts me to consider that the ideas Adrian was committed to – seeing beauty in simple intimacies, having the sensitivity to devise ways in which people could feel accepted in a ritualized space – must surely have required an enduring belief in the best aspects of humankind. I am sure this is part of what drove Adrian to make the work he did.

As I reflect on Adrian from across the world, I dwell on the dynamic interplay of light and shadow that he knew so well. Unlike the Western philosophy of seeing shadows as a metaphor for the illusory and unsavoury aspects of life, which must be eradicated to illuminate truth and goodness, I think Adrian's attitude was more akin to the Japanese philosophical perspective. Perhaps by considering the darkness as evidence of light, we might see the shadow as

verification and conformation of the radiance itself. In this spirit, I commit to celebrating all the shades of Adrian Howells (after all, 'it's all allowed').

I first met Adrian in 2001, as a student on the Contemporary Performance Practice (CPP) course at the Royal Scottish Academy of Music and Drama (now the Royal Conservatoire of Scotland). I remember him directing me and my peers in an exercise that involved delivering the filthiest, most outrageous swearing at maximum volume, between stints of exhausting, durational running. He told us to 'let it all out'.

Over the years, Adrian became an unofficial mentor (advising me on everything from my love life to my performance work), a colleague in a community of practice, and of course a friend. After graduating I began to cut my teeth as a young, aspiring performance-maker. No matter where or what I was performing, a hand-written card would always arrive for me at the venue's box office on the day I was to present. They were always from Adrian and he told me time and again to believe in what I was doing and to embrace the beauty in my own work. I felt enormously supported by his understanding of the vulnerabilities of presenting new ideas. No longer receiving those cards is one of the many things that remind me, with a painful jolt, that my friend is no longer around.

In 2009 we shared the St. Stephen's church space at Edinburgh Fringe Festival, run that summer by The Arches. I was presenting *Trilogy* (2007-10), he *Foot Washing for the Sole* (2008-12). Neither of our works complied with the usual patterns of presenting work at the Fringe. He needed a carefully constructed, contemplative space where a single audience member would have their feet washed. I needed a private and safe community space, where the troupe of women who danced naked in Part One of *Trilogy* could rehearse, discuss and (re)discover confidence in their own skins. Committed to these priorities, it felt as if we were located on the edges of a theatre cyclone, the eye of the storm whipping up the most efficient, best-marketed and most lucrative of pieces. Being in St. Stephen's together, in a quiet part of Edinburgh, was our gentle movement against the forces of such a climate. I remember that time as an exercise and an experiment in care, where the people participating in our artwork were always and uncompromisingly at the very centre of our processes.

As our friendship grew over the years I began to see the shadows that danced around the glow I came to know as Adrian. 'I've had enough of cynicism', I recall him saying one rainy, Glasgow evening. Adrian's sensitivity allowed for accuracy, care and generosity in his arts practice, but it also left him vulnerable to every bad review, every unsympathetic audience and every instance of inappropriate support from venues or producing organisations. Negative experiences could send him 'spiraling downward', as he used to put it.

Later in our friendship Adrian came to stay with me and my partner during one such 'spiral' period. He mostly slept, came down to join in quietly at

Clockwise from upper left:

Set for Adrian Howells, *An Audience with Adrienne*, performed at the International Women's Festival in Holon, Israel, 2008. Photographer unknown.

Detail of set for Adrian Howells, *An Audience with Adrienne*, Singapore, 2009. Photo by Dan Prichard.

Set for Adrian Howells, *An Audience with Adrienne: Her Summertime Special*, performed at Drill Hall, London, 2007. Photo by Robert Day.

The mounting debris across the week in Adrian Howells, *Adrienne: The Great Depression*, performed in Room 103 of the Brunswick Hotel, Glasgow, as part of Glasgay!, 2004. Photographer unknown.

Set for Adrian Howells, *An Audience with Adrienne*, Singapore, 2009. Photo by Dan Prichard.

Set for Adrian Howells, *May I Have the Pleasure...?*, an Arches commission performed at the Traverse Theatre as part of the Edinburgh Fringe Festival, 2011. Photo by Niall Walker.

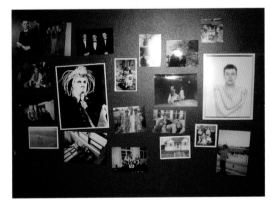

Clockwise from upper left:

Detail of the set for Adrian Howells, *Adrienne's Dirty Laundry Experience*, performed at Home Live Art, Camberwell, London, 2005. Photo by Manuel Vason.

Set for Adrian Howells, *Held*, performed in a private apartment in Glasgow, 2007. The table is the scene for the first interaction in a series. Photographer unknown.

A shrine in the set for Adrian Howells, *Adrienne's Trashy Party*. Information about the location and year of this performance has not been recorded. It likely took place around 2005. Photographer unknown.

Detail of the bathroom in Adrian Howells, *Adrienne: The Great Depression*, performed in Room 103 of the Brunswick Hotel, Glasgow, as part of Glasgay!, 2004. Photographer unknown.

Detail of detritus on the set for Adrian Howells, *Adrienne's Trashy Party*. See above. Photographer unknown.

Detail of the bathroom in Adrian Howells, *Adrienne: The Great Depression*, performed in Room 103 of the Brunswick Hotel, Glasgow, as part of Glasgay!, 2004. Photographer unknown.

mealtimes and we shared the occasional chat or walk. I remember we all went to the beach one overcast day in Ayrshire. We clambered over rocks to see the view and I recall his pain being tangible. We know now there wasn't a Scottish wind strong enough to blow away his sadness.

The legacy Adrian has left, not just to me but to a whole community of makers and thinkers, lies both in his artistic achievements and in the wider story of his life-shades. His acute sensitivity, spiritual intuitions and unconditional belief in the capacities we all have for kindness participated as much in his struggle and depression, as in his successes and happiness. He encouraged me to commit to the explicit attempt for connection in my own work, even if this put me in a more vulnerable position too. He also taught me that there is almost always the potential for a joke, and that you shouldn't take yourself too seriously too much of the time.

His departure has also raised many shadow-questions, which must also be asked. What can Adrian's story tell us about how well we look after mature artists in our artistic communities? Is sustainability part of how we should think about the long-term methodologies of art-making? And what are the personal effects of vulnerability in performance and how can these be attended to and cared for?

In remembering Adrian it would be all too easy to put his life in the stark light of the white cube, illuminated cleanly, erasing the shadows. However, Adrian would have preferred the dusty old church, the dinginess of a basement studio, or the coziness of a softly lit front room. He always put himself in places where the shadows could live, alongside radiance, as if the one were dependent on the other. We must grant him the honor of this and remember him in all of his diversity, dancing dynamically, between light and shadow.

1. Jun'ichiro Tanizaki, *In Praise of Shadows*, trans. by Thomas J. Harper and Edward G. Seidensticker (1933 rpt. Stony Creek: Leete's Island Books, 1977), p. 42.

Distance Relation: On Being with Adrian

Jennifer Doyle

In October 2011, Adrian Howells and I had a long talk on the phone. We were supposed to appear together at a conference, onstage, in order to have a conversation about our work. But as the event approached, he let the conference organisers know that he would not be attending.[1] He was just emerging from a deep depression. He could not be on stage, but, he thought, he could talk with me on the phone and we could broadcast his voice to the audience. That is what we did. Here, I share a holistic memory of our exchange. I share some of Adrian's insights and words, and describe the more difficult questions that surfaced in our conversation. These recollections are shadowed by the fact of Adrian's death, and the manner of it, as our talk orbited around depression, grief, loss, and experiences of profound failure in and around our own work.

As I write this, I confront those failures again. Reading the transcript requires a kind of dissociation, as does writing this essay. That situation mirrors the problems that we explored together – the challenge of being, the difficulty of being present to others, and the limits of words.

We were brought together in this conversation by our experiences of a contradiction in the meaning of the word 'personal' to our practices. Adrian's work unfolded within the space of the live encounter, often taking forms that seemed to reduce, as much as possible, the distancing effects of theatricality in favour of what he described as an 'accelerated intimacy'. If the spaces created by his work are intimate, they are also exposing.

Adrian's practice was rigorous – in a one-to-one encounter with him, there was no hiding – but it was also profoundly forgiving. My encounters with his performances transformed my scholarship – something about the way he was with me, as an audience member, gave me permission to acknowledge the limits and failures of the way I had been thinking, and to think again from those failures, to work them through. It made me want to translate that into my work – meaning, it made me want to create a similar experience for the reader, and for my students.

People have experienced us both as having a certain openness in our work. Where Adrian's performances are often autobiographical, my writing is often anecdotal. I situate myself, as a critic and as a person, in my work. For example: *Hold It Against Me* grew from writing about my failure to see Adrian's performance, *Held* (2006).[2] I introduce the book with a story about the emotional roller coaster of missing my appointment. The idea of that performance genuinely challenged me – acknowledging and confronting my failure in that context is essential to that book's project, which is the creation of a critical language for addressing the relationship between emotion and difficulty in art. As a scholar, I wanted to create a space in which the reader might be invited to reflect on her or his own limits, through an encounter with mine. My work, and Adrian's, can feel personal, and sometimes is personal. But what does this mean? Who is the person we encounter in writing, or in performance? People see our work as about us (as narcissistic), but they also find themselves in our work. In the latter situation, is it that they identify with us, as people? Or is it that they find themselves not in the figure of our person, but in its traces, or perhaps in something more abstract – in the texture, or affective environment of our work, in the shape of my sentence, or in the sound of Adrian's voice. Our relationship to the personal is crafted, and, in important ways, it is also strategic.

We were both interested in how we address people through our work, and we had both run up against the wild properties of language as a site of intimacy and distance. Words at once carry our selves, and do not. They can open us up to each other, but they can also take on the aspect of walls. Adrian's work confronts the distance between us. It is concerned with the situation of facing and addressing each other. Communicating the challenge of Adrian's work requires that my writing, on some level, does more than describe. I want to create a space in which one might think, and think with feeling; to think about, and with, the experiences of being with Adrian Howells – because this was what his work asked of us.

This is to say that Adrian's work makes me want to write philosophically, to write in a way that performatively enacts an intimacy of thinking with someone. In this case, I suppose, that someone is you – but, who are you, to me? Who am I, to you?

On the question of how, in writing, we might explore what happens when 'thinking addresses itself, to thinking', Jean-Luc Nancy writes,

> A treatise [...] is not sufficiently discursive. Nor is it enough to dress discourse in the form of an address (for me to address you with the familiar 'you' [*tu*] the whole way through). The address means that thinking itself addresses itself to 'me' and to 'us' at the same time; that is, thinking addresses itself to the world, to history, to people, to things: to us. Another ambition springs from this [...]: to allow thinking's address to be perceived, an address that comes to us from everywhere simultaneously, multiplied, repeated, insistent, and variable, gesturing only toward 'us' and toward our curious 'being with one another', [*être-les-uns-avec-les-autres*], toward our understanding one-another.[3]

A treatise, in this context, is a scholarly essay expressed in a traditional format. The traces of the author, as a particular person, are erased in order to make room for authority. Glitches, like a jarring change in tense (a problem here) are smoothed over; repaired. Our encounter is generalised in the 'neutralization of address', and dissolved by a 'subjectless discourse', a professional discourse.[4] The thinking that takes up thinking as an object of thought, the writing that addresses writing, the address that addresses, appears as something else.

If, here, you recoil at the direct address (Who are you, to me?), it is because I have not done enough, here, to make that turn feel inviting. (Who am I, to you?) The turn to the audience or reader risks becoming turning away. (If the writer of this is me, it is not you.) The 'personal' of I, you – even we – in the wrong environment, in an environment that is, perhaps, too proper, too bounded, is not enough to unravel the disciplinary protocol, the demand of a report.

All of this is to say that I think Adrian's work explores the possibilities of 'being with one another' within the context of addressing each other. This mode of address opened up the possibility of understanding one-another, through the sense of another's being.

The point is not to tell you about Adrian Howells, but to engage the situation of telling you about Adrian Howells, as a way of remembering the situation of being with Adrian, as that situation is the heart and soul of his work. That is where his work seemed like not-work, where it slips from the yoke of theatre, 'live art' and all that (the treatise), and approached something closer to a philosophical exploration of what Nancy describes as 'being with'.

To return to our conversation: we cycled a few times through stories describing our own struggles with words. He had been thinking about the distancing effects of language, and was enjoying the wordless forms of disclosure that could unfold in certain performance actions. He gave the following example:

> I particularly became imbued with that idea when I did research for what ended up becoming *The Pleasure of Being: Washing, Feeding, Holding* [2010-11]. I had a gentleman, who was about 22 stone, sitting on my lap, and I had my arms around him and we sat there for about 20 minutes in silence. I became very aware that he wasn't really giving me all of his weight and that actually he was trying to keep weight on his left foot, off of my body. But I had asked him to absolutely sit on my lap and that was what I was expecting to experience. But actually in that 20 minutes what was fascinating to me was that there was a dialogue that went on, there was an exchange that went on between our two bodies, no words were exchanged, and I really felt strongly afterwards when he left me that in many ways he said more about how he felt about being who he was, his self image and

Overleaf: Adrian Howells before a performance of *An Audience with Adrienne: A Lifetime of Servicing Others*, at the Arches, Glasgow, as part of Glasgay!, 2006. Photographer unknown.

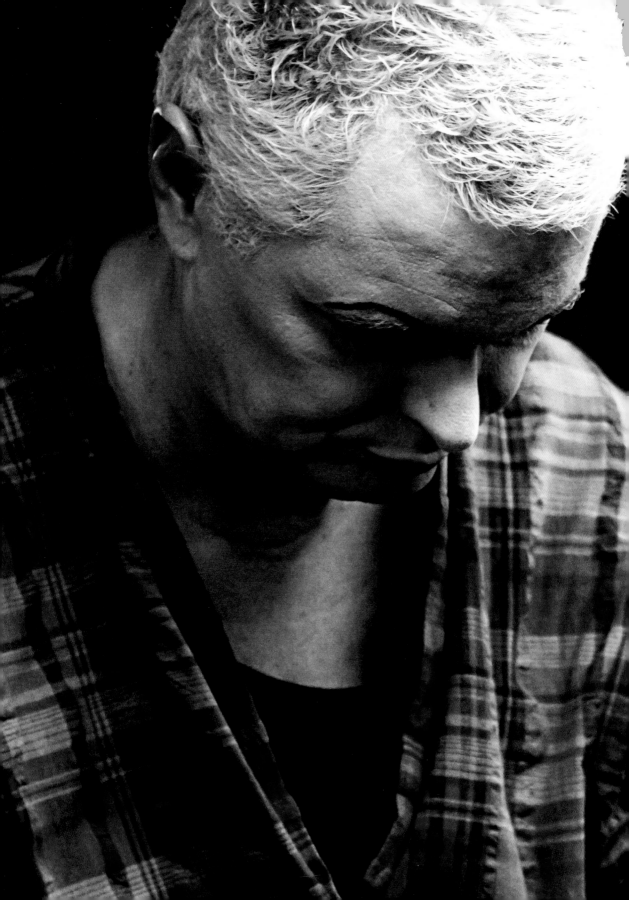

what have you, through the silence and the bodily interactions that we had than he would ever possibly be prepared to say verbally. And so I thought confession, or the idea of confession, is a very delimiting term, and actually I think what's happening much more is a kind of revelation rather than a confession in that sort of context. And I also think that confession is inextricably linked to religion and ideas of shame and guilt and I wanted to move away from an understanding of confession from that sort of context and background.[5]

Confession structured Adrian's performances as Adrienne (for example, *An Audience with Adrienne* [2006-10]), and many of his one-on-one encounters (for example, *Adrienne's Dirty Laundry Experience* [2003], *or 14 Stations in the Life and Times of Adrian Howells* [2007-8]). It is the explicit form for a whole category of his work. If, in those performances, he wanted to remove self-disclosure from institutional structures (religious, psychiatric) that saturate such scenes with 'shame and guilt', he also wanted to interrupt or at least slow down the equation of self-disclosure and confession that structures so much mass and social media and that churn out versions of the 'authentic self' as a rapidly consumed commodity. A pile-up of throwaway selves. There is, he said in other interviews and conversations (in which he sounds very much like a twentieth-century person), no real catharsis in those forms.[6]

Within an institutional framework, confession marks out the deficiencies and needs of the self in order that one might be forgiven, or healed. Confession can enable collaboration in the experience of sharing each other's worries, burdens and limits. In a dialogue with Deirdre Heddon, Adrian explains that as he expanded the situation and meaning of confession in his practice, he realized that he 'had used "talking" as a mask, something to hide behind'.[7] In our conversation, Adrian described himself as feeling 'sick of [his] own voice'.

Adrian had a beautiful voice, and an easy eloquence that made talking on the phone with him intensely pleasurable. Before our public conversation, we talked for a long while about all sorts of thing. I confessed my revulsion, after the disastrous end of a romance, at everything I wrote to the person that I'd loved. That writing is so needy – I recoil in humiliation when I think about it.

As if that weren't bad enough, at the time Adrian and I spoke, I was recovering from being stalked by a student who mirrored my writing back to me in what felt like a zombie take-over of my work, in which my writing-self came back to me in the form of a psychotic delusion. It is hard to describe how poisonous such experiences are. For a period, this impacted my writing, profoundly. That my work feels personal to some readers (and narcissistic to others) informed how my situation was understood at work (a few people felt I invited harassment, because of the way I write; a few others questioned whether what I write is scholarly enough, or scholarship at all). It was a terrible situation. Through it all, I was dogged by this psychotic version of myself; I found traces of her in that small library of my abject love letters.

Until that experience, I had a playful relationship to sentimentality in general, and to my own in particular. But (a confession) I'm not sure I've had a feeling in the same way since all of those things happened. Life, of course, is a sequence of disasters that change how you think and feel. If there is anything to be said about growing older, depending on how things are going, time's passage can increase the likelihood of knowing/feeling that you will not feel however you feel forever – this was also something Adrian and I talked about, as we talked about struggling with depression (him) and anxiety (me). When it feels like those states will never end, they are unbearable.

'Putting ourselves out there' does not always have happy results. Perhaps because we have to work so hard to advocate for performance (as a creative and scholarly practice), we do not speak as often as we should about the frightening side of putting ourselves in our work. The space of emotion that our work describes (or enables, or creates) – the space that unfolds in a reader or audience member as their feeling – holds pockets of alienation and loneliness. We hold some of those spaces inside us, and sometimes we find ourselves caught out – sliced by other people's madness, anger, shame and disgust. One need not, in fact, make work that is particularly autobiographical in order to encounter the worst in one's readers or audience. The work need only be just queer enough, or just black or brown or feminine enough.

This goes back to the situation described by Nancy. The roots of queer theory are anchored in a feminist and anti-racist resistance to those disciplinary discourses that sift the personal from the professional, which abject all forms of reproductive labour (e.g. nurturing, caring), and pathologise those who organise their lives around something other than monogamy, marriage and home-ownership.

The queer forms of intimacy that Adrian enabled around his work drew us right into the Gordian knot that binds feminine, reproductive labour to a toxic discourse on love and family. Although gay countercultural spaces make room for non-reproductive modes of being, they make less room for expressing such modes of being within a profoundly feminine (soft, watery, maternal) context of non-reproductive (or even anti-reproductive) domestic care and nurturing. The queer expression of such gendered modes of relation outside socially sanctioned forms (marriage, child-rearing) is rare, as even queer folks now have babies and church weddings. Add onto this the gender-diversity of Adrian's work – in which he moved across gender positions in performance, staged his work in queer and non-queer spaces, and received a diversity of people in his one-on-one encounters – we can begin to appreciate the singularity of his practice, in terms of its sex/gender politics.

Adrian confronted the sharp edges of queer alienation from the love-apparatus in *May I Have the Pleasure...?* (2011). In this performance, a small audience (approximately 30 people at a time) encountered Adrian in an environment designed to mimic 'the bitter end of a wedding reception disco'. The audience was encouraged to relax into the space. He talked with these participants 'about being

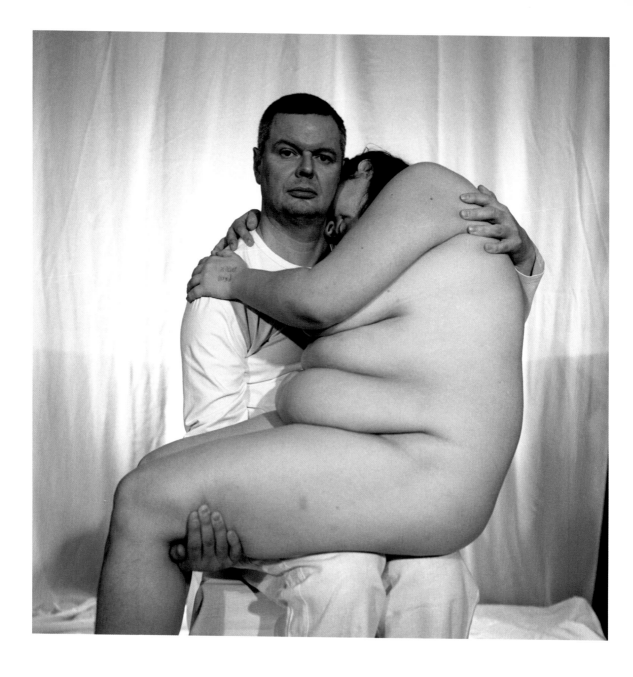

Above: Adrian Howells performs with a series of invited audience-participants – here with the artist Katy Baird – in images produced to accompany lectures by the artist. Gilmorehill Theatre, University of Glasgow, 2008. Photo © Hamish Barton.

49, gay, still single, having never been in a serious committed relationship and the painfulness of the loneliness'. He continued, 'I was sharing that with people that had such – quite often a really judgemental and negative attitude'. At the time we spoke, he felt that this performance cost him. The audience members for this particular performance, he explained,

> didn't want to be there but didn't know how to leave the space because they didn't really know the rules of the space, and that was a double-whammy for them. They were [also] angry towards me because I was making them uncomfortable, [making them] look at things that they didn't really want to look at in their lives.

Although he had worked with these subjects before, he had done so through his persona, Adrienne:

> *An Audience with Adrienne* was a similar kind of autobiographical piece [in which I talked] about people and things in my life, but I always had the persona, the mask, of Adrienne to perform the autobiographical stories with. But with this piece it [was] without any sort of persona, and actually, all that judgement and negativity and *then* press criticism would actually…

At this point there was a brief pause, before he named his experience of that paralysing collapse of work and self, of public and private selves. What was at stake, he said, was 'me and my life, it wasn't the show or the material of a show, it was me and my life'. He continued, with difficulty, 'it really, really wounded me, and it really hurt me and I know that's because the last five years have been a cumulative effect of me being exhausted and running on empty'.

Many of us in the auditorium at Toynbee Hall looked at each other. That day, a lot of his peers were in the audience. Many of the artists in the audience that day are defining figures in performance. The endless, often humiliating economic struggle of artists is enough, in and of itself, to wear one out. Most of the people in the room do what they do as a matter of survival, however – meaning, there are other struggles that make art-making not a luxury, not a lifestyle choice, but a vital necessity.

A few people in the room had brushed up against this awful collapse in which a judgment made against your work becomes a judgment made against you as a person. The most professional of rejections feels like a slap in the face, even when those rejections and criticisms are fair. But the rejection of feminist, queer and non-white artists and writers is often framed by the mischaracterisation of our work as propagandistic 'identity art', and as categorically 'insufficient' (to borrow language from my own history of professional rejection). Criticism can be mediated by bias and fear, and it is hard to tease out the sting of rejection from the paranoia such criticism breeds among those of us who have felt the freezing wind of exclusion. The 'subjectless discourse' of art criticism, at its worst, presents raw sexism, homophobia, racism and classism as a 'treatise' on, for example, what really counts as contemporary art.

This lining up of your work, your body, and your personal life can be experienced as a violent negation of your dignity and worth. This is, actually, how sexism, homophobia and racism work. You are locked into your body; your body is a problem, an insurmountable symptom of your worthlessness. Your life – your way of living – is a perversion. Your work is an expression of that perversion. Your work is worthless. It takes a lot of emotional strength to rise above all that.

The hours and sometimes days after a performance are strange, even if the performance went well, and was well received: the post-performance let-down can be debilitating, and disoriented. Even when you know everything went well, as often as not you feel a certain abjection and despair in the event's wake – not because it is over, but because something was let loose.

Adrian spoke very explicitly about this problem, and his words in the transcript of our conversation are freighted with depression's weight. But his words remind us that how work feels personal for an artist and for that artist's audience or reader is not symmetrical. One does not mirror the other's feelings.[8] It is not quite right, even, to say that the feelings of artist and audience are mediated by the work of art. More nearly, one encounters the traces or consequences of the other's (absent) presence. Sometimes, those traces and effects are familiar, but sometimes they are alien, and totally unanticipated. We discover those traces as we feel them: there is no knowing the other's feelings. Only the feeling of the other, the sense of another's presence. We know each other by knowing the shape of the distances between us.

We tend to privilege the live encounter in our thinking about questions of presence and proximity. Each medium has its own intimacies; however, each has its way of giving the space between us a form through which we can know it. 'Writing', Roland Barthes explains, 'is the destruction of every voice, of every point of origin. Writing is that neutral, composite, oblique space where our subject slips away, the negative where all identity is lost, starting with the very identity of the body writing'.[9] These lines are from a philosopher who threw himself into his writing with such force that his work is as singular as Roland Barthes himself, as a person ('the body writing'). His embrace of the negative space of writing was, for him at least, liberating.

'Whoever you are', Walt Whitman writes, 'holding me now in hand,/ Without one thing all will be useless,/ I give you fair warning before you attempt me further,/ I am not what you supposed, but far different'.[10] The 'me' of those lines is not quite Whitman, but *Leaves of Grass*, the volume of poetry Whitman wrote and rewrote over the arc of his life. He made *Leaves of Grass* to be touched and handled by the reader. *Leaves of Grass* was and is Walt Whitman. He *is* poetry, but only because he is also *not*: 'I am not what you supposed, but far different'.[11]

Although one might want to claim for writing a kind of dominion over this conjuring of the absent presence, absence structures all forms of representation, and, in fact, all modes of address, including those which Adrian explored in his work.

Julia Kristeva described the artist as 'melancholy's most intimate witness and the fiercest fighter against the symbolic abdication enveloping him'.[12] Her influential writing on melancholia (for example, in *Black Sun*) is anchored by her curiosity about the nature of the artist's intimacy with despair.[13] In a profound depression, one can be submerged by a thick atmosphere from which language has been exiled. The desire to speak recedes with all other forms of desire ('I am sick to death of the sound of my own voice'). Within this situation – a situation that must but cannot be explained – speaking and writing may not be just painful. Sometimes, it is impossible.

For some psychoanalysts, depression is a nearly primordial, cosmic state. At its core is an inability to disavow the kernel of despair in all meaning. 'There is no meaning', Kristeva writes, 'aside from despair'.[14] All symbolic forms – all forms of expression – are empty. There is nothing in, nothing to our words in and of themselves. Within this space of such awareness – an awareness of the void – Kristeva writes, 'sorrow can be the most archaic expression of a narcissistic wound, impossible to symbolize or name, and too precious for any exterior agent (subject or object) to be correlated to it'.[15]

Our words carry meaning only within a social universe held together by the disavowed knowledge of this void, the void internal to the word but also the void into which our words spill. Language is oriented by lack; it is precipitated in us by our separation from 'mother', let us say, as a symbolic space (that zone of feminine care, reproductive labour and devotion, from which we are all, initially and eventually, expelled, was one to which Adrian was profoundly dedicated). Language emerges as a means for navigating one's separation, one's expulsion from a state in which there was no other – from a state in which there is no need for language, because one was absorbed in a state of total communion. There is no self, in fact, in such a union. And, in a very real way, that union is beyond our capacity to know and think it; we conjure it in a dream composed from the flotsam and jetsam of what we can know.

Language emerges with the self, with being. The self is never a being in and of itself, outside meaning and language – which is to say, outside despair. Language bridges. All kinds of languages do this, including the language of a man's body lifting its weight off of you with the ball of his left foot. We unfold, with each other, in a constant navigation of, and bargaining with, the annihilating threat of alienation. Language carves out boundaries – these boundaries are not carved in wood or stone, but from the air. These boundaries are like skin: they define our edges, but they also allow for touch, for experiences of connection, shared sensation and understanding. The self flows through the world as a mobile, fluid state of interlocking fictions. Kristeva writes,

> Rather than seeking the meaning of despair (which is evident or metaphysical), let us acknowledge that there is no meaning aside from despair. The child-king becomes irremediably sad before uttering his first words. It is being separated from his mother, despairingly, with no

going back, that prompts his attempts to recuperate her, along with other objects, in his imagination and, later, in words. The semiology interested in the degree zero of symbolism is unfailingly led to pose questions to itself not only about the amorous state but also about its sombre corollary – melancholy. This entails recognizing, in the same movement, that no writing exists that is not amorous, nor can there be an imagination that is not, manifestly or secretly, melancholic.[16]

If love and melancholia have a primary importance for the artist, this is, for Kristeva, because the drive to make forms – to play with language, sound, images, social rituals and habits – expresses an openness to spending time in the moment of recognising that there is 'no going back'. The disavowal available to the non-depressive subject is not exactly a forgetting of this sense of total, irreversible loss but a means of living with it, of internalising and externalising the problem of meaning, and of being in relation to each other – one must be able to play with this:

> As a lay discourse creating and dissolving the transferential bond, psychoanalysis is an apprenticeship in living beyond despair. It offers not a manic defense against it, but rather a receptivity to it – a way of endowing despair with meaning. By consolidating it in the same way, artistic creation allows the ego to assume an existence on the basis of its very vulnerability to the other.[17]

In this functional if not always happy state, we make that leap of faith enabled by knowing that our language may not be 'full' – it cannot carry the full and total sense of our being – but it is full *enough* (to invoke the vocabulary of Melanie Klein and her 'good enough' mother).

Teachers who work with student writing encounter a version of the disabling situation that Kristeva describes, and a version of the creative challenge that Adrian described. We encounter young writers unable to disavow their awareness of the intimate relationship between meaning and despair, the knowledge of Nothing. This learning-writer can be crippled by a sense of their own inadequacy. No sentence is good enough. Their sentences fill them with lacerating self-hatred. These students can't write; a distorted perspective on the abjection of their own writing hobbles them. And yet, sometimes, these students are the Writers — those kinds of writers write because the activity of writing allows them to keep company with this cosmic despair, to tame it even, or almost. But this is a terrifying business. Perhaps all the more so because the entire situation – the depressive artist, stewing in his (always *his*) own misery – is itself such an awful cliché, cemented in a romantic tradition that exalts some psychic struggles as heroic and abjects others as weak and self-indulgent. So, the depressive creative subject who can't create (who can't speak, can't write) is burdened with a failure – the embarrassment of having a wrong form of melancholia, being the wrong kind of depressed.

Opposite: Adrian Howells, *May I Have the Pleasure...?*, an Arches commission performed at the Traverse Theatre as part of the Edinburgh Fringe Festival, 2011. Photo by Niall Walker.

'There is no meaning if meaning is not shared', Nancy writes, 'and not because there would be an ultimate or first signification that all beings have in common, but because meaning itself is the sharing of Being'.[18] It is not that each being has meaning in itself, nor is it that we have a shared, universal meaning (e.g. the value of the 'Human'). We are meaning only insofar as we are with one another. The word 'with', in Nancy's writing, holds the world. 'I' is unbearable, impossible without it. For Nancy, 'Because not being able to say "we" is what plunges every "I," whether individual or collective, into the insanity where he cannot say "I" either. To want to say "we" [and here the resonance with Adrian's work is especially powerful] is not at all sentimental, not at all familial or "communitarian." It is existence reclaiming its due or its condition: coexistence'.[19] If it feels like a lot to frame Adrian's work in relation to existential questions, it is because his work was so touchy-feely, so closely aligned with feminist, anti-heroic modes of creative expression dedicated to engaging the ways that we connect with, and rely upon each other.

This is what our conversation was about. Not how to *be*, but how to be *with*. When asked if he might protect himself from post-performance exhaustion by drawing stronger boundaries around his performance-self and his self-out-of-performance, he explained:

> I find it really difficult to have boundaries. People ask me if I have particular rituals or whatever in place, either before or at the end of the one-on-ones, for example, and I don't. People have told me about things like wiping myself, wiping my arms or my legs with my hands in the way of wiping off negative energy, and stuff like that, and I just can't really compute that. I just feel that's a really disrespectful thing to do – to wipe somebody's… sort of, *being* off of you when you've been holding them.

Being with, in the sense Adrian practiced it, means being responsible to the weight of the other – be that weight symbolic, affective, or material. In our conversation Adrian did not cite the one-on-one performance as problems – not in the sense he describes above, in which it is the weight of the other that bears down on him. The particular post-performance let-down that he was working through at that moment was, he said, specific to the more theatrical performances in which he was, perhaps, asked to perform 'being for' rather than 'with'. In this context, he had extended himself into the situation of forced social intimacy, meaning, the forced sense of community produced through marriage – a rite that settles who you are really 'with', once and for all. Those rites of belonging are, indeed, very lonely-making. A gay man, staging his isolation and sense of sexual/romantic abjection within the ruin of a wedding reception was too much for a resistant audience that felt trapped by the whole affair. And it was too much for the artist, triply framed by his own performance and a misalignment between the audience's expectations and needs, and the shape of the actual encounter (surprisingly more participatory than theatrical, in just the way that weddings are).

When Adrian spoke about the shape of the post-performance let-down for the 'one-on-ones', the problem was, largely, the scale of his own need as it emerged in that performance's wake. He holds because he needs to be held, he cares because he needs to be cared for. He thought with and through that situation. These performances yield a basic encounter with one's own vulnerability – why would we think they didn't do this for the artist, or that they shouldn't? Adrian said that a spiritual part of himself was held by his audience when they embraced, but an elemental part of himself was not and could not be held.

1. The event was *Trashing Performance*, part of a three-year research programme, *Performance Matters*, convened by Gavin Butt, Adrian Heathfield and the Live Art Development Agency, 2010-13. The specific event in question was a series of conversations titled *Under- and Overwhelmed: Emotion and Performance*, Toynbee Hall, London, 26 October 2011.

2. See Jennifer Doyle, *Hold It Against Me: Difficulty and Emotion in Contemporary Art* (Durham and London: Duke University Press, 2013), pp. 1-8.

3. Jean-Luc Nancy, *Being Singular Plural*, trans. by Robert D. Richardson and Ann E. O'Byrn (Stanford: Stanford University Press, 2000), p. xvi.

4. Ibid., p. xv.

5. Unless otherwise indicated, all direct quotations from Adrian Howells are taken from a transcription of our conversation at the conference *Trashing Performance*. I have edited these passages, but only to remove small words (e.g. superfluous uses of 'and') and hesitations, and to better translate to the page some of the conversation's cadences. I thank Harriet Curtis for preparing the transcription.

6. See, for example, Kimberly Hall, 'Selfies and Self-Writing: Cue Card Confessions as Social Media Technologies of the Self' in *Television and New Media Studies* (2015), 1-15 [accessed 1 August 2015].

7. Deirdre Heddon and Adrian Howells, 'From Talking to Silence: A Confessional Journey', in *PAJ: A Journal of Performance and Art*, 33.1 (2007), 1-12. This essay is reproduced in full in the present publication.

8. I wrote a few sentences like this in an essay on grief. See Jennifer Doyle, 'Untitled', *Social Text*, 32.4 (2014), 27-31.

9. Roland Barthes, 'The Death of the Author', *Image Music Text*, trans. and ed. by Stephen Heath (London: Harper Collins, 1977), pp. 142-8 (p. 142).

10. Walt Whitman, 'Leaves of Grass', in *The Portable Walt Whitman*, ed. by Michael Warner (London: Penguin, 2003), pp. 213-215.

11. Ibid.

12. Julia Kristeva, 'On the Melancholic Imaginary', in *New Formations*, 3 (1987), 5-18 (p. 6).

13. See Julia Kristeva, *Black Sun: Depression and Melancholia*, trans. by Leon S. Roudiez (New York: Columbia University Press, 1992).

14. Kristeva, 'On the Melancholic Imaginary', p. 5.

15. Ibid., p. 7.

16. Ibid., p. 5.

17. Ibid., p. 17.

18. Nancy, *Being Singular Plural*, p. 2.

19. Ibid., p. 42.

Further Reading

The following series of published resources are collected here to enable further research on Adrian Howells. The references include substantial critical engagements, interviews, and other materials. We have chosen to omit reviews and briefer discussions of Howells' work. We have included a further list of audio-visual materials available online. In all cases, where provided here, URLs were active at the time of this book's publication. References for published materials are listed alphabetically by author's surname; however, the final section (which generally lacks author attribution) is ordered chronologically.

Bottoms, Stephen, 'Materialising the Audience: Tim Crouch's Sight Specifics in *ENGLAND* and *The Author*', *Contemporary Theatre Review*, 21.4 (2011), 445-63

Brennan, Mary, 'Performer and Teacher', *The Herald*, 21 March 2014 <http://www.heraldscotland.com/opinion/obituaries/13151563.Adrian_Howells/>

Cairns, Jon, 'Ambivalent Intimacies: Performance and Domestic Photography in the Work of Adrian Howells', *Contemporary Theatre Review*, 22.3 (2012), 355-71

Crawley, Peter, 'I Think We're Alone Now', *Irish Times*, 7 August 2010, <http://www.irishtimes.com/culture/stage/i-think-we-re-alone-now-1.635109>

Crouch, Tim, 'The Author', in *Tim Crouch: Plays One* (London: Oberon Books, 2011), pp. 161-203

Doyle, Jennifer, 'Introducing Difficulty', in *Hold It Against Me: Difficulty and Emotion in Contemporary Art* (Durham: Duke University Press, 2013), pp. 1-27

—, 'Untitled', *Social Text*, 121, 32.4 (Winter 2014), 27-31

Ellis, Mark Richard, 'A Masquerade Dance of Liars: Reality, Fiction and Dissimulation in Immersive Theatre', unpublished doctoral thesis, University of Huddersfield, 2012

Field, Andy, 'Adrian Howells: "He Created Performances of Courageous Honesty"', *Guardian*, 19 March 2014, <http://www.theguardian.com/stage/2014/mar/19/adrian-howells-performance-artist-theatre-tribute>

Gardner, Lyn, 'How Intimate Theatre Won Our Hearts', *Guardian*, 11 August 2009, <http://www.theguardian.com/culture/2009/aug/11/intimate-theatre-edinburgh>

—, '"I Didn't Know Where to Look"', *Guardian*, 3 March 2005, <http://www.theguardian.com/stage/2005/mar/03/theatre2>

—, 'In the Theatrical Confession Box', *Guardian*, 2 June 2008, <http://www.theguardian.com/stage/theatreblog/2008/jun/02/inthetheatricalconfessionb>

—, 'One-on-One Theatre: Why do we Love to be so Up-Close and Personal?', *Guardian*, 29 June 2011, <http://www.theguardian.com/stage/theatreblog/2010/jun/29/one-on-one-theatre>

Groves, Nancy, 'Theatre Legend Adrian Howells Dies Aged 51', *Guardian*, 19 March 2014, <http://www.theguardian.com/stage/2014/mar/19/adrian-howells-glasgow-theatre-legend-dies>

Harari, Dror, 'Laotang: Intimate Encounters', *TDR: The Drama Review*, 55.2 (2011), 137-49

Heddon, Deirdre, 'Conclusion: These Confessional Times', in *Autobiography and Performance* (Basingstoke: Palgrave Macmillan, 2008), pp. 157-72

—, 'The Cultivation of Entangled Listening: An Ensemble of More-than-Human Participants', in *Performance and Participation: Practices, Audiences, Politics*, ed. by Helen Nicholson and Anna Harpin (Basingstoke: Palgrave Macmillan 2016)

Heddon, Deirdre and Adrian Howells, 'From Talking to Silence: A Confessional Journey', *PAJ: A Journal of Performance and Art*, 33.1 (2011), 1-12

Heddon, Deirdre, Helen Iball, and Rachel Zerihan, 'Come Closer: Confessions of Intimate Spectators in One to One Performance', *Contemporary Theatre Review*, 22.1 (2012), 120-33

Heddon, Dee, 'In Memoriam: Adrian Howells (9 April 1962-16 March 2014), *Contemporary Theatre Review*, 24.3 (2014), 418-20

Heddon, Dee, 'Obituary: Adrian Howells, performer and teacher', *The Scotsman*, 22 March 2014, <http://www.scotsman.com/news/obituaries/obituary-adrian-howells-performer-and-teacher-1-3349793#axzz3qvTXVkXg>

Higgins, Charlotte, 'Art on the Fringe: Intimate Performances at the Edinburgh Festival', *Guardian*, 13 August 2011, <http://www.theguardian.com/culture/2011/aug/13/edinburgh-festival-fringe-adrian-howells>

Howells, Adrian, 'The Burning Question #3: What's it Like Washing Feet Every Day?', *Fest*, 16 August 2009, <http://www.theskinny.co.uk/festivals/edinburgh-fringe/fest-magazine/the-burning-question-adrian-howells >

—, 'Foot Washing for the Sole', *Performance Research*, 'On Foot', 17.2 (2012), 128-31

Iball, Helen, 'A Mouth To Feed Me: Reflections Inspired by the Poster for Tim Crouch's *The Author*', *Contemporary Theatre Review*, 21.4 (2011), 431-44

—, 'My Sites Set on You: Site-Specificity and Subjectivity in "Intimate Theatre"', in *Performing Site-Specific Theatre: Politics, Place, Practice*, ed. by Anna Birch and Joanne Tompkins (London: Palgrave Macmillan, 2012), pp. 201-18

—, 'Theatre Personal Workshop: Adrian Howells', *Theatre Personal: Audiences with Intimacy*, 1 July 2011, <http://theatrepersonal.co.uk/workshops/with-adrian-howells/>

—, 'Towards an Ethics of Intimate Audience', *Performing Ethos: An International Journal of Ethics in Theatre and Performance*, 3.1 (2013), 41-57

Johnson, Dominic, 'Held: An Interview with Adrian Howells', in *The Art of Living: An Oral History of Performance Art* (Basingstoke and New York: Palgrave Macmillan, 2015), pp. 262-85

—, 'The Kindness of Strangers: An Interview with Adrian Howells', *Performing Ethos: An International Journal of Ethics in Theatre and Performance*, 3.2 (2012), 173-90

Jones, Gwyneth Siobhan, 'Expose Yourself to Art: Towards a Critical Epistemology of Embarrassment', unpublished doctoral thesis, Goldsmiths, University of London, 2013

Kaye, Helen, 'Life is No Drag for Adrian Howells', *Jerusalem Post*, 3 March 2008, <http://www.jpost.com/Arts-and-Culture/Entertainment/Life-is-no-drag-for-Adrian-Howells>

LaFrance, Mary, 'The Disappearing Fourth Wall: Law, Ethics, and Experiential Theatre', *Vanderbilt Journal of Entertainment and Technology Law*, 15.3 (2013), 507-82

Lightman, Sarah, 'Confessions, Cuddles and Footwashing', *Haaretz*, 13 August 2009, <http://www.haaretz.com/confessions-cuddles-and-foot-washing-1.281981>

Machon, Josephine, 'Adrian Howells: The Epic in the Intimate', in *Immersive Theatres: Intimacy and Immediacy in Contemporary Performance* (Basingstoke and New York: Palgrave Macmillan, 2013), pp. 260-8

Mansfield, Susan, 'Interview: Adrian Howells, Theatrical Producer', *Scotsman,* 18 May 2010, <http://www.scotsman.com/news/interview-adrian-howells-theatrical-producer-1-476044>

McMillan, Joyce, 'Obituary of acclaimed theatre-maker Adrian Howells', *The Scotsman,* 20 March 2014 <http://www.scotsman.com/what-s-on/theatre-comedy-dance/obituary-of-acclaimed-theatre-maker-adrian-howells-1-3346849#axzz3qvTXVkXg>

Overend, David, 'Making Routes: Relational Journeys in Contemporary Performance', *Studies in Theatre and Performance,* 33.3 (2013), 365-81

Pearson, Deborah, 'Unsustainable Acts of Love and Resistance: The Politics of Value and Cost in One-on-One Performances', *Canadian Theatre Review,* 162 (spring 2015), 63-67

Svich, Caridad, 'You and I: On Theatre and Audience (With a Nod to Adrian Howells), *TCG Circle: Audience (R)Evolution,* 2015, <http://www.tcgcircle.org/2015/03/you-and-i-on-theatre-and-audience-with-a-nod-to-adrian-howells/>

Thomson, Steven, 'A Tribute to Adrian Howells 1962-2014', *Glasgay!,* 24 March 2014, <http://glasgay.com/index.php/2014/03/24/a-tribute-to-adrian-howells-1962-2014/>

Tilley, Sue, *Leigh Bowery: The Life and Times of an Icon* (London: Hodder & Stoughton, 1997)

Tomlin, Liz, 'From Spect-Actor to Corporate Player: Reconfigurations of Twenty-First Century Audiences', in *Acts and Apparitions: Discourses on the Real in Performance Practice and Theory, 1990-2010* (Manchester: Manchester University Press, 2013), pp. 171-206

Walsh, Fintan, 'Therapeutic Dramaturgies and Relations in Contemporary Theatre', in *Theatre & Therapy* (Basingstoke: Palgrave Macmillan, 2012), pp. 47-71

—, 'Touching, Flirting, Whispering: Performing Intimacy in Public', *TDR: The Drama Review,* 58.4 (2014), 56-67

Wotjas, Olga, 'Performance Artist Dresses up Academy's Act with Sole', *Times Higher Education,* 29 May 2008, <https://www.timeshighereducation.co.uk/news/performance-artist-dresses-up-academys-act-with-sole/402158.article>

Zerihan, Rachel, 'La Petite Mort: Erotic Encounters in One to One Performance', in *Eroticism and Death in Theatre and Performance,* ed. by Karoline Gritzner (Hatfield: University of Hertfordshire Press, 2010), pp. 202-23

—, *One to One Performance: A Study Room Guide,* Live Art Development Agency, 2012, <http://www.thisisliveart.co.uk/resources/catalogue/rachel-zerihans-study-room-guide>

Audio-visual resources (online)

'Salon Adrienne – Adrian Howells', Fierce! Festival 2006, *YouTube,* 28 March 2007, <https://www.youtube.com/watch?v=M7XcWo2GzSo>

'Salon Adrienne', Homotopia Festival, *YouTube,* 19 November 2007, <https://www.youtube.com/watch?v=mmUn2ZTzeY0>

'Adrian Howells', British Council Arts Interview with Adrian Howells, April 2010, <https://www.youtube.com/watch?v=C7btf8Tdg_s> [in two parts].

Karl James in conversation with Adrian Howells, 'Prepared to Love: Karl James – The Dialogue Project', *2 + 2 = 5*, 19 July 2010, <http://understandingdifference.blogspot.co.uk/2010/07/dear-listeners.html>

'Adrian Howells Interview, Foot Washing For The Sole, Kilkenny Arts Festival', Kilkenny Arts Festival, *YouTube*, 14 August 2010, <https://www.youtube.com/watch?v=y9PPEbAU5z8>

'Adrienne's Bar & Grill', The Arches, *Vimeo*, 8 November 2010, <https://vimeo.com/16635191>

'Interview with Adrian Howells Part 1', Balcony Productions/British Council, *Vimeo*, 24 December 2010, <https://vimeo.com/18162606> [in two parts]

'Adrian Howells: research ethics processes', GU data management (University of Glasgow), *YouTube*, 22 February 2011, <https://www.youtube.com/watch?v=CHhVlTDzE1g>

'Adrian Howells part 1', Mariel Marshall/Harbourfront Centre, *YouTube*, 2 March 2011, <https://www.youtube.com/watch?v=Hyd57BdUi8I> [in two parts]

'Sit Down with Adrian Howells', Harbourfront Centre, *YouTube*, 8 March 2011, <https://www.youtube.com/watch?v=4HzO2ZzenAw>

'York U Fine Arts & Harbourfront Centre Welcome Adrian Howells', School of the Arts, Media, Performance & Design at York University, Toronto, *YouTube*, 17 March 2011, <https://www.youtube.com/watch?v=PYMlqod82HU>

'Adrian Howells (UK): Just a Whispered Talk with Adrian Howells', Uovo (Performing Arts Festival, Italy), *Vimeo*, 23 March 2011, <https://vimeo.com/21402578>

'Adrian Howells (UK): "The Pleasure of Being: Washing/Feeding/Holding"', Uovo (Performing Arts Festival, Italy), *Vimeo*, 23 March 2011, <https://vimeo.com/21441897>

'Performance Artist Adrian Howells Offers 'Soleful' Experience to Theatre Students', *York University*, 1 April 2011, <http://yfile.news.yorku.ca/2011/04/01/performance-artist-adrian-howells-offers-soleful-experience-to-theatre-students/>

Minnie Ripperton – Lovin' You: Adrian Howells' Desert Island Discs (Part 1)', The Arches Glasgow, *YouTube*, 4 July 2011, <https://www.youtube.com/watch?v=oQtSeY0mOHM> [in four parts]

Adrian Howells, Fuel and Roundhouse Radio, 'Everyday Moments 11: Audio Drama for Private Performance', Guardian Culture Podcast, *Guardian*, 21 November 2011, <http://www.theguardian.com/culture/audio/2011/nov/21/everyday-moments-podcast-adrian-howells>

'TPAM 2010 (15 of 17) Adrian Howells', Adrian Howells, *Foot Washing For The Sole* at Tokyo Performing Arts Market 2010, *YouTube*, 10 May 2012, <https://www.youtube.com/watch?v=k_a8PDfErtA>

Oldenburger Flurgespräche – FRAGE EINS – Bitte beschreibt eure Arbeit in drei Sätzen!' / 'Oldenburger Hallway Conversations – QUESTION ONE – Please give a short description of your artistic work', PAZZ Festival, Oldenburg, 2012, Dramazone, *Vimeo*, 20 May 2012, <https://vimeo.com/42487663> [in nine parts]

'Lifeguard – Trailer on Vimeo', National Theatre of Scotland, *Vimeo*, 4 October 2012, <https://vimeo.com/50775059>

Heddon, Deirdre, Nic Green, Farida Mutawalli, and Joyce McMillan, 'Theatre, Therapy and Intimacy', *The Dust of Everyday Life*, 26 March 2015 <http://www.mhfestival.com/conference>

Contributors

Nick Anderson is an artist who makes performances, usually in close collaboration with Peter McMaster. *Wuthering Heights* was touring across the UK until the end of 2014. From 2015 onwards, Nick and Peter have been developing a showing a new work called *27*. Shortly after graduating from the Contemporary Performance Practice degree at the Royal Conservatoire of Scotland, Nick and his best friend Rosana Cade set up //BUZZCUT//, an artist-led performance festival based in Govan at The Pearce Institute. It was through //BUZZCUT// that Nick got to know Adrian Howells closely as he was a mentor to the festival and part of the programme selection panel. Adrian had also shown work at //BUZZCUT// satellite events. Nick is also working as programmer of live events at Stereo Cafe Bar in the city centre of Glasgow working alongside Iain Findlay Walsh.

Laura Bissell is a Lecturer in Contemporary Performance Practice at the Royal Conservatoire of Scotland and teaches on the MRes in Creative Practices at Glasgow School of Art. Laura has previously taught at the University of Glasgow and for the Transart Institute in Berlin. Laura is Associate Editor of the journal *Theatre, Dance and Performance Training* and is on the board of A Moment's Peace Theatre Company. Laura has published her research in the *International Journal of Performance Art and Digital Media*, *Contemporary Theatre Review* and *Body, Space, Technology* amongst others. Laura's research interests include: contemporary performance practices and methodologies; technology and performance; feminist performance and performance and journeys. Laura recently co-authored an article for *Contemporary Theatre Review* titled 'Early Days: Reflections on the Performance of a Referendum' with David Overend (UWS) exploring the role of performance during the Scottish Independence Referendum.

Laura Bradshaw is a performance maker and Lecturer in Contemporary Performance Practice at the Royal Conservatoire of Scotland. Since 2005 Laura has made both solo and collaborative works including *29/92 (Phyllis)* (2012), *An Invitation to the Dance* (2010-12), *Terra Incognita* series with Murray Wason (2009-13), *Afterwards* with Murray Wason (2015), *Trilogy* by Nic Green (2007-10), *It is Like it Ought to Be (A Pastoral)* by Uninvited Guests (2006-08), *Otter Pie, Bicycle Boom and Near and Far* by Fish and Game/ Eilidh MacAskill (2006-14), and *Waiting for the Sun to Rise with Tashi Gore* (2015). In 2012, Laura completed an MA in Dance and Somatic Wellbeing where she began her research into 'The Ancestral Body', which she delivered as a paper at the Dance and Somatic Practices Conference in 2015. Laura is currently developing a sited performance for families in response to the sea stories of British folklore and the nature of water in the human body. She is also one of the artists behind 'Intergenerational Dance Party', which launched in October 2015 as part of Luminate.

Rosana Cade is a queer artist based in Glasgow, Scotland. For her, queerness means rebellion, imagination and celebration. Rebel passionately against anything that tells you how to be normal, wildly imagine new ways of being/doing/thinking/seeing/moving, celebrating ferociously all those who are under-celebrated. Rosana created *Walking: Holding* in 2011, which has since been shown extensively across the UK and internationally, and continues to tour across the world to great acclaim. Along with her best friend Nick Anderson, Rosana is co-founder of //BUZZCUT//, a collaboration between two artists in Glasgow dedicated to creating holistic and progressive environments for artists and audiences to experiment with live performance across Scotland and beyond. They host an annual five-day festival, and also work with other organisations throughout the year to create different opportunities for artists.

Jon Cairns is a Senior Lecturer in Fine Art at Central Saint Martins. His work on art and intimacy has appeared in *Contemporary Theatre Review*, and he edited a special issue of *Visual Culture in Britain* on art's value in the context of recession (2013). Previous collaborative practice with artist Julia Spicer has included writing, online work and curation, centring on explorations of the fictive and the fabulatory, in, for example, *The Art of Queering in Art,* ed. by Henry Rogers (2008).

Tim Crouch is a Brighton-based theatre maker. He was an actor before starting to write and he still performs in much of his work. His plays include *My Arm*, *ENGLAND (a play for galleries)*, *An Oak Tree*, and (with Andy Smith) *what happens to the hope at the end of the evening*. For the Royal Court, his plays include *Adler & Gibb* (2014) and, in 2009, *The Author*. Adrian Howells was a cast member of *The Author* for its London run. Tim also writes for younger audiences: a series of plays inspired by Shakespeare's lesser characters includes *I, Malvolio*. For the Royal Shakespeare Company, Tim has directed *The Taming of the Shrew*, *King Lear*, and *I, Cinna (the poet)* – all for young audiences. Tim is published by Oberon Books.

Jennifer Doyle is Professor of English at the University of California, Riverside. She is the author of *Campus Sex/Campus Security* (2015), *Hold It Against Me: Difficulty and Emotion in Contemporary Art* (2013), and *Sex Objects: Art and the Dialectics of Desire* (2006).

Marcia Farquhar is known for her work in performance, installation, audio arts and object making. Conceptual in nature, much of her practice revolves around the stories and interactions of everyday life, as well as the engineering of unexpected social interactions in which the distance between audience and performer is frequently breached. Her site-specific events have been staged and exhibited internationally in museums and galleries, as well as in cinemas, kitchen showrooms, pubs, parks and leisure centres.

Lucy Gaizely is a producer and maker of new work, encompassing live art practice, participation and hybrid art forms, with a particular focus on diversity. She makes performance art that interrogates motherhood and society's collective (or not) responsibility to this, and works collaboratively as an artist with Gary Gardiner, developing arts projects through 21st Century Challenges and Off The Rails. She recently left her role as Creative Learning Programmer at The Arches, Glasgow. Lucy managed an annual programme of participatory and public arts events, artistic residencies, talent development and supported the curation of Behaviour, The Arches annual international festival. Lucy has produced the work of the renowned international performance group Mammalian Diving Reflex, as well as Janice Parker, Adrian Howells, Peter McMaster, Catrin Evans and Solar Bear. She is a board member of award winning performance company (G) lass Performance and an advisor of the arts for Sense Scotland.

Gary Gardiner is a performer, director, producer and creative learning practitioner, working across a range of local and international contexts. He is the Artistic Director of 21 Century Challenges, which pioneers arts education practice and contemporary performance work. Gary is an advisor and assessor for the nationally accredited Arts Award and currently works as Lecturer in Applied Performance at the Royal Conservatoire of Scotland. Gary is particularly focused on both the engagement and knowledge exchange aspects of the arts and social enterprise as tools for sustained personal and social change. Key themes in Gary's work are critical and creative learning; knowledge exchange; equality and human rights; democracy and social justice; gender and capitalism. Recent works include *Santa: A Very Merry Businessman* (5 stars) and *Thatcher's Children* (4 stars) for which he won The Arches Platform 18 Award in 2012.

Kathleen M. Gough is an Assistant Professor and resident dramaturge in the Department of Theatre at the University of Vermont. From 2006 to 2014 she was a Lecturer in Theatre Studies in the School of Culture and Creative Art at the University of Glasgow. Katie recently published *Kinship and Performance in the Black and Green Atlantic* (Routledge, 2013), which won the 2014 Errol Hill Award for outstanding scholarship in African-American Theatre and Performance from the American Society for Theatre Research. More recently, she has been writing about the way sound and image – particularly as they are conceptualized in Byzantine and medieval culture – can be put to greater critical use in understanding current trends in contemporary experimental performance. Katie is also devising a conceptual storytelling project that works at the intersection of medieval and digital culture, and will culminate in an autobiographical surrealistic performance.

Nic Green works across the fields of Live Art, New Performance and Place-Based Practice. Her diverse and comprehensive art-making spans award-winning dance/theatre performance, community and public art projects and musical/audio composition. She remains committed to the study and development of a practice which can be named as *ecological* in its nature, in the sense that her practice focuses on the study of reciprocal relationships encountered and examined through immersive, time and place-based processes. The political aim of this work is to (re)understand and (re)present the narrative of the individual as a part of a mutually dependent relational paradigm, or a *gestalt ontology*. Her work has been presented both nationally and internationally to critical acclaim, winning 'Best Production' at Dublin Fringe, a Herald Angel at Edinburgh Fringe and The Arches Award for Stage Directors. She currently lives afloat the River Clyde in Glasgow, Scotland.

Stephen Greer is Lecturer in Theatre Practices at the University of Glasgow where his work focuses on the intersection of queer theory and contemporary culture. He is the author of *Contemporary British Queer Performance* (2012), a book about the politics of collaboration. His recent publications include essays on disidentification in the work of Slavoj Žižek, visibility in the BBC's *Sherlock* and the design of sexuality in mass-market videogames. He is currently writing a monograph on solo performance and the politics of the exceptional subject.

Shelley Hastings has worked at Battersea Arts Centre for the last ten years as a Senior Producer, commissioning, supporting, and developing work with some of the most exciting and influential artists working today, often from the beginning of their careers. These artists include Nic Green, Adrian Howells, The TEAM and Rachel Chavkin, 1927, Adam Bohman, Abigail Conway (subject to_change) Sleepwalk Collective, Geraldine Pilgrim, Kneehigh Theatre, Ridiculusmus, and Daniel Kitson. She was a lead programmer of Battersea's BURST festival of live art and music from 2006 to 2009. Shelley has also worked freelance for the Wellcome Trust and NT Studio and has written about performance for Fierce

Festival and Live Collison. Shelley was one of the first graduates of the National Theatre's Step Change Programme where she was seconded to LIFT festival, is a former Bristol raver, and mum of Milly and Herbie.

Deirdre Heddon is Professor of Contemporary Performance at the University of Glasgow. She is the author of *Autobiography and Performance*; co-author of *Devising Performance: A Critical History*; and co-editor of *Histories and Practices of Live Art*, as well as *The National Review of Live Art 1979-2010: A Personal History (Essays, Anecdotes, Drawings and Images)*, and *Political Performances: Theory and Practice*. Dee is also a contributor to *Walking, Writing and Performance: Autobiographical Texts*. Her work has been published in numerous journals including *Performance Research, Research in Drama Education,* and *Contemporary Theatre Review*. She also undertakes practice-based research: *The Walking Library* is an ongoing project with Misha Myers, whilst *40 Walks* was completed recently. Dee is co-editor of a series for Palgrave, *Performing Landscapes,* for which she is writing *Performing Landscapes: Forests*. She was Adrian Howells' academic mentor from 2006 onwards.

Helen Iball launched the research project 'Theatre Personal: Audiences with Intimacy' in 2009, with published outcomes to-date in *Contemporary Theatre Review, Performing Ethos, Critical Live Art,* and *Performing Site-Specific Theatre*. Dialogues and workshop collaboration with practitioners were fundamental to her recent publications on Bobby Baker, Tim Crouch, and Adrian Howells. Whilst her longstanding interests are in contemporary British theatre, the trans-disciplinary span of Helen's work has expanded with her interest in the potential applications of 'interactive' theatre, which her current project explores in relation to empathy and compassion. Helen teaches in the Workshop Theatre, School of English at the University of Leeds.

Dominic Johnson is a Senior Lecturer in the School of English and Drama, at Queen Mary University of London. He is the author of *Glorious Catastrophe: Jack Smith, Performance and Visual Culture* (2012); *Theatre & the Visual* (2012); and most recently, *The Art of Living: An Oral History of Performance Art* (2015),

which includes an interview with Adrian Howells. He has edited four books, including *Critical Live Art: Contemporary Histories of Performance in the UK* (2012). He is an Editor of the journal *Contemporary Theatre Review* (with Maria M. Delgado and Maggie B. Gale). He is a Series Co-Editor of 'Intellect Live', co-published by Intellect and Live Art Development Agency, which includes his edited book *Pleading in the Blood: The Art and Performances of Ron Athey* (2013).

Ian Johnston has blazed a trail for other artists and performers who have complex communication support needs. He is a dancer, actor and performer, and over the last few years has held a number of leading roles in contemporary performances presented by Sense Scotland, as well as collaborating widely with organisations such as Dance Ihayami, Artform and Indepen-Dance and performing at Edinburgh International Festival. Ian is dedicated to his creative practice and during his time with Sense Scotland has developed a relationship with Jon Reid his arts tutor. Through this Ian has not only performed in many works created under Jon's direction; he now has a facilitation role in the drama group where he guides and takes the lead supporting his fellow artists.

Stewart Laing is Artistic Director of Untitled Projects, which he formed in 1998. Projects for the company include: *J. G. Ballard Project* (1998-2000); *blind_sight*, 2004; *Slope* (2006); *An Argument About Sex* (2008); *The Salon Project* (2011 and 2013); *Paul Bright's Confessions of a Justified Sinner 2013*, (2014 and 2015); and *Slope Redux* (2014). Other directing work includes *The Homosexual* (Tramway); *Brainy* (CCA); *Happy Days* (Tramway, Traverse); *The Father, The She Wolf, A Long Days Journey into Night, Medea, The Pleasure Man*, *Dance of Death, The Maids* (Citizens); *Home: Stornoway*. (National Theatre of Scotland); *Les Parents terrible, Titus Andronicus* (Dundee Rep); *10 Plagues* (Traverse); *Ophelia* (Oran Mor). Stewart also directs opera, including: *Così fan tutte, La bohème* (Scottish Opera); *L'heure espagnole, The Breasts of Tiresias* (Grange Park Opera); *Tosca* (Norrlandsoperan); *Faust, Dead Man Walking, La fanciulla del West, La vie parisienne* (Malmo Opera); *La fedeltà premiata* (Bavarian State Opera's Opera Studio). www.untitledprojects.co.uk

Peter McMaster is an award-winning experimental performance- and theatre-maker based in Glasgow, Scotland. Artistic works under his directorship span from educational and community projects to international touring studio-based performance works and research. Peter likes to imagine his works fulfill a function of destabilizing what is perceived as 'normal', particularly within the realms of hegemonic masculinities, as well as contributing to the cultural and artistic landscape of Scotland and beyond. He has received commissions from organisations and venues such as The Arches, Glasgow; National Theatre of Scotland; the British Council; Live Art Development Agency; Battersea Arts Centre; and In Between Time, Bristol. He has been a tutor on the BA Contemporary Performance programme at the Royal Conservatoire of Scotland for four years. He has a dog and lives on a boat. www.petermcmaster.org @mcmaster_peter

Robert Softley Gale is an established figure in the Scottish arts scene as actor and performer, writer, artistic director and advocate of equality of access to the arts for disabled people. Robert's professional acting debut was with Theatre Workshop (Edinburgh). Since then he has appeared in many productions and has developed his own artistic practice – including instigating, co-writing and performing in *Girl X* for the National Theatre of Scotland. His award-winning writing debut and solo performance – *If These Spasms Could Speak* – was a hit of the 2013 Made in Scotland programme and has subsequently toured internationally to countries including Brazil and India. A graduate of Glasgow University with an MSc (Hons) in Business and Management, Robert is an Artistic Director of Birds of Paradise Theatre Company, Scotland's touring company that promotes the work of disabled artists. Robert also sits on the board of the National Theatre of Scotland.

Caridad Svich is a playwright. She received the 2012 OBIE Award for Lifetime Achievement in the theatre, and the 2011 American Theatre Critics Association Primus Prize for her play *The House of the Spirits*, based on Isabel Allende's novel. She has twice won the National Latino Playwriting Award, and has been shortlisted for the PEN Award in Drama four times.

Among her key works are *12 Ophelias, Iphigenia Crash Land Falls…* and *JARMAN (all this maddening beauty)*. Seven of her plays are published in *Instructions for Breathing and Other Plays* (Seagull Books/University of Chicago Press, 2014). Five of her plays radically re-imagining ancient Greek tragedies were published in *Blasted Heavens* (Eyecorner Press/University of Denmark, 2012). She has edited several books, among them *Innovation in Five Acts* (TCG, 2015). She is associate editor of *Contemporary Theatre Review*. www.caridadsvich.com

Jess Thorpe is co-Artistic Director of the critically acclaimed performance company Glas(s) Performance and co-creator and director of the award winning young company, Junction 25. She is the Visiting Lecturer in the Arts in Social Justice at the Royal Conservatoire of Scotland in Glasgow. In this role she is involved with designing creative projects with Scottish prisons and communities affected by crime. Through this work she a founder and current steering group member for the Scottish Prison Arts Network (SPAN) and author of the publication *Working in Scottish Prisons: An Artists Guide*. Jess is also currently a trustee and artist with the International Schools Theatre Association and has directed projects and led creative consultancies in schools across the world including South Korea, Malaysia, and Russia.

Fintan Walsh is Senior Lecturer in Theatre and Performance Studies in the Department of English and Humanities at Birkbeck, University of London, where he is Co-Director of the Centre for Contemporary Theatre. His recent publications include *Queer Performance and Contemporary Ireland Dissent and Disorientation* (2015), *Theatre & Therapy* (2013), and *Male Trouble: Masculinity and the Performance of Crisis* (2010); and the edited collection *'That Was Us': Contemporary Irish Theatre and Performance* (2013). He is Associate Editor of *Theatre Research International*.

Robert Walton is a collaborative artist whose work spans theatre, installation, writing and media art. His core studio practice is as a theatre director and dramaturg. Throughout his career he has also created interdisciplinary live art works that are more difficult to categorise including correspondence projects, durational performances, events for small groups or one-to-ones, interactive encounters and work with portable media devices. His research interests include performance pedagogy, practice as research, smartphones, mobile screens, theatre and everyday life, immersion, transmediality and live art. Robert co-founded Reader Performance Group in 2001 and Fish & Game in 2005. He leads the Honours programme in Theatre Practice at The Victorian College of the Arts, The University of Melbourne.

Murray Wason is a performance artist and filmmaker from Glasgow. He is currently a visiting artist and tutor at the Royal Conservatoire of Scotland where he previously studied on the BA (Hons) Contemporary Theatre Practice. His work often focuses on themes of masculinity, identity and ritual. Murray frequently collaborates with other artists in ensemble creative processes to realise live performances and events. He recently performed in Peter McMaster's *Wuthering Heights*, which was a recipient of The Arches Platform 18 award and has toured the UK. Murray has previously performed and collaborated with Live@ LICA, Glasgow City's Culture and Sport, Glasgow Commonwealth Games, Nic Green, Tim Crouch, Lieux Publics, Fish & Game, Mischief La-Bas, Grace Surman, Adrian Howells, Glas(s) Performance, Gary Gardiner, and Kieran Hurley. His performance and film work has been presented at several international festivals including Edinburgh Fringe, Behaviour Festival at The Arches, Imaginate Festival, Manipulate, //BUZZCUT// Festival, and the National Review of Live Art.

Jackie Wylie is a Glasgow-based arts producer and programmer. During her decade at The Arches, first as Arts Programmer and then from 2008 as Artistic Director and joint Chief Executive, Wylie transformed the venue into one of the major European centres of contemporary performance. She established the Behaviour Festival in 2009, with a focus on ground-breaking international companies including Mammalian Diving Reflex, Ontroerend Goed, Gob Squad, The TEAM, Ann Liv Young, Taylor Mac, and Tim Crouch. Its partnerships included the National Theatre of Scotland, Citizens and Traverse Theatres,

Glasgow Museums, Conflux and the CCA. She is equally proud to have developed new Scottish work, receiving multiple Herald Angel, Total Theatre, CATS and Fringe First awards and touring as widely as the National Theatre's Shed, Brazil, Brits Off Broadway and the Spoleto, Sydney, New Zealand, Push and Hong Kong festivals. Her former experience was in film and television as a location scout and unit manager and she is currently being supported by Creative Scotland and Glasgow Life to lead a project that considers The Arches' 25-year legacy.

Rachel Zerihan is a Lecturer in Theatre and Performance at the University of Sheffield. Her PhD thesis examined 'Catharsis in Works of Contemporary Female Performance' (Roehampton University, 2009), out of which developed an ongoing interest in one-to-one performance. Rachel has published on this and other related subjects in international peer-reviewed journals including *Theatre Research International* and *Contemporary Theatre Review* and she was commissioned by the Live Art Development Agency to write its Study Room Guide on one-to-one performance (2008). Recent projects include co-editing a special issue of *Performing Ethos* journal on ethics in one-to-one performance (2014) and co-editing two publications with her long-term collaborator, Maria X, namely *Intimacy Across Visceral and Digital Performance* (2012), and *Interfaces of Performance* (2009). Maria and Rachel are currently co-editing a volume on Live Art in the UK, due for publication by Methuen in 2016. Rachel is also currently working on the first monograph on one-to-one performance due for publication by Palgrave MacMillan in 2016.

Acknowledgements

Creating a book about the work of Adrian Howells for the series *Intellect Live* has been a bittersweet endeavour from the start. Co-published by Intellect Books and the Live Art Development Agency, *Intellect Live* provides invaluable space for a close focus on influential artists working in and across performance forms. It also presumes close collaboration between the artist and other writers, with the format to date proposing the partnering of an artist with an informed scholar. Whilst the word 'live' in the title of the series signals a mode of performance practice (live performance, live art), when held against the devastating background – or foreground – of Howells' death, it reverberates also with the capacities of aliveness and the living. *Intellect Live* is a series by and about 'live' artists: those who not only make live art, but who live and breathe amongst us. *Intellect Live* then, as a home for a book about Adrian Howells, seemed a bitter irony. But the very rationale for the series – to focus on influential artists working at the edges of performance – also suggested it as the ideal place for the first substantial and comprehensive study of, and engagement with, Howells' extensive catalogue of performance practice. It goes without saying that we would much prefer it if Howells had been here, collaborating with us directly on the production of this – his – book. And yes, we do wish we had proposed this collaboration whilst he was still a *live* artist.

Our deep immersion in Howells' papers, performances, writings and the vast store of memories we and others carry of him at least made it feel like Howells was with us, in some ways, throughout our emotional labour. This is the 'sweet' part of this bittersweet project – thinking and writing about Howells has been a means of keeping him close at hand still. He has been in our dreams and thoughts, conversations and discussions, emails and telephone calls. We speak of him and we speak to him; and, so, we acknowledge that this act of testimony has accompanied us at least some of the way through the difficult process of mourning.

Our relationships with Adrian motivated the writing of this book. Deirdre (Dee) Heddon first met Adrian in 2005, soon after her appointment as Senior Lecturer in Theatre Studies at the University of Glasgow. Her colleague Professor Adrienne Scullion, alert to Dee's developing monograph on autobiography and performance, introduced her to Adrian and invited them to work together on a funding application for an Arts and Humanities Research Council (AHRC) Fellowship in the Creative and Performing Arts. The application proved successful and Adrian worked at the University of Glasgow as an AHRC Creative Fellow from 2006 to 2009. A condition of the award was the appointment of an academic mentor, a role fulfilled by Dee for the duration of the fellowship. Dee and Adrian had regular meetings – much like a PhD supervision schedule – to discuss theoretical texts, emerging ideas, developing practice, and the methodology of practice-led research. Dee participated in and provided feedback on Adrian's work as it developed. She also supported subsequent funding applications submitted by Adrian to the AHRC, co-produced a final symposium (*i confess…*, Glasgow 2009) and collaborated on writing for publication.

Dee and Adrian were committed to a model of mutual benefit: Dee wrote about his work in her monograph *Autobiography and Performance,* Adrian taught on Dee's course, 'Autobiography and Performance' (his one session always singled out by students as the highlight of the whole course), and led a number of practice-based options on the undergraduate curriculum. Both were invited to Singapore by the British Council to participate in a symposium on auto/biography and performance organised jointly by the British Council and the National University of Singapore (Howells presented *An Audience with Adrienne* there, whilst Heddon co-curated a platform of speakers addressing auto/biographical performance in South East Asia). The relationship between Dee and Adrian proved hugely generative. The AHRC Fellowship ended in 2009. Seeking to extend the productive collaboration,

Dee submitted an application to the University of Glasgow for Adrian to be appointed as an Honorary Research Fellow – a non-remunerated role but one allowing access to resources and the retention of a formal relationship with the University. This too was successful and Dee continued to act as Adrian's mentor. Throughout their relationship, Adrian flatteringly introduced Dee to everyone in his network as his 'expert mentor'. Dee's role, meanwhile, was to introduce Adrian to the world – to set the stage for him and then hand it over to him; a role she continues with the preparation of this book. At their first meeting in Glasgow, in 2005, Dee informed Adrian that she had just returned to Scotland, having lived in Devon for the preceding seven years. From that moment, they referred to each other as 'my lover', a familiar, everyday Devonian term of endearment: 'all right my lover?'

Dominic Johnson's relation to Adrian was more exclusively that of a friend. They met in a doorway on Broadway at a performance studies conference in New York in 2007, and met frequently in subsequent years, at theatre and live art events (including at each others' performances) and elsewhere. Dominic invited Adrian to give guest lectures on courses he taught at Queen Mary University of London, and was attempting to secure Adrian a non-stipendiary position as an Honorary Fellow at Queen Mary at the time of his death. Adrian and Dominic's friendship included plenty of talk – by turns both bawdy and frank – of sex and sex workers, gay histories and gay lives, depression, anomalous methods of care of the self, feeling toxic, and getting better. Dominic and Adrian enjoyed each other's senses of humour, and ribald tendencies, and took pleasure in the others' self-protective shows of unshockability. Adrian was particularly amused when, after inviting Dominic to speak as a respondent at *i confess…*, Dominic compared one-to-one performance to sex work, which put a number of well-meaning contributors' noses out of joint. A productive outcome of their friendship was the extended critical interview published here, which was recorded a year before Adrian died.

So, first and foremost, we thank our friend Adrian, for whom this book was made. We want to say 'without whom it wouldn't have been possible', but the sad fact is that we made it *without him*, and it would have been possible – and ultimately more pleasurable – to make this book with Adrian's active collaboration. With and without, though, we prize his friendship, and his permanent influence.

Others made the present book possible. Lois Keidan and CJ Mitchell at the Live Art Development Agency commissioned this book, and have been unflinching in their support for the project. We thank them and their colleagues at the Live Art Development Agency.

We thank the archivists at the Adrian Howells Collection, Scottish Theatre Archive, University of Glasgow, who allowed us unrestricted access to Howells' papers and recordings. Thanks too go to Adrian's family, especially his brother, Julian Howells, and their father, Danny Howells – they gave their blessings for this project and permission to reproduce materials from Adrian's archive, including images and published and unpublished writings.

We are grateful to Creative Scotland, the University of Glasgow, Battersea Arts Centre, The National Theatre of Scotland, Queen Mary University of London, and the Society for Theatre Research for providing funding to support the project in its various stages.

Immense thanks go to our designer, David Caines, for his insight, creativity, patience and empathetic sensitivity. We imagine that Adrian would have fallen in love with David and we are sorry they didn't get to meet.

We thank Harriet Curtis and Lucy Amsden for providing research assistance, and Eleanor Roberts for copyediting and additional support in preparing the manuscript for publication.

No book is launched without a party, so thanks to our launch party hosts (and friends of Adrian): Shelley Hastings and her superb team at Battersea Arts Centre; and Tony Sweeten at the University of Glasgow.

We are grateful for the time given and care shown by all of our contributors and for their commitment to this project. For each of them, too, this was a bittersweet endeavour and a labour of love. We also thank those who contributed to the biographical survey chapter: Richard and Joy Wolfenden-Brown, Arthur Pritchard, and Beatie Edney, who provided details about Adrian's time at Bretton Hall; and Giles Havergal, for discussing Adrian's years at Citizens Theatre. There are so many hilarious stories to tell of Adrian, and we are sorry we didn't have the space to include more. Thanks also to Graham Clayton-Chance for providing access to archival recordings of Nigel Charnock + Company featuring Adrian, and to Michael McCann, Roberta Doyle, Ella Finer, Dan Prichard, Laura Nanni, Jane Marriott, Itay Yatuv and Jeanette Berrie for all their assistance.

We aspired for this book to be filled with textures, colours, emotions and aesthetics. We wanted it to be beautiful, informative, and engaging. Capturing something of the 'spirit' of Adrian – his personhood and his work – was dependent in large part upon to the range and quality of photographs we had access to. We offer our immense thanks to the photographers for their permission to reproduce their images of Adrian: these include Hamish Barton, Niall Walker, Marko Waschke, Ed Collier, Hugo Glendinning, Stewart Laing, Manuel Vason, and others.

A number of chapters in the present book have been previously published. Dominic Johnson's 'Held: An Interview with Adrian Howells' was previously published in the author's book *The Art of Living: An Oral History of Performance Art* (Basingstoke and New York: Palgrave Macmillan, 2015), pp. 262-85. The short chapter titled 'On *The Homosexual*' by Adrian Howells has been excerpted from the same source.

Deirdre Heddon and Adrian Howells' essay 'From Talking to Silence: A Confessional Journey' was first published in *PAJ: A Journal of Performance and Art*, 33.1 (2011), 1-12. We thank Bonnie Marranca for permission to reproduce this essay. An earlier version of Jon Cairns' chapter 'My Audiences with Adrian: Performance, Photography and Writing the Intimate Encounter' was published as 'Ambivalent Intimacies: Performance and Domestic Photography in the Work of Adrian Howells', *Contemporary Theatre Review*, 22.3 (2012), 355-71. Caridad Svich's 'You and I: On Theatre and Audience (With a Nod to Adrian Howells)' was published on the blog *TCG Circle: Audience (R) Evolution*, 2015: http://www.tcgcircle.org/2015/03/you-and-i-on-theatre-and-audience-with-a-nod-to-adrian-howells/. The chapter by Deirdre Heddon, Helen Iball, and Rachel Zerihan is an abridged version of 'Come Closer: Confessions of Intimate Spectators in One to One Performance', *Contemporary Theatre Review*, 22.1 (2012), 120-33. Adrian Howells' essay on *Footwashing for the Sole* was published as 'Foot Washing for the Sole', *Performance Research*, 17.2 (2012), 128-31. Finally, Helen Iball's chapter is an abridged version of her article 'Towards an Ethics of Intimate Audience', *Performing Ethos: An International Journal of Ethics in Theatre and Performance*, 3.1 (2013), 41-57.

Index